THE PEACEFUL LIBERATORS Jain Art from India

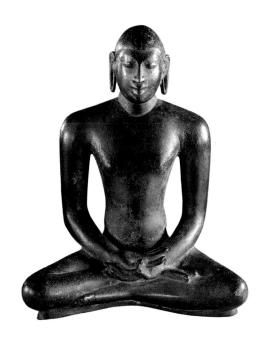

WANDSWORTH LIBRARY SERVICE

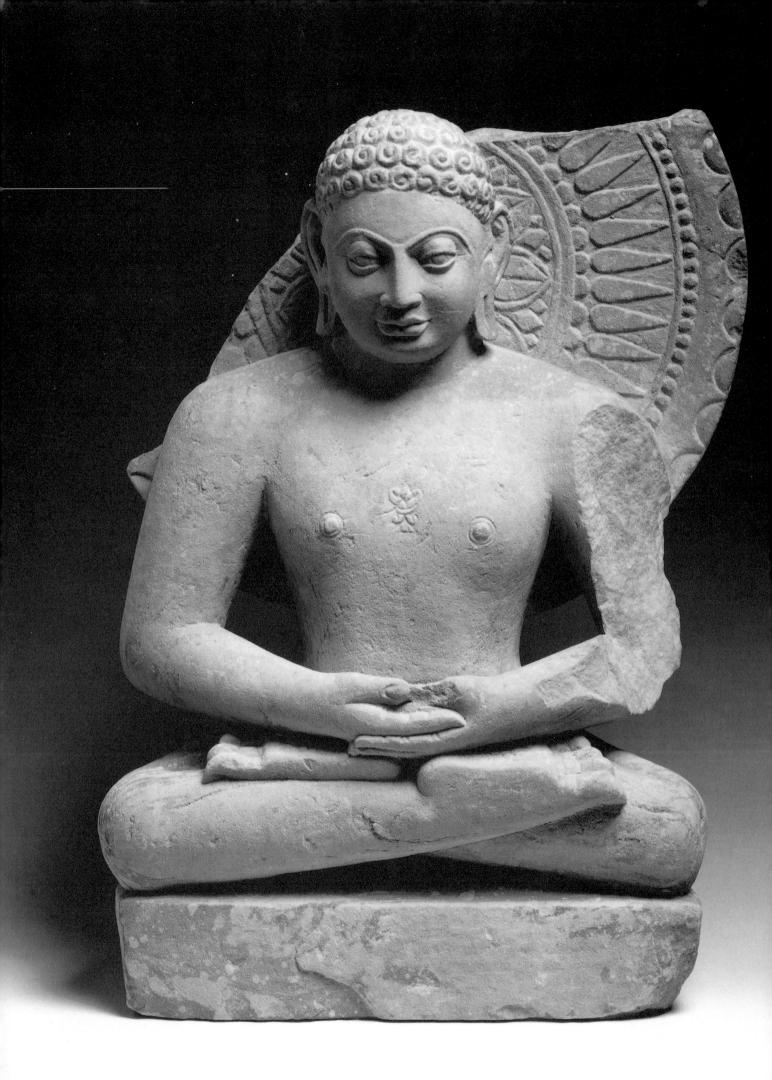

THE PEACEFUL LIBERATORS

Jain Art from India

PRATAPADITYA PAL

with contributions by
SHRIDHAR ANDHARE
JOHN E. CORT

SADASHIV GORAKSHAKAR
PHYLLIS GRANOFF
JOHN GUY

GERALD JAMES LARSON
STEPHEN MARKEL

THAMES AND HUDSON
LOS ANGELES COUNTY MUSEUM OF ART

Exhibition Itinerary

Los Angeles County Museum of Art November 6, 1994—January 22, 1995

Kimbell Art Museum March 5—May 28, 1995

New Orleans Museum of Art July 15—September 17, 1995

Victoria and Albert Museum November 2, 1995—January 21, 1996 Copublished by

Los Angeles County Museum of Art 5905 Wilshire Boulevard Los Angeles, California 90036

and

Thames and Hudson Ltd. 30 Bloomsbury Street London wcib 3QP

This book was published in conjunction with the exhibition *The Peaceful Liberators: Jain Art from India*, which was organized by the Los Angeles County Museum of Art. The exhibition was funded in part by generous grants from the National Endowment for the Humanities and the National Endowment for the Arts.

Additional funding was provided by the Lanai Institute for Business and Culture, the Indo-U. S. Subcommission on Education and Culture, Sotheby's, Mr. Navin Kumar, Dr. and Mrs.

Narendra L. Parson, Suresh and Vimala Lodha, the International Mahavir Jain Mission-Siddhachalam, and the Brotman Foundation of California.

Additional funds for the presentation of the exhibition at the New Orleans Museum of Art were provided by Kirit R. Jasani, Nikhil P. Manilal, Mahendra M. Mehta, Prabodh K. Mehta, Mahendra C. Parikh, and Vijay S. Shah.

Copyright © 1994 by Museum Associates, Los Angeles County Museum of Art. All rights reserved. No part of this book may be reproduced or utilized in any form or by any means, electronic or mechanical, including photocopying, recording, or by any informationstorage and -retrieval system without permission in writing from the publisher.

British cataloguing-in-publication data. A catalogue record for this book is available from the British Library.

ISBN: 0-500-27870-9 LCC: 94-61006

Printed in Hong Kong

COVER/JACKET:
A Digambara Jina, Karnataka
or Tamilnadu; 850—900
CAT. 46

FRONTISPIECE:

A Jina, Uttar Pradesh, Mathura
2nd—3rd centuries
CAT. 16

CONTENTS

- Foreword 6 Lenders to the Exhibition 7 8 Preface PRATAPADITYA PAL Acknowledgments 9 Note to the Reader and Map of India 10 Introduction PRATAPADITYA PAL 13 Following the Jina, Worshiping the Jina: 39 An Essay on Jain Rituals 2 JOHN E. CORT Are Jains Really Hindus? Some Parallels and Differences between 57 Jain and Hindu Philosophies & GERALD JAMES LARSON Jain Pilgrimage: In Memory and Celebration of the Jinas 63 2▶ PHYLLIS GRANOFF Jain Monumental Painting 2 SHRIDHAR ANDHARE 77 Jain Manuscript Painting 2 JOHN GUY 89 Catalogue of the Exhibition 101 102 Architectural Pieces Ritual Objects and Symbols 118 Images of Jinas 126 Images of Deities 168 The Art of the Book 198 The Cosmic and Mortal Realms
 - 258 Appendix
 - 262 Bibliography
 - 272 Index

FOREWORD

The Peaceful Liberators: Jain Art from India is the most comprehensive presentation to date of the artwork emerging from the Jain religion. The Jains, despite their rigorous ideal of nonattachment to the physical world, have produced a cultural heritage paradoxically regal in its imaginative splendor and its physical realization.

The approximately 150 works in this exhibition, spanning nearly two millennia and displaying an astonishing variety of modes and styles, reveal the presence of a major artistic tradition unfortunately little known in the West. We are pleased to help remedy that situation by coordinating this comprehensive exhibition.

A major undertaking of this sort cannot be successful without the cooperation of many people and funding agencies. The museum is especially indebted to the National Endowment for the Humanities and the National Endowment for the Arts, without whose generous support the exhibition would have remained an unfulfilled dream. The Lanai Institute for Business and Culture, the Indo-U. S. Subcommission on Education and Culture, Sotheby's, Mr. Navin Kumar, Dr. and Mrs. Narendra L. Parson, Suresh and Vimala Lodha, the International Mahavir Jain Mission-Siddhachalam, and the Brotman Foundation of California provided additional funding.

It is especially gratifying that so many collectors and museums around the world have responded so favorably and have agreed to share their objects so generously. It is also a pleasure that the exhibition will travel to the Kimbell Art Museum, Fort Worth, the New Orleans Museum of Art, and the Victoria and Albert Museum, London. A special note of thanks is due to the Prince of Wales Museum, Bombay, and its director, Mr. Sadashiv Gorakshakar, for agreeing to act as the nodal agency for coordinating the Indian loans. We also express our gratitude for their cooperation to Mr. G. Venkataramani, Director of Culture for the government of India, and to Sushil Dubey, the Indian Consul General in San Francisco.

Finally, we would like to thank Dr. Pratapaditya Pal, senior curator of Indian and Southeast Asian Art, and the other members of his department, for the tremendous efforts they have made in bringing *The Peaceful Liberators: Jain Art from India* to fruition.

WILLIAM A. MINGST

President

Board of Trustees

Los Angeles County Museum of Art

LENDERS TO THE EXHIBITION

The Art Institute of Chicago Asian Art Museum of San Francisco Dr. Alvin O. Bellak, Philadelphia Dr. and Mrs. Siddharth Bhansali, New Orleans C. L. Bharany, New Delhi, India Bharat Kala Bhavan, Varanasi, India The British Museum, London, England Central Museum, Nagpur, India Jean-Claude Ciancimino, London, England The Cleveland Museum of Art Stan Czuma, Cleveland The Denver Art Museum Anthony d'Offay, London, England Robert Hatfield Ellsworth Personal Collection, New York R. H. Ellsworth, Ltd., New York Figiel Collection, Atlantis, Florida Collection of Berthe and John Ford, Baltimore Frei Collection, Pfaffhausen, Switzerland Government Museum, Madras, India Government Museum, Mathura, India Chester and Davida Herwitz Family Collection, Worcester, Massachusetts Indian Museum, Calcutta, India Dr. Jaipaul, Philadelphia Jina Collection (Arthur M. Sackler Gallery, Smithsonian Institution) Kapoor Galleries, Inc., New York Subhash Kapoor, New York Ravi Kumar, New York Lalbhai Dalpatbhai Institute of Indology, Ahmedabad, India Linden-Museum, Stuttgart, Germany Los Angeles County Museum of Art,

Terence McInerney, New York The Metropolitan Museum of Art, New York The Minneapolis Institute of Arts Dr. David R. Nalin, West Chester, Pennsylvania National Museum, New Delhi, India The Nelson-Atkins Museum of Art, Kansas City, Missouri The New York Public Library Nitta Group, Tokyo, Japan Norton Simon Collection, Los Angeles The Norton Simon Foundation, Pasadena, California Paul Nugent, Melbourne, Australia Mrs. Carola Pestelli, Turin, Italy The Pierpont Morgan Library, New York Prince of Wales Museum of Western India. Bombay, India Royal Ontario Museum, Toronto, Canada The Russek Collection, Maennedorf, Switzerland San Diego Museum of Art, California Seattle Art Museum, Washington Gursharan and Elvira Sidhu, Menlo Park, California Raphael Star, San Francisco State Museum, Lucknow, India Peter and Susan Strauss, Beverly Hills, California Victoria & Albert Museum, London, England Virginia Museum of Fine Arts, Richmond Paul F. Walter, New York Doris and Nancy Wiener, New York

Private collections

Los Angeles

PREFACE

Of all the artistic traditions of India that of the Jains is the least known. Even though Jainism is older than Buddhism, the latter is far more familiar to the world at large. Buddhism, like Christianity and Islam, became a universal religion. Jainism did not, partly because of a lack of interest in proselytizing and partly due to strictures placed upon the travels of Jain monks.

Ever since the "discovery" of Indian religions and cultural achievements by the Europeans beginning in the seventeenth century, Hinduism and Buddhism have been regarded as the principal religions of India, even though Buddhism ceased to be a major presence there after the sixteenth century, and Jainism has flourished continually to this day.

Reflecting this attitude of benign neglect among art historians, museums in Europe and America have shown little interest in the art created to serve the Jain faith. In most exhibitions of Indian art the emphasis has been on the Hindu, Buddhist, and Islamic traditions. Primarily to redress that imbalance I decided some six years ago to develop an exhibition consisting entirely of Jain art.

The task of organizing such an exhibition has been more difficult than I anticipated. It soon became apparent that a comprehensive presentation of Jain art, with an emphasis on works of the highest quality, could not be assembled from Western collections alone. Because of the indifference of collectors and museums, much great Jain art has remained in India. Thus, we began a protracted period of negotiations with various institutions and the government of India for appropriate loans. In this we were only partially successful. Nevertheless, we have borrowed a substantial group of objects from India that considerably enhances the significance of the exhibition.

Jain manuscript illuminations have heretofore received the most attention in art historical books. Created between the eleventh and sixteenth centuries, they fill a large gap in the history of Indian painting. The other form of Jain cultural expression that has been generally noted is the group of extraordinary marble temples created between the eleventh and thirteenth centuries at Mount Abu, in Rajasthan. Otherwise, except for a few individual objects, such as first- and second-century votive tablets known as ayagapata, or the colossal statue of Bahubali in Sravana Belgola, few Jain objects are discussed in art books. In this exhibition and its catalogue we have attempted to provide for the first time a wide-ranging survey of Jain art, showing its enormous variety in all artistic media and forms.

At the same time, within the limitations of an exhibition, we have endeavored to indicate the uniqueness of the Jain aesthetic tradition in the context of Indian art in general. We also hope to familiarize the public with the basic tenets of the Jain faith as expressed through art.

It is not possible here to thank individually all my colleagues at this and other museums whose cooperation and diligence have made this project a reality, but I collectively and whole-heartedly acknowledge their unstinting support.

PRATAPADITYA PAL
Senior Curator
Indian and Southeast Asian Art
Los Angeles County Museum of Art

ACKNOWLEDGMENTS

THE STATE COUNTY
LOS ANGELES COUNTY
MUSEUM OF ART
Victoria Blyth-Hill
Peter Brenner
Jane Burrell
Rosalie Calone
Steve Colton
Anne Diederick
Jim Drobka
Emily Dunn
Rene Fisher
Thomas Frick
Sarah Gaddis
Sarah Gallop
Dale Gluckman
Janine Gray
John Hirx
Eiko Iwata
Tom Jacobson
Melody Kanschat
Bernard Kester
Barbara Lyter
Stephen Markel
Catherine McLean
Don Menveg
Pieter Meyers
Renee Montgomery

Daic Gluckillali
Janine Gray
John Hirx
Eiko Iwata
Tom Jacobson
Melody Kanschat
Bernard Kester
Barbara Lyter
Stephen Markel
Catherine McLean
Don Menveg
Pieter Meyers
Renee Montgomery
Tom Nixon
Steve Oliver
Lisa Owen
Art Owens
John Passi
Carol Pelosi
Nina Roy
Maureen Russell
Mitch Tuchman
John Twilley
Cara Varnell
Lawrence Waung
Jennifer Weber
Talbot Welles
Elvin Whitesides
Tamra Yost

OWLEDGN
CALIFORNIA
Terese Bartholomew
Steven L. Brezzo
Robert L. Brown
Sara Campbell
Rand Castile
Chris Chapple
Robert Del Bonta
Sushil Dubey
Orrin Hein
Jain Community Center
Padmanabh Jaini
Gerald James Larson
Dr. and Mrs. Narendra Parson
Maria Porges
Jennifer Jones Simon
Ellen Smart
Michael Tobias
Gloria Williams
COLORADO
Ronald Otsuka
Lewis I. Sharp
FLORIDA
Roy Craven
Leo S. Figiel
ILLINOIS
James N. Wood
LOUISIANA
Yasho and Siddharth Bhansali
E. John Bullard
William Fagaly

n	Philippe de Monto Timothy S. Healy Ramesh Kapoor Steven Kossak Martin Lerner Anne Mountain Charles E. Pierce Robert Rainwater Carlton Rochell, J Elizabeth Stone Sloane Tanen Ted Tanen William Voelkle
	он 10 Robert P. Bergma John Cort Stanislaw Czuma
	TEXAS Jennifer Casler Janice Leoshko Edmund P. Pillsb
	итан Sandy Bell
	VIRGINIA Joseph M. Dye Katherine C. Lee
li	washington Michael Knight Mary Gardner N William J. Rathb
	washington Milo C. Beach Thomas W. Lent
	CANADA Dori Dohrenwen Phyllis Granoff Elizabeth Knox John McNeill Barbara Stephen

EW YORK
Philippe de Montebello
Timothy S. Healy
Ramesh Kapoor
steven Kossak
Martin Lerner
Anne Mountain
Charles E. Pierce
Robert Rainwater
Carlton Rochell, Jr.
Elizabeth Stone
Sloane Tanen
Гed Tanen
William Voelkle
OHIO
Robert P. Bergman
ohn Cort
Stanislaw Czuma
ГЕХАЅ
lennifer Casler
Janice Leoshko
Edmund P. Pillsbury
UTAH
Sandy Bell
VIRGINIA
Joseph M. Dye
Katherine C. Lee
WASHINGTON Michael Unight
Michael Knight
Mary Gardner Neill
William J. Rathbun
WASHINGTON, D.C.
Milo C. Beach
Thomas W. Lentz
CANADA Davi Dahannyand
Dori Dohrenwend
Phyllis Granoff
Elizabeth Knox
John McNeill

Richard Braiton
John Clarke
Elizabeth Esteve-Coll
John Guy
J. Robert Knox
Claire Randall
Deborah Swallow
Sir David Wilson
GERMANY
Gouriswar Bhattacharya
Gerd Kreisel
Peter Thiele
1 N D I A
Nasim Akhtar
American Center, usis,
New Delhi
American Institute of
Indian Studies
Shridhar Andhare
Asok Bajpai
Sachin Biswas
T. K. Biswas
R. N. Choudhari
Kalpana Desai
M. A. Dhaky
Sadashiv Gorakshakar
The Government of India
Ranjit K. Datta Gupta
A. P. Jamkhedkar
K. T. John
Vinod Kanoria
Naval Krishna
M. Raman
S. K. Rastogi
R. C. Sharma
Pushpa Thakurel
S. D. Trivedi
G. Venkataramani

SWITZERLAND Willy Frei

Dr. and Mrs. Rene Russek

ENGLAND

Richard Blurton

MINNESOTA Robert Jacobsen Evan M. Maurer

MISSOURI Dorothy H. Fickle Marc F. Wilson

NOTE TO THE READER

All dates are c.e. unless otherwise specified. Figure references, in parentheses, indicate the consecutively numbered illustrations in the essay section of the book. When these depict items in the exhibition, catalogue numbers are given as well. Numbers in square brackets refer the reader to catalogue entries for illustration, comparison, or additional information. Height only is given for most objects. Accession numbers of items in public collections and photo credits will be found on page 278. In an effort to simplify reading for the nonspecialist, diacritical marks have been eliminated from transliterated terms except in quoted matter and the appendix. A list of Sanskrit names and terms with their diacritical marks appears on pages 270–71.

Contributors

Pratapaditya Pal [P.P.] Senior Curator, Indian and Southeast Asian Art Los Angeles County Museum of Art

Shridhar Andhare [s.a.] Director L. D. Institute of Indology, Ahmedabad

John E. Cort Assistant Professor of Religion Denison University, Ohio

Sadashiv Gorakshakar [s.g.] Director

Prince of Wales Museum of Western India

Phyllis Granoff Professor of Religious Studies McMaster University, Ontario

John Guy [J.G.]
Deputy Curator, Indian and Southeast Asian Collection
Victoria and Albert Museum, London

Gerald James Larson Professor of the History of Religions University of California, Santa Barbara

Stephen Markel [s.m.] Associate Curator, Indian and Southeast Asian Art Los Angeles County Museum of Art

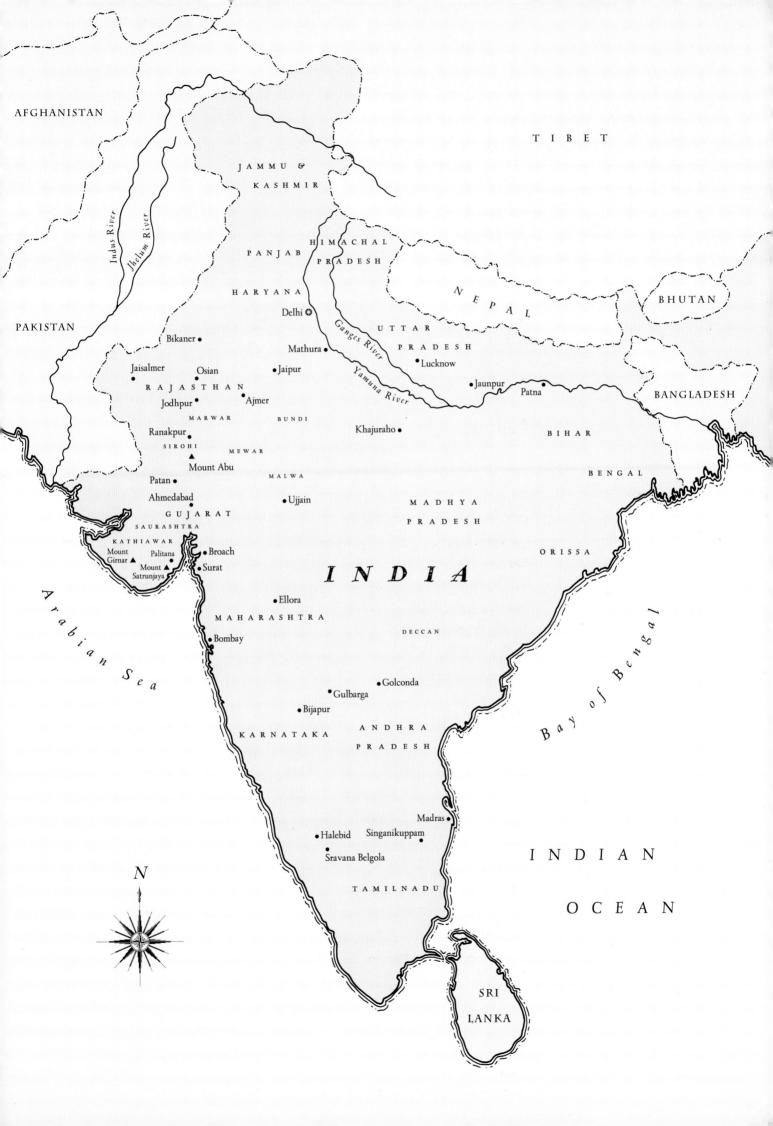

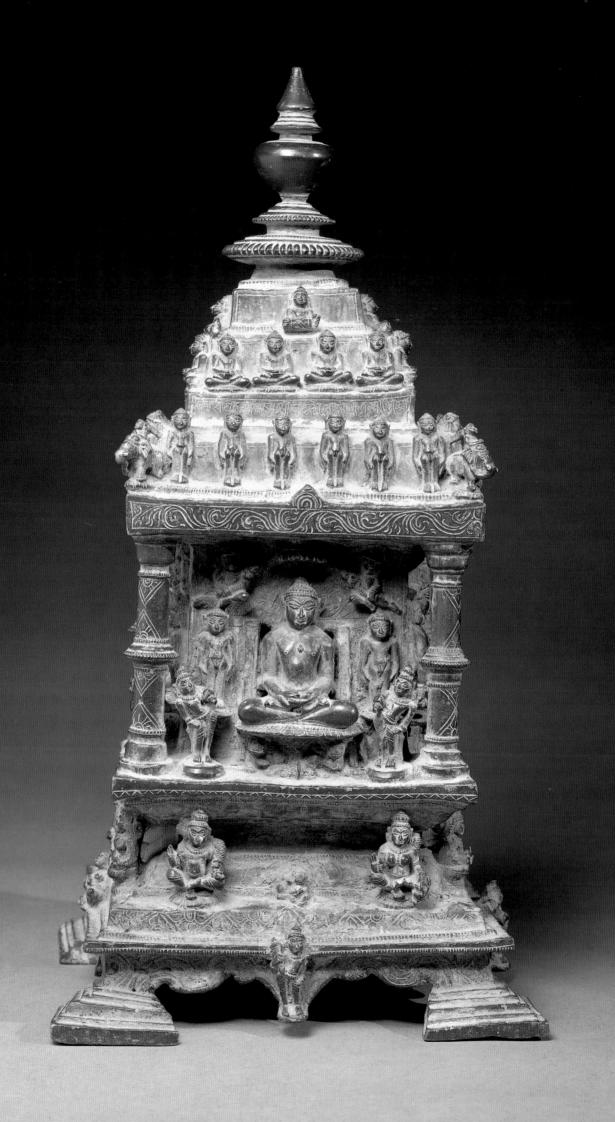

Introduction

PRATAPADITYA
PAL

All sounds recoil thence, where speculation has no room, nor does the mind penetrate there. The liberated is not long or small or round or triangular. . . he is not black. . . or white. . . he is without body, without contact (of matter), he is not feminine or masculine or neuter; he perceives, he knows, but there is no analogy (whereby to know the nature of the liberated soul); its essence is without form; there is no condition of the unconditioned.

—Mahavira

The Jain Religion and Image Worship

religions of the world: Buddhism, Hinduism, and Jainism. Today Hinduism is the predominant religion of India, Nepal, and the island of Bali and has many practitioners in other parts of the world as well. Like Christianity and Islam, Buddhism developed as a world religion and is widely established, though in India it lost ground after the twelfth century and has only recently been revived. Jainism has been continuously practiced since at least the sixth century B.C.E., if not earlier, and has a current following of some six million people. Although once familiar all over the subcontinent, it is now concentrated mainly in the Indian states of Gujarat, Karnataka, Madhya Pradesh, Maharashtra, and Rajasthan. Unlike Buddhism and Hinduism, the religion did not spread beyond India, largely because of the Jains' disinterest in proselytizing and the fact that monks are prohibited from travelling on a boat for more than a day's journey.

The faith's name derives from the word jina, meaning conqueror, or liberator. Jains believe that an immortal and indestructible soul (jiva) resides within every living entity, no matter how small. Passions such as greed and hatred render the soul vulnerable to the effects of former deeds (karma), which cause the soul to suffer by being subjected to repeated rebirth. Such suffering is believed to cease only when the chain of rebirth is broken. The final goal of a Jain—like that of a Hindu or Buddhist—is to sever the chain of rebirth and achieve a state of liberation known as kaivalya, moksha,

CAT. 11 Image of Nandisvara Island or Continent Gujarat; 1039 or nirvana. Whereas the Buddha remains the preeminent liberator and teacher among the Buddhists, the Jains believe in a group of twenty-four Jinas; each is also known as a *tirthankara*, or "forder," who fords the gulf between *samsara*, or the phenomenal world, and liberation. The last of these teachers, Vardhamana Mahavira (c. 599–527 B.C.E.), was an elder contemporary of the Buddha. His immediate predecessor, Parsvanatha, is also regarded as a historical figure and is believed to have lived in the eighth century B.C.E.

The predominant religious system at the time of both Mahavira and the Buddha was a form of proto-Hinduism, based on the authority of sacred texts called the Vedas (1500-800 B.C.E.). The men responsible for composing these texts and the rituals they contain were known as brahmins (brahmana), who alone could serve as the intermediaries between the mortal and the divine realms. Philosophically they believed in the existence of a supreme being called Brahma, and hence this early form of Hinduism is called Brahmanism. Since the religion involved elaborate sacrificial rituals, it was dependent largely on the economic support of other social groups, or castes, such as the warriors (kshatriya), the farmers and traders (vaisya) and the peasants and the plebeians (sudra). By the time of Mahavira and the Buddha, the caste system had become complex and, to many, meaningless. Some influential people, especially those belonging to the kshatriya caste, became resentful of the Brahmanical system, which they renounced, becoming instead homeless wanderers in search of truth and enlightenment. Such people were known as sramana, and their tradition has come to be characterized as Sramanical. Both Mahavira and the Buddha were members of the warrior caste. Both questioned the efficacy of sacrificial rituals involving the killing of animals, became advocates of nonviolence toward all sentient beings, and rejected the caste system. Jainism espoused the cause of nonviolence even more passionately than Buddhism and some followers of Hinduism.²

While both the Buddha and Mahavira asserted that the path to liberation from the misery of existence was one of asceticism and meditation, the Jains have stressed the importance of austere and rigorous ascetic practices much more than the Buddhists. The Buddha himself had practiced extremely harsh austerities before rejecting them as a suitable method to enlightenment, and hence his path is referred to as the Middle Way. Mahavira was not a compromiser. A simple example will suffice to demonstrate the difference between the two religions. While the Buddhist monks symbolize their renunciation by shaving their heads, the Jains adopt the more painful process of plucking their hair out. While both religions deny the existence of a supreme being or creator, unlike the Buddhists the Jains believe in the existence of a soul. Over the centuries both religions developed their own ritualistic practices, though these were much less elaborate in Jainism than, for instance, among followers of Vajrayana Buddhism. Both faiths also adopted the use of images, shrines, and temples, sharing devotional concepts and attitudes with the Hindus.

While every Jain should aim for liberation from the cycle of rebirth conditioned by individual karma, only a few succeed, because the path recommended by Mahariva involves total renunciation and arduous ascetic practices. What constitutes total renunciation, along with disagreement over the ability of women to attain liberation, were questions that divided the Jain community early in its history into two

14 PAL

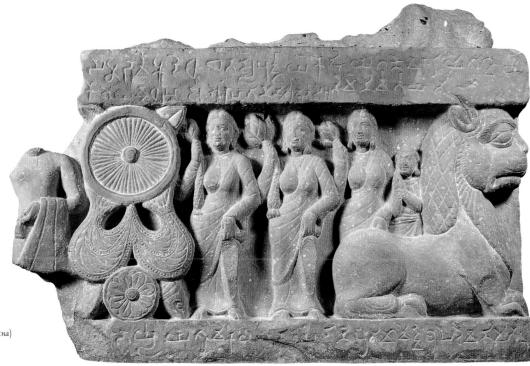

Figure 1
Base of an Image
with Devotees and Symbols
Uttar Pradesh, Mathura,
Kankali Tila; 157
The "three jewels" (triratna)
symbol is at left.

orders: the Digambaras ("sky clad," or naked) and the Svetambaras ("white clad"). According to the Digambaras all possessions, by fostering attachment to the world, are a hindrance to liberation. Hence Digambara monks do not wear a stitch of clothing, which is one reason why they were targets of derision by both Hindus and Buddhists. Digambara nuns, however, do wear clothes, because it was realized how socially disruptive their naked presence could be. In the realm of Digambara art, apart from the monks only the Jinas and the saint Bahubali are represented naked; all other deities are not only clothed but ornamented, which is strange for a religion that lays such emphasis on the state of renunciation. It is also curious that while all Digambaras are image worshipers (murtipujak), the Svetambaras include a minority group who do not worship images.

Although the renouncers are important components of the Jain community, most Jains are laypersons who follow the ideal of well-being rather than seeking complete liberation. This path symbolically incorporates the "three jewels" (fig. 1) of the pure path to liberation, the three fundamental tenets for a Jain: right knowledge, right faith, and right conduct. A pursuit of these goals involves modest living and prescribed behavior, such as nonviolence and stringent vegetarianism, and also various rituals and acts of devotion (puja). The worship of images of mortal teachers as well as divinities is common to Buddhists, Hindus, and Jains alike, but the approach of the Jains to their Jinas and deities differs from that of the other groups.

The Jinas, having attained complete liberation, do not actually exist at any level, and although they are referred to as saviors and their representations are popular, Jain scholars are quick to point out that devotees expect no earthly rewards to come from their veneration. In the words of Padmanabh Jaini:

The popularity of these practices should not, however, be construed to mean that Jains expect worldly help of any sort from the Jinas thus worshiped; they know full well that these perfected beings are forever beyond the pale of

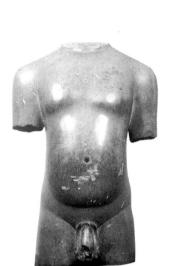

Figure 2
Torso
Lohanipur, Patna, Bihar
3rd century B.C.E. [?]
Polished buff sandstone
26 ½ in. (67 cm)
Patna Museum, Patna

human affairs. In other words, there is basically no "deity" present in a Jain temple; a one-way relation obtains between the devotee and the object of his devotion. Hence we must understand Jain image-worship as being of a meditational nature; the Jina is seen merely as an ideal, a certain mode of the soul, a state attainable by all embodied beings. Through personification of that ideal state in stone, the Jain creates a meditative support, as it were, a reminder of his lofty goal and the possibility of its attainment.³

To some extent this is also the position of Buddhism; whereas to the Hindu the image is both a symbol and a reality, and the Hindu expects the deity to return favors.

When exactly Jains began venerating images of their Jinas is not known. Some scholars identify as a Jina figure a small nude male torso discovered at Harappa and said to belong to the third millennium B.C.E. The Jain tradition itself believes that images of Mahavira were created during his lifetime. Inscriptional evidence indicates that a Jina image was set up in Kalinga (modern Orissa) at least as early as the fourth century B.C.E., when it was taken away by an invading Nanda ruler of Magadha, to the north. The earliest incontestably Jain figure is the famous polished sandstone torso (fig. 2) found in Lohanipur in Bihar and now in the Patna Museum, though its exact date is disputed. Epigraphical evidence at Mathura, supported by Jain tradition, indicates that a stupa (solid hemispherical shrine enclosed by a railing) must have been built at Kankali Tila several centuries before the common era [2]. If indeed it was, then it may have been a large and unostentatious structure of wood and rubble like the early stupas of the Buddhists and the so-called Asokan stupas surviving only in Patan, Nepal, today.⁴

Historical Development

As was the case with the Buddhists, the early activities of the Jains were concentrated in eastern India, mostly in the modern states of Bihar and Uttar Pradesh. Around 300 B.C.E., during a famine in Bihar, groups of Jains moved both west and south. While both tradition and inscriptional evidence indicate the presence of the Jains in the south a couple of centuries before the beginning of the common era, they appear to have settled in Mathura as early as the first century B.C.E. With one or two noted exceptions, all early Jain sculpture belongs to Mathura and its environs. The most important site is Kankali Tila, where major archaeological discoveries were made between 1888 and 1896. Around the beginning of the common era Mathura, under foreign Saka (Scythian) and Kushan rulers, appears to have been the major mercantile and religious city in north India. It also appears to have been a remarkably cosmopolitan place, for Buddhism, Hinduism, and Jainism prospered there simultaneously. Indeed, Mathura may well be regarded as the birthplace of the iconography of all three religions.

Because of the situation in Mathura, other deities began to be accepted and worshiped by the Jains apart from Jinas. During the time of Mahavira Vedic sacrificial rituals were performed, mostly by the upper castes; at the grassroots level the practice of venerating local guardian spirits, yakshas and yakshis, and other protective and fertility deities was commonplace. The monks could do without the services of such

supernatural beings, but laypersons could not. As a matter of fact, according to Jain accounts Mahavira himself could not have been born properly if the gods had not intervened [83A]. From his conception to his liberation the Vedic deity Indra, or Sakra, came to Mahavira's aid frequently [86B].

By the sixth century, when the last Jain council was held at Valabhi in Gujarat, the Jains (like the Hindus and the Buddhists) had developed a pantheon of divinities, some of whom became specifically associated with the lives of the Jinas in a benevolent manner. These divinities are guardian spirits (sasanadevata), who fulfill the mundane wishes of their devotees but remain subservient to the Jinas. Some of them, such as Ambika [60–64], a mother goddess, and Sarasvati [55–57], the universally revered goddess of knowledge, are important figures in their own right. Indeed, the expansion of the Jain pantheon directly reflected changes in the expression of devotion in Indic culture. The development of Jain temple architecture and imagery reveals the evolving concerns of the Jain lay community. Not only does the art define primary characteristics of the religion, it also documents how Jain ideas were modified

Figure 3 Goddess Sachika, Rajasthan; 1179 CAT. 66

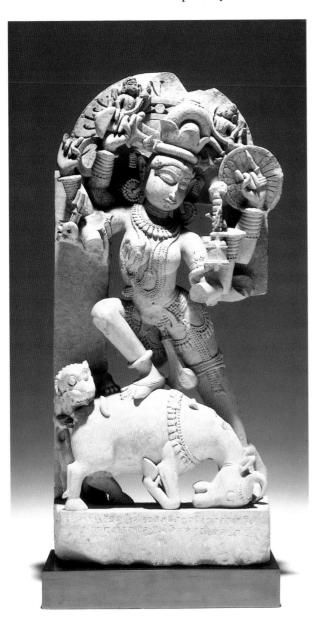

in response to the changing socio-religious climate of the time. For instance, after the sixth century there was a pan-Indian growth in the popularity of the Divine Feminine that influenced all three religions. Even the bloodthirsty Hindu goddess Durga Mahishasuramardini was adopted by the Jains and worshiped as Sachika (fig. 3) or Sachiyamata. This was one way the Jains managed to survive in a predominantly Hindu world.

Jain mythology and didactic literature are filled with stories of the involvements of gods and goddesses. Two examples here will clearly demonstrate the average Jain's attitude to a deity no matter what the scholastic viewpoint.

In the city of Tihuyanapura there was a wealthy merchant called Sumai who had no children. He was instructed by the king to worship Tihuyanadevi, who was not only the monarch's clan deity but also the city goddess. The merchant came home and told his wife about the royal advice, but as a devout Jain she said, "My Lord! If you do that, you will insult the true faith, for we are Jains." Sumai's typically Jain response was, "Beloved! If I do it as an order of the king, then there can be no insult to my faith." This justification not only shows perspicacity in solving a social problem but also demonstrates an important survival tactic.

The second example is from the *Prabandhakosa*, a compendium of Jain biographies. It concerns Sri Harsha, a poet, who was also, according to Granoff, "a brilliant scholar of logic, poetics, music, mathematics, astronomy, gemology, spells and grammar." Having practiced the "wishing gem spell," he was able to summon Tripura (perhaps the Hindu tantric goddess of the same name) and receive boons from

her. On another occasion he went to the shrine of Sarasvati in Kashmir (presumably at the temple of Sarada, the tutelary goddess of the valley) to seek her approval for one of his books.

The two stories clearly demonstrate the ambivalent attitude of the Jains towards Hindu deities, how they overcome their qualms, and how they depend on divine intervention. In fact, it is common for Jain merchants along with Hindus to worship Sri-Lakshmi, the goddess of good fortune, on the annual Diwali festival in autumn. The second story also makes it clear that ultimately Jainism adopted tantric practices—involving spells, arcane rites, and worship of esoteric deities by means of mystical diagrams known as yantra—as did the Hindus and the Buddhists. This development in the history of Indian religions occurred generally after the onset of the seventh century. As the ninth-century Jain philosopher and mystic Haribhadra laments:

These pseudo-monks live in temples, start worshiping there like laymen, enjoy the wealth dedicated to the worship of the Jinas, take active part in erecting temples and residence halls. . . . They engage themselves in astrology and predict the future for the lay disciples. . . . To increase their support they buy young children and make them into their own disciples, and do business in buying and selling Jain images. They are clever in medicine, in *yantra* [mystical diagrams], in tantric practices, and in other such techniques forbidden to monks.⁷

In general Jains seem to have been circumspect in their acceptance of tantric beliefs and rituals, shunning the more extreme practices.

Among the major duties of a Jain is to worship images (*devapuja*), to dedicate images and sacred books, and to build temples and libraries. This not only fulfills the obligation of charity (*dana*) and public service but also helps to satisfy the individual's need for achieving the proper mental attitude for spiritual guidance. Most affluent Svetambara houses once included a domestic shrine where the family worshiped, but this is no longer true. Others—mostly womenfolk—visited the community temple, daily if possible and if not, then certainly on all auspicious days. This practice continues. Most surviving domestic shrines are from Gujarat and are carved from wood (fig. 4) [5]. They have a rich iconography that includes figures of musicians for the entertainment of the deities, and of course the goddess Sri-Lakshmi, presiding deity of good fortune and prosperity.

The inclusion of Sri-Lakshmi's image is particularly appropriate for a community whose principal occupation has been trade. Indeed, until the second half of this century, when Jains began to enter various professions, the Svetambaras were primarily traders. Because of their extreme fastidiousness about taking life the Jains were limited in the professions they could adopt. To this day they have maintained their leadership in commerce. Jain bankers were able to wield considerable influence with the ruling classes, who were always in need of money. Both of the Sramanical religions—Buddhism and Jainism—seem to have flourished by linking up with the mercantile and ruling classes. In the early days, however, the Jains appear to have been less adventurous. Although Jain stories tell us about extensive sea voyages by Jain merchants [120], there is very little independent evidence to indicate that they par-

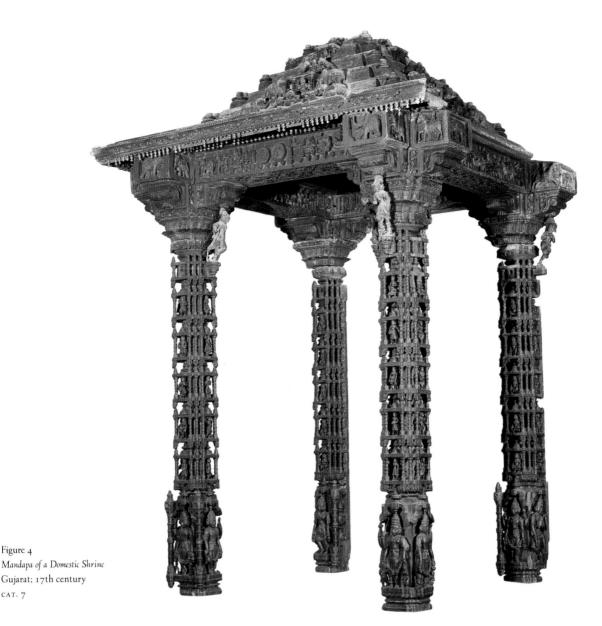

ticipated either in the caravan trade across the silk route in Central Asia, as did the Buddhists, or in the vigorous seaborne trade in Southeast Asia in the first millennium of the common era. Even though they were well settled in the south, they do not appear to have crossed over to Sri Lanka.

The Jains seem to have begun traveling abroad after the tenth century, mostly from the Gujarat coast. This trade flourished while Gujarat was under Muslim rule and even more so after the arrival of the British early in the seventeenth century. The British established their first important port at Surat on the Gujarat coast. By the thirteenth century Buddhism had ceased to be a strong presence in the Indian subcontinent. West Asian Muslims now occupied much of the northwestern region of the subcontinent as well as Central Asia. In order to protect themselves from forced conversion by Muslim conquerors the Hindus not only became stricter about caste rules but also about traveling overseas. Although Jain temples were not spared by the Muslim conquerors, the Jains themselves had no caste taboos about either dealing with the Muslims or traveling abroad. Prospering, they continued to renovate old temples, build new ones, dedicate images, and commission illustrated manuscripts of their sacred literature for their libraries.

Figure 4

CAT. 7

A second reason why the Jains survived was their close association with ruling houses. As Professor Jaini has succinctly stated:

A cardinal feature of the śramaṇa movements which arose in India circa 550 B.C. was their emphasis upon the superiority of the princely class (kṣatriya), whether in a spiritual context or a secular one. Hence these movements tended to find common cause with local kings, who were themselves engaged in a constant fight against the claims to supremacy of the brahman class. . . . By opening their ranks to members of any age group or caste (and, in the case of the Jains, even to women), the śramaṇa groups in fact created an entire separate society, parallel to the Vedic one. They were able to recruit large numbers of mendicant and lay followers and thus constituted a significant force—social, political, and economic, as well as spiritual—within the large cities where they were concentrated. 8

This was, of course, true of Buddhism as well. Indeed, without this royal support it is doubtful if either Buddhism or Jainism would have survived. A classic instance is the status of Jainism in Tamilnadu. As late as the seventh century the Jains were flourishing in the Pallava kingdom. But after a Jain Pallava king had been converted to Saivism (the worship of Siva) by an aggressive Saiva saint, the Jains never regained their preeminence. In fact, the insignificant status of the Jains in the Tamil country under the Chola dynasty can be directly attributed to lukewarm royal patronage and the hostility of the Hindu saints.

In neighboring Karnataka, however, Jainism has continued to flourish largely because of an abiding and stable relationship with the Ganga dynasty. As a matter of

fact, a Digambara monk called Simhanandi is credited with the establishment of the dynasty around 265. Thereafter, for almost seven centuries the Jain communities of Karnataka enjoyed the continuous patronage of this dynasty. And it was a Ganga general, Chamundaraya, who commissioned the colossal rock-hewn statue of Bahubali at Sravana Belgola in 948 (fig. 5), which has become the holiest of all Jain shrines today. The Hoysalas, the successor dynasty of the Gangas, also were supporters of the Jains, and legend has it that this dynasty too attained power with the help of the Jain mendicant community. Thus, from the third until the fourteenth century the largely Digambara communities of Karnataka flourished and were able to build temples and shrines without hindrance. To a degree the same is true of the Deccan (now parts of Maharashtra state), where they were able to gain the support of the powerful Rashtrakuta dynasty that held sway in the region from the eighth through the eleventh centuries.

Through the Gupta period (300–600) the northern Jains prospered in Bihar, Uttar Pradesh, and Madhya Pradesh. The second Jain council was held in the fourth century at Mathura. Unfortunately this was the very area that suffered extensively from

Figure 5 Colossal Bahubali Sravana Belgola, Karnataka; 948 Sandstone; 59 ft. (18 m)

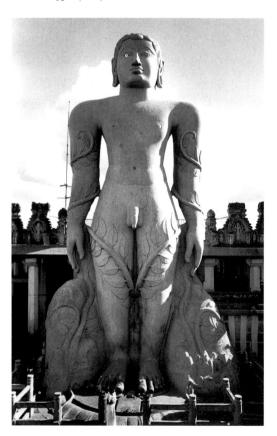

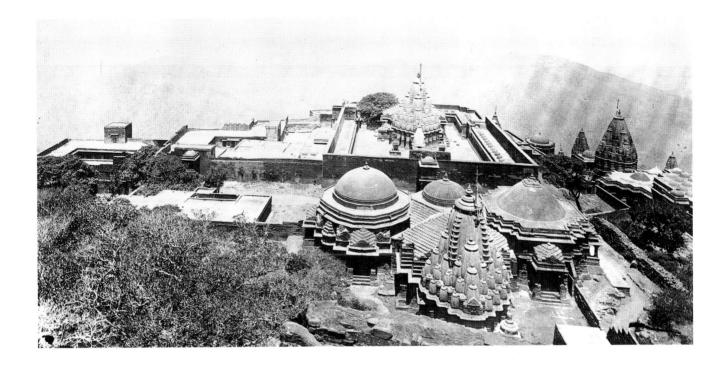

Figure 6 Temple at Girnar, Kathiawar, Gujarat 15th century

The organization of a separate council at Valabhi (Gujarat) concurrent with the Mathura synod indicates that by the fourth century a substantial number of Jains had moved west. In fact, the western immigration may have begun before the common era if the kernel of the story of the Svetambara monk Kalaka [82] is historically valid. It was only after the eighth century that the Jains succeeded in attaining royal support; this is corroborated by the lack of earlier archaeological evidence. In Gujarat as well as Karnataka a Svetambara monk succeeded in placing a protege on the throne. This was Vanaraja, whose long reign (746–806) proved to be particularly propitious for the Jains. Although under Vanaraja's Saiva successors the Jains continued to enjoy power and wealth, the patronage was not as continuous as it was in Karnataka.

It was during the Solanki rule in the mid-twelfth century that a Jain became a kingmaker once again. Upon the death of Jayasimha Siddharaja without an heir, a distant cousin, Kumarapala, succeeded to the throne, largely due to the efforts of the great Jain polymath Hemachandrasuri and a Jain minister. Ever since the eighth century, even though the rulers in this region were Hindus, the Jains often served as ministers and thereby maintained their power base. Among them the most munificent were the brothers Tejahpala and Vastupala, who were extremely wealthy ministers at the thirteenth-century Bhagela court in Gujarat. They are still remembered because of the world-renowned white marble temples they erected on Mount Abu in Rajasthan. They were also responsible for rebuilding structures destroyed by Muslims in Satrunjaya and for their profuse construction activities at Girnar in Gujarat (figs. 6 and 7). Indeed, no other patrons in India, whether Hindu, Buddhist, or Muslim, have matched the generosity of these two brothers to their faith.

Figure 7 Interior dome of Vimala temple Mount Abu, Rajasthan; 11th-12th centuries; white marble

Patrons and Artists

Unlike both Hindus and Buddhists, Jain patrons have left much documentation of their benefactions. Their images are frequently inscribed, and, because of their early archival interests, they have left an enormous number of documents providing a great deal of information about the donors and the reasons behind the donations. The typical dedicatory inscriptions on bronzes or manuscripts, apart from providing a date, include the names of the donors and members of their families, the chapters they belonged to, and the monk who encouraged the donation and consecrated the object. What becomes apparent from the Jain donations is the strong sense of community that has been a contributing factor in their survival. The Jain mode of worship, without the intermediary of a priest, makes it more of a community affair, particularly among the Svetambaras, than that of the Hindus. This becomes particularly clear if one visits a Hindu and a Jain temple and compares their rituals.

Often the inscriptions and pilgrimage texts provide information about patronage. The motives for making a donation, either of an object or a temple, were varied. In general, it was an act of giving, which is an obligatory duty of every Jain. Most donations were made at the urging of a teacher, a fact explicitly stated in the inscriptions, unlike those of the Hindus and Buddhists. It is also clear that the more affluent the donor the more ostentatious was the gift.

The earliest records of Jain dedicatory inscriptions have been recovered from Mathura and belong to the Kushan period (first to third centuries). It is interesting to note that a large number of the donors were women, who seemed particularly fond of dedicating votive tablets or tablets of homage known as ayagapata [10]. A typical inscription reads:

Adoration to the Arhats [Jinas]! A tablet of homage was set up by Achalā [?], daughter-in-law of Bhadrayaśas and wife of Bhadranadi [Bhadranadin] for the worship of the Arhats.9

In another Mathura inscription we are told how the female donor made her gift "at the request of Dhāmathā [?], the female pupil of the Aryya Araha[dinna], from the Koṭṭiya gaṇa [residence unit for monks], from the Thāniya kula [family], from the Vaīra śākha [branch]." In neither instance is the specific purpose of the donation made clear, but very likely they were set up for the entire community's benefit.

One of the most interesting Jain dedicatory inscriptions is carved on a column in the village of Kahaum in Uttar Pradesh. Dedicated in the year 146, during the tranquil reign of Emperor Skandagupta, a certain Madra,

being alarmed when he observed the whole of this world [to be ever] passing through a succession of changes, acquired for himself a large mass of religious merit. [And by him],—having set up, for the sake of final beatitude [and] for the welfare of [all] existing beings, five excellent [images], made of stone, [of] those who led the way in the path of the *Arhats* who practice religious observances,—there was then planted in the ground this most beautiful pillar of stone, which resembles the tip of the summit of the best of mountains, [and] which confers fame [upon him].¹¹

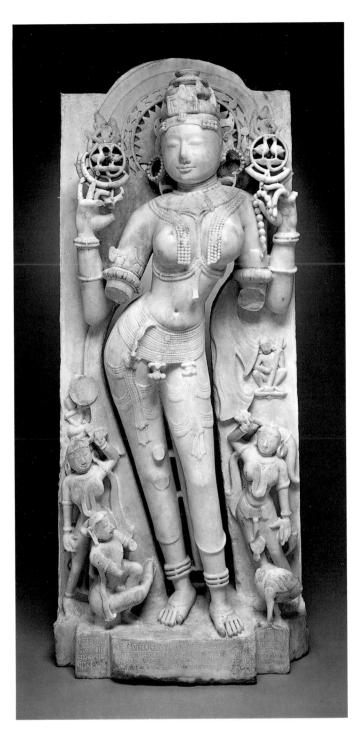

Figure 8 Goddess Sarasvati, by Jagadeva Gujarat; 1153 CAT. 57B

This inscription offers the most varied justification of a Jain gift known. Very likely the author was influenced by the Buddhists, since the expression "for the welfare of [all] existing beings" has a distinctly Buddhist ring. Another inscription of the period at Udaygiri in Madhya Pradesh informs us that a nobleman set up an image of Parsvanatha and declared that he "has set aside whatever religious merit [there is] in this [act], for the purpose of destroying the band of the enemies of religious actions."¹²

An unusual reason is provided in an inscription at Ellora, in Maharashtra. In the year 1078 one Chakresvara of Vardhamanapura dedicated "on the hill that is frequented by Chāraṇas [bards], a monument of Pārśvanātha, and by [this act of] liberality [he made] an oblation of his karma!"¹³ "The great defilement of Karma-particles" is also the intent of an eighth-century donor in Vasantgadh (Rajasthan), who in addition expected to acquire right knowledge, right action, and right faith from his donation.¹⁴

Many of the objects in the exhibition are inscribed and provide interesting information about the donors and their motives (see appendix). One donor dedicated an image for increasing the merit of his father [113]. The fulfillment of personal desire was the reason for the dedication of a victory yantra [99], and the image of Sachika [66] was also given for the donors' merit. A Sarasvati image [55] was set up for the welfare of all beings, and a painting [103B] was dedicated with the statement, "Everyone reaps the fruits of one's own deeds and experiences the share of the fruit accordingly." An intriguing inscription is that on the base of the Los Angeles Sarasvati (fig. 8),

which informs us that the sculpture was a replacement for an earlier image damaged accidentally. In fact, restoration of old images and shrines has remained as strong a motivating factor for the Jains as it is for the Buddhists and Hindus.

Very little information is available about the artists. While the names of some have survived, almost nothing is known about them. Some of the finest Vasantgadh bronzes of the eighth century were created by an artist called Sivanaga, "who is very like the great Pitāmaha (Brahmā, the Creator), creating numerous different forms." Names of several masters who worked on monuments in Karnataka in the eleventh and twelfth centuries have survived; most were professionals. Many of them were boastful of their achievements, comparing themselves with the divine architect Visvakarma. They enjoyed high social status and some were even soldiers. The Los Angeles Sarasvati was carved by Jagadeva, a famous sculptor in Gujarat and presum-

ably a professional artist. Professionals were certainly responsible for doing most of the miniatures and paintings. One such professional group in Rajasthan was known as Mathen.

What is generally true is that the artists were craftsmen whose own religious beliefs or caste affiliations had no effect on their vocation. The same artist was available for Buddhist, Hindu, or Jain patrons. Later on, Muslim artists were also recruited. The inscription on a painting in the exhibition [103B] employs a term—chitram—apparently used by Muslim painters of Mewar to refer to artists as well as to cloth paintings. A study of the traditional marble sculptors of Jaipur, Rajasthan, states that "the master artisans are often Adi-Gaud Brahmins whereas many workers come from various castes of smiths, carpenters, potters, many farmer castes and Muslim groups." The master artists were not only paid but were honored with garlands, shawls, betel nut and sandalwood paste, exactly as were poets and dance teachers. Generally the principal form of payment was money, but land was also an accepted form of remuneration. The price of one of the paintings in the exhibition [103B] was 151 rupees exactly a century ago, not an inconsiderable sum. This provides some idea of how well artists were compensated, at least by affluent Jains.

Interesting information can be gleaned from biographies about the relation between artists and donors. We have already mentioned two of the greatest builders in ancient India, the Jain brothers Vastupala and Tejahpala. For one of the major temples built by Tejahpala at Mount Abu, Sobhanadeva was the chief architect, and his brother-in-law Udala kept the accounts. One day Tejahpala and his wife visited the site and expressed concern about the slow progress. They learned that the sculptors and masons found the mornings too cold and took very long noon breaks in order to go home for their meals. Anupama then advised her husband to hire more craftsmen and to provide all workers with free lunch. Needless to say, the work proceeded much more smoothly thereafter.

Jainism and Its Art

All works included in this exhibition had a religious function. Stone sculptures served either architecturally as part of religious structures or were set up as images to be worshiped. A number of them certainly graced sanctums and were the direct focus of devotion. Images on external walls (fig. 9) represent both Jinas and the denizens of the celestial realm, including deities and dancers, ascetics and angels. Jain temples are often sumptuously decorated on the inside with figures and reliefs. Most domestic shrines, especially in Gujarat, were built in wood, and several examples of Jain woodwork are included in the exhibition [5–8]. Included are a porch, a section of an assembly hall, and a richly carved panel that must once have adorned a wooden structure. Not only are they instructive in demonstrating the narrative tradition in Jain art, but they also reflect the high quality of woodwork in Gujarat.

Apart from stone, metal was a popular medium. In fact, surviving evidence indicates that the Jains may have been the leaders in making metal representations of spiritual icons. The Chausa bronzes (figs. 10, 14) are among the earliest surviving religious images in metal discovered so far on the Indian subcontinent. As may be gleaned from the inscriptions, the bronzes were made both for personal use and for

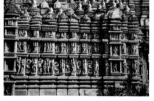

Figure 9 Parsvanatha temple wall, Khajuraho, Madhya Pradesh; mid-10th century Sandstone

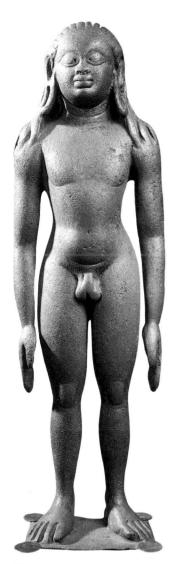

Figure 10 Jina Rishabhanatha Bihar, Chausa (Shahabad District) Late 3rd century Copper alloy; 8 ½ in. (21 cm) Patna Museum, Patna

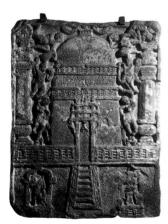

Figure 11 Carved Relief of a Stupa Uttar Pradesh, Mathura; 1st century Mottled red sandstone; 28 in. (71.1 cm) Government Museum, Mathura

dedication in religious establishments. Most surviving Jain bronzes are of modest size, but large versions for temples were also made [34]. The technique used was the cire perdue or lost-wax process. Most bronzes of the early period reveal high copper content; this remained the case in Bihar, Orissa, Karnataka, and Tamilnadu. In Gujarat and Rajasthan, however, shiny brass became the favorite material from about the ninth century. Metal sculptures follow the same basic styles as stone. Unlike the Buddhists and the Hindus, the Jains do not seem to have used clay or ivory, very likely because of their aversion to killing. The former would require destroying insects and micro-organisms, while the latter, of course, involves the slaughter of elephants.

Like those of the Buddhists and the Hindus, many of the early Jain monuments must have been adorned with murals, but very few examples have survived. Since knowledge plays so important a role in Jain philosophy and religion, religious books have always held special interest for the Jains. Until paper was adopted around 1300—largely due to Islamic influence—books were written on palm leaves and protected with wooden covers. Many of these, as early as the twelfth century, were illustrated; they form an important corpus of work in the history of Indian painting. Apart from these, the Jains made many paintings on cloth (patachitra) for various religious purposes. Most important are the yantra and the pilgrimage paintings. By the eighteenth century pilgrimage paintings had assumed gigantic proportions, as can be seen from the three examples included here [117]; as a type they probably constitute the largest surviving pictures on the subcontinent. Unfortunately these and other forms of Jain painting have received little attention from scholars, who have generally concentrated on the manuscript illuminations. The various types of paintings were first rendered in the style of the early book illustrations, whereas after 1600 a mode derived from Mughal artwork became common. Undoubtedly the same artists were given commissions for both types of paintings.

Jain art does not differ from Hindu and Buddhist art in matters of form. The same aesthetic norms, theories of proportions, and formal concepts are basic to the art of all three religions. Even in iconographic terms the differences are limited and visible mostly in the figures of the Jinas. Several of the divine figures in this exhibition could as well have come from Hindu monuments, and only their context establishes their Jain association. Unlike the Buddhists, who use Buddha images on the head-dresses of their deities or add a special sacred formula or mantra, the Jains rarely used distinctively Jain signs.

In general the history of Jain art can be divided into three phases. ¹⁹ In the early phase (second century B.C.E. to third century C.E.) the most important center was Mathura, where stupas appear to have been the focal point of the Jain religious establishment. From the remains found in Kankali Tila it can be surmised that they were surrounded by railings with elaborate gateways, as one also sees at the well-known Buddhist site at Sanchi, Madhya Pradesh. A freestanding pillar with a capital also formed part of this complex and has remained an important component of Jain religious architecture (fig. 11). The pantheon, however, was relatively simple, consisting largely of images of Jinas. Most figures are naked, indicating the preeminence of the Digambaras. At this stage the images are not clearly differentiated, and cognizances are conspicuous by their absence.

Another important votive object is the ayagapata, or tablet of homage [10]. It may be regarded as the precursor of the later tantric mandala, or yantra, which became a common instrument of worship among the Hindus, Buddhists, and Jains. Curiously, the ayagapata was used by the Jains only in Kushan-period Mathura (first three centuries of the common era) and has not been encountered subsequently in Jain art. Very likely it was also the precursor of the later samavasarana, (universal assembly where a Jina sermonizes). Ayagapata are remarkably varied, though in most the center is occupied by a Jina. The rest of the space is filled with flying celestials, vegetation, and various symbols. These symbols are sacred to Hinduism and Buddhism as well, but perhaps not with the same intensity as they are in Jainism, where they continued to play an important role in later work.

Apart from undifferentiated Jina figures and ayagapata, few deities are encountered in Jain art at this time. The most important were Sarasvati (fig. 12), the goddess of knowledge, and Balarama or Baladeva [53], the elder brother of Krishna, who was not yet the important figure that he became in later Hinduism. More difficult to determine is the association of the image of Harinegameshin [54], as he is also included in the Hindu pantheon. Considering his essential role in Jain mythology in connection with the birth of Mahavira, this image very likely graced a Jain shrine. Many additional celestial creatures, all of them belonging to the common pool of Indian

Figure 12 Goddess Sarasvati Uttar Pradesh, Mathura, Kankali Tila 132 [?] CAT. 55

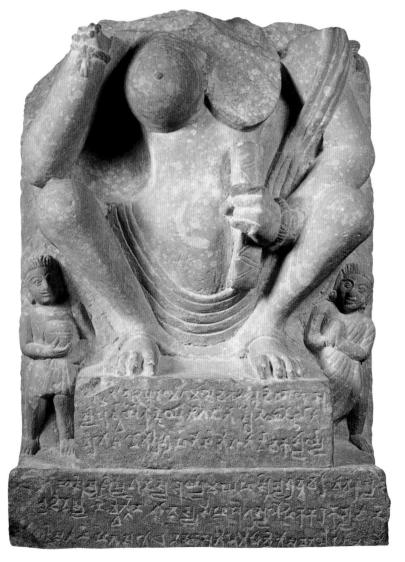

mythology, are found represented in Jain art of the period. These include humans such as yakshas and yakshis and hybrids such as Garuda, gandharva, and kinnara, as well as animals and plants. By and large, though, the Jain pantheon, as reflected in the surviving art of the period, is relatively simple, with the Jinas being the primary figures.

In the second phase, stretching roughly from about the fourth until the eighth century, there is an expansion of the pantheon, with the inclusion of new deities and more elaborate sculptural compositions, especially in the rock-cut temples of the Deccan. In fact, few structural temples of the Jains of this period have survived. Unlike in the earlier period, the artistic output was not confined to one or two centers but spread across the subcontinent. The Jain faith flourished in the heartland, comprising the central states of Uttar Pradesh, Bihar, and Madhya Pradesh. It was also, of course, well entrenched in the south, particularly in Karnataka and Tamilnadu, and by the

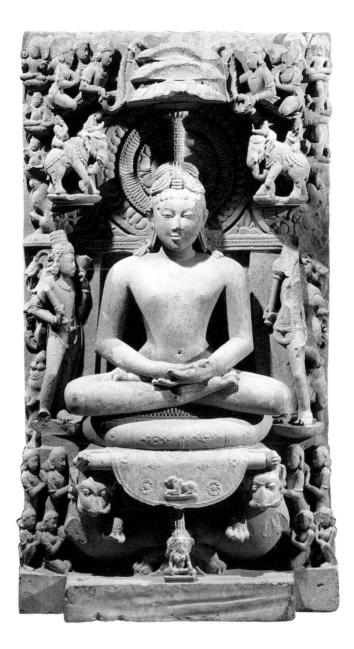

Figure 13 Stele with Rishabhanatha Uttar Pradesh; 10th century CAT. 23

Figure 14
Wheel with Yakshis
Bihar, Chausa (Shahabad District)
2nd century
Copper alloy; 12¾ in. (32.5 cm)
Patna Museum, Patna

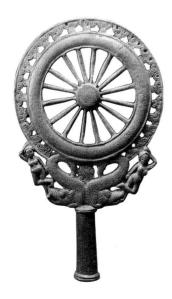

fourth century began to find a foothold in Gujarat and Maharashtra as well.

The art from this period consists of both stone and bronze sculpture and some surviving murals. The Jinas, still preeminent, are now represented in stone steles with several companions. The typical iconography of a Jain stele (fig. 13) became codified at this time. Apart from the Jina, two divine flywhisk bearers and two celestial garland bearers enliven the compositions with their graceful and animated postures. The Jina either sits on a lion throne or stands on a lotus, and often cognizances are provided. A three-tiered umbrella rises above his head, thereby emphasizing his spiritual sovereignty. In many instances when he is seated, the motif of a wheel flanked by deer is added below the throne. In the Buddhist context this motif symbolizes the Buddha's first sermon in the deer park at Sarnath, where his teachings set the law, or dharma, in motion. The Jains appear to have employed the wheel more generally to indicate that a Jina is not simply meditating but is also teaching (fig. 14). Needless to say, many of these additional features were borrowed, probably from Buddhist art. Certainly the flywhisk-bearing attendants appear first in Buddhist steles at Mathura in the first century.

Figure 15 Rock-cut relief of Parsvanatha. Ellora, cave 6, Maharashtra; 9th century

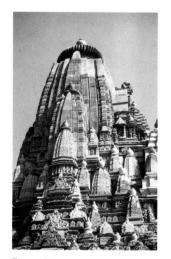

Figure 16 Adinatha temple at Khajuraho, Madhya Pradesh; mid-11th century

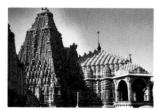

Figure 17 Adinatha temple at Mount Satrunjaya, Palitana, Gujarat; 1157

After the sixth century many other deities began to be represented. The Jinas were now attended by guardian deities, just as the Buddha is provided with bodhisattvas. The most important new development was the wider acceptance of female divinities, both as companions to the Jinas and as independent deities of well-being. This was obviously a very important concession to the growing and influential lay community, for which the concept of well-being became a basic ingredient of the religious life. Thus, in magnificent reliefs in the Jain cave temples at Ellora (fig. 15), in Maharashtra, we see Jinas accompanied by a variety of goddesses. Indeed Jainism, though stricter in its emphasis on the passionless ascetic ideal than Hinduism and Buddhism, has not found it contradictory to mix erotic (sringara) and tranquil (santa) flavors (rasa) in religious art. Just as there is no clear distinction between the sacred and the secular in the life of a Jain, so also the spiritual and the sensual realms coexist comfortably in Jain art. The nude Jina is always an athletic, youthful, handsome, and well-formed figure who remains unperturbed by the seductively elegant, half-naked female figures standing beside him. The contrast only helps to accentuate the saints' complete victory over desire and passion.

The final phase of Jain art may best be characterized as one of codification and elaboration. According to Periera, by the tenth century the Jina "with his accessories, his identifying emblems, his yakṣa attendants, the whole pantheon of the gods and the favorite episodes of Jain mythology were all religiously fixed and elaborated." Even though ostentatious giving is frowned upon by the Jains, the wealthier and more powerful adherents, perhaps not to be outdone by Hindu patrons, began to build some of the most luxuriously elegant temples in the history of Indian architecture. Although not as impressive as some of the Hindu temples at the site, the Jain shrines at Khajuraho, built in the tenth and eleventh centuries, are still among the most elegant examples of Indian architecture (fig. 16). These patrons also commissioned some of the most colossal sculptures on the subcontinent, as if in competition with the Buddhists; the best known of these is the aforementioned Bahubali at Sravana Belgola, Karnataka.

The three centuries from around 1000 until 1300 may be regarded as a sort of golden age for Indian temple architecture. The contribution of the comparatively small Jain community to what may be characterized as frenetic building activity was totally disproportionate to its numbers. Unfortunately, as with the Hindu temples, many of the Jain shrines built across the northern Indian plains have not survived, but what remains is impressive. Apart from the two at Khajuraho, there are examples in Rajasthan, Karnataka, and in Gujarat, where veritable cities of temples were built at such sites as Girnar and Mount Satrunjaya, in Palitana. This region was also hit hard by Muslim conquerors, and most of the early temples were destroyed, but some fragments from Palitana have survived, and a few are included here [4]. Girnar and Satrunjaya (fig. 17) are still temple cities, but most of the structures are later replacements. In the south the Jains continued to build in the local styles. Some fine temples with elaborate stellate ground plans and highly ornate carvings were raised in the Hoysala kingdom. However, the hallmarks of Jain temple architecture and the buildings most familiar to both natives and tourists are the white marble temples at Mount Abu, Rajasthan. From about the twelfth century marble became a favorite construc-

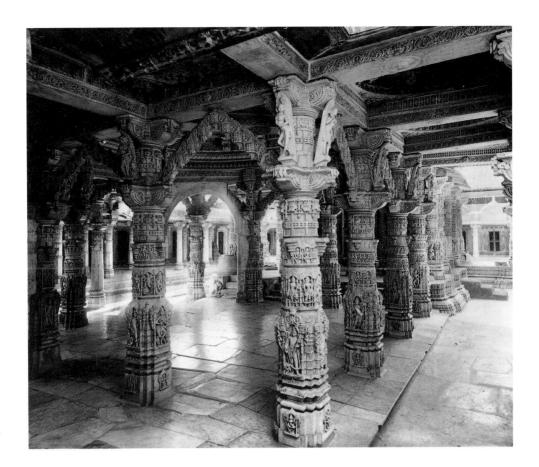

Figure 18
Interior of Vimala temple, Mount
Abu, Rajasthan; 11th—12th centuries
White marble

tion material in this region, though the white marble sculptures exhibited here are probably not from Mount Abu. The Jain patrons of Rajasthan and Gujarat seem to have been particularly sensitive to refined carving with a high finish, turning every temple into a delicately rendered ornament as if created by a goldsmith. As Pereira puts it, "The love of supple and graceful brackets, slender arches and light domed interiors of the Rajasthani and Gujarati architects possessed the Jain hearts of those territories more than it did the Hindu, and impelled them to chisel out of marble those configurations of white tracery which are the temples of Abu." 21

One reason why temples became such elaborate and ornate configurations in Jainism (fig. 18) is that rather than being the residence of a deity, as in Hinduism, they came to be regarded as replicas of the celestial assembly halls (samavasarana) of Jinas. This idea retained the primacy of the liberated, nonexistent Jinas and kept the plethora of divinities in proper perspective, but at the same time it allowed the sculptors to emphasize the lavishness of the samavasarana. The figures and mythologies that fill almost every available inch of a Jain temple introduce both visual variety and dramatic flavor in a tradition whose "saints are colourlessly moral, its sinners and malicious beings are not charged with an evil of any excessive potency, and its stories are too uniform to be exciting." One of the largest and most elaborate renderings in stone of the universal assembly hall may be seen in the fifteenth century temple at Ranakpur in Rajasthan. 23

This phase of Jain art also witnessed the introduction of illuminated books, which are well known among students of Indian art. It is also the period when Jainism increasingly came under tantric influence; one result was the introduction of the yantra, necessary for propitiatory, protective, and fertility rites. Here again the

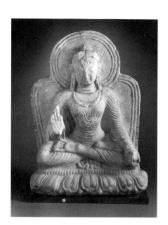

Figure 19
Buddha Sakyamuni
Afghanistan [?]; 8th—9th centuries
Marble; 17¹/4 in. (43.8 cm)
Los Angeles County Museum of Art
Given anonymously

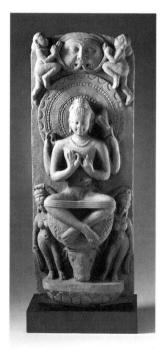

Figure 20
Lakulisa (one of the manifestations of Siva)
India, Uttar Pradesh; 7th century
Beige sandstone
19 ¾ in. (48.9 cm)
Los Angeles County Museum of Art, purchased with Harry and Yvonne
Lenart Funds

Jains share interests with contemporary Hindus and Buddhists, though by and large the Jain community remained less affected by esoteric tantric cults. Almost no Hindu and Buddhist *yantra* or mandalas have survived in India proper, and therefore it is not possible to compare the three traditions. In Nepal, where both Hindu and Buddhist mandalas do survive, there are no significant variations between the two. The Jain *yantra* therefore are of unique importance for the study of this kind of painting.

Also distinctive are Jain pilgrimage paintings, which are impressive both for their size and their compositional audacity. Although essentially topographical, the artists' skillful creation of striking visual designs is admirable. Another form of painting used only by Jains is the letter of invitation [116], with its representation of the hosts' town designed to entice the invitee, a monk, to spend the following rainy season there. It should be noted that, as with both architecture and sculpture, Jain paintings did not differ in style from those of the Hindus. Jain pictures are distinguishable by means of their contents rather than their formal elements.

The Jain Pantheon

As most Jain art represents deities and spiritual beings, a few words should be said about the pantheon, the ideals it expresses, and the principles behind its organization. There can be no doubt that the Jain pantheon, although large in size, is really the simplest among the three Indian religions. Although the Buddhists also attempted to systematize and organize their innumerable Buddhas and deities, the relationships and hierarchical positions are not always clear. The most important difference between the Jain pantheon on the one hand and the Buddhist and Hindu on the other is that in the former only peaceful forms prevail, while in the latter blood and gore are the rule rather than the exception. In both Hindu and Vajrayana Buddhist art, deities often manifest their ferocious side, which, from the artistic point of view, leads to dramatic and animated images. For Jain art and iconography tranquility (santarasa) is the prevailing sentiment, in keeping with the Jain insistence on nonviolence (ahimsa). Although under tantric influence one does encounter some deities holding weapons, and in Rajasthan even Durga [66] and Kali were adopted, by and large violence in any form is avoided, except where required in biographical representations.

The highest ideal in Jainism is the ascetic, homeless, possessionless, and above all, passionless wanderer. That is why the Jinas are always portrayed as mendicants or yogis. This, of course, is an ideal the Jains share with the Hindus and Buddhists. The Buddha is always portrayed as a yogi (fig. 19). In the Hindu pantheon Siva remains the archetypal yogi (fig. 20), Brahma is depicted as an ascetic brahmin, and Vishnu is frequently associated with a yogi. For instance, in his form as Narayana, when he is recumbent on the cosmic serpent in the cosmic waters, Vishnu is said to be in his yogic sleep. The great Hindu goddess too is a yogini and is specifically called Yaganidra, which means "yogic sleep." Thus, the yogi has always remained the model for divine representations in Indian civilization. Another model has been the king; often, even though the figure is an ascetic, he or she is crowned and ornamented in a regal manner. Thus, although the Jinas are normally not adorned, they are given thrones and the three parasols above their heads to emphasize their spiritual sovereignty. On special occasions the images of Jinas in shrines are profusely adorned with

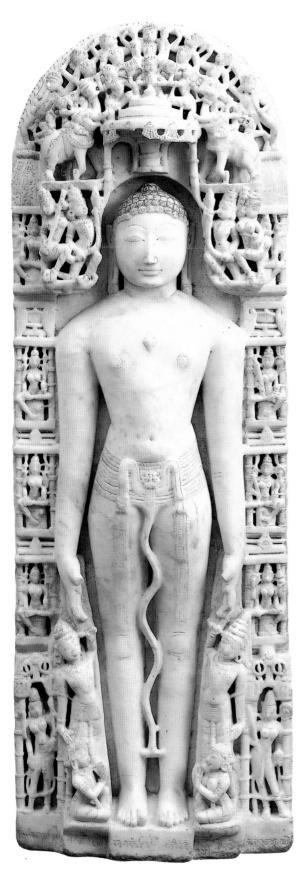

Figure 21 Jina Ajitanatha and His Divine Assembly Gujarat; 1062 CAT. 32

costly jewelry. The Jains add a halo behind the heads of the Jinas to indicate divinity, as the Buddhists and the Hindus do for their own deities. Even though the Jains believe that the liberated being ceases to exist, they have in point of fact divinized them and granted them a kind of immortality through their images.

All three religious traditions provide liberated teachers with some extraordinary bodily features in order to demonstrate these beings' superhuman character. Notable in a Jina figure are his disproportionately long arms and legs, large hands and feet, elongated earlobes, short hair curling to the right (dakshinavarta), and sometimes a cranial bump and an auspicious srivatsa mark on the chest. It may be observed that the last two elements are rarely encountered in South Indian images, and that the srivatsa is also a mark of Vishnu. Unlike Buddhist and Hindu figures, the Jinas have no multiple heads or limbs emphasizing their divinity, but the palms of their hands and the soles of their feet may be marked with lotuses.²⁵

The Jina, again unlike the Buddhas, Siva, Vishnu, and other members of the Hindu and Buddhist pantheons, is portrayed in only two positions. He is shown either seated in the classic lotus posture (padmasana) or upright in the exclusively Jain body-abandonment (kayotsarga) posture (fig. 21). In the latter case the Jina stands erect like a column, completely motionless, his unnaturally long arms hanging alongside his body. It is said that a Jina cannot be shown in a recumbent position because liberated beings never sleep. In padmasana a Jina is also engaged in teaching, although his hands rest on his lap in the meditation gesture (dhyanamudra). Only rarely are other hand gestures used by the Jains, again in contrast with the Buddhists and Hindus.

The primary Jain pantheon is a group of twenty-four Jinas, beginning with Rishabhanatha and ending with the historical Mahavira. (Curiously, the Hindus believe in a group of twenty-four emanatory forms of Vishnu.) Of the twenty-four Jinas only two are visually distinguished from the others: Rishabhanatha by his long, loose hair and Parsvanatha, the twenty-third Jina, by the snake canopy above his head. Therefore, in order to artistically differentiate among the rest each was assigned a distinct emblem and a different tree.

However, often artists did not include the cognizance or did not distinguish the tree, and unless other distinctive features—such as individual attendant figures or inscriptions—are included, it is extremely difficult to identify Jina images.

A few comments about Rishabhanatha, Parsvanatha, and Neminatha will be helpful in understanding the relationships between the three religions. Apart from his

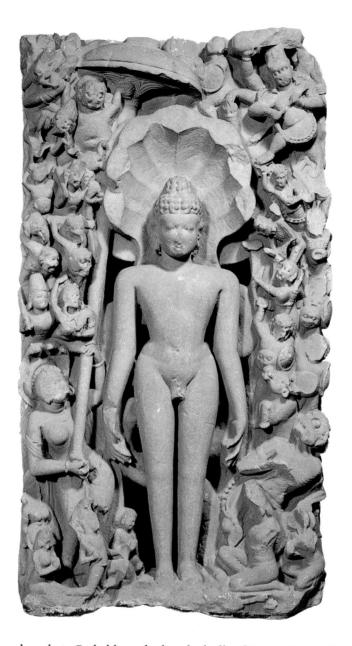

Figure 22 Samvara Attacking Parsvanatha Uttar Pradesh; c. 10th century CAT. 22

long hair, Rishabhanatha has the bull as his cognizance; he is thus known also as Vrishabhanatha, or lord of the bull. Among Rishabhanatha's other epithets are Sadyojata, Vamadeva, Tatpurusha, and Aghora. As any student of Hindu iconography will be able to recognize, these are all familiar designations of Siva. Not only is Rishabha the first of the Jinas, he is also the cosmic creator who invented fire, methods of warfare, castes, and the various arts. Thus, he appears to be a combined form of Siva, Vishnu, and Brahma.

Parsvanatha's association with the snake is interesting in that there are close similarities between the myth behind this connection, in which the guardian spirit Dharanendra protects Parsvanatha (fig. 22), and that of the serpent Muchalinda, who similarly protects the Buddha. The serpent, or naga, is also closely associated with the two most important Hindu deities. Siva uses serpents as his ornaments, while Vishnu uses the cosmic serpent Vasuki as a couch, the reptile's multiple hoods serving as a canopy. This close association of snakes with the teachers and gods of all three religions clearly demonstrates the widespread importance of serpent worship in ancient India.

Jina Neminatha's symbol is the conch [50], which is not surprising because of his involvement with Vasudeva Krishna, the popular focus of Vaishnava devotion

(the worship of Vishnu). Not only is Neminatha a cousin both of Krishna and his half brother Balarama/Baladeva, but the two play a major role in the Jina's life. The conch is also an important attribute of Krishna. Jain tradition even claims that Krishna was converted to Jainism and that Balarama was a strong advocate of the Jina's teachings. There can be little doubt that the close association of Jainism with the Krishna cult, especially in Gujarat and neighboring Rajasthan, was due largely to Krishna's popularity in the region. Among the Gujaratis it is not uncommon for Jains and Vaishnava families to intermarry, for they also have vegetarianism in common. In fact, the two Hindu epics, the Ramayana and Mahabharata, with their strong Vaishnava coloring, provide many of the themes for Jain literature and art.

Another iconographic development during the last phase of the history of Jain art is the belief in an infinity of Jinas. Just as a Buddhist believed in gaining additional merit by commissioning multiple stupas or images of the Buddha, and the Hindus by erecting *sivalinga*, so Jains dedicated images with numbers of Jinas exceeding the original twenty-four. A multiplicity or infinite number of Jinas is consistent with the Jain concept of time. "Eras of time," writes Dundas, "are conventionally represented

in Jainism as being a continual series of downward and upward motions of a wheel. . . . During each motion of the wheel, twenty-four teachers. . . appear in succession," and the process is without beginning or end. 27

Several objects in the exhibition depict the idea of countless

Jinas, although in a finite manner (fig. 23) [11-12, 45].

While the Jinas retain their primacy in Jain devotion, there are many other subservient figures, including guardian spirits, celestial beings, and divinities. Known generally as sasanadevata, or tutelary deities, they are systematized in several classes such as yakshas and yakshis, vyantaradevata (peripatetic gods), vidyadevi (goddesses of knowledge), etc. The term yaksha was once used synonymously with deva or devata to mean a god but later acquired the connotation of a demigod. In Jainism the original meaning appears to have been maintained, for most yakshas and yakshis are regarded as divine beings and often have multiple limbs. They generally serve the Jinas as their guardian angels and are frequently present in images. Some of them appear to have been more popular than others and may, in fact, have been the focus of independent cults. Impressive depictions from Karnataka of Dharanendra (fig. 24) and Padmavati, the yaksha and yakshi of Parsvanatha [51], indicate their status in that region. The rock-hewn cave temples of Ellora clearly reveal the importance of Sarvanubhuti and Ambika, while in a thirteenth-century panel we are shown the worship of the yaksha Gomukha [113]. What is curious is that though in Jain literature yaksha cults seem very ancient, yaksha images

Figure 23 An Altarpiece with Multiple Jinas Gujarat or Rajasthan 15th–16th centuries CAT. 37

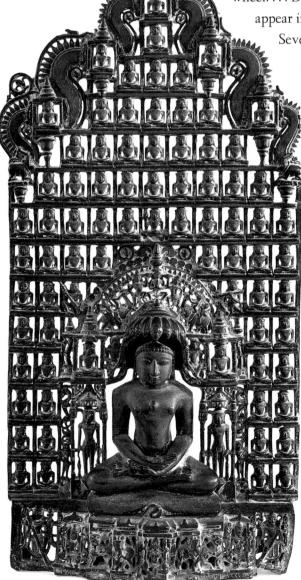

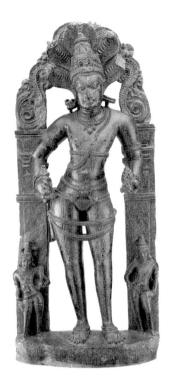

Figure 24 Yaksha Dharanendra Karnataka; 10th century CAT. 68A

do not appear in art much earlier than the fifth century.

Indra, or Sakra, the leader of the Vedic deities, is an example of a *vyantara* god; he is a very important figure in Jain mythology, where he is also known as Saudharmendra, and is represented frequently in narrative art depicting the lives of the Jinas. Among other *vyantara* gods encountered in Jain art is the group of nine planetary deities known as *navagraha*. This again is a group revered by the Hindus and Buddhists as well. The reason for their universal popularity is obvious, as they are believed to influence the destinies of all human beings and their affairs.

The Hindu deity Ganesa occupies a peculiar position in the Jain pantheon. This popular elephant-headed god is regarded by the Hindus as the benevolent remover of all obstacles and is given a shrine to himself in every Hindu temple. One can easily understand why both the Jains and the Buddhists found it difficult to ignore such a potent and helpful deity. The Jains transformed him into a yaksha [4A, 73] and gave him at least two different names. Or perhaps it is more accurate to say that Ganesa (like Gomukha and Harinegameshin) was a folk deity adopted by all three religions.

The worship by the Jains of Sri-Lakshmi, the universally admired ancient goddess of wealth and good fortune, like that of Ganesa, also needs little explanation. She is encountered first in the Vedic pantheon and has remained popular with the Hindus. Her earliest representations, where she is shown being bathed by four elephants, symbolizing rain clouds and the four directions (diggaja), are to be found in Buddhist monuments. She must have been revered from antiquity by the Jains as well, since she is also the presiding goddess of commerce. Today the Jains celebrate her festival in the autumn with as much devotion and pomp as the Hindus, and many worship her images in the Hindu mode, through a brahmin priest.

The three yakshis who have enjoyed the greatest attention are Padmavati, Chakresvari, and Ambika. The yakshi of Parsvanatha, Padmavati [65] may originally have been a snake goddess like the Hindu Manasa. Apart from her serpent attributes, her most distinctive cognizance is a curious creature combining the forms of a serpent and a rooster. Chakresvari [67] has the wheel as her principal attribute and Garuda (a half-human, half-avian creature) as her mount. Clearly she is the Jain counterpart of Vaishnavi, the personified energy of Vishnu and one of a group of powerful mother goddesses worshiped by the Hindus. It should be noted that, as is the case with many other yakshis in the Jain pantheon, both Padmavati and Chakresvari have varied iconographic forms with multiple arms and sometimes even additional heads.

The most important and popular yakshi is without question Ambika (fig. 25) [60–63]; she is also known as the "little mother" to the Svetambaras and as Kushmandini to the Digambaras. Her most distinctive attributes are one or two boys, emphasizing her maternal aspect, and a mango tree and its fruit, signifying her fertilizing powers. She has the lion as her mount, as does the Hindu Durga, who is also known as Ambika; otherwise their images are quite different. Ambika's earliest Jain images appear in Bihar. Images of the Hindu goddess seated on a lion with a child are also not uncommon in this region. In the early phase her ambiguous position is clear from her association with Rishabhanatha, Parsvanatha, and Neminatha, but from the tenth century she became allied exclusively with Neminatha. Thereafter, in keeping

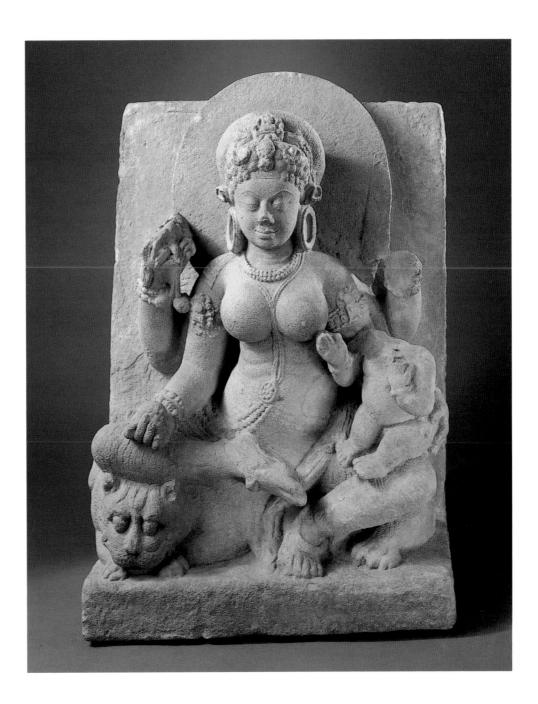

Figure 25 Goddess Ambika Bihar; 6th century CAT. 61

with the growing influence of tantrism and Sakti worship (those who believe in the supremacy of divine femininity), Ambika's cult proliferated and became permeated with tantric elements.

Although Ambika appears around the fifth century in Bihar, her legend probably originated in the west. It tells that she was the wife of Somabhatta, a brahmin living in Kodinar, in Saurashtra (Gujarat). One day at the annual memorial feast in honor of his ancestors, while the invited brahmin guests were bathing, Ambika fed some Jain monks. When the brahmins returned for their meal and realized what had happened, they refused to eat. Her enraged husband threw Ambika out along with her two boys, Siddha and Buddha. After wandering the whole day, the exhausted Ambika sat below a dried-up mango tree to rest. Miraculously the tree produced ripe fruit, and a pool of cool water appeared nearby. In the meantime, angry with Somabhatta, the gods burned down the city except for the brahmin's house. Realizing his error, Somabhatta set out to find his family. Ambika, seeing him approach and

Figure 26 Goddess Chakresvari Karnataka; 10th century CAT. 67

fearing further punishment, jumped into a nearby well and died. She was then reborn as the guardian of Neminatha.

Another group of important Jain deities are known as vidyadevi. The word vidya literally means knowledge, but from the earliest times it came to imply a special knowledge that gave power. Vidya may be regarded as mantras devoted to a particular rite for controlling both natural and supernatural elements. Mentioned as early as the Atharvaveda (c. 1000 B.C.E.), these spells became an integral part of tantric religion. The presiding deity of a vidya is always female. Jainism identifies as many as 48,000 vidya, but sixteen, known as mahavidya, are given greater prominence. The cult of the sixteen mahavidya is also popular among the Hindus, and some of them appear originally to have been Buddhist goddesses. Names such as Vajrasrinkhala and Vajrankusa point to Buddhist influence, while Kali, Mahakali, and Gauri are distinctly Hindu. Chakresvari (fig. 26) is both a yakshi and a mahavidya. Mahavidya are much more popular with the Svetambaras than with the Digambaras.

Finally, a goddess who has remained one of the most important for all Jains is Sarasvati, the personification of knowledge. Familiar in Vedic culture, she is encountered in Jain art from as early as the Kushan period [55] and is frequently represented in later art [56–57]. Usually she is shown as a graceful female with four arms holding, among other objects, a book. She may also carry a vina, a stringed musical instrument, and she has the gander, also a symbol of wisdom, as her mount. Knowledge is of the most fundamental importance to Jains, since the ultimate aim of the religion is to gain the omniscience that will result in release from all karma. 2*

NOTES

- 1. As quoted in Jaini 1979, 271. For excellent discussions of the religion and its history see Jaini 1979 and Dundas.
- 2. See Chapple for the latest literature on the subject.
- 3. Jaini 1979, 193-4.
- Slusser.
- 5. Granoff 1990, 100.
- 6. Ibid., 157.
- 7. As quoted in Jaini 1979, 308.
- 8. Ibid., 275.
- 9. Smith 1969, 18, plate x1.
- 10. Ibid., no. 24.
- 11. Fleet 1970, 68.
- 12. Ibid., 260.
- 13. Pereira, 93.
- 14. U. P. Shah 1955-56, 64.
- 15. Ibid.

- 16. See Settar 1992, 83–143 for the most extensive discussion of Jain Indian artists to date.
- 17. Fischer and Jain 1977, 13.
- 18. Sivaramamurti 1979, 132-33.
- 19. This tripartite division is a condensation of the four-stage division given in Pereira, 10.
- 20. Ibid., 14.
- 21. Ibid., 15.
- 22. Ibid.
- 23. Ghosh 1974-75, 2, pls. 240-43.
- 24. For the most extensive study of the Jain pantheon and iconography see U. P. Shah 1987A. A briefer work on the subject is B. C. Bhattacharya 1974.
- 25. The only exception is a late image of Jina Chandraprabha in the Victoria and Albert Museum showing seven heads. See Jaini 1979, 73, fig. 13.
- 26. U. P. Shah 1987A, 113.
- 27. Dundas, 17-18.

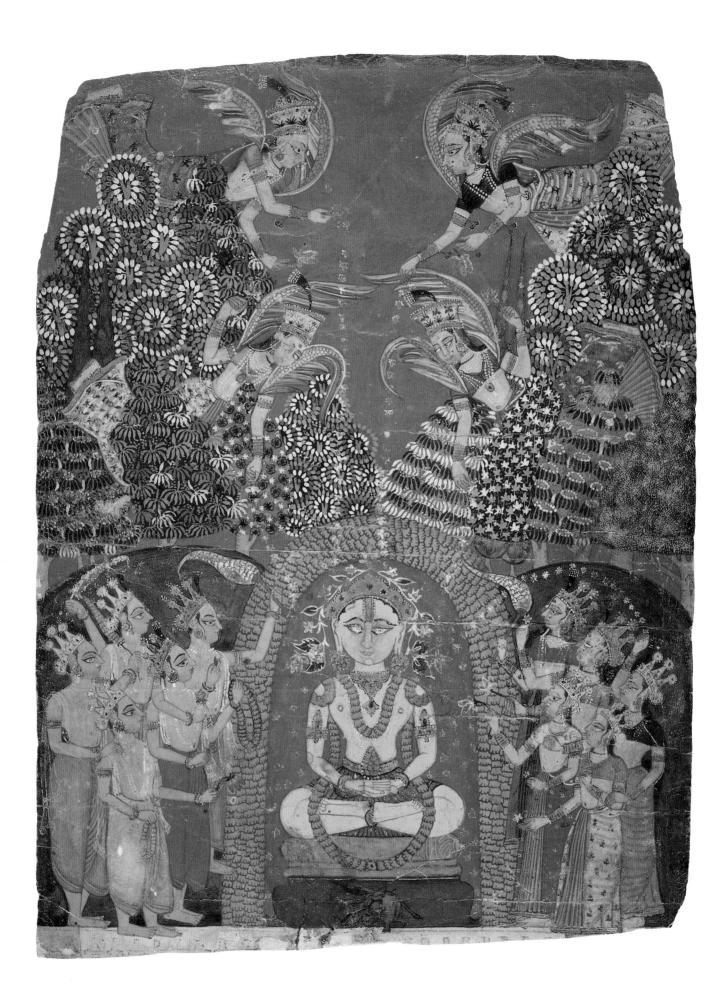

Following the Jina, Worshiping the Jina: An Essay on Jain Rituals

JOHN E. CORT

Where in contemporary India, either in a major metropolis like Bombay or a small village far from the nearest city. Early in the morning the members of the local Jain congregation, after bathing and donning clean clothes, proceed to the neighborhood temple. Each person carries a small metal tray on which are fruit and flowers, a few small coins, a bag of rice, and a rosary. In the central shrine of the temple are several dozen stone and metal images, all seemingly identical, of human figures in meditative postures. For the next forty-five minutes each Jain, at his or her own pace and without the assistance of a priest, bows down before these images, places offerings of flowers and sandalwood paste on them, and makes designs of rice, fruit, and coins on a small platform, all the while softly singing hymns. Were you to return to this temple on any given day you would see the same routine each time.

What exactly are these people doing? Why do they repeat the same actions over and over again, rather than devising new ones? Are they trapped in some sort of empty ritual? Are they, in worshiping pieces of inanimate stone or metal, mistaking the material for the spiritual? Finally, who are the figures being worshiped, and why are they all so nearly alike?

Several barriers come between Jain art and a contemporary Western audience. The first is that it is not "art for art's sake." In the Jain tradition, aesthetic values have generally been subordinate to religious ones. Jain art communicates specific religious ideals, such as renunciation, liberation, and the proper norms of interaction among Jain monks and laypeople. But even more important is its involvement with the ritual activities of the believer. While Jain art is intended to be aesthetically pleasing and to communicate core religious values, it is largely designed to serve a ritual function.

Introducing the concept of ritual raises another barrier for a Western audience, for contemporary Western culture is deeply suspicious of all forms of ritual. This suspicion stems from a number of sources, only two of which I will mention here. The first is the theological position advanced by Martin Luther, which was one of the central principles of the Protestant Reformation: that the individual Christian is saved not by works (i.e., sacraments, charity, and all other forms of ritual behavior) but by faith alone. As a result of this doctrine, Protestant Christianity was shorn of much of the accumulated ritual tradition that to a large extent defined Catholic cul-

CAT. 115A Adoration of a Jina Rajasthan, Marwar; c. 1670 ture. Ritualized activities were criticized as betraying a concern with outer material form rather than inner spiritual meaning. According to this Protestant position the core of Christianity, and therefore by extension the core of any religious tradition, is an experience of divine presence that cannot be prompted by ritual activity. In fact, ritual is seen as extraneous and even dangerous insofar as it leads the believer away from what is truly important.

A second source of the contemporary suspicion of ritual is a later, more secularized development of the Protestant critique. The anthropologist Margaret Mead (1973, 87) has described ritual as "behavior that is repetitious." A well-performed and efficacious ritual is one that is done in the same way every time. But this emphasis on repetition runs counter to one of the dominant paradigms of Euro-American civilization for the past two centuries, which places ultimate importance upon innovation and novelty. To quote Mead again (ibid., 98), contemporary Westerners, and especially Americans, have an acute "boredom with anything done more than once." The never-ending quest for the new and unique prevents Westerners from appreciating ritual in its proper context. This attitude is seen in a number of ways in Western culture, from the romantic valorization of the uniqueness of the artist, to the modernist dictum of Ezra Pound to "make it new," to the concept of an artistic avant-garde, and finally to the contemporary intellectual fascination with the deconstructionist project of tearing down the walls of tradition in a quest for a pure knowledge and experience beyond all that has gone before.

If one is to understand the power of Jain art, one must put aside these deeply ingrained Western biases. Further, to understand the logic behind the many forms of Jain ritual, one must understand the world as the Jains see it and live in it.

The Jain community consists of four branches, two of renouncers (monks and nuns) and two of householders (laymen and laywomen). A major difference, however, exists between Christian and Jain monks: whereas Christian monks take vows of stability that tie them to a single community, the Jain monastic vows commit them to lives of perpetual peregrination. The Jains are divided into two main traditions, the Digambaras and the Svetambaras. While the names refer to specifics of monastic practice—Digambara monks are "sky clad" or totally naked (fig. 27), while Svetambara monks are "white clad," i.e., they wear several pieces of unstitched white cloth (fig. 28)—many of the broad features of ritual life are similar in the two communities, especially among the laity.²

The Jain worldview is fundamentally materialistic. While the human senses are unable to reveal all that exists, there is no doubt to the Jain that the universe does exist in a very tangible and material sense. Matter, which is everywhere, is made up of an uncountable number of invisible atoms, devoid of all consciousness. Consciousness is the defining characteristic of the other fundamental building block of the universe, the soul. Souls, of which there are also an uncountable number, are the nonmaterial, sentient aspect of every living thing, from the tiniest single-celled amoeba to the largest whale, and most importantly, of every human being. Every soul possesses the innate characteristics of infinite knowledge, infinite perception, infinite potential, and infinite bliss. But only a very few souls have realized these four infinitudes. The souls of all living beings on earth, in heaven, and in hell are unable to realize their full

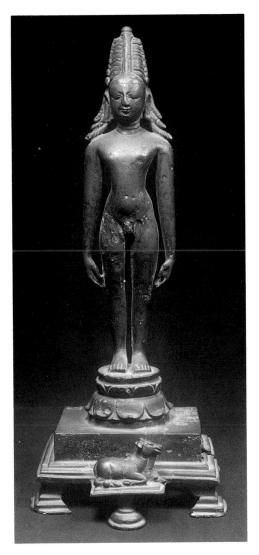

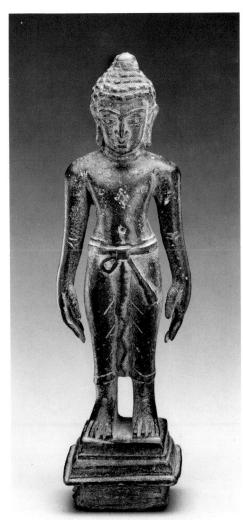

Figure 27 ➤
Jina Rishabhanatha
Orissa, Manbhum; 11th century
CAT. 40

Figure 28 >> A Svetambara Jina Gujarat, Valabhi; c. 600

plenitude, for they are locked in bondage by a subtle form of matter known as karma. The Jains understand karma, however, in quite a different fashion from the way matter is understood in Western philosophy. Karma exists only as the result of the actions of living beings. Jains are most concerned with the actions of humans, since only humans have the ability to choose between right and wrong. Thus the Jain emphasis on karma is a recognition that the imperfect condition of each and every person is the result of prior action. It is also a call for the individual to act upon that recognition in a manner that will improve the moral condition of everyone.

There is a seeming contradiction here that forms yet another barrier to our understanding of Jain art. The Jain goal is to attain a liberated state completely free from all effects of karma. To attain this state it is necessary to halt the impact of karma on the soul and at the same time to eliminate the previously acquired karma that enmeshes the soul. But the only way to attain victory over karma is through further, refined action. This form of spiritual homeopathy is the attitude that informs Jain understandings of the need to perform ritual actions.

Since the individual of necessity must act in a world of karma, it is crucial to distinguish between actions that are good, auspicious, and meritorious and those that are bad, inauspicious, and demeritorious. Short of completely renouncing all actions,

which in the present context is proper only for the individual on the verge of death, the Jain strives to maximize the positive effects of action through ritual and to minimize the negative effects incumbent upon all actions. Through such striving one's spiritual balance sheet in time will show such a surplus of merit that one will attain the superior goal of renouncing all action. A ritual action is meritorious to the extent that it is performed in a spirit of renunciation of all desires except the subtle desire for liberation. Thus Jains are called to distinguish between good and bad actions, while at the same time striving to transcend such a goal-oriented perspective.

There is a further distinction that informs Jain attitudes toward ritual, that between *bhava* (spirit) and *dravya* (matter). At its most basic, this parallels the division between monks, who have renounced all material possessions (and so operate in the spiritual economy of *bhava*), and householders, who are still within the world of material possessions (and so partake of the physical economy of *dravya*). But the distinction between *bhava* and *dravya* is not identical to that between monks and householders, for while monks are expected to have nothing to do with *dravya* in a ritual context, the rituals of the householders involve both *bhava* and *dravya*.

Now that we have briefly looked at the logic of Jain rituals, let us examine the rituals themselves and how they are involved with Jain art. According to Jain tradition, those people of the ancient past who succeeded in liberating themselves totally from the effects of karma reside in their perfection at the very top of the universe, in a special abode shaped like a horizontal crescent moon or an inverted umbrella, and known as Isat-pragbhara ("the slightly curving place") (fig. 37). Certain of these souls are doubly special. After they attained enlightenment, but before their final liberation from the residual effects of karma, they taught the Jain path of liberation to the world. These special souls, of whom there are only twenty-four in any sector of the universe in any one cycle of time, are known as Jinas, or victors, because they have won the greatest victory of all, over suffering, ignorance, and death. Those who follow the teachings of the Jinas are known as Jains. There is no God in the Jain worldview except for the totality of these Jinas. In other words, God for the Jain is the ultimate expression and realization of human perfection.

There is no difference between the souls of Jinas and those of unliberated Jains. All souls possess the four innate characteristics listed earlier, but except for Jinas these qualities are obscured by karmic bondage. The monks are further along the path to liberation than the householders. One of the monastic vows involves the renunciation of all possessions, and so monks have only their own bodies and souls to work upon in their quest. Through their actions they seek to transform themselves into liberated souls and eventually to become like the Jinas.

Householders, however, still live within the world of material possessions. While recognizing that liberation is the ultimate goal of every human being, they have postponed the great sacrifice required to become a monk or a nun, either until later in this lifetime or until another lifetime (for every soul will be reborn countless times until it attains liberation). While monks seek to become purified from all karma, householders seek instead to transform their karmic status through venerating, praising, and worshiping the spiritual ideal of the Jina, and to a lesser extent through similar ritual actions directed toward beings who are closer to that goal.

42 CORT

Figure 29 Contemporary Svetambara Murtipujak nun performing obligation of hymn to twenty-four linas. Koba, Gujarat.

As part of the initiation ritual, the Jain monk undertakes the lifelong observance of five great vows: not to harm any living creature; to speak only the truth; not to take anything that has not been freely offered; celibacy; and to have no possessions and to remain emotionally unattached to all material objects. To support these great restraints the monk also follows more specific rules of conduct, which involve increased control over the activities of mind, body, and speech, and constant attention to all actions and thoughts, even during sleep.³

Because these rules are framed largely in negative terms, they do not provide clear guidelines for spiritual practice. This practice consists of six obligations, performed in some cases constantly and in other cases at set times of day, that are a mix of ascetic and devotional activities. The obligations are: perpetual meditative equanimity; recitation of a devotional hymn of veneration to the twenty-four Jinas (fig. 29), often in the presence of their stone or metal images; veneration of the monastic superior; a twice-daily rite of atonement for improper actions; the ritualized statement of intention to perform certain karma-destroying austerities (usually lengthy fasts or other acts of physical deprivation); and "abandoning the body," which is not a separate rite, but a constituent part of several of the other obligatory rituals, and is enacted by standing in the meditative posture seen in many Jina images.

The goal of the monks' regimen is to remove all individual choice. The problem with choice is that to choose to do something one must first intend to do it. To intend to do an action involves the desire to do it, and desire inevitably leads to karma and the furtherance of the bondage of one's soul. But through ritual actions the monk is able simultaneously to prevent further karma from binding the soul and to eliminate some of the karma accumulated from previous activities.

While texts for the ideal lay life, as written by monks, are modeled upon the monastic discipline of ritualized restraints and obligations, in actual practice the spiritual life of the Jain layman or -woman involves a wide range of ascetic and devotional activities. The ultimate goal for the layperson is the same as for the monk—the elimination of all karma with the result of liberation—but in practice the layperson is more concerned with eliminating bad karma and maximizing good karma so as to enhance both well-being in this life and the chances of a better rebirth. Intention, however, is still crucial, Jains believe, for if the layperson acts with a total disregard for the ultimate goal of liberation, and instead seeks only to increase good karma for worldly ends, such practices at best will be only marginally successful. Conversely (and paradoxically) if a layperson practices with the sole intention of eliminating karma and advancing along the spiritual path, Jains believe that as karmic balance improves, so automatically will the person's worldly position. In other words, as long as the person is not attached to the worldly benefits of religious activity, that person will receive those benefits. It is by this logic that Jains insist that their prosperity and they have been one of the wealthiest communities in South Asia for many centuries—is the direct result of their ritual life.

In certain ways the religious life of the Jain householder resembles the life of the monk. This is especially the case in terms of the rigorous asceticism that is one of the hallmarks of the Jain tradition. While laypeople do not carry asceticism to the same lengths as monks, the average Jain certainly leads a much more austere life than

Figure 30 A Jain Monk Receiving a Prince Folio from an unidentified manuscript Rajasthan, Mewar; c. 1635–45 CAT. 94

Figure 31 Pato with Auspicious Symbols Gujarat; c. 1950-75 cat. 15

that of most other Indians. Jains are firm vegetarians, since they view eating meat as one of the cruelest forms of violence. Most Jains carry this logic of dietary asceticism even further and avoid leafy vegetables, as eating such plants also involves some measure of harm, both to the plants themselves and to the small organisms found upon them. Many Jains also avoid eating root crops, since according to Jain biology roots contain an infinite number of single-sensed organisms.

In the Jain community monks are superior to laypeople due to their single-minded pursuit of liberation. Whenever they come into the presence of a monk, laypeople perform a stylized rite of veneration (fig. 30). They are also expected to render service to monks by providing them with shelter, food, clothing, books, and ritual paraphernalia such as the thread used by Svetambara nuns to embroider the cloth that covers the handles of the brooms each monk carries to sweep away insects (fig. 31). In return for this service, monks informally advise laypeople on all aspects of their religious lives and in more formal settings deliver public lectures on the principles of the Jain tradition (fig. 32).

Jain monks are necessarily peripatetic, since to stay in one place would engender attachment. Thus in any given city or town where Jains reside there may be no monks present for long periods of time. Before the renaissance of Jain monasticism in recent decades, which has seen the number of monks and nuns increase from a handful to thousands, many Jains would not see a monk for years, or even decades. Therefore, in addition to personal ascetic practices, for most Jains ritual life has long centered around temples containing stone and metal images of the Jinas. Whereas the monks are striving to emulate and eventually equal the liberated Jinas, the lay Jains instead aim to improve both their worldly and spiritual lot by offering worship to images of the Jinas.

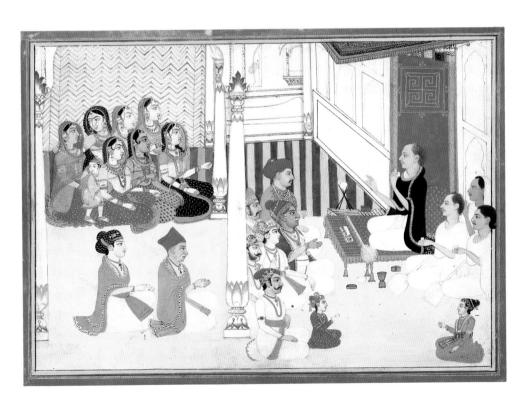

Figure 32 Scene of Instruction Rajasthan, Jaipur; c. 1800–25 CAT. 119B

The temple ritual has two hymns at its historical core.⁵ One of them praises the Jinas as "illuminators of the world" and "creators of religion, which is the vehicle to liberation." After reciting the names of the twenty-four Jinas of this era, they are venerated as "freed from the dirt of karma, and having overcome illness and death." In the final of the seven verses, the worshiper prays for liberation equal to that of the Jinas.

The other hymn is found in the ancient *Kalpasutra* in the context of the birth of Mahavira, the twenty-fourth and last of the Jinas, who lived some 2,500 years ago in north India. The *Kalpasutra* says that at the time of Mahavira's conception Indra, the king of the celestial beings, stepped off his throne, bowed down, and recited what is still known as "Indra's Hymn." This contains a long series of praises of the Jinas for having attained liberation and given humanity the most wonderful of all gifts, the religion that allows one to overcome death and suffering. This hymn has become the model for the worship of Jina images. In imitating Indra the worshiper imagines that he or she is face to face with the Jina.

Jains believe that since the Jinas have eliminated all desires and intentions, they cannot respond to an individual's worship, for any kind of response would involve at least a trace of intention. The image in the temple, therefore, contains no real presence of the Jina. Rather, it is a symbol of perfection that points the worshiper to a spiritual goal. The Jain doctrine of the gradual corruption of time states that no Jina can exist on earth at present. But the Jain worshiper is able to overcome this separation through an act of psychological projection, by imagining that he is Indra or that she is Indra's queen, Indrani, and thus is present at the moment of the Jina's conception or in the audience of the preaching Jina and so is able to worship him directly. The element of projection is brought out in Jain paintings of adoration, in which it is not at all certain whether the worshiper is directly experiencing the Jina or is simply in front of an image (fig. 33). This projective quality is also expressed in devotional hymns, in which again it is unclear whether the poet is describing the Jina or a temple image. When the medieval poet Manatungasuri sings the following Sanskrit verses, the Jina and the image are fused in a single devotional perception:

Your body glows golden-colored on the lion throne, shining in the beams, refracted through gems like the disc of the thousand-rayed sun, its rays flashing across the sky like a canopy of vines onto the peak of a high mountain.

The triple canopy shines above you, lovely as the moon placed on high, blocking the burning rays of the sun, its beauty enhanced by strings of pearls as it proclaims your supreme lordship over the three realms.⁶

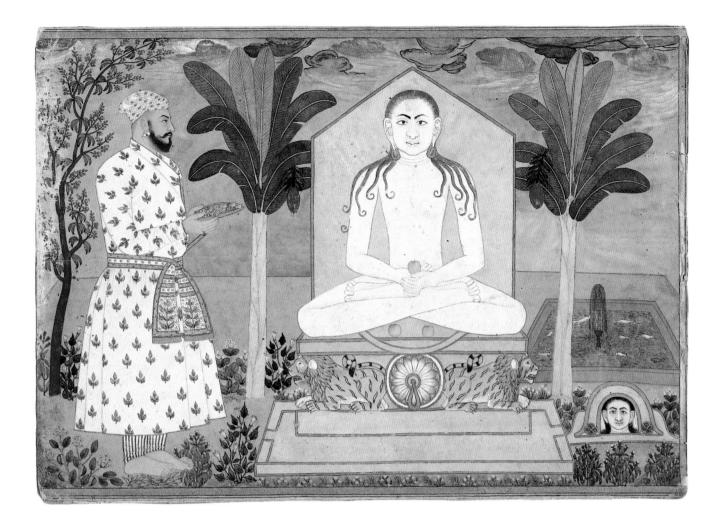

Figure 33 Adoration of a Jina Andhra Pradesh, Golconda; 1675–1700 CAT. 1158

In contrast to most Hindu temples, where a Brahman priest is essential as an intermediary between the worshiper and the image, Jains perform the temple rituals themselves. Most Jain temples employ caretakers (non-Jains in Svetambara temples, poor Jains in Digambara temples), but they do not fill any essential priestly function. South Indian Digambara temples often have hereditary Jain priests, but even these are not required. A further difference between Jain and Hindu temple ritual is seen in the greater number of ritual implements used by Hindus. Symbolically, both Hindu and Jain rituals are extremely complex and share many formal qualities drawn from the pan-Indian etiquette of social hospitality to a guest. However, the material simplicity of the Jain ritual indicates the extent to which its central concern is the transformation of the worshiper's spiritual condition.

The standard ritual is known as the eightfold worship, because eight offerings are involved. Having no prescribed form, it allows for much individual interpretation and personal expression. The symbolism of the different acts described below is neither universal nor mandatory, nor would all Jains immediately express these meanings. They do, nonetheless, represent the understanding of many contemporary Jains, as I have discovered in the course of extensive fieldwork as well as in popular literature on Jain worship.

Before entering the temple, the worshiper bathes and puts on pure clothing, to emphasize the goal of purifying one's soul of the stain of karmic bondage. As an act of separation from the profane world some Jains will recite three times an ancient

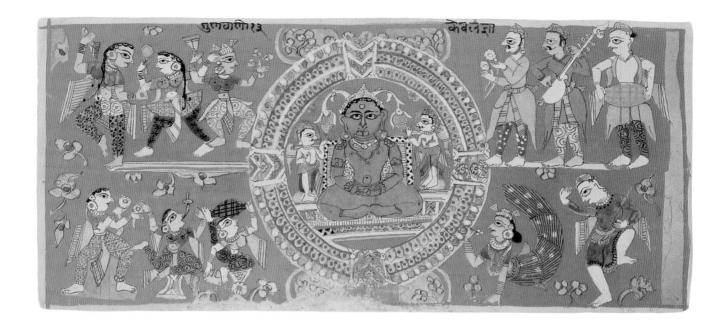

Figure 34
Assembly for a Jina
Folio from a Laghu Samgrahanisutra
manuscript
Western India; c. 1575
CAT. 90A

Prakrit phrase meaning "it is abandoned." The first act after entering the temple is to take *darsana* of the image of the Jina, a word that literally means "seeing." The worshiper imagines that he or she is not just in front of a stone or metal image but is in the actual presence of the Jina, who is a witness to the individual's spiritual efforts. To emphasize the emotional power of this act, most Svetambara images are adorned with large enamel eyes on top of the carved ones, so that even from the back of a crowded temple the individual can have a personal interaction with the image. As part of the rite of *darsana* the worshiper bows down with folded hands and might even lie prostrate on the floor, as a sign of submission to the Jina's teachings.

The image symbolizes the qualities of omniscience and dispassion that are the hallmarks of the liberated state. Many Svetambara images are elaborately decorated in royal regalia to indicate that the true king of the world is the Jina, thereby reminding the Jain of the superiority of spiritual to worldly pursuits. Most images represent a single Jina seated in dispassionate meditation, though some depict a standing figure in the posture of abandoning the body. But images also come in a rich variety of other forms, a fitting embodiment of the rich variety in Jain devotion. Some consist of four Jinas facing in the cardinal directions in symbolic representation of the samavasarana

Figure 35 Birth of Mahavira Folio from a Kalpasutra manuscript Gujarat; 15th century CAT. 83A

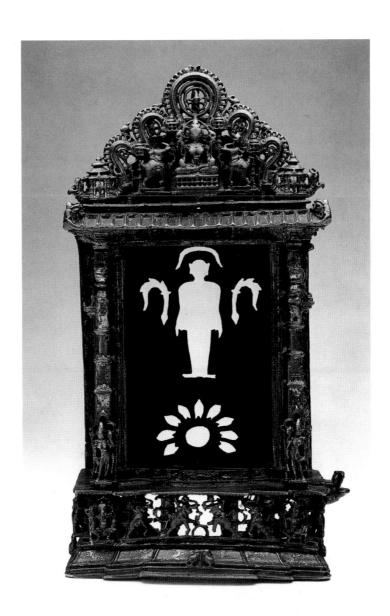

Figure 36 Siddhapratima Yantra Western India; 1333 CAT. 14

[20], the universal sermon delivered by each Jina upon attaining enlightenment (fig. 34). Others show the twenty-four Jinas of our cosmic period [45]. Most temples contain additional images both inside and outside that are not designed to receive worship, but instead perform a more representational function, with scenes such as the birth of a Jina (fig. 35). A particularly striking example of a nonritual image found in the Digambara tradition depicts a liberated Jina's absence from the world of karma by outlining in metal his empty silhouette (fig. 36).

In temples where the central chamber is a separate room, the devotee circum-ambulates it three times, to symbolize right faith, right understanding, and right conduct, the "three jewels" of the Jain tradition that lead one to liberation. Throughout the ritual, devotional hymns are sung to the specific Jina whose image is in the temple or else the universal Jain prayer known as the Namaskara Mantra, or litany of reverence:

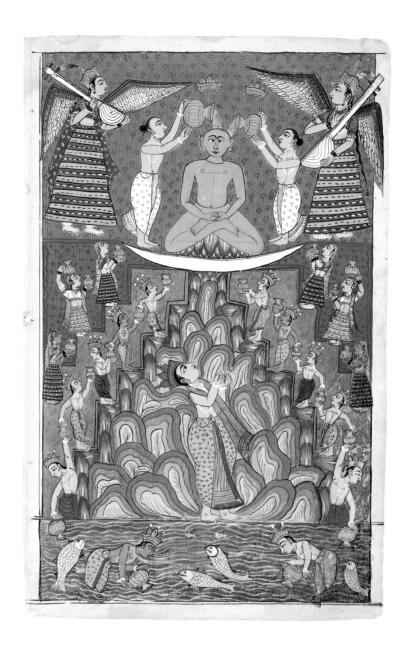

Figure 37 Lustration of a Jina Gujarat; c. 1800—25 CAT. 108

I revere the Jinas.
I revere the [other] liberated souls.
I revere the monastic leaders.
I revere the monastic preceptors.
I revere all monks in the world.
This fivefold reverence
destroys all demeritorious karma
and of all holies
it is the foremost holy.8

The worshiper then commences the eightfold offering by entering the chamber in which the Jina image is enthroned. In allowing all worshipers, both men and women, to enter the sanctum and touch the images, Jainism is distinct from most Hindu ritual systems. (In most Hindu temples there is a strict physical separation between the image and the layperson, with only professional male priests allowed into the sanctum.) A small amount of water is poured on the image—another symbol of spiritual purity (fig. 37). The second offering is the application of small dabs of sandal-

Figure 38 Offering of rice (in shape of Jain svastika), dried food, and fruit on platform. Koba, Gujarat.

wood and saffron paste to different parts of the image. According to South Asian folk wisdom, sandalwood cures a person of fever and so here represents the need to cool off the passions if one is to overcome karma. Saffron adds to the pleasant smell of the sandalwood, symbolizing the "sweet scent" of the Jina's teachings. Furthermore, the high cost of saffron underscores the attitude of sacrifice that pervades the ritual. The third offering consists of sweet-smelling, visually pleasing, unbroken flowers, which declare that the worshiper has unbroken, satisfied faith in the Jina's teachings. The fourth offering is made by waving a stick of burning incense before the image, to symbolize the eradication of the "bad odor" of ignorance and worldly desire. The fifth offering consists of swinging a lit butter-lamp to evoke the disappearance of the darkness of ignorance in enlightenment.

These five offerings are known collectively as the "limb worship," for in them the devotee touches the image's limbs. Afterwards the worshiper steps out into the larger public hall for the final three offerings. These are known as the "facing worship," for they are conducted in front of the image rather than while touching it. We can see embedded in the ritual a gradual movement from *dravya* to *bhava*, from matter to spirit, that symbolizes the spiritual path itself. The final three offerings are made on a small, raised platform. Sitting before it, the worshiper draws the Jain *svastika* with unbroken grains of rice. The four arms of the *svastika* represent the four possible states into which one can be reborn—human, celestial being, infernal being, and plant or

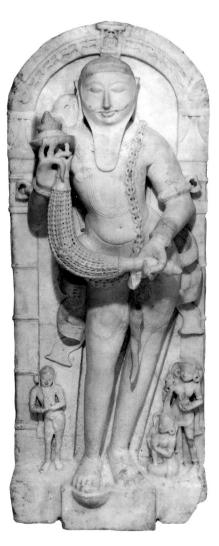

animal; the three dots represent the three jewels of the path to liberation; and the dot and crescent moon represent liberation itself by visually approximating the abode of liberated beings at the top of the universe (fig. 38). Onto this design is placed a piece of fruit, meaning that the desired fruit of the ritual action is spiritual benefit, and a piece of cooked food, usually of a dry variety such as sugar candy. While the first seven offerings have a direct meaning, the food has a reverse symbolism. Because Jains understand the Jina to have overcome all karma and thereby to have ceased all activities, the state of liberation is called "the state of not eating." The food offering is thus a giving up of food that symbolizes the liberated state. Most Jains will also place a coin on the rice, representing the renunciation of money in the pursuit of spiritual well-being. While this offering of money is usually quite small, on other occasions Jains will make large contributions for the upkeep of temples. Medieval sculptures show donors offering up money-belts or other elaborate gifts in a show of munificence (fig. 39).

Figure 39
Portrait of a Patron
Gujarat; c. 1100
CAT. 111

Figure 40 Contemporary Svetambara laywoman performing obligation of hymn to twenty-four Jinas. Patan, Gujarat.

Figure 41 Stone plaque of pilgrimage shrine in Svetambara temple at Ranakpur, Rajasthan.

Many worshipers follow the eightfold worship with a version of the second monastic obligation, the hymn of veneration to the twenty-four Jinas (fig. 40). Also sung are "Indra's Hymn" and other personal favorites, such as the hymn by Manatunga quoted above. Some people use a rosary to count 108 or 1008 repetitions of the Namaskara Mantra or another favorite prayer. This part of the ritual completes the movement from *dravya* to *bhava*. Instead of offering physical belongings, the worshiper is now offering spiritual devotion. From here it is a short step in the logic of the ritual, although a long step in the lives of most Jains, to the greatest offering of all: that of oneself in monastic initiation.

Most Jains live in a neighborhood that contains a temple and thus are able to worship by themselves every morning and to gather with the entire congregation in larger, more festive rituals on special holidays. Most temples have a large number of Jina images, since their commissioning and donation is a highly meritorious action. In past centuries many wealthy Svetambara Jains preferred to erect shrines in their homes as indicators of status and personal piety. These household shrines were often elaborately carved in wood [5, 7]. Such a shrine allowed one to perform extended devotional rituals without the distractions of others. In recent decades, however, most of these shrines have been dismantled or sold and their images shifted to public temples. In one of the most important centers of Svetambara Jains, the town of Patan in north Gujarat, there were around five hundred home shrines in the early nineteenth century. By the mid-twentieth century this number was down to sixty, and now there are less than a dozen.¹⁰ In part this change has been due to the migration of Jains from their traditional homes in Rajasthan and Gujarat to big cities like Bombay or even overseas. But it is also in part because of the belief that, once installed, an image should be worshiped every day; this cannot always be accomplished in a home shrine, given the mobile nature of Jains as merchants and traders.

Jains do not worship only in their local temples. Over the centuries many have gone on lengthy pilgrimages to important shrines commemorating special events in the lives of the Jinas. For those Jains who for whatever reason are unable to go on pilgrimages, most temples have carved stone or wooden plaques of pilgrimage shrines (fig. 41). As part of the daily worship service an individual waves incense or a lamp in front of the plaque, while singing a hymn extolling the virtues and sanctity of that site. On annual festivals cloth paintings of the holiest shrines are displayed for public veneration [117].

Jina images and representations of shrines are not the only objects of worship by lay Jains. Many temples also contain images of deceased monks to whom hymns of veneration are sung. Some deceased monks are believed to be residing in celestial realms, and since they are not liberated they are capable of responding favorably to petitions, much like saints in the orthodox Christian traditions. While the veneration of a deceased monk in some ways resembles the veneration of a living one, it is actually closer to the worship of a Jina, although the ritual is slightly different so that the two cannot be confused in action or thought.

While it is inappropriate to worship the Jina for any reason except the pursuit of liberation, it is proper to worship deceased monks and other nonliberated Jain deities in the pursuit of worldly goals such as health, wealth, passing an exam, or

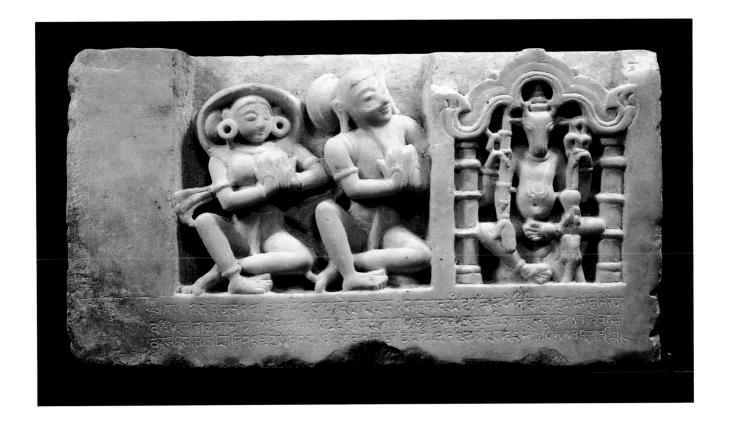

Figure 42 Couple Worshiping the Yaksha Gomukha Gujarat, Ladel; 1299 CAT. 113

other forms of success and well-being (fig. 42). Among these other deities one finds yakshis and yakshas; Sarasvati, the goddess of learning; and various protectors who look after temples and shrines. These deities are viewed as fellow Jains, who are also on the path toward liberation but have not yet attained it and so can act in powerful ways to further the welfare of the Jain community.

With the worship of unliberated monks, gods, and goddesses for worldly purposes we seem to have come far from our original discussion of the need to remove the bondage of karma. The pious Jain, however, would respond that even ritual with worldly motives is successful only to the extent that it is done in the spirit of renunciation and the pursuit of liberation. Such rituals do not involve destroying karma; instead they improve one's situation by substituting good karma for bad. This is a necessary aspect of the pursuit of liberation, for without worldly well-being the Jain community could not build temples to worship the Jinas, nor could it support the world-renouncing Jain monks and nuns.

The scholar would point to another factor. Despite the Western suspicion of ritual, it is an inherent part of human nature, whether it be as simple as the act of shaking hands when greeting someone or as elaborate as Jain temple rites. Humans cannot live without ritual. At the same time, artistic expression is an equally ingrained part of human nature. It should therefore not be surprising that at the core of the Jain religious life we find these two primal forces, ritual and art, fused into a single, all-encompassing paradigm of what it means to be a Jain. For the Jain, ritual and art cannot be separated, as both are profoundly connected with the quest for the ultimate expression of one's humanity in spiritual liberation. 20

This essay has benefited from the insightful comments and advice of Alan Babb, Brian Hatcher, James Laidlaw, Janice Leoshko, Pratapaditya Pal, and Karl Sandin.

- In this essay I use the term "monk" to refer generically to all renouncers, both male and female. Jainism is unique among Indian religious traditions in having a larger number of nuns than monks. This seems to have always been the case, for ancient texts such as the *Kalpasutra* give the number of nuns as several times the number of monks, while in the contemporary monastic community nuns outnumber monks by more than three to one. See Cort 1991B, 659.
- 2. The distinguishing features of the two traditions are clearly seen in illustrations both of monks and of Jinas. The Svetambaras are further subdivided between the majority Murtipujak ("image-worshiping") tradition, and the smaller, more recent Sthanakvasi and Terapanthi groups, who do not practice such worship. This essay deals primarily with Svetambara Murtipujak ritual. For fuller discussions of Murtipujak ritual life, see Cort 1989 and Laidlaw 1990. For the best introductions to the Jain tradition as a whole, see Dundas 1992 and Jaini 1979.
- For example, when a monk rolls over in his sleep, he should first wake and sweep the space with his whiskbroom to ensure that he does not crush any minute insect.
- 4. On this dramatic expansion see Cort 1991B.
- 5. See Cort 1989, 348-57; and forthcoming.

- 6. Manatungasuri, *Bhaktamara Stotra*, verses 29 and 31. My translation.
- 7. The Svetambara version of this ritual has been the focus of much scholarly inquiry. See Babb 1988, Cort 1991A, Humphrey 1985, and Humphrey and Laidlaw, forthcoming. The Digambara ritual has been much less studied; see Jain 1926, Stevenson 1910, 86—92, and Vasantharaj 1985. The following description is of the Svetambara version, as generalized from extensive fieldwork in Gujarat.
- 8. My translation.
- 9. A pan-Indian sacred number symbolizing wholeness, 108 is the lowest common multiple of 12 (the number of lunar months in a year) and 27 (the number of mansions [nakshatra] through which the moon passes), and thus represents the year as a basic symbol of wholeness and totality. A common expansion upon this sacred number is 1008.
- 10. Kalyanvijay 1966, 85. This sharp decline in the number of domestic shrines also accounts for the ones found in Western and Indian museum collections, as they have become available through Bombay art dealers.
- 11. On Jain pilgrimage, in addition to the article by Phyllis Granoff in this volume, see Cort 1988 and 1990, and Dundas 1992, 187–94.
- 12. See in particular Babb 1993, 13—20, and Laidlaw 1985.

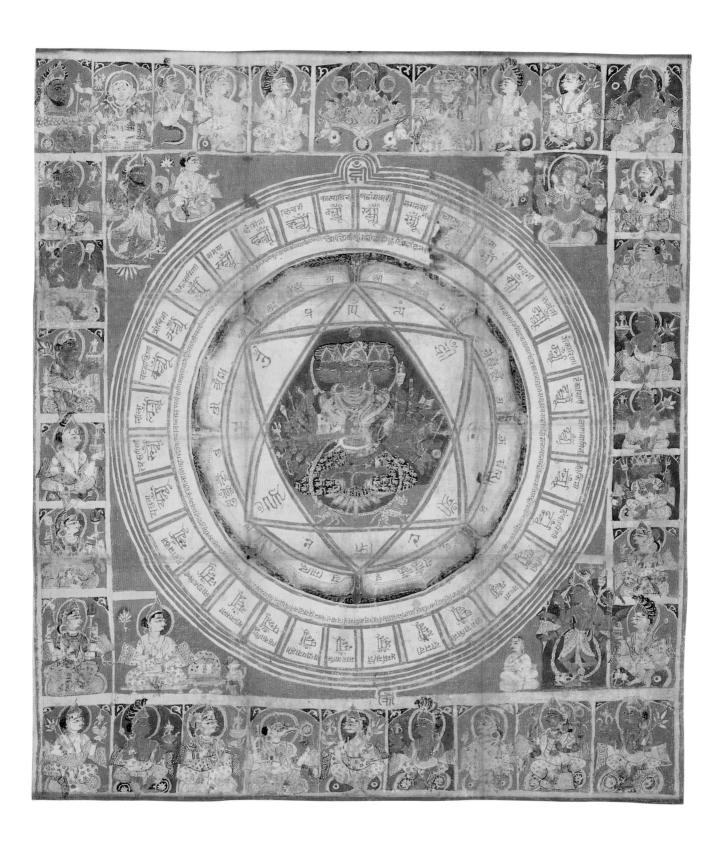

Are Jains Really Hindus? Some Parallels and Differences between Jain and Hindu Philosophies

GERALD JAMES
LARSON

had some years ago with Mr. N. P. Jain, proprietor of the publishing house Motilal Banarsidass in Delhi, India. Mr. Jain, a member of the faith his name betokens, was preparing for the wedding of one of his brothers, and I asked him how a Jain wedding would differ from a Hindu wedding. His immediate reply was that there was hardly any difference. To be sure, the content of certain prayers, utterances, and rituals would vary, he said, but the overall procedure and its social significance would be nearly identical. I then asked: In your view, then, are Jains really Hindus? His response was a sort of "yes-and-no" answer: yes, in many respects Jains do appear to be Hindus; and no, in many other respects they do not. His overall inclination, however, was to stress the parallels and to play down the differences.

Mr. Jain is a Delhi businessman operating in a largely Hindu milieu; his company publishes primarily Hindu materials. Consequently it is not surprising that he would take this position. But I suspect that his response is not atypical of many Jains, both in present-day India and throughout the history of the subcontinent, for Jain religion and philosophy have from the outset contained a kind of yes-and-no aspect. To some extent they reflect the conventional patterns of South Asian culture and life, but they also provide a fascinating contrast, indeed a unique and crucial presence, in that culture. In many ways this yes-and-no mind-set is a key to grasping the Jain tradition, both as a path to salvation and as a philosophical perspective.

The Jain tradition is at the fountainhead of that group of South Asian spiritual practices, including Buddhism, whose origins were in the Gangetic plain during the first millenium B.C.E. These were the ascetic (Sramanical) traditions, which grew up in opposition to the Brahmanical one.¹

These two traditions have been in creative tension with one another throughout the history of the subcontinent. The Brahmanical tradition has represented Vedic orthodoxy: the sacrificial rituals (yajna), the centrality of the brahmana priestly function, the six schools of Hindu philosophy, and the caste system (varnasramadharma) as set forth in the sacred texts (dharmasastra). The Sramanical tradition has maintained opposing principles, rejecting the sacrifices and their priestly functionaries, repudiating the caste system, and celebrating the monastic ideal and the notion of what Max Weber has called the "spiritual virtuoso."

CAT. 101 Tantric Diagram with Goddess Pratyangira Western India; c. 1500 Nevertheless, though the two traditions have been quite distinct over the centuries, they have continuously interacted with one another. The Brahmanical tradition early on came to accept the ideal of the spiritual virtuoso as portrayed in the *Upanishads* and the later literature of Samkhya, Yoga, and Vedanta philosophy. The Sramanical tradition picked up the Brahmanical philosophical method (astika darsana), the medium of classical Sanskrit, and certain aspects of the caste system.

On all of the basic social issues—caste, endogamy, food exchange, and trade the Jains have not been all that different from the Brahmanical tradition.3 They have consistently accommodated themselves to the larger Brahmanical or Hindu environment. The great Jinas or spiritual virtuosi, especially Vardhamana Mahavira. belonged to the warrior or ruling (kshatriya or rajanya) caste, and among the householder Jains the caste system prevails, although not as rigidly as among the Hindus. Jains are frequently identified with the merchant or business caste, primarily in western India; it is quite common in Rajasthan and Gujarat for marriages to be arranged between Jain and Hindu families of this caste. Food can likewise be shared, and there are no prohibitions against business transactions between Jains and Hindus. Thus, although the Jain tradition officially rejects the Hindu dharmasastra and the whole caste system, it has nevertheless accommodated itself by maintaining social equivalences and surrogate ritual procedures that allow coexistence within the larger Brahmanical-Hindu environment. There is a distinctively Jain style of life, but it adapts itself to the Hindu manner in a great variety of ways. Jains observe many of the Hindu religious festivals, such as Diwali, and have adopted esoteric tantric rites and some of the social customs and behavioral patterns of the Hindus. In fact, simply by meeting an Indian or visiting a home, today one cannot distinguish a Hindu from a Jain.

The Jains have made a remarkable contribution to Indian philosophy in terms of their distinctive theory of being (sat) and their concepts of partial truths (nayavada), multiple aspects (anekantavada), and qualified assertions (syadvada).4 In this regard the Jain philosophers and their teachings, beginning with Umasvati's Tattvarthasutra and Kundakunda's Pravachanasara (both c. second century) and continuing with a series of important figures and works well into medieval times, are very much in the mainstream of Indian philosophy. Indeed, it is impossible to recount the history of Indian philosophy without constant reference to various Jain thinkers who were in polemical dialogue with Hindu philosophers on one side and Buddhist philosophers on the other.5 Jain philosophers, in other words, were important players in the history of classical Indian thought. The basic issues in all of these traditions were the same: What is the source of valid knowledge (pramana)? What is the nature of being (sat)? What is the nature of the self (atman, purusha, jiva) or consciousness? What is the nature of the nonself or material stuff (maya, prakriti, pudgala-paramanu)? How is the soul or self related to material stuff? What is karma? How does the self or soul become bound in material stuff, and how can this bondage be overcome?

For the most part, Jain philosophers through the centuries (both Digambara and Svetambara) were the great mediators. Hindu philosophers tended to be hard-core eternalists (nityavadin), believing that being is everlasting. This could take the form of the monistic eternalism of Samkara's Advaita Vedanta with its cosmic atman

or self, or the dualist (though still eternalist) position of Samkhya and Yoga with the dyadic entities of purusha (self or consciousness) and prakriti (nature or materiality). Buddhist philosophers tended to be hard-core annihilationists (anityavadin), believing in radical transience or change. They repudiated substantive notions of self and nature, arguing instead for continuing process and holding that nothing abides permanently over time. Everything is in continual flux. Jain philosophers argued that both the Hindu and Buddhist positions were absolutist (ekanta) and needlessly onesided. The truth, for them, is necessarily somewhere in the middle. To some extent the self (jiva) is an existent entity that continues over time (contra the Buddhist position), and to some extent the self is continually changing (contra the Hindu view of a changeless, contentless consciousness). The self, argue the Jains, is inherently omniscient and conscious (caitanya), but it is also characterized by feeling (sukha) and willing (virya) and therefore changes over time. And though it is sentient and omniscient, it is neither all-pervasive nor is it atomized; rather, it assumes the size of the body in which it resides. The Jain notion of selfhood is unique in Indian philosophy, combining as it does both Hindu and Buddhist ideas and arguing for a multidimensional (anekanta) perspective.6

Equally unique is the Jain notion of karma. Jains acknowledge several categories of being (sat): (1) self (jiva) characterized by consciousness, feeling, and willing (chaitanya, sukha, and virya); (2) nonsentient material stuff (pudgala-paramanu) distinguishable by touch, sight, taste, and smell; and (3) nonsentient, formless entities, including motion, rest, space, and time. Interestingly, karma is under the category of pudgala-paramanu, the material stuff. In contrast to the Hindu and Buddhist traditions that construe it as an abstract moral force, the Jains view karma as a material substance that actually clings to the jiva, thereby bringing about physical bondage to the world of matter. Karma does have a moral dimension, but it is the genius of Jain philosophy to have formulated its profound physical implications. Any action, especially violent action, has important physical as well as moral effects. Hence, to curtail one's actions and to practice ahimsa (nonviolence) is not only to change oneself morally but also physically. This explains the Jains' overwhelming focus on vegetarianism. The taking of flesh is not only a violent act. It is a material transaction, whose results become even more pronounced if one actually eats the physical karma of the action.

Such views regarding the nature of the self and the nature of karma had the effect of downplaying the importance of knowledge. Here again the Jains have made an important contribution to Indian philosophy. Along with the Hindu and Buddhist inclination toward absolutism (ekantavada), came the great importance they placed on issues of knowledge. The Hindu and Buddhist philosophies are based on what in modern terms we would call a two-valued, "either-or" logic. Jain philosophers understand logical assertion as a much more subtle enterprise involving as many as seven kinds of predication (sapta bhangi naya), depending on the surrounding conditions. This sevenfold predication is also termed syadvada or what we could call the doctrine of "to some extent." For example, I might first say that a certain book is red. When I realize that its redness is related to light and my perception of color, and that in the gathering darkness the book no longer looks red, I might say now that the book is not red. I can then say that the book is, at different times or under different conditions,

red and not red. The more that I think about the book as a whole, the more I realize that I cannot say what the book is in and of itself. It transcends being red or not red or both; it becomes, fourthly, inexpressible (avaktavya). If I then combine this fourth predication with each of the first three (arriving at the inexpressibility of the book's redness, of its not-redness, and finally of its red-and-not-redness), I will reach the sevenfold predication (sapta bhangi naya). The point of this sophisticated doctrine in Jain philosophy is to demonstrate the complexities of knowing and the built-in limitations to what knowledge can accomplish. Although knowledge is basic to the philosophical enterprise, it can never, according to the Jains, exhaust the fullness of what is. There is always something that escapes verbalization and epistemological analysis.⁸

Finally, let me turn to the issues of theology and soteriology, or the doctrine of salvation, in Jain religion and philosophy. Umasvati (second century), the first systematizer of Jain philosophy, accepted by both Digambara and Svetambara traditions, begins his Tattvarthasutra with the following statement: "The path to liberation involves appropriate insight, knowledge and conduct." Unlike almost all other Indian traditions, which tend to see the problem of earthly bondage as largely an epistemological issue, the Jains argue that bondage is both an epistemological and an ontological problem. In Vedanta, for example, the world of everyday life is illusion (maya) brought about by ignorance (avidya). Once ignorance is remedied, then one immediately realizes the purity of atman or Brahman. The problem of salvation, in other words, is a matter of knowledge. So, too, in Samkhya and Yoga philosophy. Finally, one must overcome the lack of discrimination (aviveka) and come to realize that purusha (consciousness or self) and prakriti (material stuff) are forever separate and distinct. In Vedanta, Samkhya, and Yoga, bondage is an illusion to be overcome by knowledge and discrimination. In Buddhist philosophy as well it is finally wisdom (prajna) that brings enlightenment and leads one to nirvana.

The Jain tradition in this regard is interestingly different. Bondage is beginningless, that is, it has no beginning in time, and is brought about by the physical attachment of the soul to what is not the soul or self, namely, the ajiva or the karmic matter of the pudgala-paramanu. It is essential to realize why one is in bondage, but this knowledge, though necessary, can never be a sufficient condition for release, because the soul is literally imprisoned within the body. It is not the case that the soul is forever free as in Samkhya, Yoga, and Vedanta. The soul, say the Jain philosophers, undergoes change and transformation as a result of physical karmic transactions and becomes bound within those physical environments. One must literally burn off material embodiment through long penance if one's soul is to become free and attain omniscience (kevalajnana).

Liberation is very much a physical problem for the Jains, and it is no accident that many of the debates within the tradition appear to have a literal and very concrete flavor. The great debate, for example, between the Digambaras and the Svetambaras centered around three quite literal issues: (1) the Jina; (2) nakedness; and (3) women. For Digambaras the Jina can manifest no worldly activity and no longer has any bodily functions. If he did, his jiva would undergo change and he could not be truly omniscient. Similarly, according to the Digambaras, the authentic monk must be completely naked. He cannot have any possessions or connection with the world of

60 LARSON

culture. Even a simple loincloth is an unwarranted compromise. Finally, in the Digambara tradition, women cannot attain *moksha* without first being reborn as men. Svetambaras are more permissive on each of these issues, but what is important to realize is the literal nature of the dispute in each case. We are dealing here with ontological issues, and knowing has only a secondary role to play.

It is similar in the area of theology. Although the Jain tradition accepts supernatural beings in its cosmology, at no point does it acknowledge anything like a creator god or a notion of grace or divine favor in the Christian, Muslim, or Hindu devotional (bhakti) sense. Since bondage is beginningless, all embodied creatures are bound, including supernatural and celestial beings. Only the Jinas (the spiritual virtuosi) are truly free and omniscient. There is little place for bhakti in the Jain tradition, although on a popular level there is great veneration for the various Jinas. Each individual must work out his or her own salvation through a combination of knowledge and praxis.

In conclusion, I would like to return to my original question. Are Jains really Hindus? My own answer, of course, is no. Although they have been very much in the mainstream of the history of religion and philosophy in India and in that sense are part of the larger South Asian civilization, they are responsible for a number of unique contributions to Indian life and thought in their notions of selfhood, karma, ahimsa, vegetarianism, and so forth. These clearly set them apart from the larger Hindu environment. I am not sure, however, if my answer would be acceptable to Jains themselves. I suspect they might tell me that it is a mistake prematurely to divide one group from another or one tradition from another. I suspect they would tell me that I should be open to a more multidimensional (anekantavada) approach, a yes-and-no conception, as it were. Are Jains really Hindus? Well, from one point of view, yes; but from another point of view, not really. 20

NOTES

- 1. Jaini 1979, 39 ff.
- 2. Thapar, 19-22.
- 3. Jaini 1979, 274–315. A recent collection of essays that provides a useful overview of Jain society in India and around the world is Carrithers and Humphrey, especially 69–161 and 229–94.
- 4. For the best recent discussions of Jain philosophical issues see Frauwallner 1: 250–72; 2: 251–94.
- 5. Jaini 1979, 42-88.
- 6. Schubring 1962, 152 ff.
- 7. Basham, 43-92.
- 8. Jaini 1979, 89-97.
- 9. Ibid., 97.

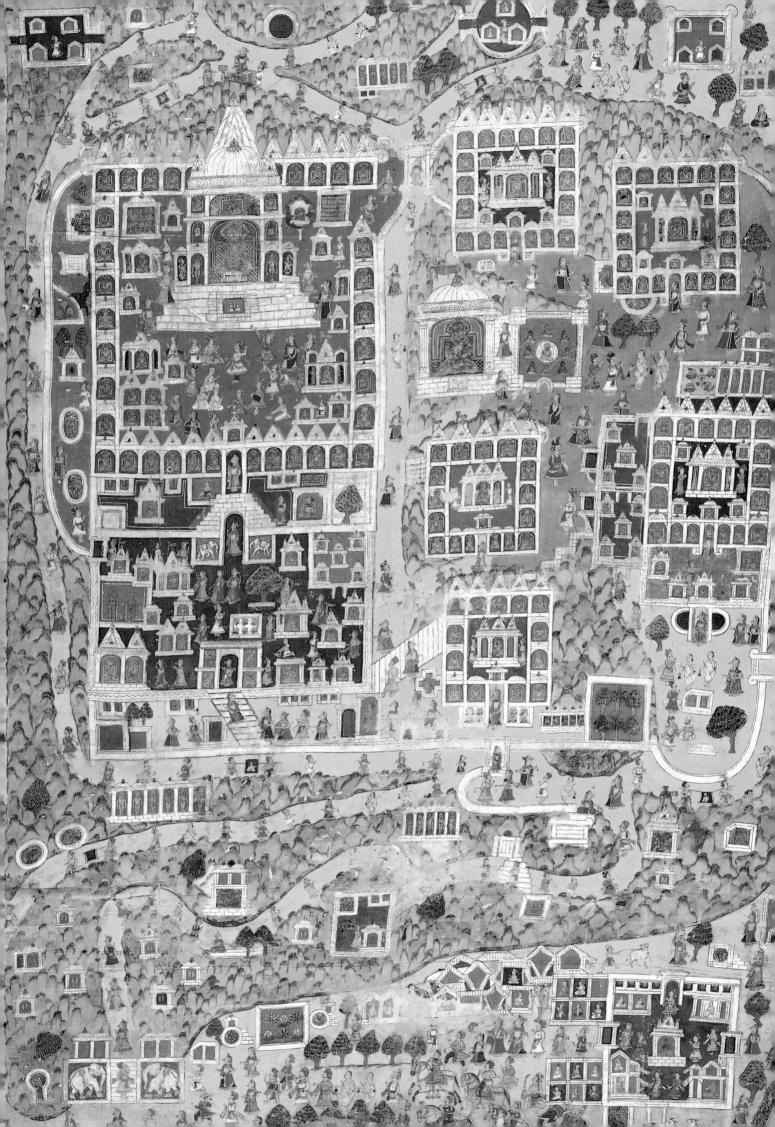

Jain Pilgrimage: In Memory and Celebration of the Jinas

Phyllis Granoff Just as cakes become sweet when they are coated with sugar frosting, so do places in this world become holy and pure when a saint abides in them.

—Pujyapada, Nirvanabhakti¹

Many are the great souls who conquered their passions and attained release in times long past; though these great souls have now vanished from our sight, we can still see the places that they sanctified by their glorious acts.

—Ravisena, Padmapurana²

Parliest places of pilgrimage were associated with events in the lives of the Jinas, those extraordinary individuals who attained perfect knowledge, taught the Jain doctrine, and achieved liberation from the cycle of rebirths. It is not entirely clear when Jains first began to make pilgrimages. The earliest texts in the Svetambara tradition condemn pilgrimages in Hinduism, but they are silent about Jain holy sites. At some time during the early centuries of our era Svetambara religious texts began to speak about certain places in heaven or in distant continents that were particularly meritorious and that were worshiped by the gods. Pilgrimage as a human phenomenon makes its first appearance in the written sources somewhat later, in the earliest commentaries to the canonical literature, when we hear of pilgrimage sites throughout India. In the Digambara sources it is not until the fifth century that names of pilgrimage sites appear. The places named in these early texts remained the most important pilgrimage sites throughout the medieval period, although there were later many additions to the list.³

CAT. 117B Pilgrimage Picture of Satrunjaya (detail) Gujarat, Surat or Ahmedabad c. 1800

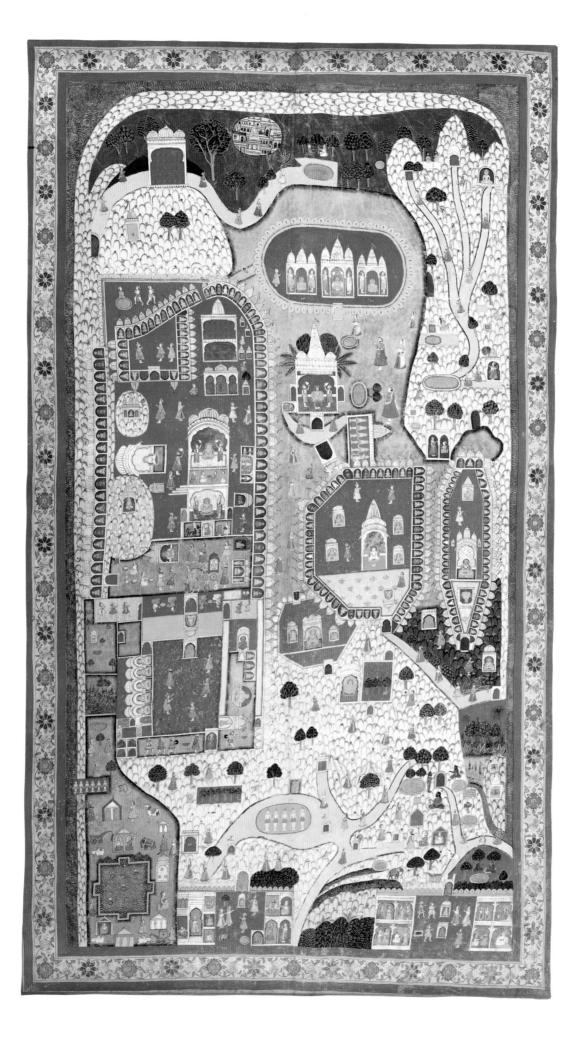

The Jain tradition singled out five central events in the life of a Jina, and the early texts were careful to note where these key events took place. The first event is the Jina's descent into his mother's womb, a moment that the mother savors as she dreams of auspicious objects portending a hero's birth. The next landmark is the birth itself, which is accompanied by marvelous signs and celebrated by the gods. The third great event is the renunciation. Jinas are born as princes and raised in luxury, only to turn their backs on worldly wealth in search of spiritual treasures. After a long and arduous career as an ascetic the Jina at last achieves omniscience, the fourth great moment in his career. He spends his remaining years as a wandering monk, teaching the Jain doctrine everywhere he goes. He practices asceticism and endures great hardship as he travels. When he knows that his death is near, he seeks out a mountain or other isolated spot where he will practice his final meditation, eliminating forever the last residues of the karma that has kept him alive thus far.

While all of these events lent to the places where they occurred an aura of sanctity, the place of the death of the Jina assumed special prominence. This death marked the accomplishment of the religious goal, the cessation of all rebirth and the attainment of the ultimate bliss of nirvana. It was both a sorrowful and a joyous event, celebrated by the gods who showered the Jina with flowers and played divine music, and by human devotees as well, who first had to come to terms with their temporary sense of loss.

Many of the most famous medieval Jain pilgrimage sites are associated with the death of a Jina or of some great disciple. The Svetambara Jains singled out five places as especially sacred; all were mountains. Satrunjaya (fig. 43) and Girnar are in Saurashtra, Abu is in Rajasthan, Sammeda [118] is in Bihar, and the fifth site, Ashtapada, is located in the Himalayas. Mount Girnar is said to be the place where the Jina Nemi attained his final release. It was on Satrunjaya that Bharata, one of the sons of the first Jina, Rishabhanatha, achieved omniscience along with many other devout worshipers. Rishabhanatha himself attained nirvana on Ashtapada, while Mount Sammeda is said to be the place where twenty other Jinas achieved release.

Four of the five sites—Ashtapada, Sammeda, Satrunjaya, and Girnar—are revered by the Digambaras as well. Sravana Belgola in south India is also an eminent center for Digambara pilgrimage. It is famous for its colossal image of Bahubali, Bharata's brother, one of many monks and nuns who died there.

Jains have always stressed the moment of death and have carefully defined what a proper and pious death should be, following closely the paradigm of the deaths of the Jinas. In small treatises devoted to proper conduct at the moment of death we find lists of famous monks who endured pain and tribulation and kept their minds steadfast, voluntarily renouncing food and confessing all their sins. These lists often report also that the place where a monk died is now a famous pilgrimage site. Many of the monks are said to have been martyred for their religious beliefs. Others were tormented for reasons having nothing to do with religious preference. But all suffered without harboring any ill will toward their oppressors. The accounts of their deeds inspired visits to the spots where they had died by men and women who similarly wished to die a pious death or more simply just to share in the sanctity of the place.

Figure 43 Pilgrimage Picture of Satrunjaya Rajasthan, Jaipur c. 1750 CAT. 117A

The Svetambara tradition associates the first building of temples and erecting of images with the death of a Jina and an act of commemoration. Bharata accompanied Rishabhanatha on his final journey up Mount Ashtapada. When Rishabha died, Bharata performed the proper funeral rituals and then began to build a memorial temple. In the temple he erected an image of his father and a statue for each of his ninetynine brothers, who had accompanied their father in death. Bharata is also said to have built the first temple on Satrunjaya. His son, Pundarika, was the first disciple of Rishabhanatha. When Pundarika died and thus achieved liberation on Satrunjaya, Bharata hastened to the mountain and built a temple that included an image of the deceased.⁴

To some extent, all subsequent temple building by pious donors would replicate Bharata's initial project. Many of the most famous medieval Jain temples, still drawing crowds of pilgrims today, are explicitly said to have been built as memorial temples. According to a fourteenth-century biography, the ministers Vastupala and Tejahpala built the Lunigavasahi at Mount Abu in memory of one of their deceased brothers, Luniga. This marble temple is still a place of pilgrimage today by pious Jains and art lovers from all over the world.⁵

Jinas could mark a site as special not only by something that they did in their lifetimes but also by a revelation made long after they had achieved nirvana. The most common means of revelation in medieval accounts was the dream. Either the Jina himself or his protecting deity would appear and tell the dreamer where to find a buried image of the Jina. The dream often included instructions to build a temple. Sometimes, instead of revealing the location of a finished image, a dream would announce where a proper stone slab might be found that could then be carved. Many famous medieval pilgrimage sites were associated with dream revelations, and the revealed images were credited with the power to heal sickness, protect the community from harm, and cleanse sins.

The medieval Jain ritual of pilgrimage did not develop in a vacuum. It clearly reflects religious preoccupations that we might call pan-Indian, for we find similar tendencies in Buddhism and Hinduism. Chronologically, Hindu pilgrimage may have preceded Jain pilgrimage as a religious institution, if we are to judge solely from the written sources. The idea that there are special places, or tirtha, which a pious Hindu should visit in order to perform various rituals seems to have begun around the third century.7 Sites were usually said to be sacred because of the presence there of one of the major deities—Siva, Vishnu, or a form of the goddess Durga—and occasionally of other deities such as Brahma, the creator, or Surya, the sun. The texts that were written and recited to extol these places, and to encourage people to undertake the arduous journeys required to visit them, describe in glowing terms the benefits to be gained just from seeing the holy place. Beyond that, they also recommend the performance of complicated and sometimes costly rituals in which lavish gifts were to be made to resident priests. While Hindu pilgrimage rituals were undoubtedly very diverse, many of them seem to have been associated with the dead and dying, just as we saw to be the case with Jain pilgrimages. To die a proper death at a holy site was as important a motivation for pilgrimage in Hinduism as it was in Jainism. In addition, Hinduism encouraged the performance of certain commemorative rituals for the dead

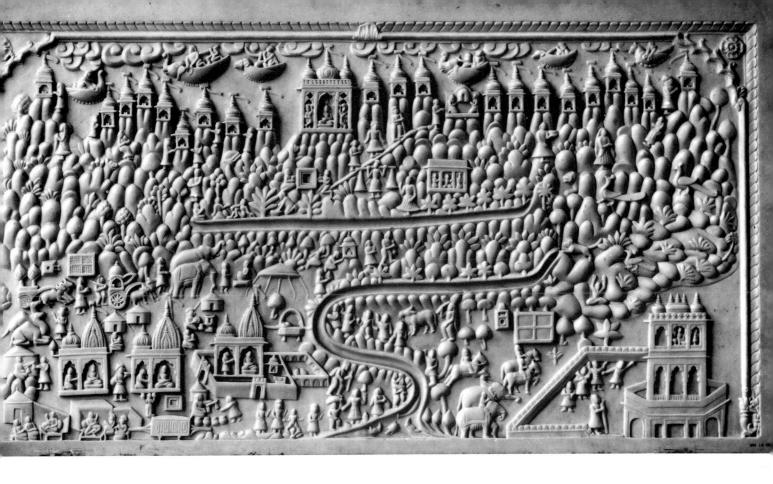

Figure 44
Panel with Sammeda-sikhara Pilgrimage
Jaipur; c. 19th century
CAT. 118

at pilgrimage sites, much as the Jains built commemorative temples, which then became centers of pilgrimage. Hinduism and Jainism also made use of the same types of revelations in their pilgrimage literature.

Pilgrimage was also an important practice for Buddhists, and adherents came from all over the Buddhist world to the sites associated with the life of the Buddha. The Buddhists seem at least initially to have structured pilgrimage around the biography of the Buddha. They later expanded their sacred map, either by incorporating new sites associated with the Buddha in his past births, or, like the Jains, through revelations of miracle-working images.

In Jainism pilgrimage is a ritual that is shared by the laity and the monastic community. Pilgrimage lends structure to the wanderings of Jain monks and nuns, who are forbidden from living long in one place and who thus spend their days in travel (fig. 44). Medieval accounts tell us that these travels were far from random. Monks structured their wanderings in accordance with the needs of the lay community and along pilgrimage routes. A unique literature was created by these monks, who wrote fervent poems expressing the deep emotions they felt upon seeing a particular Jina image. Here is a verse from the fifteenth-century monk Somasundara as he stood before the image of Parsvanatha at Stambhana:

Today my eyes are blessed, for I have had the good fortune to behold your body, which is a vessel filled with every marvelous virtue; which is like a scythe to cut down the grasses of all my grave sins.

The monk Vijayachandra wrote the following on the occasion of his pilgrimage to Mount Girnar:

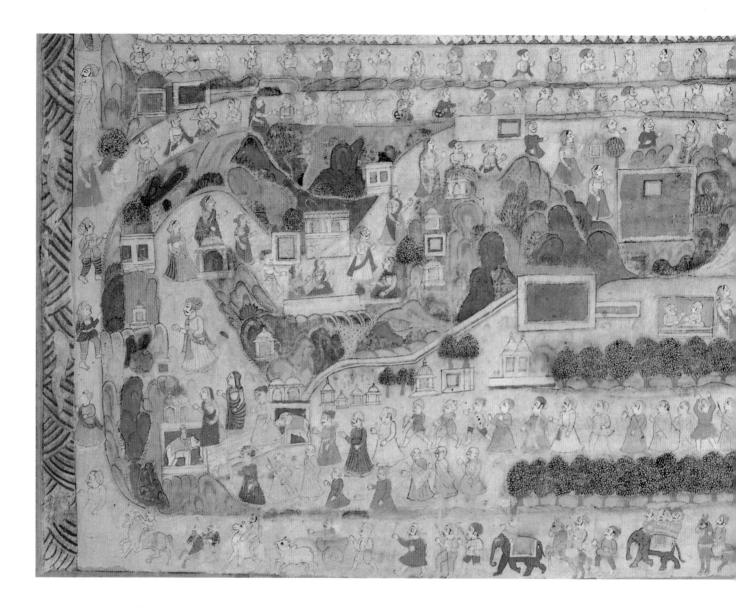

Figure 45 Pilgrimage Picture of Satrunjaya (detail) Rajasthan, Mount Abu or Sirohi 1800–50 CAT. 117C

May that glorious Mt. Girnar endure forever in all its splendor! For on that mountain, when I see the best of Jinas, Lord Nemi, purest in all the three worlds and a sight people long to see, my mind becomes calm and all my sorrows vanish.

Other monks sang of miraculous cures from terrible diseases, brought about through seeing and worshiping a Jina image.⁸

Monks and laypeople often traveled together on these pilgrimages. Medieval texts emphasize how both monk and lay patron prayed fervently, the monk by contemplating the Jina and the lay worshiper by offering flowers and incense before the image. Medieval literature also tells of many kings who traveled to Satrunjaya and Girnar. The descriptions of the journeys emphasize the large size of the pilgrimage parties (figs. 45, 47) and the generous gifts made to feed the needy all along the route. The kings' arrival in the temple was celebrated by song and dance as the image was garlanded and poems of praise were recited.

Pilgrimage became so important in medieval Jainism that we read in the literature of pious laymen and -women who yearn to gain the benefits of the act even at the cost of their lives. The biography of the Svetambara monk Bappabhattisuri tells

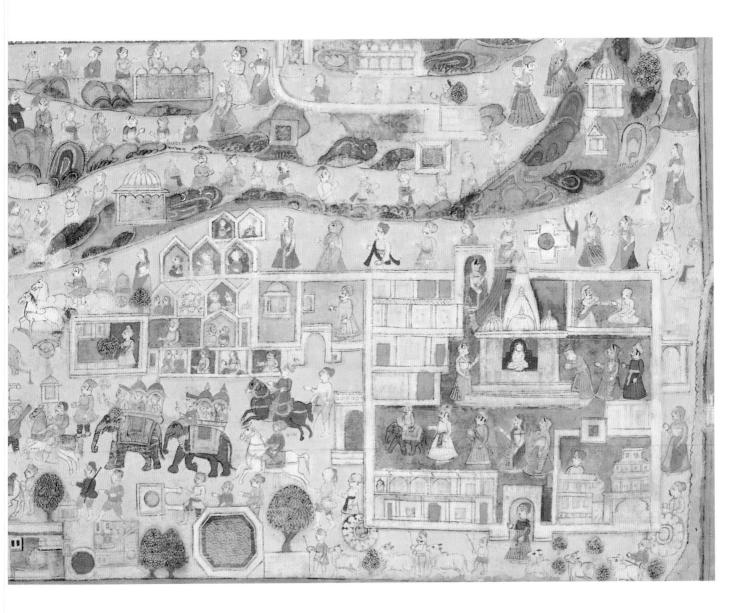

how King Ama of Gujarat, after listening to Bappabhattisuri praise Mount Girnar, made a vow that he would not eat again until he worshiped the Jina Neminatha there. The king set out with 300,000 foot soldiers, 100,000 horses, 100,000 bullocks, 20,000 camels, 700 elephants, and 20,000 families of pious lay Jains. When the king almost died on the way, Bappabhattisuri had, in effect, to make Mount Girnar come to the king, by having a goddess bring an image of Neminatha from the mountain for the king to worship so that he could eat again and regain his strength.⁹

Not every would-be pilgrim was so fortunate in his or her friends, however, and so we hear of other ways in which a devotee could complete a pilgrimage without actually making a physical journey. Some texts tell how a particularly famous Jina image would miraculously travel, bringing the essence of one pilgrimage place to other locations. We also hear of patrons donating a Jina from elsewhere to their own town or village, for example erecting a temple devoted to the Parsvanatha image at Sankhesvara in another village, thereby ensuring that many could benefit from seeing that famous image without traveling to Sankhesvara itself. ¹⁰ In addition, temples at one pilgrimage site often include representations of other pilgrimage sites on their walls; perhaps a similar logic underlies these intricate maps. They bring to the one site the benefits of all the other holy sites and illustrate the words of praise that we find

devotion, but also a sense of wonder at their beauty. Perhaps no one has captured that wonder better than the medieval poet who wrote about the famous temple built by King Kumarapala in the twelfth century. ¹² In these verses, a god in heaven envies mortals on earth, while earthly men and women, overawed by the sight of the temple, imagine themselves to be in heaven.

Indra, the king of the gods, in his heaven, was grateful to have a thousand eyes to see King Kumarapala's temple, but in truth he envied those who had been born among men on earth where in fact the temple stood. Waves of joy rippled through his body as he thought again and again of the marvelous beauty of the temple and all its unbelievable splendor, which only those with great merit might ever get to see. Such was the glory of the temple that even the gods could not have made such a marvel, and surely none could have aptly described it, though all would praise it forever, men, gods, and denizens of the nether world alike. . . . And the crowds of people who were constantly coming from afar to see the temple thought in truth that they had reached heaven. For the temple indeed seemed to float in space, as the rays of light coming from its radiant walls made of moonstone spread out in every direction, concealing from view the temple's solid foundation on earth. 2

- Verse 31, taken from Joharapurakar 1965, 6.
- 2. Ibid., 9.
- 3. See Joharapurakar 1965 for the Digambara tradition and Prasada 1992, 11–24 for the Svetambara texts. For general information on pilgrimage in Jainism see Dundas 1992, 187–94.
- 4. See Granoff 1992в for details.
- 5. I have translated some medieval biographies of temple builders; see Granoff 1992A and Granoff forthcoming B.
- 6. Many of the accounts of images revealed in dreams can be found in a fourteenth-century compilation by the monk Jinaprabhasuri about the various Svetambara Jain pilgrimage sites. The complete text has been translated into French; see Chojnacki forth-coming. Some sections have been translated into English; see Cort 1991, Granoff 1991, and Balbir 1990. The translation of the section on Phalavaddhi that appears here was originally prepared for a paper on miraculous images in Jainism; see Granoff forth-coming A.
- 7. R. N. Nandi 1980 contains one of the most interesting discussions of the origin and nature of pilgrimage in Hinduism.
- 8. These translations are taken from Granoff forthcoming B.

- 9. For my translation of the lengthy biography of Bappabhattisuri from the *Prabandhakosa* see Granoff forthcoming B.
- 10. The same practice can be found in Hinduism, where people will worship at home an image of some famous pilgrimage site. See Colas 1990, 110. The Malla kings of Nepal surrounded themselves with images of the deities of famous pilgrimage sites at a time when pilgrimage had been made impossible by constant warfare. See Toffin 1990, 102. Famous images also had a way of replicating themselves so that they were worshiped at more than one place. This was the case with an image of Krishna worshiped by the followers of Vallabha. See Clémentin-Ojha 1990, 126.
- 11. For the contest between the Svetambaras and the Digambaras over the control of Hastinapur see Balbir 1990, 128.
- 12. This is the Kumaraviharasataka of the monk Ramachandragani. Ramachandragani was a disciple of Hemachandra, King Kumarapala's preceptor. For translations of other verses see Granoff 1993, 89–90.

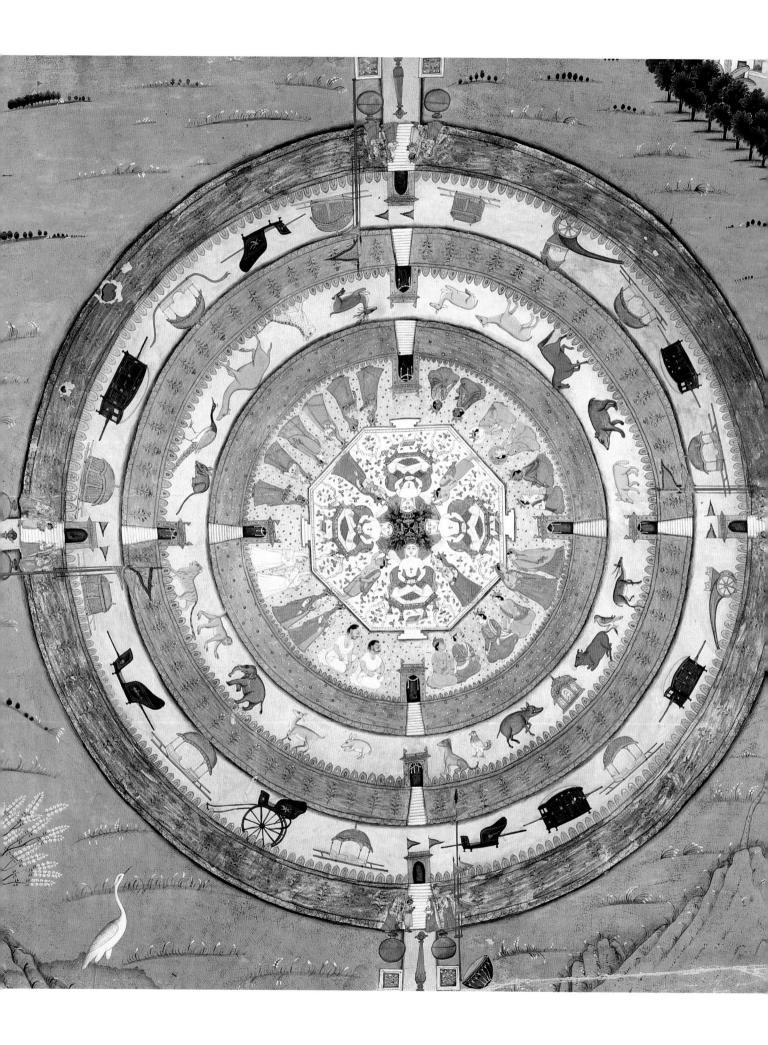

Jain Monumental Painting

Shridh ar Andhare THEN MOST PEOPLE THINK of Jain painting, they immediately recall the little manuscript illustrations frequently discussed in books on Indian painting. In addition, there is a large amount of monumental Jain painting, both on cloth and on paper, surviving in Jain repositories, museums, and private collections. A selection of such little-known but visually exciting material is presented in this volume.¹

The general term used for painting on cotton or linen is chitrapata (picture cloth) or, alternatively, patachitra (cloth picture). This Sanskrit expression is used by Jains, Buddhists, and Hindus alike and is generally shortened to pata. Although no example prior to the fourteenth century has survived, due to the perishable nature of the material in tropical climates, considerable evidence for such early painting exists in texts.² For instance, the Buddhist Samyuta Nikaya mentions paintings on dussa pata³ (a special kind of cloth) and on polished wooden boards, while another Buddhist text, the Vissuddhimagga, speaks of canvas as the ground or support for painting. The Kuvalaya Mala Kaha, a Prakrit text of 778-79, refers to a large samsar chakra pata, a scroll painting on canvas illustrating the wheel of existence: the miseries, inequalities, and futilities of human life, along with scenes of heaven and hell. These do not appear to be any different from yamapatta, paintings depicting life after death in the realm of Yama, the god of death, mentioned in the Buddhist texts. Both coarse and finely woven cotton and linen were used for painting religious as well as secular subjects. It is interesting to note that Madhavacharya5 in his Panchadashi, explaining the four modes of the higher self, cites an analogy with the four stages of preparing a painting: the canvas should be washed (dhauta), burnished (ghattita), drawn upon (lanchchhita), and colored (ranjita). The cloth is first primed with wheat- or rice-flour paste to fill up the pores of the textile. Use of tamarind-seed paste is also recommended in certain cases. After the priming is completely dry, the surface is burnished with an agate burnisher to ready it for painting. The outlines are drawn first, usually in red, and then the colors are applied. Additional decoration in gold or silver and the inscription of mantrakshara (mystic syllables) and identification labels in black or red are completed at the end. Religious paintings may have auspicious symbols in red on the reverse.

Jain pata can be divided into two main categories: tantric and nontantric. The former category includes the diagrams known as yantra, incorporating the mantras

CAT. 105 Hall of the Universal Sermon (Samavasarana) [detail] Rajasthan, Jaipur; c. 1800 and images of deities used in tantric practice, which is considered to be the "direct path" to enlightenment. The latter consists of pictures that may have religious content but are not concerned with tantric rites. They are contemporary paintings in regional styles and include a wide variety of subjects, both narrative and didactic. In addition to the *tirtha pata*, or pilgrimage picture, this category includes paintings depicting Jain cosmology and cosmography and miscellaneous banners such as the *vijnyaptipatra* (letter of invitation), *kshamapana patrika* (letter of pardon), and *chitra kavya* (pictorial poetry), which are all excellent documents of social life and culture in the periods when they were executed.

Kushan-period stone ayagapata [10], depicting some of the eight auspicious symbols of the Jains, may have been the precursors of tantric pata. Early tantric literature speaks of yantra on cloth, but due to the extremely perishable nature of the material very few have survived. These paintings occur in square, rectangular, and circular formats containing geometrical designs, seated Jina figures, yakshas, yakshis, devi, and samavasarana scenes. Some of them are simple diagrams, symbolic and stylized in expression. The symbols are generally interspersed with mystic syllables or hymns written in red devanagari script. Dates, attributions of gifts, or presentation details are sometimes written on the body of the pata.

There are three main types of tantric pata that are revered by the Jains: the Vardhamana vidya pata, the suri mantra pata [102], and the hrimkara mantra pata. In addition to these, the siddhachakra yantra or the nava pada yantra (popularly known as gattaji) are usually painted on metal, but unlike the others, they are small in size, as they are carried by monks. These highly complex diagrams are used for the performance of various rites and rituals and serve as aids in meditation. Some have more specific purposes, such as the suri mantra pata, which is presented to a monk when he becomes a teacher (acharya). For successful worship of a mantra pata it is essential that the practitioner observe utmost purity of mind and soul with regard to the objective (sadhya) of his effort (sadhana). In tantric pata the aesthetic concerns are less important than the contents, the correct rendering of which is thought to affect the potency of the representation. They were executed by Jain ascetics known as yati or by professional painters known as Mathen.

One of the earliest paintings in the exhibition is a jayatra or vijay yantra (victory banner), used in a rite to ensure victory (fig. 48). According to its dedicatory inscription, it was prepared and worshiped for the benefit of a particular family under the orders of Jinabhadrasuri, the chief of Kharataragachha, who is said to have consecrated it during the auspicious Diwali festival in 1447. This is perhaps the only published example of its type found in Jain art. The seated deities in smaller rectangles at the top and bottom and the detailed and lively landscapes with elephants and other animals are executed with great finesse and are comparable with the Vasantavilasa scroll of 1451 now preserved at the Freer Gallery of Art in Washington.⁶

This and other early cloth paintings were rendered in a style similar to contemporary manuscript illuminations [82-88]. By and large this style is strongly figurative and two-dimensional. It acquires a vitality from the torsions and distortions of body and limbs (including the convention of extending the further eye in an unnaturalistic fashion), from a radiantly vibrant palette of primary colors and gold

Figure 48
Victory Banner (Jayatra Yantra)
Gujarat, perhaps Ahmedabad or
Patan; 1447
CAT. 99

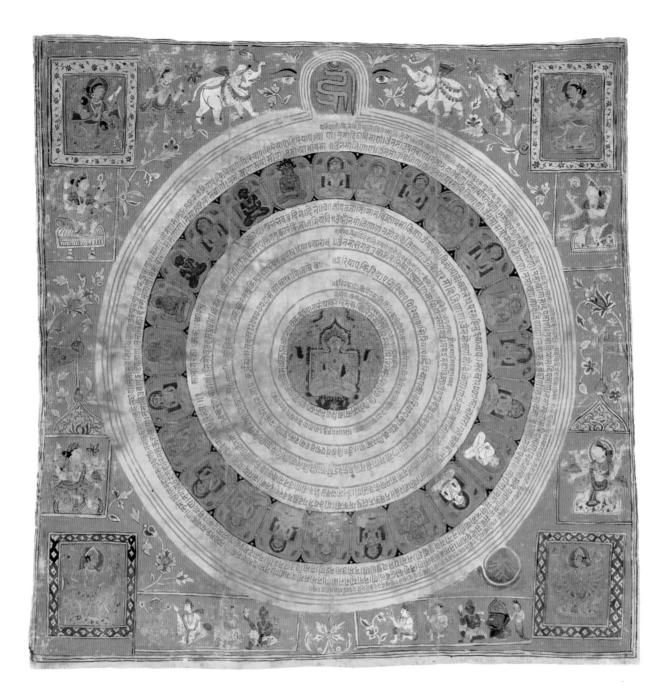

Figure 49 A Mystic Diagram of Suri Mantra Gujarat, Surat or Cambay; c. 1600 CAT. 102

(which is confined mostly to manuscript illuminations), and from a delight in intricate furnishings and luxuriant textiles.

The composition of these mystical diagrams is always dominated by the square and the circle. The principal deity or object of worship is invariably placed in the center. Although Jain yantra are not as elaborate as Buddhist mandalas (familiar today from Nepal and Tibet and preserving a tradition that was once prevalent in India), the basic principles of the configuration as well as the symbology are the same in both religious traditions. Symmetry and order in the arrangement of the figures is essential in such paintings, as their principal purpose is to calm the devotee's mind and detach him from the chaos and disorder of the phenomenal world. However, despite these basic similarities, the physical appearance of the yantra is distinctly different from Buddhist mandalas.

Another example of an unusual *yantra* included in the exhibition is that depicting the mandala of the goddess Pratyangira [101]. A powerful goddess, she is

familiar in the Buddhist and Hindu pantheon, but this is the first evidence that she was also worshiped by the Jains. That this yantra was meant for the use of Jains is clear from the inclusion of a Svetambara monk in the lower left, just outside the mandala. Moreover, directly across from him is Indra worshiping the footprint of the Jina, and at the top and bottom of the mandala are the mystical syllables hrim and krom. Both of these elements are commonly encountered in Jain pata. Unquestionably, however, the iconography of the central deity as well as of the attendant figures evinces a close relationship with Hindu concepts. It should be pointed out that no textual source accounting for this esoteric painting has yet come to light, but a complete mantra is included in the yantra.

Apart from distinctive composition and coloring, Jain yantra are also distinguished by the manner in which they make use of mantras. Thus, both in the victory banner and in the yantra of Pratyangira we encounter the liberal use of syllables and even the entire texts of esoteric rites. The mantras therefore become an integral part of the yantra in a way that is rare in Buddhist or Hindu mandalas. One seventeenthcentury suri mantra pata (fig. 49) is a good example of such a yantra, where the word is as important as the image. In fact, in tantric praxis (sadhana) one can do without the image, but the mantra is essential. Although executed in Gujarat, this painting is quite dissimilar from examples in the earlier Western Indian style. The figurative forms are different, eschewing the capacious and bulging bodies, the angular movements of the limbs, the exaggerated distortions and, most notably, the projection of the further eye. The area outside the circles shows innovations that can be attributed to the influence of the Mughal style of painting that came into vogue in the last quarter of the sixteenth century. The floral sprays used as space fillers, the naturalistic rendering of the flowers, and the rectangular frames around the figures in the four corners constitute some of the new elements. These are seen also in the artist Tularam's illustrations for a Hindu manuscript now dispersed in many collections.⁷

Among the most familiar examples of Jain paintings, other than miniature book illuminations, are those dealing with cosmographical and cosmic subjects. The examples included in the exhibition consist of two cosmographical diagrams [98] as well as two portrayals of cosmic beings (fig. 50) [1038]. The two types of paintings are interrelated, as the cosmic beings integrate the cosmographical concepts. The cosmographical paintings share with yantra and mantra pata the structural foundation of circles and squares. The two included here are from different periods. The earlier pata [98A] is probably the oldest example of this kind of painting and is rendered in the Western Indian style; the later specimen [98B] reflects the seventeenth-century Gujarati version of the Rajput style. Even a quick comparison reveals how different these diagrams are from the yantra, and from one another, both in form and content. With their unusual modes of representing landmasses, mountains, oceans, and rivers, the cosmographical diagrams make bold visual statements. Noteworthy also are the differences in the iconography both within the cosmos and outside. While these variations may have been due to religious needs, the diversity in the rendering of the continents and the oceans clearly indicates the individual preferences and imaginative powers of the artists involved.

This is also clear with the three representations of a cosmic being, or loka-

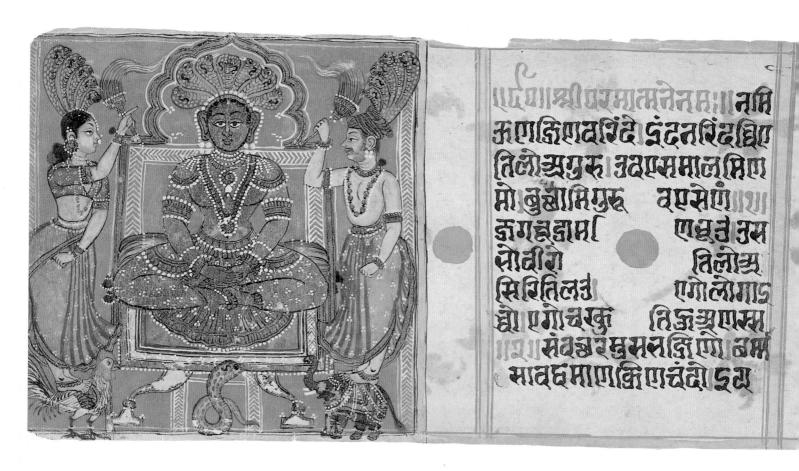

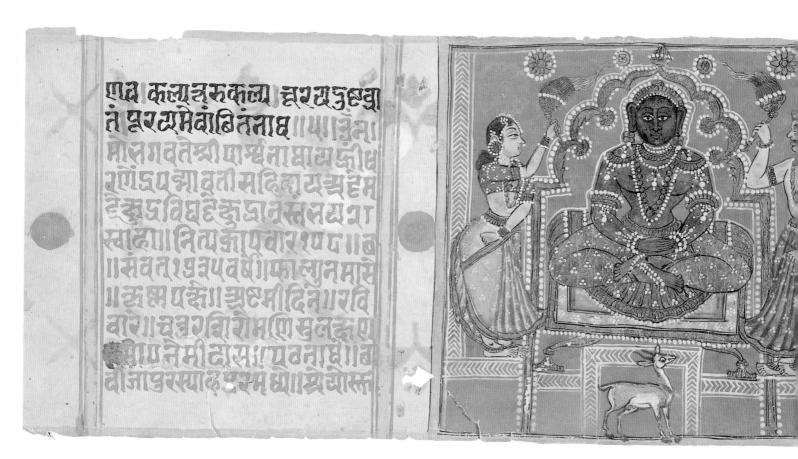

Jain Manuscript Painting

Јони G и ч

AINTING IN INDIA is one of the most ancient arts, practiced alongside and in conjunction with sculpture. It comprises mural decoration, cloth painting, and manuscript illustration. The earliest known text on the subject, the Chitrasutra, refers exclusively to mural painting, exhorting the artist to "raise up" an image, that is, to create the illusion of three-dimensional forms through such devices as modeling, foreshortening, and perspective. Banner painting appears to have been in existence from at least the first century, as suggested by the processional banners depicted on the carved gateways (torana) at Sanchi. The Chinese Buddhist pilgrim Fa-hsien, who traveled the length of India in the early fifth century, expressly referred to "brightly colored and grandly executed" banner paintings, presumably on cloth.2 The appearance of painting associated with manuscripts is more difficult to date. Fa-hsien speaks of staying two years in "the country of Tamalipti [in west Bengal]... writing down the Sutras and drawing pictures of images." It is uncertain whether these images formed part of the manuscripts he copied, but if they did, then this foreign pilgrim's account would be the earliest reference to illustrated manuscripts in an Indian context.

The Buddhist texts available to Fa-hsien may also have provided a model for the Jains when they established their own written tradition. It is unclear when Jain illustrated manuscripts first appeared, but Jain sources suggest that their religious texts were not committed to writing until as late as the fifth century, prompted by a famine that threatened to sunder the oral tradition upon which the Jain sangha (monastic order) had up until that time relied.

The motivation for producing religious manuscripts was the preservation and dissemination of sacred scripture and related literature. It is not known how early the illumination of such manuscripts became customary, but when it did, it ensured that they became the vehicles for transmitting a pictorial as well as a literary tradition. It is not the temple murals nor the processional or meditational banner cloths that are most intact from this early period, but the miniature paintings on palm-leaf folios. It is at first sight paradoxical that the paintings to survive in the most complete state of preservation were the least substantial. These brittle folios, secured between wooden covers (patli), which themselves were often richly decorated, had as their principal aid to survival the fact that they were small, highly portable objects of veneration. They

CAT. 96 Two Folios from an Upadesamala Manuscript A. Enthroned Parsvanatha B. Enthroned Santinatha Karnataka, Bijapur; 1678

Figure 54
Rock-cut relief of Mahamayuri,
Buddhist goddess of learning. At her
feet is a monk seated at a folding table
holding a palm-leaf manuscript.
Ellora, cave 6, Maharashtra
c. 7th century

Figure 55 Animals and Humans (detail) Book cover for a Jain manuscript Western India; c. 1125 CAT. 79 could readily be moved or secreted away in times of danger or persecution.

One of the greatest depositories of early Jain manuscripts was in the monastic library (bhandar) at Jaisalmer, in the deserts of western Rajasthan. Jaisalmer was removed from the metropolitan centers of medieval Jainism, and its relative isolation would have made it attractive as a secure depository. It is probable that this Jain bhandar became the repository of many of the most prized manuscripts from Patan and Ahmedabad. These would have been transferred for safety during periods of unrest, most notably the invasion by the Muslim Delhi sultanate, which was complete by 1299. Close links had been established between Jaisalmer and Patan in the previous century, as witnessed by the marriage of the Jaisalmer ruler Vijairaj II to the daughter of the Solanki ruler of Patan. The painted manuscripts discussed here are either on palm leaves or on paper folios that follow the landscape format of the palm-leaf manuscript. Palm-leaf folios were traditionally prepared from the leaves of the palm tree, especially the talipot (Coryolia umbraculifera linn). The preparation process varied in different regions but essentially involved the boiling and drying of the trimmed leaves. The resulting long, narrow palm-leaves formed the folios of the book; they were pierced in one or two positions to allow a binding cord to be threaded through. The cord was in turn bound around protective wooden covers to secure the book. The text and any decorative elements were either applied by brush or incised with the aid of a stylus. Both the folios and the covers were considered suitable vehicles for painted decoration.

There is evidence that these manuscripts assumed a sacred character early in their existence, becoming objects of religious veneration. A Buddhist sculptural relief at Ellora from around the seventh century depicts the use of palm-leaf manuscripts in worship (fig. 54). The appearance of bound palm-leaf manuscripts as attributes of Hindu, Buddhist, and Jain deities attests to the ritual authority of the sacred word. The Buddhist gods Manjusri and Prajnaparamita, together with Sarasvati, a goddess shared by Hindus and Jains, are some of the more popular deities displaying manuscripts as a principal attribute. The earliest extant Jain manuscript paintings share an iconic approach with the concurrent Buddhist tradition, in which the depictions are of deities whose presence is essentially talismanic rather than narrative in purpose. That is, the images are intended to provide an auspicious or protective presence, as

90 G U Y

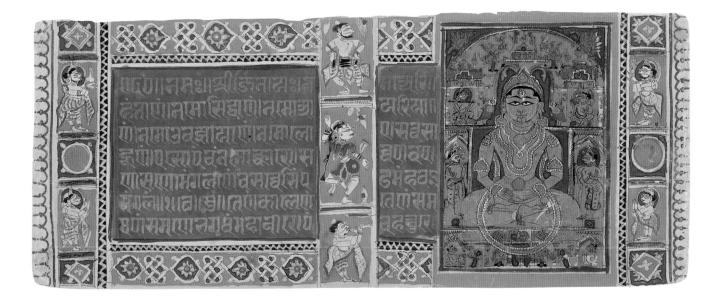

Figure 56
Folio from a Kalpasutra Manuscript
Western India; c. 1500
CAT. 88B

seen in the kirtimukha (face of glory) on an early twelfth-century path (fig. 55). The choice of subject usually bears no immediate relationship to the accompanying text, as the purpose is not illustrative but magical. A second stream of painting is in evidence by the twelfth century, more explicitly narrative in intent and drawing on the story-telling conventions of the classical mural. It concerned itself with illustrating not only events from Jain literature but also contemporary occurrences of importance to the Jain community, such as the famous debate in Patan in 1125 between leading the-ologians of the Svetambara and Digambara sects. This debate, supposedly won by the Svetambaras, is frequently depicted on path; two narrative accounts and a dramatized version also exist.

It would seem that in ritual practice, paintings in Jain manuscripts contained elements of both magical and didactic narratives. The worship of books of wisdom (jnanapuja) is a central activity in temple ritual. Even today both the recitation and the worship of the Kalpasutra manuscript (fig. 56) form important parts of the annual paryushana festival, celebrated by the Svetambara Jains during the monsoon season. The text is recited, and members of the congregation seek an opportunity to momentarily hold the sacred text, as if to symbolically read and thus absorb its holy message. Copies are carried in processions, and wealthy members of the lay community compete through donations for the privilege of having the recitation manuscript worshiped in their home overnight. On the last day of the eight-day ceremony the text is recited in full, and the illustrated folios are held up to the congregation. This public showing has a dual purpose: to provide darsana, a holy viewing, and to fulfill the more mundane but no less important storytelling role.

Among the areas of philanthropy identified in Jain ethical texts as most appropriate to the laity, the highest priority was given to the commissioning of images of the Jinas, the support of temples, and the funding of scribes. Support came from wealthy Jain laity, principally merchants who prospered from the trade that flowed through Gujarat from the coastal ports to the hinterlands of northern India. The Jain kings of the Chalukya dynasty, who ruled Gujarat and much of Rajasthan and Malwa from the tenth to the late thirteenth century, were also energetic patrons, building numerous temples and libraries. The twelfth-century king Kumarapala commissioned

the scribe, monks are only referred to as recipients of finished manuscripts. Indeed, the *Kalpasutra* expressly prohibits monks and nuns from practicing the art of painting, and the *Uttaradhyayanasutra* warns monks and nuns of the power of painting to arouse sensual feelings.¹⁰

During this period a strong tradition of manuscript illumination existed in Buddhist circles, most notably centered around the great monastic universities (mahavihara) of Bihar and Bengal. In many ways this tradition was a last flowering of the largely expired pan-Indian school, most gloriously illustrated in paintings preserved at the monastic cave-temples of Ajanta, in the western Deccan. There may have been opportunities for cross-fertilization between the mural and miniaturist traditions. We know, for example, that according to a twelfth-century Chalukyan text, the Manasollasa, an accomplished painter was "not only a fresco painter, but was [also] well versed in the technique of miniature painting on palm-leaf (patra-lekhana)." This confirms an impression given by the earliest illustrated Jain and Buddhist manuscripts of this period (1000—1200) of being in effect miniaturized murals. This can be seen in the urge to compartmentalize the composition, the interest in continuous narrative, and the use of landscape and architectural elements as spatial devices.

The beginning of the second millenium saw the emergence of a popular mode of representation that has come to be known as the Western Indian style. 12 Its development was largely complete by the beginning of the fourteenth century. It is marked by the gradual abandonment of the plasticity of the earlier style, as seen in the Buddhist paintings in the Ajanta caves, in favor of an economical, linear treatment,

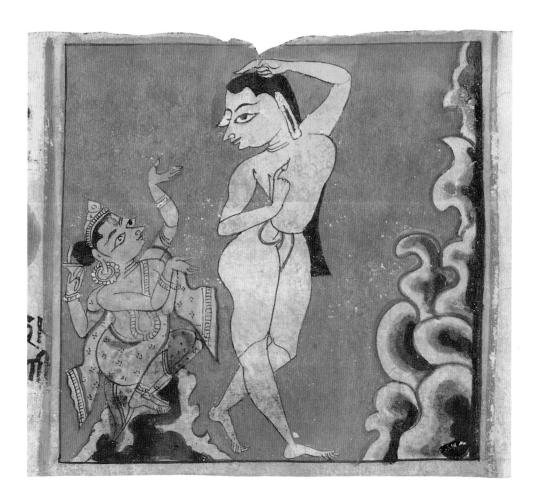

94 GUY

Figure 60 Pearl-bordered roundel with female dancers. Sumtsek temple, Alchi monastery, Ladakh; c. 1200

more akin to the linearism evident in the later murals at Ellora. Finely controlled lines define form, and color is applied in flat areas of saturated intensity, with little or no attempt at tonal modeling. The figures are angular and sharp, with slender waists, swelling chests, narrow wrists and ankles, and a distinctive pointed nose and chin. Frontal representations are largely abandoned for the use of an extreme three-quarter profile, with a characteristically projecting eye. The lotus-shaped eye, with the drooping upper lid suggestive of a meditative mood, is replaced by the fish- or tear-shaped eye, alert and worldly (fig. 59). One continuity with earlier traditions was the use of the language of dance to convey movement and expression: the earliest commentaries on painting advise the artist to seek his knowledge of movement, gesture, and posture in the study of dance. These stylistic developments were common to much of India as far as can be ascertained from the limited evidence for this period. For example, murals preserved at the Buddhist Sumtsek temple at Alchi monastery,

Figure 61
Vidyadevi Manuscript Cover
Gujarat; c. mid-twelfth century
Opaque watercolor on wood
3 x 22½ in. (7.5 x 58 cm)
Lalbhai Dalpatbhai Muşeum,
Ahmedabad

Ladakh, most recently dated to c. 1200,¹³ share many of the features under discussion, including the three-quarter profile with projecting eye. A roundel with pearl border depicting female dancers with swords and shields illustrates this western Himalayan rendition of the style (fig. 60). A near-contemporary Jain painting is found on the *vidyadevi* manuscript cover now in the Lalbhai Dalpatbhai Museum, Ahmedabad (fig. 61). Although it shares many features with the pictures encountered on contemporary Buddhist covers, it also contains the seeds of the Western Indian style.

It was in the Jain studio workshops that this style found its fullest expression. Even the limited number of illustrated palm-leaf manuscripts that survive convey the artistic achievements of these manuscript painters. The female worshipers (and probably donors) depicted on the 1278 palm-leaf folio [80] are directly descended from those seen in the *vidyadevi patli* at least a century earlier. The ambiguous framing device behind the figures in the *vidyadevi* has been abandoned in favor of a flat red ground, broken by the edge of a textile awning or umbrella visible on the upper margin of the picture.

Jain manuscript painting underwent a dramatic transformation in the first half of the fifteenth century. This was in part a consequence of the growing contacts between northern India and the Deccan and the Islamic cultures of Mamluk Egypt and Timurid Persia. The introduction of illustrated Islamic manuscripts, including Koranic decorative bindings, together with such luxury goods as Timurid carpets, textiles, and metalware, would have contributed to the enriching of the visual landscape of the Indian subcontinent. Paper, introduced from Persia, began to be employed in the manuscript arts in the course of the twelfth century. It did not come into general circulation for illustrated manuscripts until the mid-fourteenth century, and even then it generally adopted the long, narrow proportions of the palm-leaves it was displacing. By around 1400 the folios gained in height, giving the painter a larger

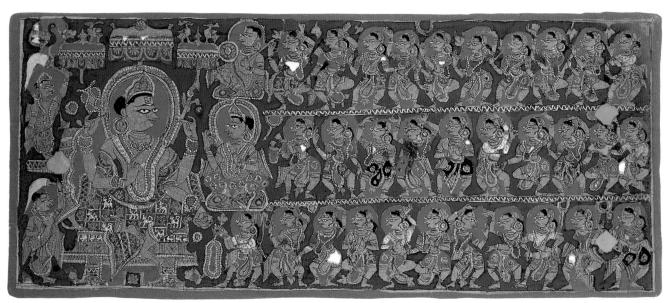

Figure 62
Entertainment at Indra's Court
Folio from a Kalpasutra and
Kalakacharyakatha manuscript
Western India; c. 1475
CAT. 87

Figure 63 Chaste Monk Avoids the Lures of Women Folio from an Uttaradhyayanasutra manuscript Gujarat, Cambay; c. 1450 CAT. 84

and better-porportioned space in which to work. The more generous format also permitted the artists to develop the border decorations that became a vehicle for some of the highly inventive passages in fifteenth-century Jain painting. The influence of Persian illumination is nowhere more in evidence than in these flamboyant borders.¹⁴

A more dramatic innovation at about the same time was the introduction of new pigments into Western Indian painting. Most notable are an ultramarine derived from lapis lazuli, a crimson, probably from a native lac (a resin secreted by insects), and gold. At first gold was employed in a restrained manner on selected highlights, but it quickly became de rigueur for wealthy patrons to request the lavish application of the precious metal, as if to demonstrate their generosity. The widespread use of gold and blue, at the expense of the traditional red ground, resulted in a dramatic shift in the color harmonies of Jain painting.

The use of new and intense colors together with a growing taste for gold and silver resulted in illustrated manuscripts of unprecedented lavishness and expense (fig. 62) [82,86]. Curiously, the opulence of these paintings often seems at odds with the ethical and aesthetic intentions of the subjects depicted, which are intended to foster personal sobriety and detachment from materialism. An instance where this opulence does seem appropriate is in the folios illustrating the *Kalakacharyakatha*, notably those scenes depicting the Sahi ruler in his Central Asian attire (tunic with cloud-collar, boots) receiving the monk Kalaka in his court, adorned with the symbols of office and the weapons of war [824].

Not all fifteenth-century Jain painting followed this path of excessive decoration. A mid-century Uttaradhyayanasutra in the Victoria and Albert Museum (fig. 63) illustrates the elegance and simplicity that some schools of Western Indian painting had been able to preserve. The quality of line has not been obscured by gilding, nor have the intense but harmonious color balances been disturbed. Although the Western Indian style is generally encountered in a Jain context, it was not confined to the Jain community alone. Some of the finest manuscripts of the fifteenth century were Hindu. One of the most popular works to be illustrated was a Hindu devotional text, the Balagopalastuti ("Praise to the youthful Krishna"), popular also with Jains. ¹⁵ Such paintings are typically infused with a warmth and joie de vivre appropriate to their subject matter [85]. They demonstrate how the contents of the paintings can influence the expressiveness of the style.

Regional styles emerged in the course of the fifteenth and sixteenth centuries, reinvigorating the Western Indian school, which was in danger of becoming excessively hieratic and lifeless. In Gujarat itself manuscripts were produced with strong borrowings from contemporary Persian sources. Borders were elaborated in a manner resembling Koran bindings, particularly in their use of complex cartouche and knot designs and the application of gold. Other paintings adopted indigenous regional styles, eroding the strict hieratic conventions of the Western Indian style. Two folios from a seventeenth-century Bijapur manuscript show the assertion of a strong regional identity [96]. The color harmonies are different, with yellow and crimson on a red ground, including a pink achieved through the blending of Indian lac with white ground. The pleated costumes display a distinctly southern Indian flavor.

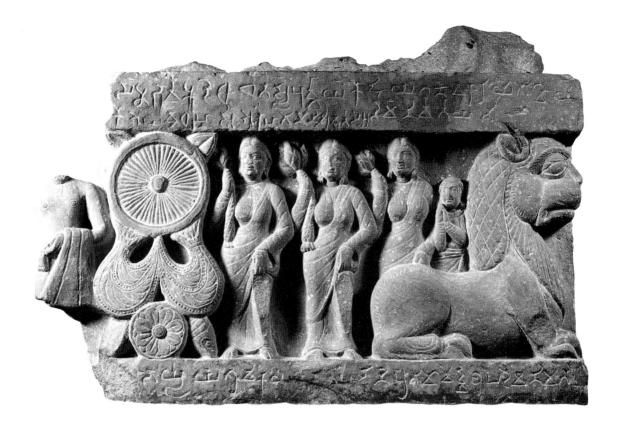

2

See color illustration on page 15.

Base of an Image with Devotees and Symbols

Uttar Pradesh, Mathura, Kankali Tila 157

Mottled red sandstone; 19 in. (48.3 cm) State Museum, Lucknow

This is the partially preserved lower portion of the pedestal of a Jain image, which is of great importance for demonstrating the antiquity of stupa worship among the Jains.

What remains is the proper left half of the pedestal, which shows three female lay worshipers holding lotus stalks and a youth with hands clasped in veneration. The pedestal terminates in the profile of a lion. The other half of the pedestal must have been similarly treated except that the figures would have been males; the extant portion supports this. The two groups flank a triratna (three jewels) symbol, which the Jains share with the Buddhists. For the Jains it symbolizes knowledge, belief, and observance. The triratna is preeminent as well in the ayagapata [10] in the exhibition.

According to the inscription (see appendix), the pedestal belonged to an image of Arhat Nandyavarta given by the female lay worshiper Dina (or Datta) on the advice of her teacher Arya Vridhahasti. This image was set up on the twentieth day of the fourth month of the rainy season in the year 79 of the Saka era (157). An even more important statement in the inscription is that the image was installed in the Vodva stupa, which was devanirmita ("built by the gods"). This epithet likely means that at the time the image was being consecrated the origin of the stupa had already become legendary. This interpretation is supported by a legend recorded in the Vividhatirthakalpa, composed by Jinaprabhasuri in the year 1326 and based on, as he maintains, earlier sources. It tells of a yakshi, Kubera, who erected overnight a "stupa of gold inlaid with precious stones" and embellished with images, arches, flags, and parasols. The people were so astonished that they called it the creation of gods. The legend also says that it was built even before Parsvanatha was born, making it the oldest stupa on the subcontinent. 20

S.G.

Railing Pillar with Yakshi

Uttar Pradesh, Mathura, Kankali Tila 2nd century Red sandstone; 34 1/8 in. (88 cm) National Museum, New Delhi

A beautiful damsel stands under a fruit tree; she holds a branch with her raised right hand as if to balance her body, which leans to the left due to the heavy sword she carries. Her firm grip on the broadsword is countered by the delicate gesture of her right hand. The elegant shape of her legs is suddenly punctuated by unusually heavy anklets.

Her bare upper body highlights the sparse but prominent jewelry that she wears, including armbands with representations of pearls or diamonds, a broad necklace, a series of bangles covering the forearm, and earrings. These ear ornaments have been described in Sanskrit literature as tatankachakra, discs symbolizing the sun and moon and indicating that time will not affect her. This is a factor dictated by Indian aesthetics, which requires that deities invariably be depicted as young and beautiful. Her transparent garment helps to emphasize her graceful body. Below her are two prancing lions facing in opposite directions.

The female figures that adorn railing pillars in early Indian art often are depicted holding the branch of a tree, a reference to the fructifying power of their touch. The motif emerges prominently in Indian sculptural art at Bharhut (c. 1st century B.C.E.), where for the first time they are referred to as yakshis and devata, indicating their divine status. Not all such females are deities, however. In a number of instances they are engaged in mundane activities such as bathing, playing, and the like. Although such figures predominate in Buddhist monuments, the present pillar was located in a Jain context at Kankali Tila. It must have formed part of the railing surrounding a stupa. 20

S.G.

CAT. 3, back

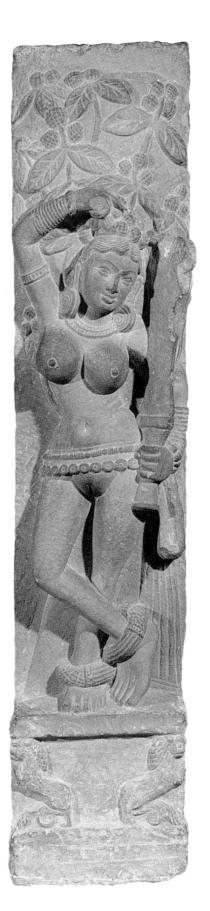

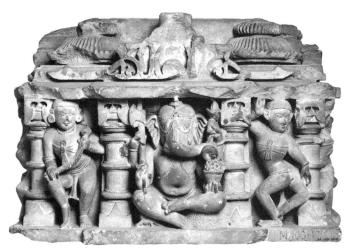

CAT. 4A

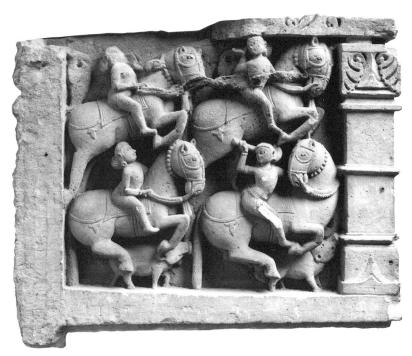

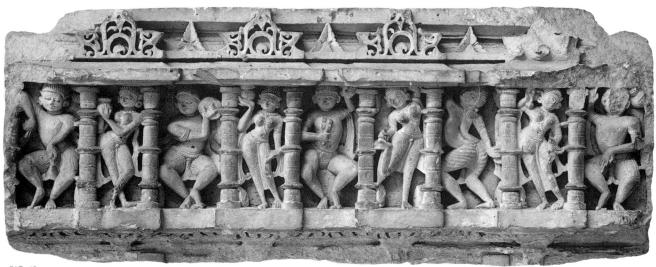

CAT. 4C

Four Architectural Reliefs

Gujarat, Palitana; early 11th century Sandstone

The Board of Trustees of the Victoria and Albert Museum, London

- A. Ganesa 13¹/₄ in. (33.7 cm)
- B. Capital with Equestrian Reliefs $15\frac{1}{2}$ in. (39.4 cm)
- c. Relief with Dancers and Musicians $11^{3/4}$ in. (29.8 cm)
- D. Relief with Kirtimukha $10^{1/2}$ in. (26.7 cm)

The Jain temple complex of Satrunjaya, in close proximity to the town of Palitana, is the largest in India. Clustered along the twin summits of Mount Satrunjaya are numerous temples. The site was devastated by Muslim invaders in the fourteenth and fifteenth centuries, and the structures in situ today postdate this period of persecution. Although many fragments would have been pillaged for the construction of new temples in the sixteenth century and later, much sculptural material remained. These four architectural elements are part of a group of fifty-two pieces gathered at Satrunjaya in the mid-nineteenth century and now preserved in the Victoria and Albert Museum, London. They were from the collection of Sir H. Bartle E. Frere, governor of Bombay (1862-67), who presented them to the British Architectural Association in 1877.

CAT. 4D

The high degree of stylistic uniformity within the series suggests that these reliefs were collected from a single temple site, or at least sites that were contemporary. They are related to known Solanki dynasty temples of the eleventh and twelfth centuries; inscriptions record that endowments were made to the Satrunjaya temples during the reign of Siddharaja Jayasimha (1095–1142), a Solanki ruler renowned for his patronage.

The highly ornate treatment and the elaboration of detail is a distinctive feature of Solanki architectural decoration. An ornately decorated capital (A) has on one side the Jain yakshi Kali in four-armed form holding a trident and bell, and on the adjacent side an image of the Hindu deity Ganesa. The borrowing of particularly popular and auspicious deities from other religions was not uncommon, as seen in the role assumed by Sarasvati [55-57]. Contemporary secular subjects also appear in this group, as seen in Capital with Equestrian Reliefs (B). On the capital two reliefs show what appears to be a pig hunt; a third depicts heavily caparisoned war horses, scenes perhaps relating the exploits of a ruler prior to his conversion to Jainism. Relief with Dancers and Musicians (c) could equally have come from a Hindu context. The use of the kirtimukha (D) is another instance of the relaxed attitude of Jain temple designers toward the use of the common visual vocabulary of the age. The kirtimukha (face of glory) is meant to frighten unbelievers and protect the faithful. Its lionlike features alternate with an extravagant flowering-tree motif. ≥

J.G.

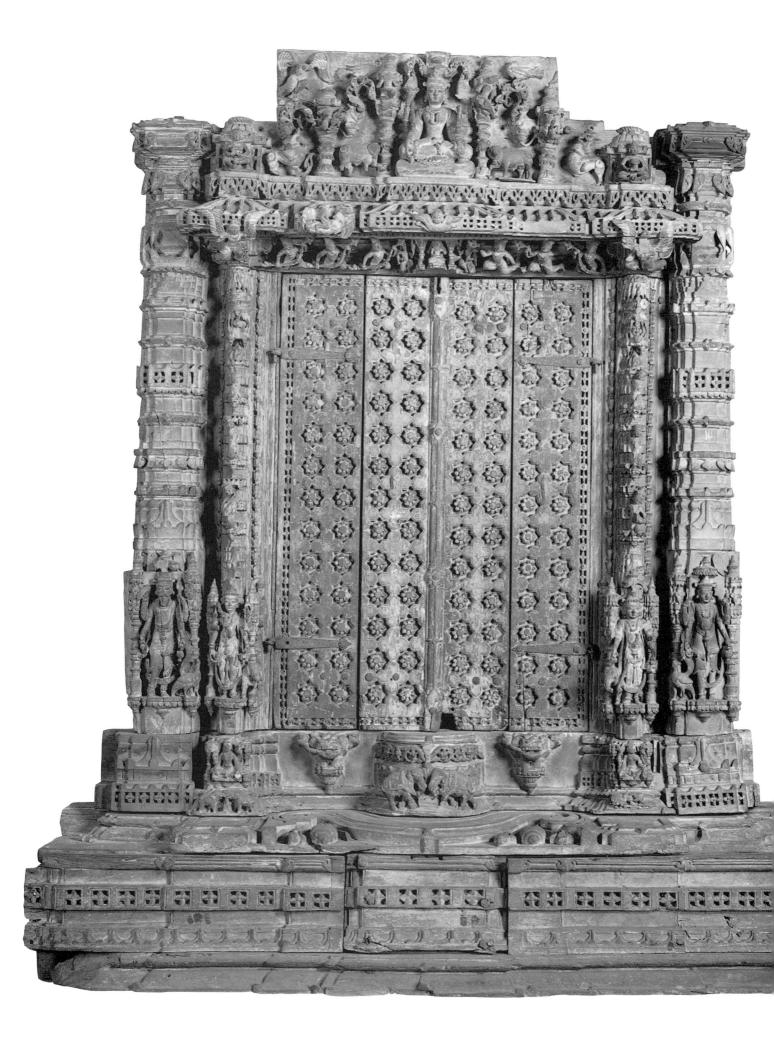

Facade of a Domestic Shrine

Gujarat, Ahmedabad c. 17th-18th centuries Teak with traces of pigment $66\frac{3}{4}$ in. (169.5 cm) The Board of Trustees of the Victoria and Albert Museum, London

Wood was a favored material for the decoration of interiors of Jain household shrines and small temples. It is recorded that the earliest Jain temples at Mount Satrunjaya were of wood, but these were replaced by stone structures as awareness of the dangers of fire became more acute. Elaborate doorways of this kind were a traditional device for providing privacy and maintaining security for the images. House shrines were frequently in wood and were modeled directly on stone temple shrines such as those to be seen at Vimala Vasahi on Mount Abu, built in 1032. The elaboration and scale of this example suggest that it would have been installed in a very wealthy Jain home, where it would have protected the family's household images. Correspondence associated with its purchase in Ahmedabad in 1910 gives no clue as to its origins, beyond stating that the shrine facade was "recently removed from its original position [unspecified] and replaced by a modern marble shrine" (V & A Museum Register, 1M342-1910).

The shrine front has an elaborate threshold decorated with lotus designs and pairs of elephants. The doors are finely carved, with a recurring pattern of eight-pointed stars inset with a raised flowering lotus. The doorjambs are flanked by attendant dvarapala (door guardians) on the lower

section, and there are gandharva (celestial musicians) at intervals above. At the far left and right are elaborate pillars that imitate the conventions of Gujarati stone architecture, with compartmentalized sections, and the lower panel given over to attendant figures. The bearded ascetic depicted at the lower left is Narada, a rishi (sage) associated with Brahma and chief of the heavenly musicians. Another mendicant occupies the pillar opposite. A small awning supported by winged angels projects above the doorway, with garland bearers and divine musicians decorating the lintel frieze. The pedimental area has as its centerpiece the enthroned figure of Sri-Lakshmi, surrounded by celestial attendants and two extraordinary makara (mythical monsters). Traces of the original polychrome are visible.

This is one of the finest Jain wooden shrine fronts to be preserved from Ahmedabad; most have fallen victim over the centuries to the custom of renovating living shrines. 2>

J.G.

Section of an Assembly Hall of a Jain Temple

Gujarat, Patan, Vadi-Parsvanatha temple; 1594—96 or slightly later Teak with traces of pigment 70 in. (177.8 cm) Lent by the Metropolitan Museum of Art, Gift of Robert W. and Lockwood de Forest, 1916

This section of a wooden interior of a peristylar assembly hall (sabhamandapa) was once part of the Vadi-Parsvanatha temple in Patan, which dates from 1594 to 1596. The rest of the structure is installed in the Metropolitan Museum of Art, New York (Brown 1949; Brown 1978c, 259—67; Cort 1994). According to the temple's consecration inscription, it was commissioned by one Ratnakumyaraji of the well-established Oswal clan of Jains. Originally the assembly hall may have been used for the recital and discussion of sacred texts.

The structural section shown here consists of an ornate balcony in the form of an architectural niche surmounted by a pediment containing a central seated Jina flanked by honorific attendants. The parapet of the balcony is appropriately graced in the center with an image of Sri-Lakshmi, the goddess of wealth, who is widely worshiped by the Gujarati Jain community, particularly the merchants.

Although not displayed in the present exhibition, the interior of the assembly hall dome is a veritable panorama of the Jain pantheon.

Numerous subdivinities are portrayed in a cosmological arrangement symbolizing the vault of heaven and the divine assembly. The eight guardians of the directions and their mounts are the most prominently depicted deities in the dome. The remainder of the ornamentation is composed of bands of mythological figures and vegetal decoration. (For a discussion of Jain temple domes, see Nanavati and Dhaky.) 2.

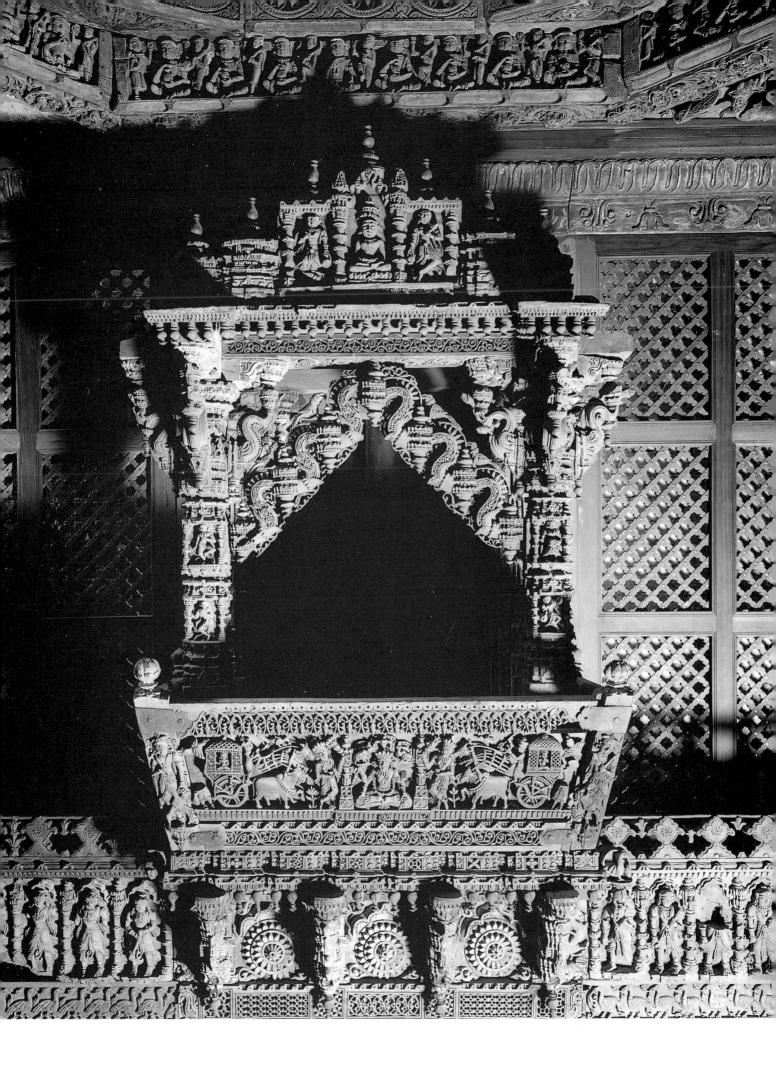

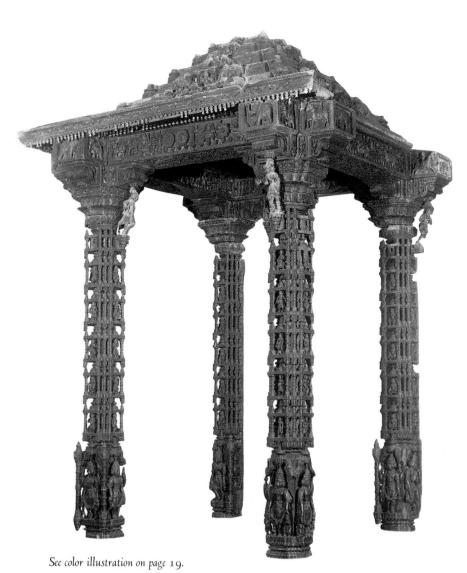

Mandapa of a Domestic Shrine

Gujarat; 17th century Polychrome wood; 99⁵/₈ in. (253 cm) Prince of Wales Museum of Western India, Bombay

This ornately carved architectural pavilion probably formed a mandapa (entrance hall) to a domestic shrine. The four columns support a terraced dome resembling the roof of a temple. The two columns in the front are intricately carved on all four sides with niches housing devangana (celestial damsels), musicians, and lay worshipers. At the bottom of the columns are kshetrapala ("guardians of the fields" or directions). The two columns at the rear are similarly carved, except for the backs, which were attached to a wall. The four crossbeams placed over these columns are superior examples of craftsmanship. The outer and inner sides are carved with processions, and the underside has a floral pattern. Interestingly, the outer and inner carvings suggest a narrative.

Over the beams rises the *sikhara* (dome) in five stepped exterior tiers; the sixth, the finial, is missing. In all probability it would have been a *kalasa* (waterpot).

On the underside is a beautiful *karotaka* (canopied ceiling) with five concentric regions intricately carved in the classically specified designs. In the center is the pendant *padmasila* (lotus medallion) amid lotus petals. Around this is a *gajatalu* (cusped hemicycle), which is in turn encircled by a *kola* (corbeled band). Next are arrayed the figures of the *ashtadikpala* (eight guardians of the directions). The outermost circle is a *karnadardarika* (lotus molding).

While it may have been common to have an entrance pavilion to a domestic shrine, it is unusual to come across such elaborately carved examples as this. The stylistic features on the figures, sartorial elements, and trimmings suggest a date in the seventeenth century. ?

S.G.

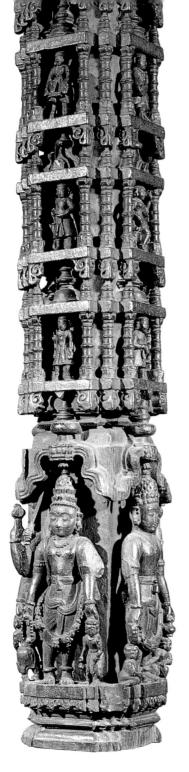

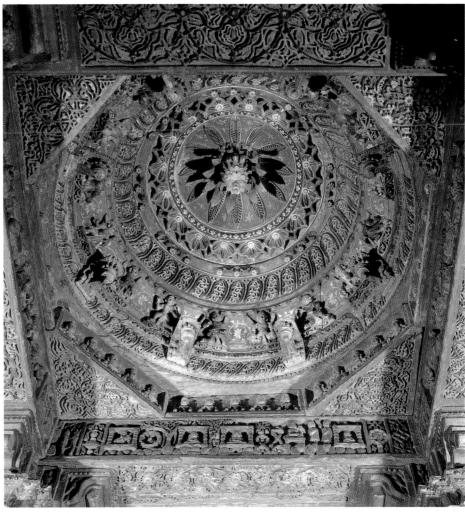

♠ CAT. 7, dome interior

← CAT. 7, column detail

¥ cat. 7, crossbeams

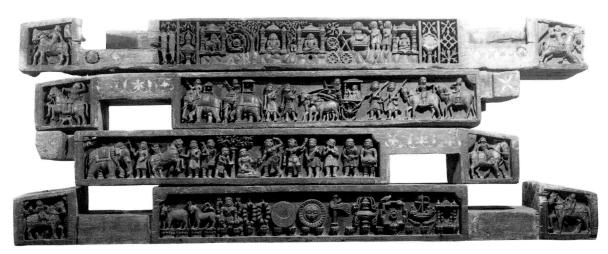

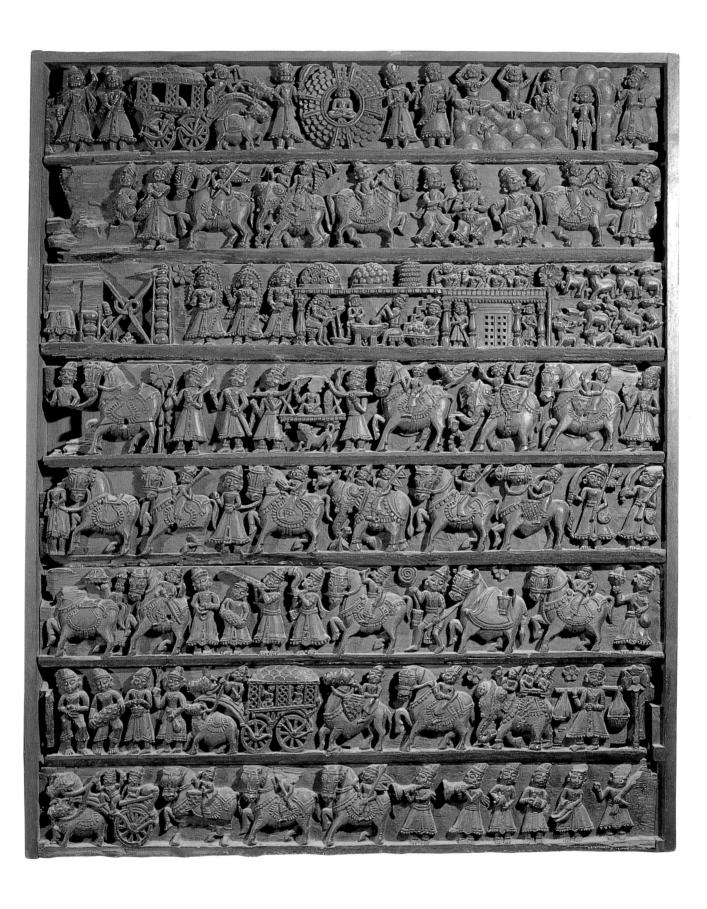

Marriage of Neminatha

Gujarat; c. 18th century Wood; 39 in. (99.1 cm) Bharany Collection, New Delhi

The marriage and renunciation of Neminatha is portrayed in this series of eight horizontal relief panels, now mounted together in a vertical arrangement that unfortunately does not preserve the original narrative sequence. The story of Neminatha's wedding is one of the most popular in Jain mythology because it epitomizes the tenet of nonviolence, which is the quintessential philosophy and moral precept of Jainism.

Neminatha, known also as Arishtanemi, was the twenty-second Jina [17, 24, 29, 31, 50]. He was the son of King Samudravijaya and Queen Sivadevi, who ruled in the Gujarati port city and kingdom of Dvaraka. This was also the home of the Hindu god Krishna, who according to the Jain tradition was Neminatha's cousin. Neminatha is said to have defeated Krishna in a contest of physical strength. As a result, Krishna urged Neminatha to marry, in the secret hope that sexual distractions would weaken the powerful Jina. Because all the previous Jinas had been householders and had raised families before beginning their spiritual path, and also in order to please his parents who wanted grandchildren, Neminatha agreed to wed Rajamati, the daughter of King Ugrasena. Accordingly, he joined a grand procession winding its way to the bridal pavilion. Upon hearing the cries of the animals slated to be slaughtered for the wedding feast, Neminatha was filled with revulsion and decided to renounce the world immediately rather than go through with the ceremony. He gave away all his possessions, a traditional Indian act of renunciation, and was subsequently carried in a palanquin to the Revataka Park. There he shed his golden ornaments, plucked out his hair, and became a monk. After fifty-four days of harsh austerities, Neminatha achieved enlightenment on the summit of Mount Girnar, in Kathiawar, and preached in the samavasarana assembly [105].

The wedding procession is represented in the second and bottom four registers. The feast preparations in the bridal pavilion and the wailing animals are shown in the third panel, while the fourth register depicts Neminatha being transported in the palanquin. Finally, Neminatha's penance in a cave and his circular preaching assembly are portrayed in the top panel. This is one of the most extensive illustrations of Neminatha's wedding and renunciation known to survive. It epitomizes the extraordinary craftsmanship and artistic merit of Jain wood carving from western India. 2>

S.M.

CAT. 8 (detail), overleaf

Lotus Mandala

Western India; 12th—17th centuries Copper alloy and crystal 7³/₈ in. (18.7 cm) Lent by the Denver Art Museum, purchased with funds from the Christian Humann Foundation

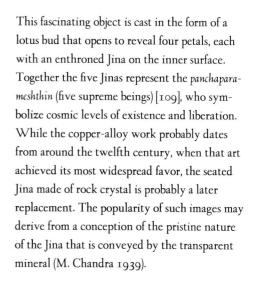

Lotus mandalas are used by Jains in rites performed to remove sin and foster spiritual achievement. Similar objects were also used by Buddhists and Hindus in analogous contexts, particularly in eastern India, Nepal, Tibet, and even China. Both Buddhist and Hindu examples consist of an eight-petaled lotus. This flower is generally symbolic of the human heart and also represents the basic form of a three-dimensional mandala where the divinities dwell. Hindu and Buddhist lotus mandalas from eastern India made during the Pala period (mid-eighth to late twelfth centuries) are typically much more elaborate in the number and types of deities portrayed, and the structural form of the lotus is more complex (Pal 1977, 96-97, no. 57). By comparison, Jain lotus mandalas are extremely rare, and very few published examples are known (Shah and Dhaky, 289, fig. 74). 20

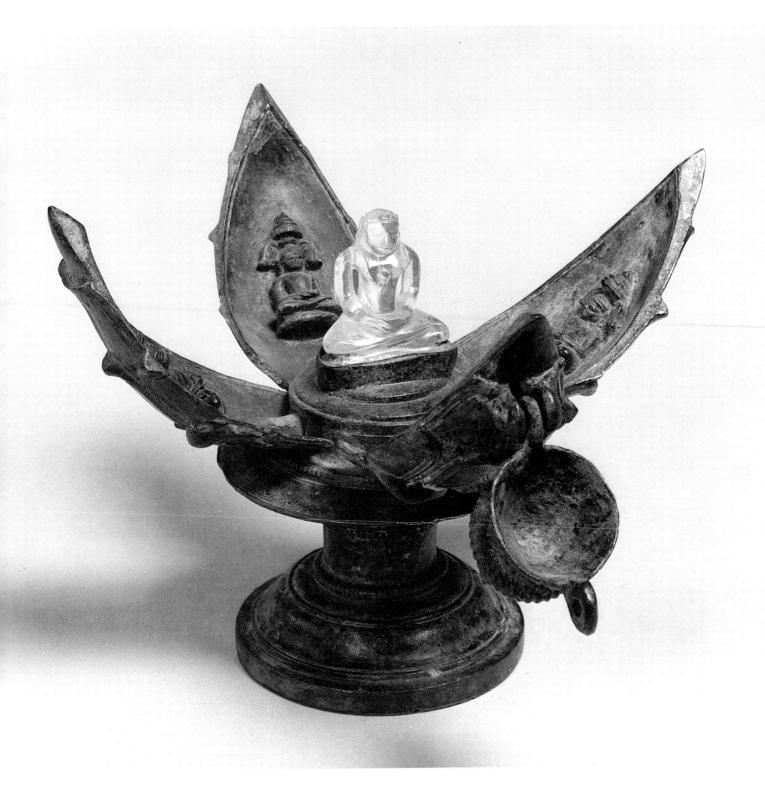

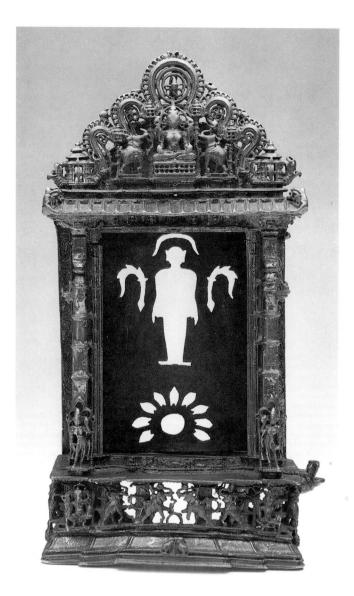

14

Siddhapratima Yantra

Western India; 1333 Copper alloy with traces of gilding 8 1/8 in. (22.5 cm) Paul Nugent

This distinctive image is known as a siddhapratima yantra, which literally means a magical diagram depicting a perfected being. A siddha, a liberated soul who has transcended corporeal form and its resultant karmic obligations, is represented in this type of image as a bodiless silhouette. There are several classes of siddha, but it is the form of a standing Jina that is invariably depicted in this fashion. This particular work may represent the fifth Jina, Sumati, since there are two geese shown in the middle of the lotus pedestal on the base, and the red goose (krauncha) is his cognizance. According to the inscription on the back (see appendix), this sculpture was commissioned by the merchant Maladeva of the illustrious Gurjara family in the year 1333. It is therefore an exceptionally early example, since silhouette images are generally considered to be a very late form of Jain artistic expression (Shah 1987A, 340).

The figure of the siddha is cut out of a copper sheet along with an umbrella canopy, flanking flywhisks, and a lotus base. The sheet is mounted in a frame in the form of a pillared shrine, which is topped by a pierced and undulating parikara arch modeled on contemporary sculpture and architecture [6, 36]. Centrally seated beneath the arch Sri-Lakshmi receives lustration from two flanking elephants. At the base of the shrine's pillars are female attendants bearing flywhisks. The stoop of the shrine is embellished with a pierced facade featuring a seated Ganesa on the left; lustrating elephants in the middle, flanked by elephants with riders; and a seated deity on the right. 2*

See color illustration on page 44.

Pato with Auspicious Symbols

Gujarat; c. 1950–75 Multicolored synthetic dyed silk and undyed cotton thread embroidery on red wool; 16 ¾ x 11 ¾ in. (42.5 x 29.8 cm) Chester and Davida Herwitz Family Collection

A pato is an elaborately embroidered covering for the handle of the rajoharana, the small broom carried by Jain monks, nuns, and ascetics [94, 114, 119B]. The practice of making these brilliant textiles is said to have begun in Gujarat during the early or mid-nineteenth century. They are primarily made by nuns of the Svetambara Tapa gachchha (chapter) in periods of prescribed social isolation during their menstrual cycles. A pato is meant to be a very private possession, viewable only during the daily ritual of padilehana, the examination of clothes and other personal objects for any trapped living creatures. Otherwise they are kept wrapped around the broom handles and are covered by an outer wrapping of plain white cloth appropriate to the white-clad Svetambara Jains. Thus, most outsiders would be unaware of their existence.

A pato may contain a variety of decorative motifs, the oldest and most traditional of which are the eight auspicious signs [95]. The present example displays the eight signs in two registers along the top and bottom. From left to right across the top are the auspicious solar symbol, auspicious srivatsa mark, water-filled pot, and auspicious seat. Along the bottom from right to left are the pair of fish, mirror, powder box, and auspicious whorl. The center is graced with a lotus medallion, flanked by vertical panels containing decorative floral motifs. The outer borders feature rows of large, white stitches that reinforce the textile and are considered symbolic by the nuns. The two vertical rows represent nonattachment and lack of hatred, while the five horizontal rows symbolize the five Jain monastic vows: nonviolence, truthfulness, nonstealing, celibacy, and nonpossession. Along the bottom edge of the work is a row of buttonhole stitches through which braided woolen tassels were originally drawn (Vora; Jain and Fischer 1978, vol. 2, 12, pl. 17). 2>

Images of Jinas

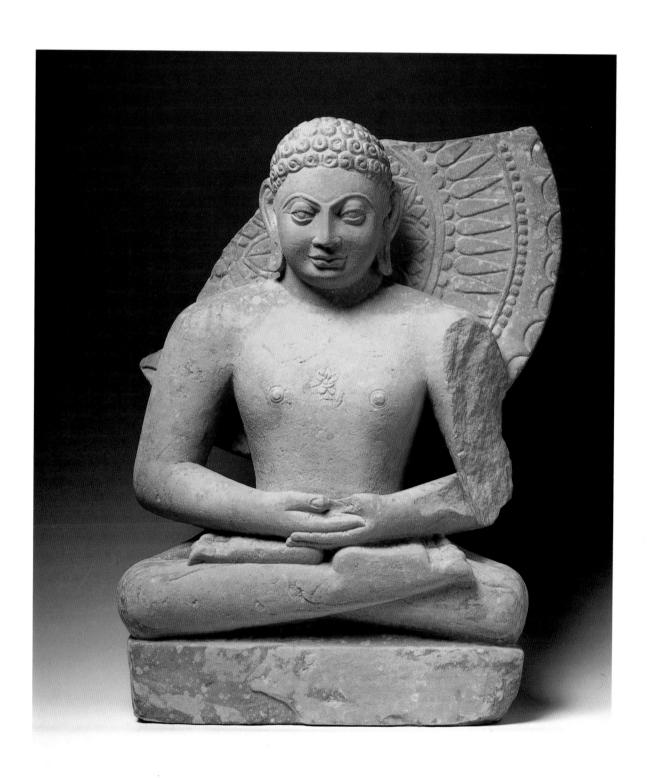

North and Central India

16

A Jina

Uttar Pradesh, Mathura 2nd-3rd centuries Mottled red sandstone 17½ in. (44.5 cm) Frei Collection

Broad-shouldered and rather heavily proportioned, the naked figure is seated in the classic meditation posture on a plain base. Both hands, one palm above the other, are placed across the soles of his feet. The only adornment is the auspicious *srivatsa* mark on his chest. Among other supernatural marks are the elongated earlobes and the caplike delineation of the curly hair on his head. A large nimbus typical of Mathura art

further announces his divinity. The nimbus is adorned with an open lotus flower in the middle and is surrounded by a row of spearheads, symbolizing rays of light, encircled by a string of pearls. The edge of the nimbus is scalloped.

Except for parts of the nimbus and the left arm the image is remarkably well preserved. Unlike most Jain figures of the period the head is beautifully shaped and proportioned, with sharply defined features and wide-open eyes. Although not modeled at the back, the figure is conceived in the round, allowing for a clear definition of volume. Despite his corporeality, the Jina has a dignified presence. 20

P.P.

17

Jina Neminatha

Uttar Pradesh, Mathura
c. 3rd—4th centuries
Red sandstone; 22½ in. (57.2 cm)
State Museum, Lucknow

This portly, nude Jina stands meditating, while a devotee couple kneels with folded hands at his right. The smaller figures at his left are probably the couple's children. On the pedestal below the Jina's feet, the *dharmachakra* (wheel of law) is flanked by a figure seated in meditation on

either side; they may represent Jinas. At either end is a rather crudely carved crouching lion.

A fairly large halo representing a lotus provides a pleasing backdrop to bring the contemplative Jina into sharp focus. At the top are two flying celestials bearing garlands.

An important feature of this image is the presence of the two flanking Vaishnavite (Vishnu sect) deities standing on pedestals. On the Jina's right is Balarama, or Baladeva [53], identifiable by the serpent hood, and on his left is Vasudeva

< cat. 16

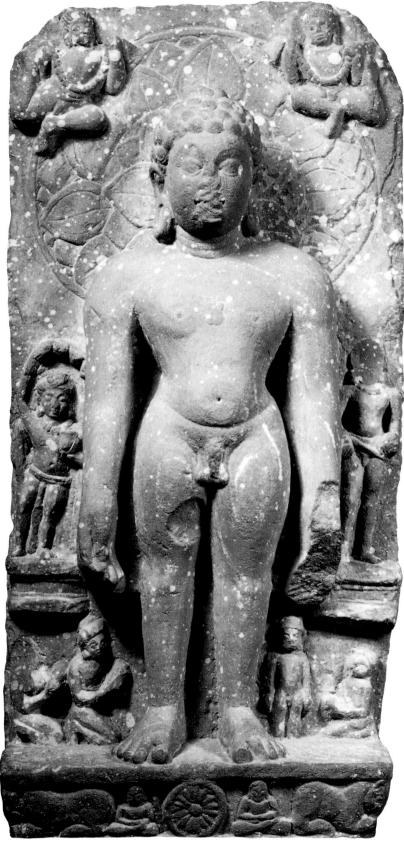

CAT. 17

Krishna, though badly mutilated. Each of the figures has four hands. In keeping with his iconography as it prevailed during the Kushan period (1st—3rd centuries) Balarama has his right hand raised, and in the left he holds a cup of wine, an identifying element. With his other two hands he seems to be holding a club and a plowshare, which are two of his other attributes. Two of Krishna's emblems, the conch and the mace, are clear, but the other objects are indistinct.

Mathura, to which area this sculpture belongs, was a prominent seat of Vaishnavism, with particular emphasis on the cult of Balarama. The Jain version of the *Harivamsa*, composed by Jinasena, as well as the *Trishashtisalakapurusha-charita*, an important work on Jain iconography, extensively refer to Vasudeva Krishna and Balarama. In some epigraphs Krishna is mentioned as a lay worshiper. In yet another work, the *Antagaddasao*, it is even said that Krishna was converted and became a Jain monk. The association of Krishna and Balarama with Neminatha is prominent only up to the beginning of the Gupta period (early fourth century).

The round, flabby face; big, open eyes; and the shape of the *srivatsa* on the chest are reminiscent of the Kushan idiom, while the triple folds on the neck (*trivali*) and the long earlobes point to Gupta influences. 2>

S.G.

A Digambara Jina

Uttar Pradesh, Mathura, Kankali Tila c. 5th century Mottled red sandstone; 49 in. (124.5 cm) State Museum, Lucknow

Representing the ideal image of the Gupta period, this figure of a Digambara Jina is stylistically similar to contemporary Buddhas of the same region. The principal differences are iconographic. The Jina is unclothed and has the srivatsa symbol on his chest. The proportions and modeling of the figure as well as the richly carved, large nimbus are characteristic features of Buddha figures of Mathura from this period as well.

The physiognomy of the image is rather athletic and heavy. The features, however, are sublime and appropriate to a saintly figure. A Jina when seated is always shown cross-legged, hands resting on his feet and palms turned upward. The half-closed eyes, full cheeks, extended earlobes, the close snail-shell curls of hair, and the triple folds on the neck indicate the fully evolved Gupta idiom and suggest a date in the fifth century.

No less attractive than the handsome figure is the elaborate halo with two inner bands of radiating rays, a floral band, and a scalloped edge. It is a fine specimen of the fully evolved halo seen prominently adorning the better-known Buddha figures from Mathura.

The damaged garland bearer to the Jina's upper right, the broken corner to his upper left, and even the damaged lower portion do not diminish the overall dignity of the image. It is difficult to assess if there were figures on the sides. The missing section of the pedestal makes identification problematic, since the cognizance is not present. 20

S.G.

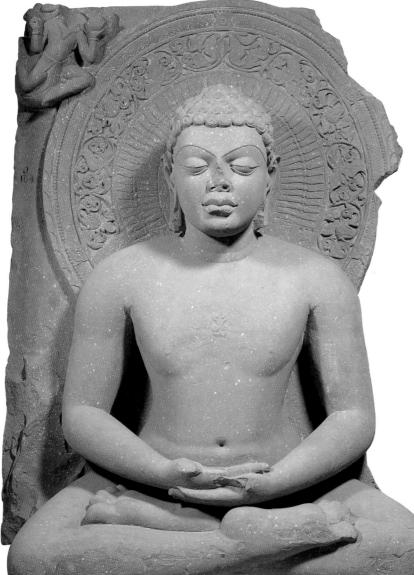

A Jina with Attendants

Madhya Pradesh; c. 500 Pink sandstone; 19³/₈ in. (49 cm) Frei Collection

A naked Jina stands in the *kayotsarga* (body-abandonment) posture on a lotus. His smooth body is adorned only with the *srivatsa* mark on his chest. The nimbus around his head, the three umbrellas above it, and the flying celestials announce the Jina's divine character.

As is typical of Gupta-period stone images, this Jina is no longer represented alone. Apart from the two celestials, he is accompanied by two divine attendants who stand on either side carrying flywhisks. They are distinguished by their headdresses but cannot be specifically identified. They represent generic yaksha attendants as described in both Digambara and Svetambara traditions (Shah and Dhaky, 58). The two celestials in the sky are here represented against foliage rather than the cloud cartouches sometimes seen in Mathura images. One simply holds a garland, while the other stretches it as if about to adorn the Jina.

One of the finest of the Gupta period, this stele is stylistically related to late fifth- and early sixth-century sculptures of Madhya Pradesh. Especially comparable are sculptures at such sites as Nachna and Nand Chand (Williams 1982, figs. 147–48, 151, 172–73). Characteristically, the elegantly proportioned figures are smoothly but sensuously modeled. The swaying attendants and flying celestials act as a foil for the immobile Jina and enliven the composition considerably. The contrasting size of the Jina and the four subsidiary figures emphasizes the former's importance. 20

Р.Р.

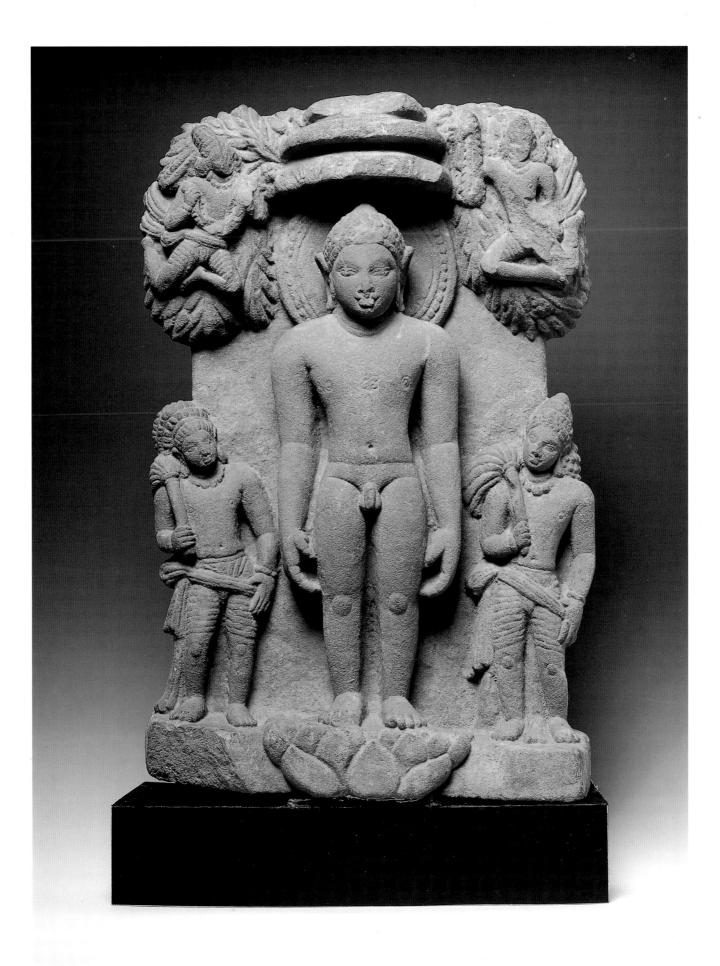

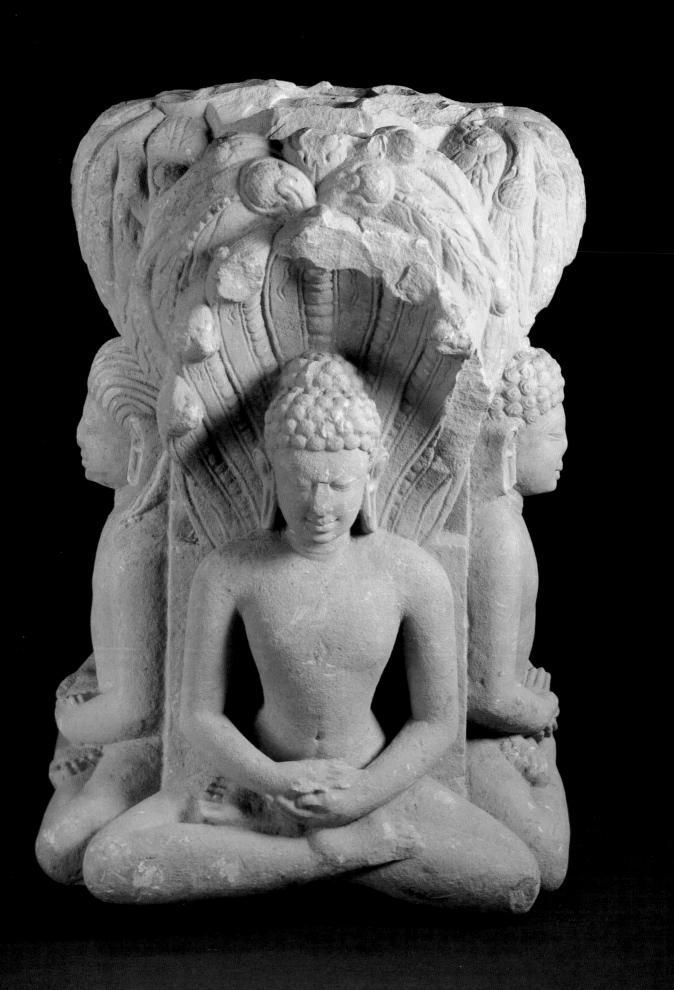

A Shrine with Four Jinas

Uttar Pradesh; 7th century Cream-colored sandstone 23 in. (58.4 cm) Los Angeles County Museum of Art Gift of Anna Bing Arnold

Four Jinas are seated in meditation on four sides of a central shaft whose top is missing. Such a configuration is known as sarvotabhadra (auspicious on all sides) or chaumukha (four-faced). There is thus a conceptual relationship with the four-faced sivalinga, the four emanatory forms of Vishnu, and the Buddhist stupa with four transcendental Buddhas on its four sides. A chaumukha [11, 12] is an essential part of Jain temples, and this particular example once graced a Digambara Jain complex.

Of the four Jinas represented here two can be definitely identified. The figure with the long hair is Rishabhanatha and the one with the snake canopy is Parsvanatha. One of the others is certainly Mahavira, and the fourth is perhaps Neminatha. Certainly these four are the most important of the twenty-four Jinas, for only their lives are described at length in the canonical Kalpasutra. It should be noted, however, that there is no iconographic tradition prescribing which four should be represented in a chaumukha.

Had the sculptor responsible for this example differentiated the foliage above each Jina, one could have distinguished the two unidentified figures. Each Jina seems to be under an identical tree, perhaps the asoka, which is a cosmic tree for the Jains (Shah 1955, 67-71), as is the bodhi tree for the Buddhists.

When complete the sculpture would have had some sort of a finial and a base that may have carried each Jina's cognizance. Very likely it was carved for a temple in Uttar Pradesh, for the stone has the same features as the buff Chunar sandstone of that region. Stylistic parallels are also found in Uttar Pradesh. Whatever its provenance, it is an impressive example of a chaumukha, with four serenely dignified Jinas. 20

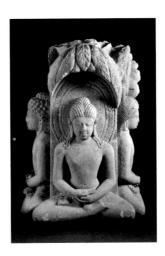

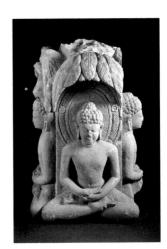

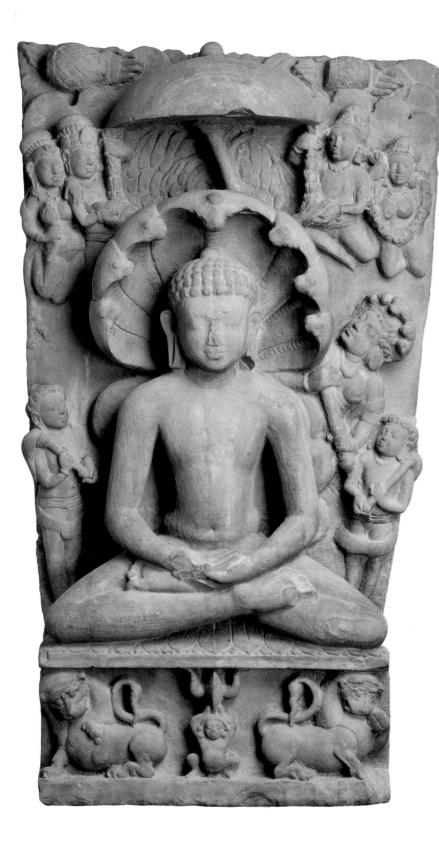

Samvara Attacking Parsvanatha

Madhya Pradesh, Gyaraspur; c. 600 Sandstone; 51½ in. (130.8 cm) The Board of Trustees of the Victoria and Albert Museum, London (Shown at the Victoria and Albert Museum, London, only)

This sublimely beautiful sculpture illustrates Parsvanatha's triumph over Samvara in considerable detail, although it is not as rich as the much later representation of the theme [22]. Parsvanatha is depicted naked beneath a dhataki tree, seated in a meditative posture on a simhasana (lion-supported throne). Samvara has sent a great storm (symbolized by the hands and drums in stylized clouds in the upper corners) to disturb his meditations, but the serpent-king Dharanendra raises up his seven hoods to provide shelter to the Jina. Dharanendra's consort Padmavati, seen to the Jina's left, holds an umbrella to further protect Parsvanatha from the forces of the storm. The wheel of law, symbolizing the Jina's teachings, is beneath the throne, supported by a squatting gana (dwarflike attendant). Flywhisk bearers stand in attendance, and celestial figures with garlands hover beneath the rain clouds.

This relief probably originated in the vicinity of Gyaraspur, near Bhilsa in Madhya Pradesh, a site with significant Jain remains. At least two major temples survive at Gyaraspur; they appear to have been originally dedicated as Hindu shrines but were evidently appropriated by the Jains in the early medieval period. 2>

J.G.

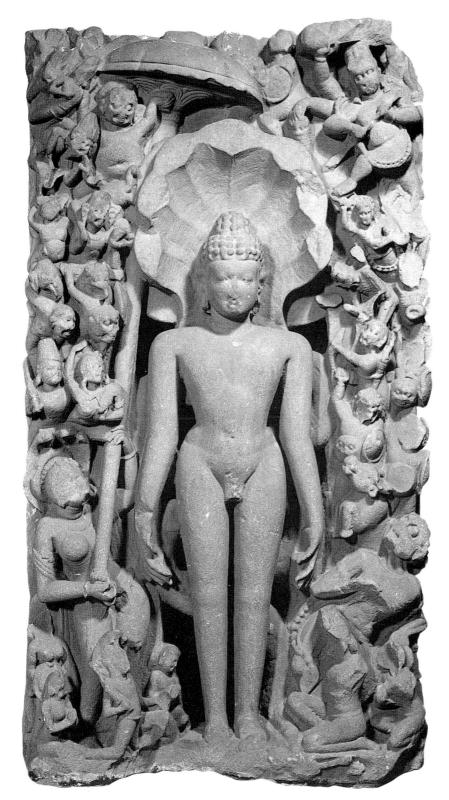

See color illustration on page 32.

Samvara Attacking Parsvanatha

Uttar Pradesh; c. 10th century Sandstone; $47\frac{1}{2}$ in. (120.7 cm) Indian Museum, Calcutta

The nude and serene figure of Parsvanatha with a seven-hooded snake canopy presents a strong contrast to the hostile activity of the figures surrounding him, who are evidently in no mood to allow the Jina to meditate. The seven-hooded snake is Dharanendra, the yaksha of Parsvanatha. To Parsva's right Padmavati holds a parasol over the Jina, while to his left the kneeling figure of Samvara (according to Digambara legend) begs the Jina's pardon before moving away.

According to one account Samvara was Kamatha in an earlier birth and was the brother of Parsva, who was then known as Marubhuti. Kamatha was an esoteric mendicant and was practicing the "ordeal of five fires." Parsva (as Marubhuti) saved a pair of serpents from being burnt in the fire, and they eventually became his yaksha and yakshi, as Dharanendra and Padmavati. Later, when Parsva was in deep meditation, Samvara attacked him with his retinue of serpents, genii, and the like for seven days; he also caused such a downpour that the water level came up to the Jina's nose. It was then that Dharanendra protected Parsva with his hoods, but Parsva, oblivious of the happenings around him, continued to meditate. Eventually accepting defeat, Samvara bowed before Parsva and left with his retinue. This rare representation of the subject is much more detailed than the earlier version in the exhibition [21].

The sculpture invokes a comparison with the more-popular Buddhist depictions of Mara's army attacking the Buddha. Undoubtedly the prototype for the Jain version is provided by these Buddhist sculptures, where the theme had gained early acceptance; however, it did not acquire for Jains the significance that it did for the Buddhists. Even apart from its rarity, this is a fine example of tenth-century narrative relief. 2

S.G.

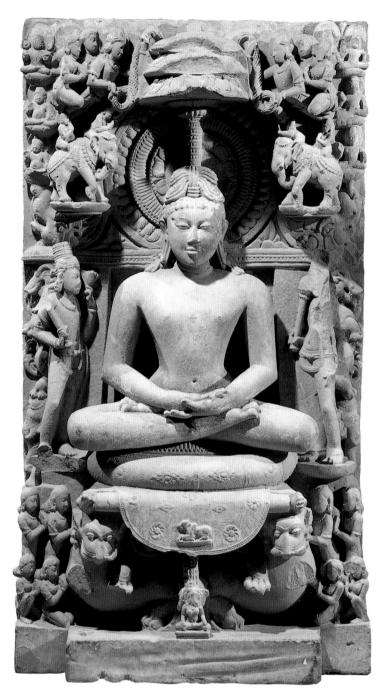

Stele with Rishabhanatha

Uttar Pradesh; 10th century Sandstone; 47 in. (119.4 cm) Private collection

This impressive stele must once have graced a subsidiary shrine in a temple of considerable dimensions. It depicts the samavasarana (holy assembly) of Rishabhanatha, who is represented in the center. He sits in meditation comfortably on a thick cushion placed on a throne with a cover or mat draping down in front. Rishabha's bull is shown in miniature against the covering. Interestingly, the animal is not depicted as embroidered on the cloth, as are the decorative motifs, but floats in air, defying all laws of gravity. Noteworthy also is the elaborate matting above the hair on Rishabha's head. Normally his hair is shown in close, knob-like curls, the usual mode of showing a Jina's hair, with additional strands falling down his shoulders. Here the saint's ascetic character receives added emphasis, as is generally the case in eastern Indian representations [39-40].

Below the throne is a pair of active lions flanking a wheel shown only from the end. The deer are not included, but the small figure of a goddess is added in front of the wheel. As her attributes are not clear, she cannot be identified. Groups of terrestrial adorants of both sexes are included on either side of the throne. In the middle of the stele the Jina is flanked by two regal chauri (flywhisk) bearers, half-turned toward the saintly teacher. Behind each of them is the motif of a lion trampling an elephant characteristic of thrones. The upper portion of the throne back is decorated with makara flanking a lotus nimbus. An ornamental pole supports the three-tiered parasol. On either side in bolder relief are groups of celestials, including elephant riders, garland bearers, and six seated deities with the sun-god, Surya, at the top left.

Despite the multitude of figures, the stele does not appear overcrowded, because of the use of receding planes. Both human and animal figures are robustly and articulately delineated. The half-turn of the chauri bearers is a departure from the more customary frontal disposition. No less noteworthy is the very youthful and expressive face of Rishabhanatha, reminiscent of Siva's physiognomy in contemporary sculptures from the region. 20

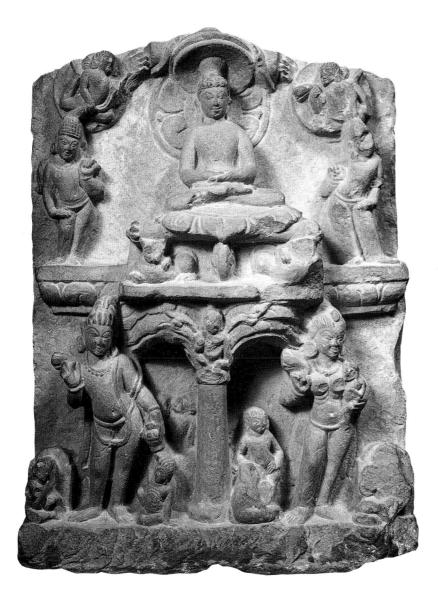

Stele with Jina Neminatha and Attendants

Uttar Pradesh, Varanasi; 10th century Sandstone; 17³/₄ in. (45.1 cm) Bharat Kala Bhavan, Varanasi

The composition of this sculpture is quite unusual and is similar to reliefs depicting the family group [58]. It is divided into two visual registers, the upper showing the seated Jina and the lower showing his yaksha and yakshi.

The twenty-second Jina, Neminatha, is on a lotus seat, below which is the wheel of law flanked by two heraldic lions. At either side are two yaksha attendants with flywhisks; above are two flying garland bearers. The lotus halo is behind his head, and above is the triple umbrella. On either side of the umbrella are two hands beating on a drum, providing celestial music.

In the lower register, flanking the central tree are yaksha Gomedha and yakshi Ambika. The yakshi holds one child in her lap, while another stands nearby. Gomedha holds a waterpot in his left hand and a lotus in his right. Both the yaksha and the yakshi were flanked by devotees, though the figure beside Ambika is badly mutilated. There is a seated figure in the tree whose attributes cannot be identified [59]. 20

S.G.

Altarpiece with Rishabhanatha

Madhya Pradesh [?]; 973 Copper alloy; 14½ in. (36.2 cm) Dr. and Mrs. Siddharth Bhansali, New Orleans

Normally such a bronze would be attributed to Gujarat or Rajasthan, but a Digambara bronze from that region is uncommon. The early Nagari script of the inscription differs from those seen in Svetambara bronzes from Gujarat, such as the one in Los Angeles [30]. Stylistically it seems to share elements with both Gujarati and Karnataka sculptures. Thus, the location of Madhya Pradesh, where Digambaras were quite prominent, seems very likely. It should be noted that the bronze is reputed to have been found in Haryana, where it may have been the property of a merchant.

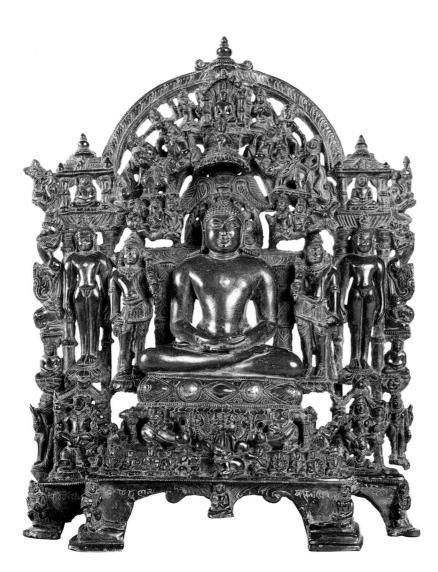

Iconographically the altarpiece offers a busy composition with numerous figures. Rishabhanatha is the central figure, but he is surrounded by seven other Jinas. Two of them flank the two chauri bearers, and four are seated, two beside the feet of the standing Jinas and two above their heads in shrines. The seventh, just below the arch, is Parsvanatha. Usually Jinas are shown in groups of odd numbers; the addition of Parsvanatha, making eight, is curious. Among the many figures hovering around the head of Rishabha, two elephants are engaged in bathing the Jina, and a celestial holds a conch immediately above him. Clearly the scene here shows the samavasarana (holy assembly) of Rishabha, also symbolized by the deer-flanked wheel below the lion throne. Seated on either side of the throne are Gomukha and Chakresvari, protective deities. Along the front of the throne are the nine planetary deities, who are shown as full figures rather than as heads only, as in the Los Angeles bronze.

According to the inscription on the back (see appendix) this bronze of Rishabhanatha was dedicated by Jinavaradasa in 973. A few additional names such as Lachana, Megha, Bharatha and Chalala are inscribed in the front, but their relationships with Jinavaradasa are not known. The two figures attached to the side legs of the altarpiece may represent Jinavaradasa and his spouse.

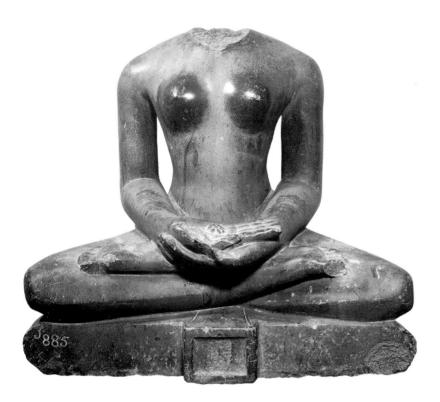

Meditating Female

Uttar Pradesh, Unnav 10th-11th centuries Black stone; 181/8 in. (46 cm) State Museum, Lucknow

The image is identified as that of the nineteenth Jina, Malli or Mallinatha, by the much-damaged waterpot in the square niche on the pedestal. All Jinas are shown either standing or seated and are identifiable only if their cognizance is represented. In this image, aside from the waterpot in the niche, the pronounced femininity helps with its identification. The lotus flower on the open palm signifies the figure's superhuman character.

The Svetambara and Digambara traditions differ fundamentally in their conceptions of Malli. Both traditions agree upon the parenthood of the Jina: King Kumbha and Queen Prabhavati of Mithila. But while the Svetambaras maintain that Malli was a daughter, the Digambaras insist upon him being a son. Yet even for the Svetambaras it is highly unusual for a Jina to be female, and hence they consider it as one of the ten "unexpected happenings." The Digambaras rigidly consider women incapable of attaining salvation; thus Malli could never be a female.

The Svetambara traditions maintain that the body color of this beautiful princess was blue. She turned down all offers of marriage and renounced the world to obtain infinite knowledge (kevalajnana).

Despite the missing head, this is a very important sculpture, as it is the only known image of Malli as a female. It is, moreover, a rare instance of an Indian sculpture of a nude female seated in meditation. 2

S.G.

CAT. 26, back

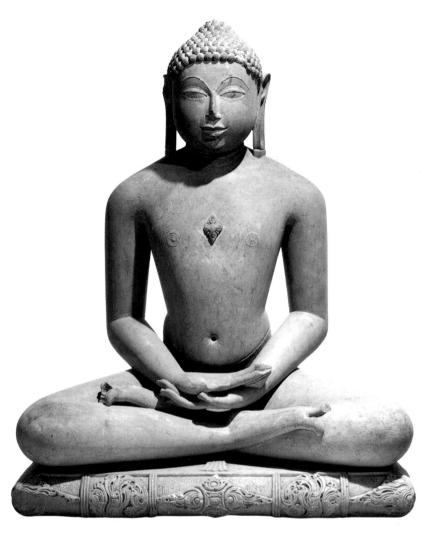

Jina Mahavira [?]

Madhya Pradesh; 1108 Sandstone; 27½ in. (69.9 cm) Dr. David R. Nalin

This beautifully polished sandstone sculpture has an inscription (see appendix) on the cushion providing information about its dedication. It was commissioned in the year 1108 by one Abhigani, son of Jata and Jamahadi, belonging to the chapter of the illustrious teacher Silabhadra. Nothing is known of the donors or the teacher. Unfortunately the inscription does not include the name of the Jina, nor did the sculptor carve a symbol on the base. Nevertheless one can surmise that the Jina intended is Mahavira, as he is the most commonly represented and there are no other identifying characteristics.

Although the figure is typical of numerous seated, meditating Jinas carved in central India during this period, this particular example is exceptionally handsome. The carving is of the highest quality, not only in figural form, but also in details such as the bold curls of the hair, the srivatsa mark on the middle of the chest, the whorls around the nipples, and the swirling floral designs on the cushion. Noteworthy is the contrast between the stylized geometric delineation of the body and the sensitive rendering of the hands and feet. The smooth modeling and highly polished surface make it an especially attractive sculpture.

Some interesting iconographic details are worth mentioning. The conical top of the head clearly suggests a cranial bump beneath the curls that sit like a cap. This may have been influenced by images of the Buddha (fig. 19). The extensions of the earlobes are rectangular and rest on small supports. The srivatsa mark differs considerably from the conventional form [16] and is now a symmetrical floral pendant of diamond shape. A strip of cloth emerging from beneath the Jina indicates that he is attired, but his legs show no signs of clothing. Finally, an elegant cushion is provided for the Jina's comfort. 2.

Western India

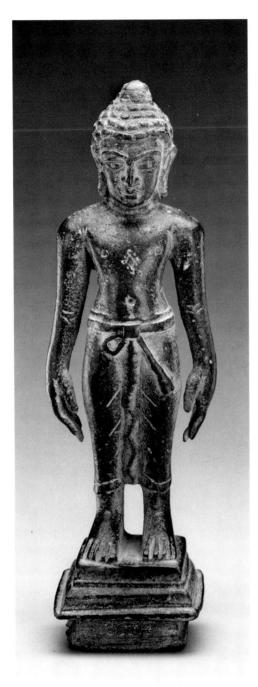

28

A Svetambara Jina

Gujarat, Valabhi; c. 600 Copper alloy; 6 1/8 in. (17.5 cm) Lent by the Jina Collection (Courtesy of the Arthur M. Sackler Gallery, Smithsonian Institution)

Valabhi, in ancient Saurashtra (now in Gujarat), was the site where important councils were held in the early fourth century and again in the year 453. One can conclude that it was an important center of Jainism during this period, but little art from the time has survived. The earliest examples constitute a small group of bronzes depicting Svetambara Jinas that are now in the Prince of Wales Museum, Bombay (Ghosh, 2: pl. 67 A).

This small bronze is stylistically so similar to the Valabhi bronzes that there can be little doubt it was made in the same workshop. The most noteworthy feature is the dhoti (loincloth), which indicates his Svetambara affiliation. The dhoti is held at the waist by a belt and buckle. Otherwise there is nothing to distinguish him from a Digambara Jina. The form of the pedestal is characteristic of the other Valabhi bronzes. All of the figures are rather small, and none can be precisely identified. 2>

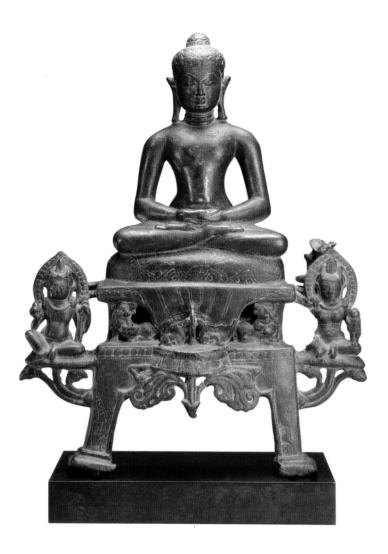

Jina Neminatha [?]

Gujarat, Akota; 7th century Copper alloy; 13^{7/8} in. (35.3 cm) Lent by the Jina Collection (Courtesy of the Arthur M. Sackler Gallery, Smithsonian Institution)

This meditating Jina is seated on a cushion atop a two-tiered lion throne draped with a carpet. The lions on either side of the overhanging carpet look up at the Jina. Projecting from the top of the lower tier is a lotus with foliage. On the lotus is a wheel flanked by a pair of deer. While the wheel is a general religious symbol for the Jains, as it is with the Buddhists, the deer is the cognizance of Santinatha, the sixteenth lina. However, as is well known, the combined motif of the wheel and the deer is a Buddhist emblem par excellence, symbolizing the Buddha's first sermon in the deer park at Sarnath. It has been suggested that this motif was borrowed by the Jains and became associated with Santinatha, who was responsible for reviving the faith through his teachings at a time when Jainism had almost disappeared (B. C. Bhattacharya 1974, 52).

Figures of a yaksha and a yakshi sit on two lotuses on either side of the throne. If the central figure is indeed Santinatha, then the yaksha's name is Garuda and the yakshi's is Nirvani. The attributes in their hands, however, do not conform to the known iconography of these two deities. The female almost certainly holds a child with her left hand, which would make her Ambika. In that case the yaksha would be Gomedha, whose attributes, a lemon and a spear, are what the figure here seems to hold. These identifications would suggest that the Jina is Neminatha rather than Santinatha. If this is true, the wheel-cum-deer motif cannot be taken as the cognizance of the Jina but as a pratiharya (generic symbol) of his teaching in the divine assembly. This elaborate bronze is certainly from Gujarat and very likely from Akota, which has yielded a large group of bronzes of exceptional quality and iconographic diversity (Shah 1959). 2>

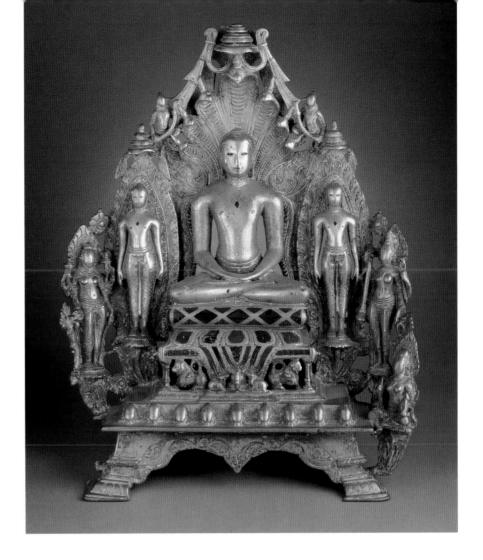

Jain Altarpiece

Gujarat, Broach; 988 Gilt copper inlaid with silver and gemstones; $14\frac{1}{2}$ in. (36.8 cm) Los Angeles County Museum of Art Gift of Mr. and Mrs. J. J. Klejman

One of the best-known and elaborate Jain altarpieces, this example is also historically important because of the dedicatory inscription on the back (see appendix), which informs us that it was dedicated in 988 in the shrine known as Mulavasati in Bhrigukachchha (modern Broach, or Bharuch, in Gujarat) by Parsvillagani, a disciple of Silabhadragani, an eminent teacher. Not only is it a fine example of complex casting, but it is handsomely enriched with smooth gilding, silver inlay, gemstones, and exquisite detailing.

As the central group consists of three Jinas, one seated and two standing, this is a tritirthika image. The clothing on the figures indicates that the donor was a Svetambara.

The central figure, sheltered by a seven-hooded serpent canopy and adored by two garland-bearing celestials, is Parsvanatha. The other two are perhaps Mahavira and Neminatha. Below Parsvanatha's seat is the wheel flanked by a pair of deer, the motif adopted by the Jains to indicate an enlightened teacher. The four-armed goddesses standing on either side are Chakresvari on Parsva's right and Vairoti on his left, two of the sixteen vidyadevi (goddesses of knowledge). The seated goddess with a child in her lap is Ambika. The missing figure at the other end would have been Sarvanubhuti. The nine heads along the ledge below the lion throne represent the nine planetary deities. 20

Rajasthan; 11th century Sandstone; $32^{3/4}$ in. (83.2 cm) Lent by the Jina Collection (Courtesy of the Arthur M. Sackler Gallery, Smithsonian Institution)

Filled with figures, this elaborate stele once served as an ancillary image in a subsidiary shrine on the outer wall of a Digambara Jain temple. The principal figure, standing in the body-abandonment posture, is Neminatha, who can be recognized from the conch shell and the wheel beside the lotus base. Apart from the fact that his name is derived from the wheel (nemi means "wheel-rim"), this object further emphasizes the Jina's connection with Vasudeva Krishna. Immediately behind his legs stand two attendants holding the stems of the lotuses supporting his hands. The two seated figures within shrines (which probably reflect the type of shrine housing the stele) are a yaksha couple: the male is Sarvanubhuti and the female is Kushmandini, known as Ambika in the Svetambara tradition [60-63]. In the middle of the stele stand two handsome, princely chauri bearers. Above the Jina's head rises the three-tiered umbrella, from whose pole spring branches with large, fanshaped leaves. They look nothing like the vetasa (reed or bamboo) that is usually associated with Neminatha. On either side of the parasols are groups of seated celestial adorants, some of whom, in the uppermost register, arrive on elephants.

As is usually the case in such steles, the active attendant figures emphasize the flux of the phenomenal world, and the motionless Jina symbolizes the unchanging state of enlightenment or nirvana. Visually, as well, the contrast results in a lively but calm composition. 20

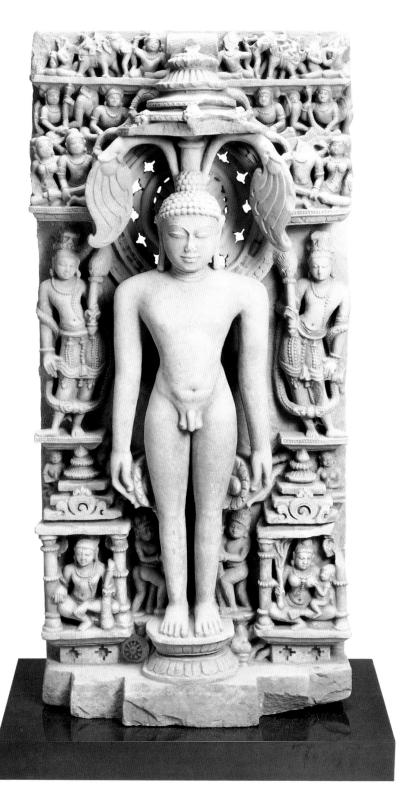

See color illustration on page 31.

Jina Ajitanatha and His Divine Assembly

Gujarat; 1062 White marble with traces of pigment 59 in. (149.9 cm) Norton Simon Collection, Los Angeles

The second Jina, Ajitanatha, is portrayed here as a monumental iconic figure that visually conveys his overwhelming spiritual presence and superiority. His name means "invincible," and his emblem is the elephant, both of which evince his great power. He is said to be invulnerable to sin and to heretics. Jain traditions record at least two birth legends for Ajitanatha. One claims that he was born to King Jitasatru and Queen Vijaya in the ancient city of Ayodhya. In the second version he was born to King Dridharaja and Sushena in Sravasti, the capital of the important kingdom of Kosala and the site of one of the Buddha's great miracles (Shah 1987A, 128; D. C. Bhattacharyya 1978, 38).

The clothed Jina stands in the body-abandonment posture. He wears an elaborately knotted, clinging dhoti, and his chest is graced with the srivatsa jewel. Ajitanatha is surrounded by a

pierced framework containing various reverential subdivinities and attendants, including, along the sides, eight female figures who may represent dikkumari (the eight maidens of the directions). These directional guardians vary in name and number in different Jain iconographic and cosmological texts and are analogous to Hindu and Buddhist deities serving similar functions (Goswami, 293-94). Celestials with floral offerings hover above the Jina, while at his feet he is flanked by a donor couple and attendants bearing honorific flywhisks. Ajitanatha's cognizance, the elephant, is shown in the center of the base.

The inscription on the base is severely effaced but states in part that the image was installed in 1062 at Pampasara by the celebrated Jain monk Jinesvarasuri (see appendix). A brilliant philosopher and writer, Jinesvara founded the Svetambara Kharatara chapter in 1024, after triumphing in a prestigious theological debate over the Chaityavasin monks in the Gujarati court of the Anahilvada king, Durlabha (r. 1008-24) (Chatterjee 1984, 2). 2>

S.M.

33

Altarpiece with Parsvanatha

Gujarat; 10th-15th centuries Copper alloy and crystal 12 in. (30.5 cm) Subhash Kapoor

The unusual feature of this altarpiece is the image of Parsvanatha, which is made of crystal. Very likely it is not the original figure but a later replacement. Although it would not have been unusual for the original altarpiece to have had a crystal Jina, the present one does not conform stylistically to the metal figures. The altarpiece itself is certainly of the tenth or eleventh century, but the crystal Jina is unlikely to be

earlier than the fifteenth century. However, that the original Jina was also Parsvanatha can be determined from the yaksha seated below him to his right. The rotund figure certainly holds a snake with his left hand, which is an attribute of Dharanendra. Probably Padmavati, on the left, also once held a serpent. These figures can either have snakes forming canopies or held as an attribute. The other figures are the usual chauri bearers, celestials with offerings, and a pair of elephants lustrating the Jina. The wheel between the lions further indicates that the scene is one of samavasarana.

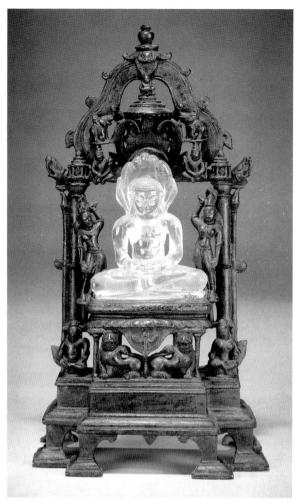

Compared to most altarpieces of this period, this particular example offers a rather simple composition with fewer figures. The architectural elements, such as the slender columns and the elegant trefoil arch, add to the buoyancy of the bronze. The sculptor was not afraid to leave empty spaces at the back that provide the figures with sharper silhouettes.

P.P.

сат. 33

34

Altarpiece with Santinatha

Western India; 1168—15th century Copper alloy with silver inlay 46 in. (116.8 cm) The Board of Trustees of the Victoria and Albert Museum, London

Santinatha, the sixteenth Jina, is especially revered in the Jain pantheon. He is said to have revived Jainism at a time when it was in danger of extinction and thus assured the faith's survival. Over time he came to be invoked to avert calamaties and ensure calm in the world, as his name suggests (santi means "peace"; natha, "lord"). The popularity of Santinatha resulted in a great many images being produced, including large-scale bronzes of superb quality as seen

here. The distinguishing attribute of Santinatha is the deer, which is usually placed on the throne-base of the image. This cognizance is independent of the deer flanking a dharmachakra, which came to be associated with all Jinas. In the present sculpture the lion throne, upon which the deer would have been represented, is missing. However, an inscription on the base of the image (see appendix) confirms the identity of the Jina and the date of its dedication: "In the year 1224, on Monday, 5th tithi of the bright half of the month Vaisakha (April-May). [This is] the means to the triumph of Sri Santinatha in the honourable Naila gaccha" (trans. A. L. Basham). Gaccha (or gachchha, literally "tree") means a branch or chapter of Jain monks; the date corresponds to 29 April 1168.

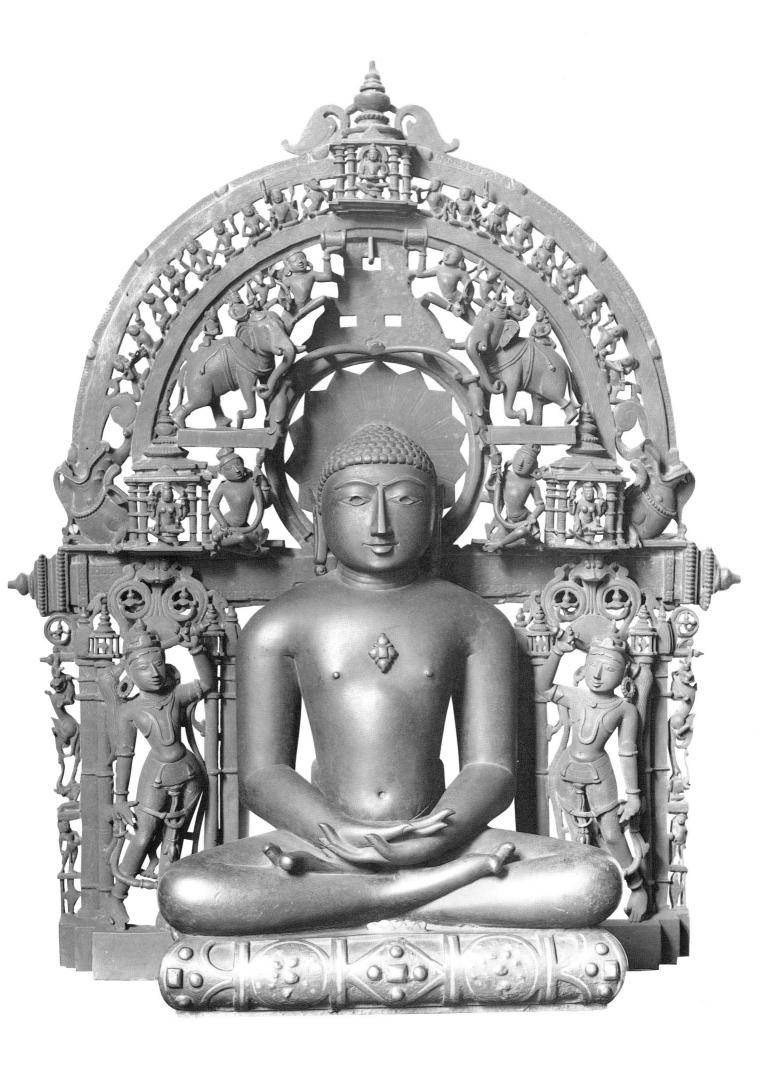

The naked Jina is seated in the padmasana meditation posture on a jeweled cushion richly decorated with silver and copper inlay. The figure is beautifully modeled, with finely articulated hands and feet. The symmetrical curls of hair frame a face of serene calm. The prominent srivatsa mark on his chest is inlaid silver and copper. The eyes are silver and were probably once set with precious stones or crystal, now missing. The backplate is cast in three sections and provides the prabhavali (radiating halo) as well as support for the flywhisk bearers and celestial beings paying homage to the Jina.

This image of Santinatha is one of the finest twelfth-century western Indian Jain monumental bronze castings recorded. The modeling and casting of the backplate, however, gives the appearance of not being contemporary. In all probability it was cast as a replacement, perhaps as late as the fifteenth century. 2

J.G.

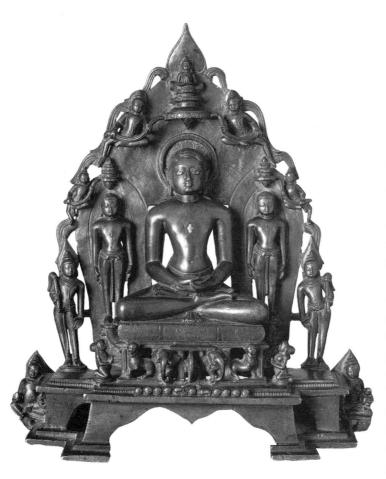

35

Altarpiece with Three Jinas (Tritirtha)

Western India; c. 1000 Copper alloy with silver inlay 9% in. (25.1 cm) The Board of Trustees of the Victoria and Albert Museum, London The identity of the central Jina is not immediately apparent, the image having no distinguishing symbol on the throne base. The dharmachakra can be seen at the base of the throne molding, flanked by elephants and lions. The enthroned central figure is seated in padmasana, or lotus posture, and has inset silver eyes. The srivatsa emblem on his chest marks him as one "beloved of fortune." He is flanked by two further Jinas standing in kayotsarga, or body-abandonment posture, making this a tritirtha image. They in turn are flanked by flywhisk-bearing yakshas. There are kneeling devotees below the throne, and projecting from the base are the yaksha Gomedha and the yakshi Ambika, the attendant deities associated with Neminatha. The backplate is embellished with flying garland bearers.

Portable images of this scale were usually commissioned by members of the Jain laity and presented to their temples. The garments indicate that the patrons (and recipient temple) were devoted to the Svetambara sect. Many such images can be seen today adorning the inner sanctuaries of Jain temples or stored in temple strong rooms. Many bear dedicatory inscriptions, often dated, though this altarpiece does not. 20

J.G.

Jina with Parikara Arch

Gujarat; 13th - 14th centuries White marble; figure: 26 in. (66 cm) Arch: 18 $\frac{1}{2}$ in. (47 cm) Private collection

The Jina sits in meditative posture on an unadorned cushion but cannot be identified, as there is no specific cognizance. Behind his head is an elaborate arch with a retinue of attendant figures (parikara). While it is not conclusively known if this arch and figure were designed for one another, the juxtaposition of the two is a traditional conceptual arrangement that is well

documented by extant examples and numerous textual descriptions (Shah and Dhaky, 53–58). When complete the assemblage would be conceptually related to the north-Indian example in the exhibition [23], in which the arch is fashioned from the same piece of stone. Like that sculpture, this too represents the *samavasarana* of a Jina, probably Mahavira.

The arch is organized along its central vertical axis, which is composed of a tiered honorific parasol surmounted by a small figure holding his hands in the gesture of devotion while receiving lustration by flanking figures carrying urns of water in their inner hands and garlands in their outer ones. Behind these figures are elephants with riders; the elephants support pots containing water for the Jina's lustration. Beneath the elephants are garland bearers and musicians set in architectural niches bordered by mythical aquatic animals (makara). 2

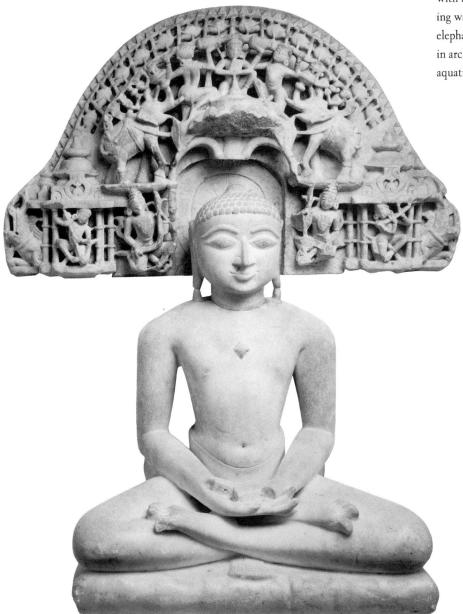

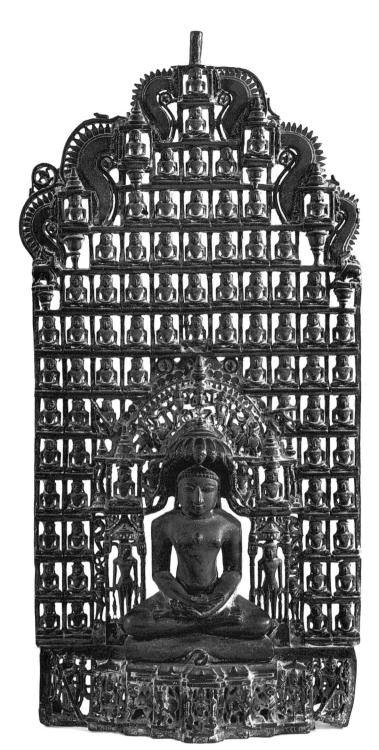

An Altarpiece with Multiple Jinas

Gujarat or Rajasthan 15th—16th centuries Copper alloy; 30¾ in. (78.1 cm) The Norton Simon Foundation, Pasadena, California

An impressive example of a later Jain bronze, this altarpiece is a technical tour de force of complex casting. The basic arrangement of the figures is severely geometric, but the artist has modified the rigidity of the composition by adding curved forms above and below the central Jina and stylized meandering dragon shapes at the top. Virtually all the figures provide clear silhouettes because of the voids around them.

The central figure is that of Parsvanatha, because of the snake cognizance against the cushion and seven-hooded snake canopy above his head. The scene represents samavasarana; hence one may assume that all the Jinas have gathered to hear Parsva preach in the assembly hall.

There are seventy-seven Jinas in this altarpiece in addition to Parsva. Apart from the two standing Jinas flanking the central figure, all are seated. The seated Jinas uniformly display the meditation gesture with the exception of the central figure directly over the pot finial of the arch above Parsva, who clearly displays the gesture of fearlessness.

While the exact significance of the total of seventy-eight Jinas is unknown, it is not uncommon to find representations of larger groups than the customary twenty-four. For instance, in depictions of the cosmic island of Nandisvara-Dvipa [11–12] one encounters a group of fifty-two Jinas. There is a published plaque with one hundred and five Jinas (Shah 1987A, pl. xcv, fig. 183), and there are representations of a thousand Jinas (Shah 1955, 24). Most of these, however, are of the late period. The idea behind such shrines is no different than that of the Buddhists dedicating a thousand Buddhas or the Saivas consecrating a thousand lingas: the larger the number of images the greater the merit. 20

Eastern India

38

A Jina

Bihar; 5th century Copper alloy; 13¹⁵/16 in. (35.4 cm) Nitta Group

This serenely elegant and poised Jina stands in the classic kayotsarga posture. Despite the immobile stance, the figure seems alive, as if he is posing for a photograph. While there is a general stylistic affinity with bronzes discovered at Chausa in Bihar, the proportions of this figure, with its broad, sloping shoulders, long torso, and even longer limbs, are somewhat unusual. It should be remembered that the Chausa bronzes do exhibit great variety in their forms and proportions.

Apart from expressing lifelike qualities, the figure has a youthful look and possesses a rather cherubic face. The pierced earlobes seem almost like rings, thereby downplaying their role as a supernatural sign. The srivatsa mark on the chest is quite faint. In fact, there is very little in this figure that makes him divine; he could easily represent an athletic youth reminiscent of archaic classical figures. 20

Jina Rishabhanatha

Bihar; 7th century Gilt copper; 13 in. (33 cm) R. H. Ellsworth, Ltd.

Seated in meditation atop a lotus placed on a throne is Rishabhanatha, the first of the twenty-four Jinas. He is distinguished from the others by the long hair curling elegantly over his shoulders. The animal on the throne in front is rather effaced but is probably a bull, which is the animal cognizance of Rishabha. Except for these iconographic designations the representation is typical, with its two flywhisk-bearing yakshas, the flaming prabhamandala (nimbus) behind the head, and the three-tiered parasol with banners.

Rishabhanatha's distinctive hairstyle first appears in the Kushan art of Mathura. The Svetambara sources explain this hairstyle in the following manner. After having ruled for a long time, King Rishabha decided to renounce the world, and one of his first ascetic tasks was to uproot his hair. The god Indra was present and began gathering up the plucked hair. After Rishabha had removed five handfuls, Indra saw how beautifully the remaining hair graced his shoulders and requested him to desist. Rishabha agreed. The Digambaras offer a different explanation. They say that originally Rishabha removed all of his hair, but as he sat meditating a jata (mat of hair) grew on his head.

This particular Jain bronze is one of the most impressive to have survived from Bihar. Probably belonging to the late seventh century, it is engaging for its balanced composition, articulation of details, and strong spiritual presence. 2

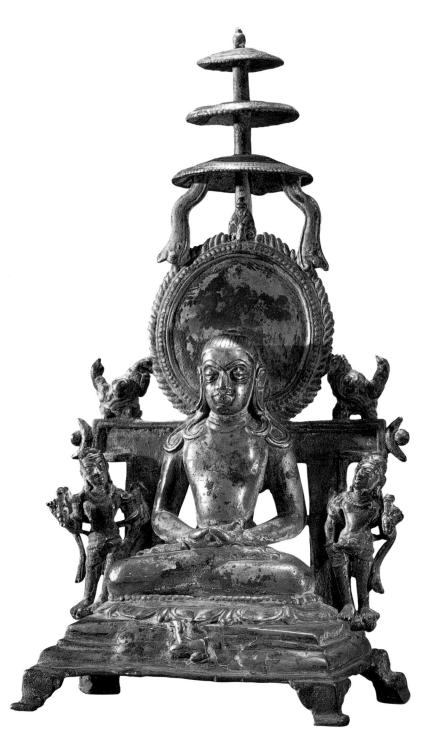

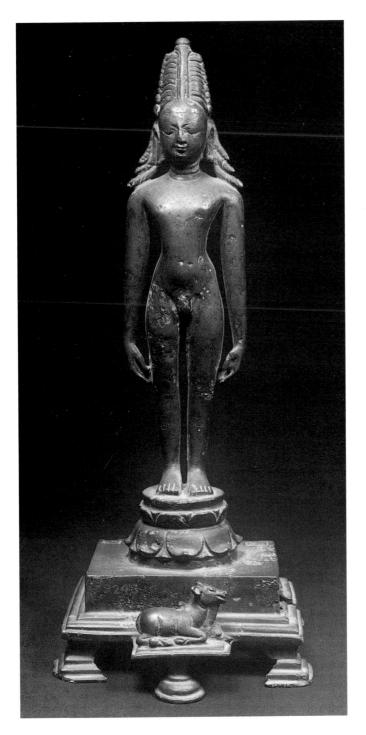

Jina Rishabhanatha

Orissa, Manbhum; 11th century Copper alloy; 12½ in. (31.8 cm) Indian Museum, Calcutta

The sculpture represents the first Jina, Rishabhanatha, who is identifiable by his cognizance, the bull, resting on the pedestal in front. The figure's nudity clearly indicates a Digambara association. The Jina stands in the kayotsarga posture with his fingertips reaching his knees.

The most notable aspect of this figure is the hairstyle. Normally a Jina would have snail-shell hair with a protuberance of the skull (ushnisha). The coiffure in this case, even though resembling the jatamukuta (crown of matted hair) usually seen in Saivite images, is nonetheless distinctive. This feature is not only restricted to the Manbhum region but is exclusive to Rishabhanatha's images.

The canonical requirements of Jain iconography ensure a certain rigidity in such Jina images. It is then up to the individual craftsman to imbue his figures with a sense of movement. In this image, the artist has succeeded in so doing, but at the same time the expression on the face conveys the inner calm induced by meditation. 20

S.G.

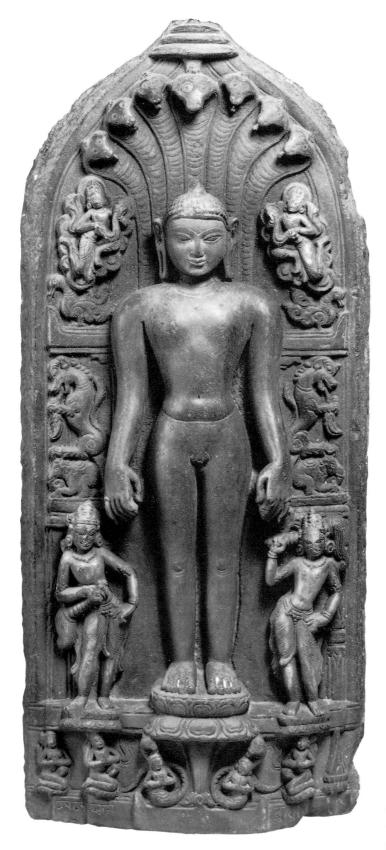

Jina Parsvanatha with Attendants

Bangladesh; 11th century Gray-black stone; 23¹/₄ in. (59.1 cm) Asian Art Museum of San Francisco The Avery Brundage Collection

The principal figure on this richly carved stele is Parsvanatha. He stands in the kayotsarga posture on a lotus that rises from the waters symbolized by an adoring naga (serpent) couple on either side of the stem. A beautifully rendered sevenhooded serpent forms an elegant canopy above his head. Two celestials with garland offerings fly gracefully about the Jina's head. Above the serpent canopy is the triple umbrella. On either side of the base, two yakshas holding flywhisks stand gracefully, each on a small lotus. Below, flanking the central naga couple, are two saluting figures who are very likely the yaksha Dharanendra and the yakshi Padmavati. On the extreme left is the conventional figure of a donor, who appears to be a female. The inscription below may include her name, but it is not legible.

Carved in gray-black stone, the stele is characteristic of images that were popular in both Bihar and Bengal during the Pala period (c. 750—1150). Compositionally it is very similar to popular contemporaneous steles representing the Hindu god Vishnu. The central figure's inertness is made even more emphatic by the movement expressed by all the other figures. Especially noteworthy are the articulate delineation of the throne back, with its motif of the rampant lion and crouching elephant (gajasimha), and the ganders above it. 20

Orissa; 11th-12th centuries Schist; 37³/₄ in. (96 cm) Courtesy of the Trustees of the British Museum

The conventions of Jain image-making do not preclude multiple groupings, since all of the twenty-four Jinas are theoretically seen as equal in the Jain pantheon. In practice some have assumed a special status and thus attracted the greater attention of image makers and patrons. A particularly popular pairing is of the first Jina, Rishabhanatha, and the most recent, Mahavira. Here both saints are standing naked in the kayotsarga austerity posture, with their arms hanging free from their bodies. Rishabhanatha is readily identified: he is the only Jina with uncut hair, which in this superb stele is depicted as a jatamukuta (crown of hair) with locks extending across his broad shoulders. Mahavira's hair is characteristically in short curls, and he has a skull protruberance.

Both figures have multiple-umbrella canopies and celestial garland bearers hovering around their nimbuses; flywhisk bearers are also in attendance. Each Jina stands on a lotus support and beneath each is an identifying attribute: for Rishabhanatha the bull, and for Mahavira the lion. The Hindu deity Indra was absorbed early into the Jain pantheon and is shown riding his elephant Airavata [107]; kneeling figures of the donors are to be seen at the lower left.

This sculpture once formed part of the collection of General Charles Stuart, known as "Hindoo" Stuart for his devotion to Indian art and society. Stuart served in India from 1777 to 1828; his collection came chiefly from Bihar and Orissa. This piece was acquired by the Bridge family in 1830 and passed to the British Museum in 1872. 2

J.G.

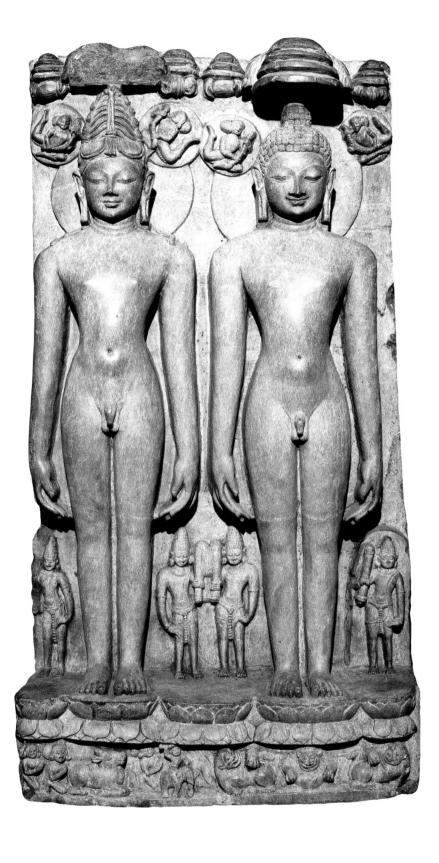

Southern India

43

Jina Parsvanatha

Originally the serpent canopy must have consisted of seven hoods, which would suggest identification of the figure as Parsvanatha. Naked, he stands in the body-abandonment posture on a lotus placed on a high, molded pedestal of a type seen commonly in Pallava-Chola bronzes of Tamilnadu. Although the Tamil inscription on the base is indistinct, the paleographical features indicate a date around 800. The coils of the snake have been rendered discreetly but the rearing heads once formed an impressive parasol. An unusual feature of this Parsvanatha is the faintly etched *srivatsa* mark in the shape of a cup with a flame on his right pectoral area. Usually this mark is absent in south-Indian Jinas.

Apart from this iconographic peculiarity, which may also indicate an early date, the figure offers some unusual formal features. The torso and the limbs are highly elongated, making it unusually slim and tall. Except in the region of the waist, almost no attempt has been made to articulate the transitions of the body. The face is round, and the hair sits on the head like a cap. The long arms and hands reflect Marifanoid features that are commonly encountered in early bronzes. In some ways the figure is reminiscent of the second-century bronze Parsvanatha in the Prince of Wales Museum (Sivaramamurti 1983, fig. 319), but closer parallels are offered by several bronzes assigned to the eighth and ninth centuries (ibid., 315, 318; also Sundaram 1955-56, pl. xx, 3, right figure). There can be little doubt that this figure is earlier than the ninth-century sculpture included in the exhibition [46]. 2

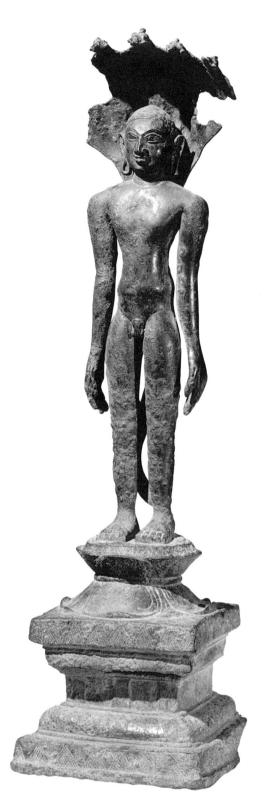

Bahubali

- A. Karnataka; 7th century [?] Copper alloy; 43/8 in. (11.1 cm) Lent by the Metropolitan Museum of Art, Samuel Eilenberg Collection, Gift of Samuel Eilenberg, 1987
- в. Rajasthan; 16th century Black schist; 36 1/4 in. (92 cm) Courtesy of the Trustees of the British Museum

To the Digambara Jains, particularly of south India, Bahubali is as important a figure as the major Jinas. He is the focus of devotion at Sravana Belgola in Karnataka, one of the holiest of Jain shrines. Known also as Gommatesvara, the colossal (c. 18 meters) and monolithic statue of Bahubali is unquestionably one of the sculptural wonders of India (fig. 5). Although not monumental, the two examples included here are no less interesting.

According to the Jain tradition, Bahubali and Bharata were the two most eminent sons of Rishabhanatha, or Adinatha, who was originally a king. Upon renouncing his kingdom, he divided it between his two sons. Soon thereafter the ambitious Bharata embarked on a trip to conquer other kingdoms and, upon his return, expected Bahubali's submission as well. Bahubali refused, and a war ensued. Troubled by the consequent carnage, the elders persuaded the two brothers to fight a duel instead. During the duel, as Bahubali was about to crush Bharata, he was filled with remorse and decided to follow in his father's footsteps. He retired to the forest, pulled out all his hair, and, standing in the body-abandonment posture, began to meditate. So absorbed was he that years went by. An anthill grew around his feet, vines and snakes began to embrace his body, and birds built a nest in his overgrown hair. However, even such severe austerities did not help him in realizing kevalajnana (complete knowledge), which he did only after forgiving his brother.

The tiny bronze is the earlier of the two sculptures. It has been suggested that this may be the earliest representation of Bahubali in India (Lerner and Kossak 1991, 100, no. 68). Be that as it may, what is intriguing is that the saint has been portrayed as a child, like the infant Buddha or Krishna. Bahubali was certainly an adult when he renounced his kingdom, and so his depiction as a boy so early in the history of the form seems puzzling. Later on, however, when the cult of the baby Krishna gained currency in the south, it would have been less unusual. Whatever the reason, this miniature figure remains a charming and novel representation of the saint.

CAT. 44A > CAT. 44B, overleaf

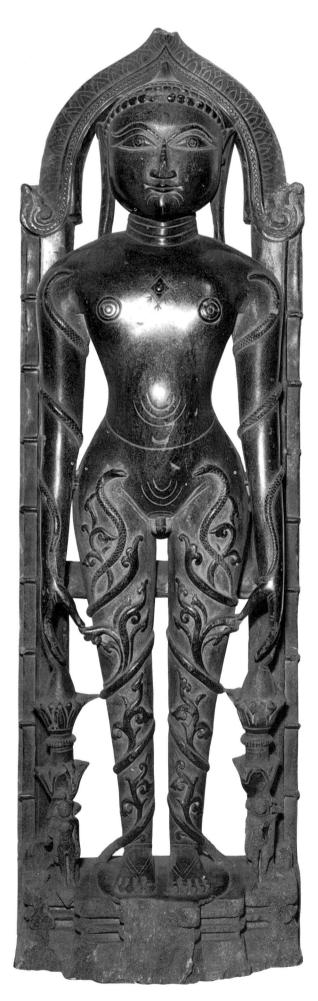

No less rare is the larger stone sculpture, since depictions of Bahubali in northern India are less common than in the south. His motionless stance is given much greater emphasis in this figure. In addition to the creepers entwining his legs, the sculptor has added serpents on his thighs and arms. Two small naked Jinas are carved against two short lotus columns on either side. Who they are remains unknown. For its period it is a very handsome sculpture. Apart from its polished surfaces, the vegetal forms, the serpents, and the anatomical details are rendered with stylized elegance. 2

Р.Р.

CAT. 44B

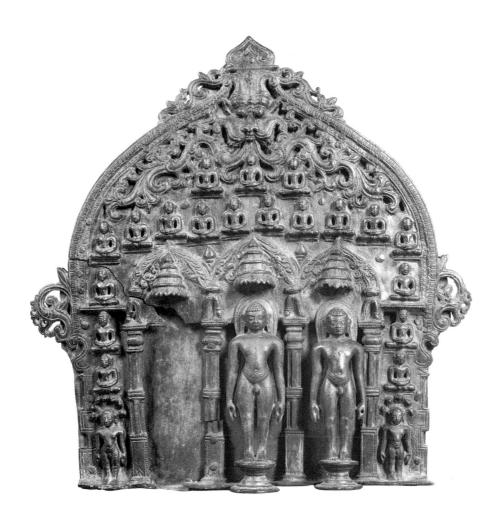

Altarpiece with Twenty-four Jinas

Karnataka [?]; 10th century Copper alloy; 13 in. (33 cm) Dr. and Mrs. Siddharth Bhansali, New Orleans (Shown at the New Orleans Museum of Art only)

This type of shrine, with all twenty-four Jinas represented together, is known as a chauvisi or chaturvimsatika patta, which literally means "twenty-four-figure plaque." Usually in such images one Jina, generally Rishabhanatha, is the dominant figure, and the other twenty-three are arrayed around him. Here, however, three of the twenty-four are given prominence. Unfortunately, one of the three standing Jinas is missing. Even if it were present, it would have been difficult to identify, since no cognizances are included. None of the twenty-three figures has long hair, hence even Rishabhanatha is not dis-

tinguishable. The only two recognizable figures are the two smaller standing Jinas at the bottom left and right. The one with the seven-hooded serpent is Parsvanatha; the other is Suparsvanatha because of his five-hooded snake canopy.

The composition is enlivened by the swirling floriate forms emerging from the mouth of the expressive kirtimukha (face of glory) that dominates the apex of the main arch. This auspicious symbol as well as such luxuriant vegetal motifs are frequently found in steles and altarpieces made in Karnataka. The pillared niches are also characteristic of Karnataka sculptures [68, 71]. (For an elaborate stone chauvisi in the western Chalukya style, with standing images of Parsvanatha and Suparsvanatha flanking the central Jina, see Sivaramamurti 1983, fig. 205.) **

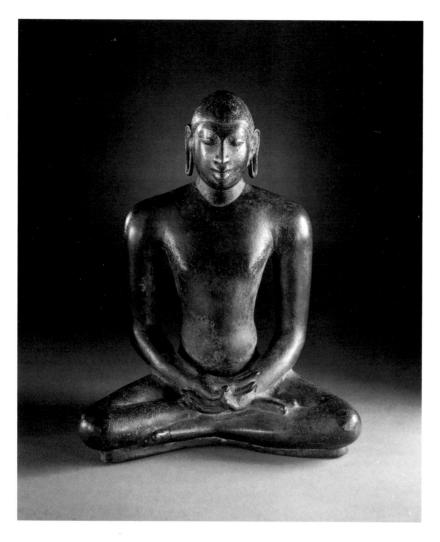

A Digambara Jina

Karnataka or Tamilnadu; 850–900 Copper alloy; 8 1/8 in. (22.5 cm) Los Angeles County Museum of Art From the Nasli and Alice Heeramaneck Collection Museum Associates Purchase The Bhagavadgita, the classic Hindu religious text, describes a perfect yogi, or yogin, as follows:

Let the yogin yoke himself at all times, while remaining in retreat, solitary, in control of his thoughts, without expectations and without encumbrances. . . . As he sits on his seat, let him pinpoint his mind, so that the working of mind and senses are under control, and yoke himself to yoga for the cleansing of his self. Holding body, head and neck straight and immobile, let him steadily gaze at the tip of his nose, without looking anywhere else. Serene, fearless, faithful to his vow of chastity, and restraining his thinking, let him sit yoked (van Buitenen 1981, 95).

Few sculptures in the entire range of Indian art have realized the ideal yogi as perfectly as this bronze figure. Although the proportions are idealized, the meditating figure is convincingly lifelike. Even as the body is immobile, it exudes a spiritual vitality that is almost palpable. The human body here is represented as pure form combining the spiritual and the sensual with remarkable aplomb.

The Jina is also remarkable in that the genitalia are represented on the underside of the sculpture. This unusual feature confirms the image's Digambara affiliation.

The exact provenance of this Digambara Jain bronze is difficult to determine. It could be from either Karnataka or Tamilnadu, though it is easier to find stylistic parallels in Tamilnadu (Pal 1988, 244). Wherever it was cast, this majestically dignified figure of a Jina, perhaps Mahavira, remains one of the finest Jain bronzes known.

Two Jinas

Tamilnadu; 10th century

- A. Stone; 62 in. (157.5 cm) Private collection
- в. Copper alloy; 13½ in. (34.3 cm) Lent by the Jina Collection (Courtesy of the Arthur M. Sackler Gallery, Smithsonian Institution)

Neither of the two Jinas can be precisely identified, but both were used in Digambara worship. Very likely both figures represent Mahavira. The arms of the stone figure are broken but originally they would have hung loosely at the sides as in the bronze. The stone figure probably adorned a niche or subsidiary shrine in a temple, which is why the back is not as well finished as the front. The bronze, however, is modeled in the round.

As is usual in Chola-period bronze images from Tamilnadu, the bronze Jina stands on a lotus atop a rectangular plinth, which would have been sunk into a base. Originally the figure would have been framed by an aureole. Although the two figures are stylistically similar, there are subtle differences in the proportions and modeling. The stone figure has a particularly elongated torso and rather square shoulders, while the muscles have received greater articulation in the bronze. The hands of the bronze figure are sensitively rendered. The bronze exhibits a more relaxed, naturalistic form, whereas the stone figure has been stylized into an austerely linear pattern. 20

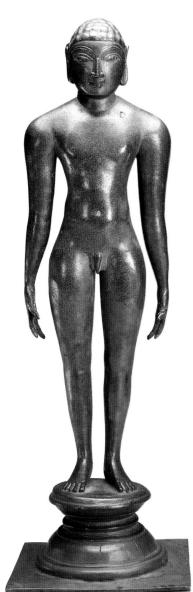

A CAT. 47B CAT. 47A ➤

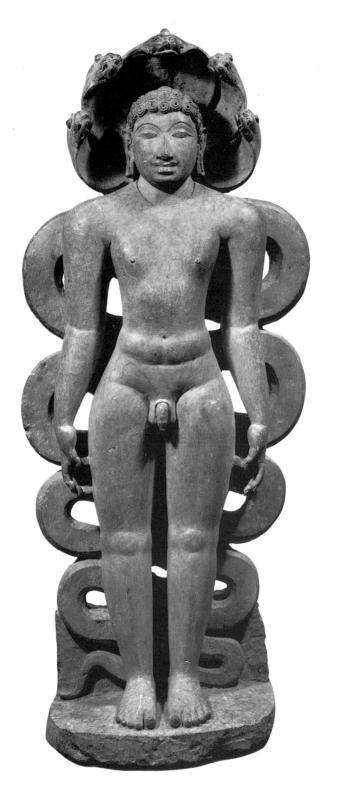

Jina Suparsvanatha [?]

Karnataka; 9th century Schist; 32¹/₄ in. (81.9 cm) The Norton Simon Foundation, Pasadena, California There is some uncertainty about the exact identity of this figure. He has been generally identified as Parsvanatha (Dehejia 1988, 58-59), but he may in fact represent Suparsvanatha, the seventh Jina. Usually Suparsvanatha is portrayed with a five-hooded serpent canopy, while Parsvanatha's serpent has seven heads (Shah 1987A, 140). However, in the south it is not uncommon for Parsvanatha to have a five-hooded canopy. Without additional iconographical attributes, it is impossible to be certain. If the yaksha pair in the Simon collection [69] is associated with this image, then it might indeed represent Suparsvanatha, for Parsvanatha's principal yaksha usually is provided with a serpent canopy as well [68, 71A].

Suparsvanatha was born as the son of King Supratishta and Queen Prithivi of Varanasi. While he was in his mother's womb, her parsva (sides) looked su (beautiful), and hence he was named Suparsvanatha, or the "lord of the beautiful sides." It is also related that his mother dreamt she was lying on coils of snakes with alternatively one, five, or nine hoods. Suparsvanatha is shown with a five-hooded serpent; the number may have been selected to differentiate him from Parsvanatha. However, there is no direct connection between Suparsvanatha and snakes as there is with Parsvanatha.

Whatever the exact identification, the figure is a fine example of the Chalukya sculpture of Karnataka. The Jina's body and limbs are more naturalistically modeled than is usually the case with such figures. The joints at elbow, knee, and wrist, the hair curls, and the serpent heads are articulately rendered. The hands and the toes show the same sensitivity to details as in the yaksha couple [69]. Most striking, however, is the rendering of the rising coils of the serpent. These provide a lively, curvaceous foil for the motionless, columnar Jina. Like the yaksha couple, both the Jina and the serpent are almost fully modeled in the round.

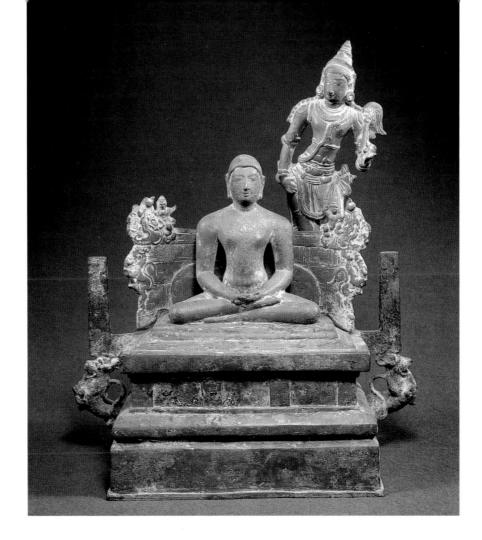

An Altarpiece with a Jina

Tamilnadu, Sivaganga c. 10-11th centuries Copper alloy; 20½ in. (51 cm) Government Museum, Madras

On an elaborately molded pedestal the Jina sits in meditation with his palms resting on his crossed legs (dhyanamudra). Quite like the earlier images from the Gupta period [18-19], this figure has an athletic and heavy body in contrast to his sublime features expressing serenity. A noticeable element is the thinly cropped hair. Elsewhere in India the hair is rendered in snailshell curls. In north, east, and central India a Jina, like the Buddha, has an ushnisha-like protuberance on the head, which in the south (Karnataka and Tamilnadu) is conspicuously absent. In Tamilnadu both Vaishnavite and Saivite saints have closely cropped hair, such as we see in this image. Another southern trait is the absence of the srivatsa mark on the chest.

An interesting feature that this altarpiece shares with Jain images in Karnataka is the elaborate composition, with sumptuous thrones and yakshas wielding flywhisks. The backrest comprises a bolster placed against a crossbar supported by two heraldic leogryphs. The terminals of the uppermost bar are shaped as a makara ridden by dwarfish figures.

Above the crossbar appears a flywhisk-bearing yaksha. Originally there were two such figures [51]. Their presence on the parikara backdrop of the image is a characteristic of the Karnataka school. The entire configuration is in the Karnataka tradition; it is likely that a patron obtained it there and took it to Tamilnadu. 20

S.G.

Karnataka; 10th-11th centuries Copper alloy; $8^{11}/_{16}$ in. (22 cm)

Stan Czuma, Cleveland

This unusual bronze depicts Neminatha, the twenty-second Jina, in a special form familiar in southern Karnataka (Shah 1987A, 168—69). It portrays the Jina standing in kayotsarga atop his symbol, the conch shell. Generally a symbol is attached to the base of an image, but in this instance it is used as the base itself. Textual and epigraphical evidence as cited by Shah demonstrates that such images were housed in shrines known as sankhajinalaya or sankhabasti. The former means "the abode of the conch-shell Jina" and the latter, "conch-shell habitation."

Like Parsvanatha, Neminatha is considered to be a historical figure. Known also as Arishtanemi, he is said to have been a cousin of Krishna and Balarama [53], whose lives form the subject matter of the Harivamsa. There is no historical evidence of their existence. Nemi was so named because he was compared to the rim, or felly (nemi), of the wheel of true law. He was called Arishtanemi, which literally means "the rim of an undamaged wheel," because his mother saw a wheel in a dream while carrying him. He is said to have obtained nirvana on Mount Girnar, one of the most sacred pilgrimages of the Jains in Gujarat. 20

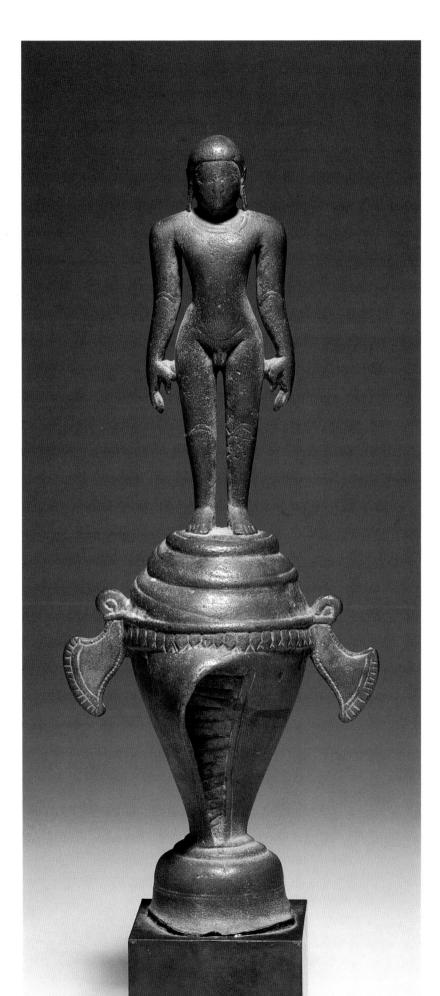

Karnataka; 11th—early 12th centuries Schist; 38¾6 in. (97 cm) Courtesy of the Trustees of the British Museum

The seated figure of Parsvanatha is represented in deep meditation, undisturbed by the storms which have been unleashed against his quietude. He is sheltered by the seven-hooded serpent king, Dharanendra, who is also represented in anthropomorphic form seated adjacent to the Jina, with his yakshi, Padmavati, on the opposite side. Their respective vehicles, elephant and rooster, are beneath them. Parsvanatha is honored with the triple-tiered umbrella rising above his head. At the apex of the stele is a kirtimukha mask, a pervasive motif in the art of southern India. From the mouth of this monster issues a wondrous flowering vine that binds the composition together.

In this image far less emphasis is given to the protective role of the serpent than is seen in other treatments of the subject [21-22, 52]; indeed, that role appears to have passed to the flywhisk bearers, who have been elevated to the status of guardians, rather than to the protective yaksha couple. Noteworthy also is the fact that in addition to the flywhisks the two hold lemons. This sculpture, which echoes Buddhist compositions of southern India, illustrates the way in which iconic conventions were transposed between faiths.

This sculpture was produced during a period of both royal and merchant patronage in the southern Deccan. Related pieces at such sites as Kambadahall, near Sravana Belgola, suggest an eleventh- or early twelfth-century date.

J.G.

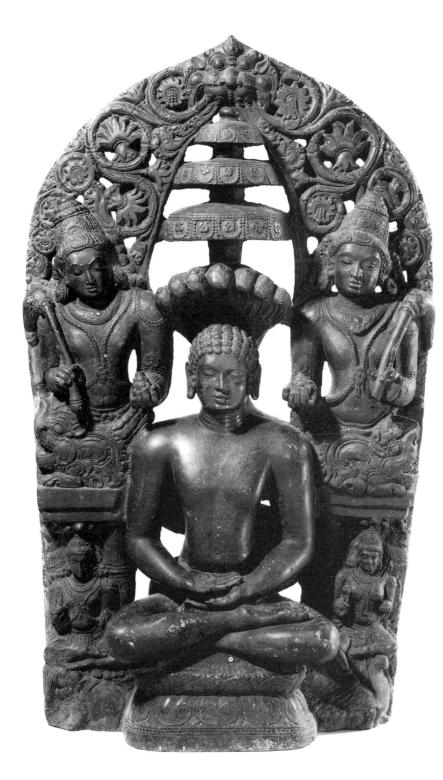

Jina Parsvanatha

- A. Andhra Pradesh, Gulbarga
 12th century
 Black shale; 59½ in. (151.1 cm)
 The Board of Trustees of the
 Victoria and Albert Museum,
 London
 (Shown at the Victoria and Albert
 Museum, London, only)
- B. Deccan; 12th century

 Stone; 57 in. (144.8 cm)

 The Board of Trustees of the

 Victoria and Albert Museum,

 London

Both images of Parsavanatha are seen standing in the *kayotsarga* posture. Long periods of immobility, with the arms hanging freely from the body, represent one form of severe penance undertaken on the path to liberation. The proportions of both figures follow iconic convention: the shoulders are broad and the chest is slightly expanded, representing an inner breath. The waist is slim and athletic, with muscular details represented on the abdomen. Parsvanatha is here represented as a naked, Digambara image.

Of all the Jinas, Parsavantha is the most readily identifiable. According to both sects of Jainism he was dark blue in complexion and had the snake as his distinguishing mark. In these sculptures the serpent king Dharana protects the Jina with the coils of his body and shelters him with his multi-headed hood. In A, Parsavantha is attended by the yaksha Dharanendra and the yakshi Padmavati, each of whom holds a noose and an elephant goad. A triple umbrella together with the relief depictions of flywhisks to the left and right of the deity's head establish his status as a spiritual conquerer. In в the attendant deities are not represented, nor the triple umbrella or flywhisks, but curiously he is provided with a nine-hooded serpent.

On the base of image A is an inscription in Kannada recording that it was commissioned for a Jain shrine at Gulbarga. It states that the image of Parsvanatha was made at the time of the temple's restoration under the direction of a venerated Jain teacher, and that this work followed a period of persecution at the hands of Mummudi Singa, possibly Singa II, who ruled the region at the beginning of the twelfth century. This image is probably from the latter part of the twelfth century when, the inscription tells us, Malli Setti commissioned the stone engraver Chakravarti Paloja.

The sculpture also bears a second inscription that throws light on another chapter of its history. On the reverse of the back-plate is an anglicized rendition of the deity's name, Parasa-naat, and the mark "C. McK 1806," which would suggest that this sculpture once formed part of the collection of Colonel Colin McKenzie, the British antiquarian whose survey of the Deccan was completed in that year. This sculpture and the second Parsvanatha image (which may well share the same provenance, though sadly no records survive) were both transferred from the India Museum of the former East India Company to the Victoria and Albert Museum in 1880. 2

J.G.

CAT. 52A >>

CAT. 52B >>>

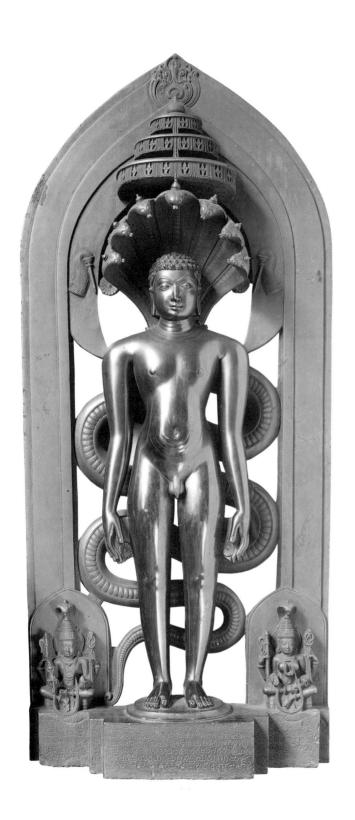

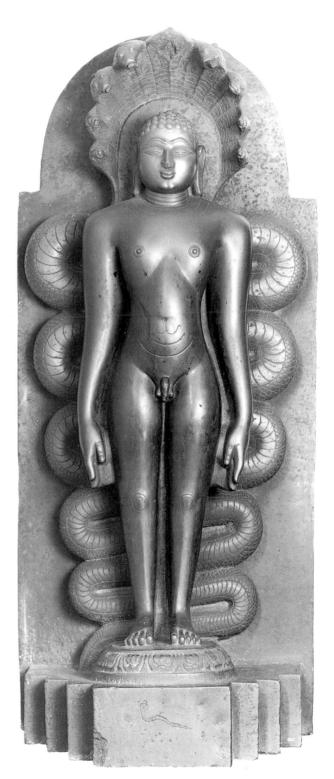

Images of Deities

The God Baladeva

Uttar Pradesh, Mathura; 100–300 Mottled red sandstone 31½ in. (81 cm) Private collection, Switzerland

This is one of the most interesting sculptures in the exhibition, not only as an example of Jain art but also for the history of Indian art. Carved on both sides, it depicts a splendid figure of a makara on one side and a regally attired seated figure on the other. However, the two carvings are not contemporaneous. Originally the makara image served as an endpiece of the crossbeam for a gateway. Stylistically comparable examples belonging to the end of the first century or the beginning of the second have been excavated at Sonkh (Hartel 1993). Sometime thereafter the gateway must have been destroyed and this endpiece reused to carve an image of a deity. This probably happened toward the end of the third century.

The partially legible inscription, according to Dr. Hartel (personal communication), identifies the deity as Baladeva. The donor's name cannot be read, but he was a Svetambara Jain. Apparently there is also a date, though it is not clear enough to read. It is possibly the earliest-known representation of a Jain Baladeva.

There is no doubt that this Baladeva is none other than the personality known more commonly as Balarama, the elder foster-brother of the Hindu deity Krishna. Both Krishna and Baladeva are regarded as cousins of Jina Neminatha. In the later Jain pantheon many protective deities were known by the name Baladeva.

A number of monumental images of the god have survived in Mathura, making it clear that he was the focus of an independent cult. In nearly all of these he is shown standing and is distinguished by the snake-hood, a club or a plowshare or both, and a wine cup. His seated images are rare. Here the club is seen behind his right arm, which is raised in the gesture of reassurance (abhayamudra) and a damaged plowshare is visible behind the left arm. The clenched fist of the left hand is placed on his thigh. The posture is known in Sanskrit as lalitasana (graceful posture). Two Svetambara monks are depicted against the lotus seat, and a third figure, dressed in a tunic and trousers in the Scythian mode, is shown in front of the club. If he is meant to be the donor, he could have been a Scythian or Kushan convert or a native who had adopted the foreign attire. 2

P.P.

сат. 53, back >

Uttar Pradesh; 2nd century Mottled red sandstone 19¹¹/₁₆ in. (50 cm) The Russek Collection

Except for the goat's head, the figure is essentially human. As is characteristic of both mortals and immortals in the Kushan art of Mathura, he wears a dhoti held around the waist with a sash. A shawl comes down the left arm and goes around the right leg, and he is adorned with a necklace and heavy bangles. The right hand exhibits the gesture of reassurance and the left clutches the hand of a small boy. At least two more boys may originally have been near his feet. The two perched on his shoulders seem to be playing with his hair.

The realistically rendered goat's head identifies the figure as Harinegameshin. An ancient folk deity, he was venerated for safe childbirth. He is clearly portrayed here as a patron deity of children (similar to the Buddhist goddess Hariti). Harinegameshin was a constant companion of Skanda-Kumara, the divine general in Hindu mythology. Originally he may have been widely worshiped at Mathura, where a number of images have been found, though none as impressive as this example. He became associated with Jain mythology early on, which makes it possible that this image was part of a Jain shrine and was the focus of a cult. Each temple complex most likely had a separate shrine devoted to Harinegameshin, much as each Hindu temple today has a shrine to Ganesa 2.

Р.Р.

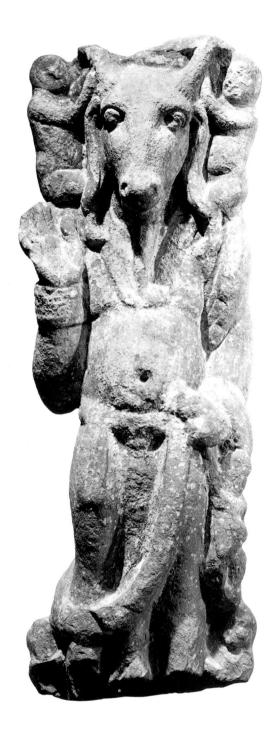

See color illustration on page 26.

Goddess Sarasvati

Uttar Pradesh, Mathura, Kankali Tila 132[?]

Mottled red sandstone; 22½ in. (57 cm) State Museum, Lucknow

The front of the two-tiered pedestal is filled with a long, dedicatory inscription in clear Brahmi script (see appendix). The date of its fabrication and donation is the year 54, which if referred to the Saka era (132) would make it the earliest Indian image of Sarasvati. Gova, who was a smith, donated this image at the inspiration of his teacher Aryadeva.

Sarasvati is shown seated on her haunches, a posture which is typical in work from the Mathura area during the period. Her posture emphasizes the crescent folds of her sari, whose end is drawn over her left shoulder. Except for two bracelets, the image is strikingly devoid of any ornamentation. Held in her left hand is a palm-leaf manuscript wrapped in cloth, and

according to early descriptions of her iconography, she must have originally held a lotus in her right hand.

She is flanked by two male figures. The one on her right, wearing a short pleated dhoti, holds a waterpot; the other, his hands clasped in veneration, is clothed as a monk. The former probably represents the donor, Gova, and the latter the teacher Aryadeva, although they are by no means portraits.

Sarasvati, the goddess of learning and wisdom, is an ancient deity, whose history can be traced back to the Vedas, the earliest Indian sacred literature (1500-800 B.C.E.). Since knowledge plays a fundamentally important role in Jainism, Sarasvati has remained one of the most popular Jain goddesses. This impressive image, showing all the typical characteristics of the Kushan style, clearly demonstrates that as early as the second century she had become the focus of an independent cult. 2>

S.G.

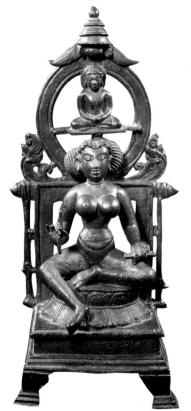

56

Goddess Sarasvati

Maharashtra, Rajnapur Khinkini 10th century Copper alloy; 91/8 in. (23.2 cm) Central Museum, Nagpur

The goddess is seated gracefully (lalitasana) on a lotus, which in turn is placed on a rectangular pedestal. Like the much earlier image of Sarasvati from Mathura [55] this depiction is austerely simple, except for an elaborate coiffure. This device is comparable to that of a yakshi image in the exhibition [70], and very likely both are the work of the same sculptor. The goddess holds a book in her left hand and, unusually, a stylus in her right.

The configuration of her throne is also very simple. Its back is made of two simple vertical columns supporting a crossbeam, which in turn supports an oval halo. Within this halo is seated a Jina in meditation. The triple umbrella over his head is characteristic of the southern Digambara idiom. Unlike Ambika, who is associated with Neminatha, Sarasvati presides over the preachings of all twenty-four Jinas.

The site of Rajnapur Khinkini has yielded Jain bronzes of consistently high quality, as may also be seen from the other example in this exhibition [70]. The elegantly modeled figures, simplicity of composition, exquisitely rendered details, and almost flawless casting make these bronzes among the finest of Indian metal sculptures. 20

S.G.

Goddess Sarasvati

- A. Madhya Pradesh; 1061 Sandstone; 33³/₄ in. (85.7 cm) Peter and Susan Strauss
- B. by Jagadeva
 Gujarat; 1153
 White marble; 47 1/4 in. (120 cm)
 Los Angeles County Museum of Art
 Gift of Anna Bing Arnold

These two depictions differ significantly from the earlier images of the goddess [55, 56]. Whereas in those images the goddess is shown seated and with only two arms, in these two representations she stands and was carved with four arms. The iconographic constant among Sarasvati images is the book, which she carries to proclaim her role as the goddess of learning.

Sarasvati became particularly popular in western India and to a lesser extent in central India from around the eleventh century through the thirteenth century. While she is primarily the goddess of learning and speech, during this period Sarasvati may have been worshiped "for destroying all miseries" (Shah 1941, 196). The disrupting presence of various iconoclastic Muslim invaders, such as Mahmud of Ghazni in 1025, motivated many local Jains to donate images for religious merit to over three hundred new temples in an attempt to ensure salvation for themselves and their families.

In both images the goddess stands in the classic flexed posture and originally had four arms. Each upper right hand holds a lotus stalk: that of A terminates in a blossom, while B's encircles a pair of pecking geese. Figure A carries a book in her upper left hand, while B carries a rosary and holds a lotus stem that matches the one in her right hand. A carries an ascetic's waterpot in her lower left hand, which B has lost. Both A and B are missing their lower right hands, which were probably held in the gesture of charity. Female attendants bearing flywhisks flank the legs of each goddess, while at thigh level B has two diminutive figures with musical instruments that allude to Sarasvati's cultural role as the preceptress of music. On the proper right of the base of B is a small male figure who may represent the donor, while on the other side is the goddess's mount, a gander, which is now headless. Three small Jinas grace the top of image A.

Both images are inscribed (see appendix). The inscription on the base of A states that it was commissioned by Ramana and Vahada at the Samva monastery. Neither the donors nor the location are known. More informative is the inscription on the base of B, which states that it was carved by Jagadeva in April—May 1153 by order of the officer Parasurama as a replacement for a sculpture of Sarasvati that was damaged the year before.

S.M.

CAT. 57A ➤

CAT. 57B ➤➤

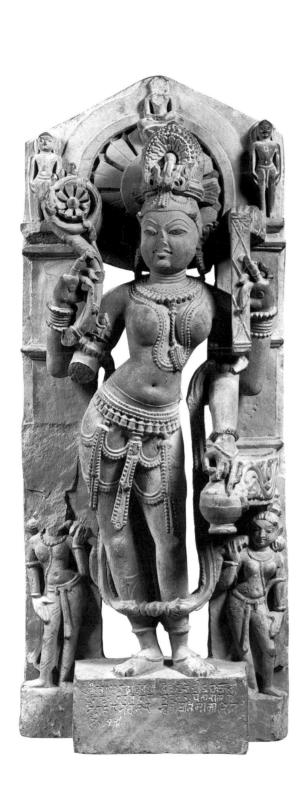

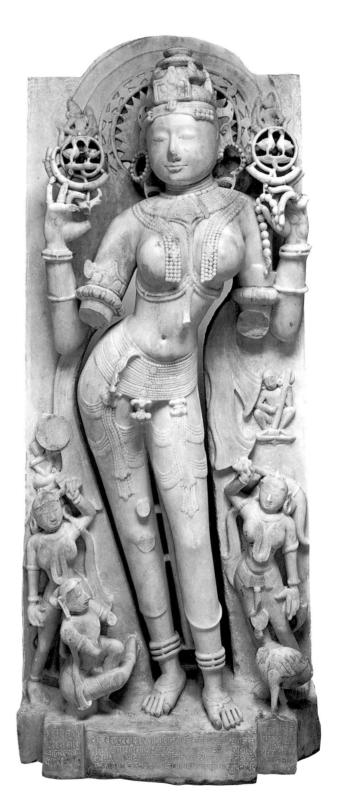

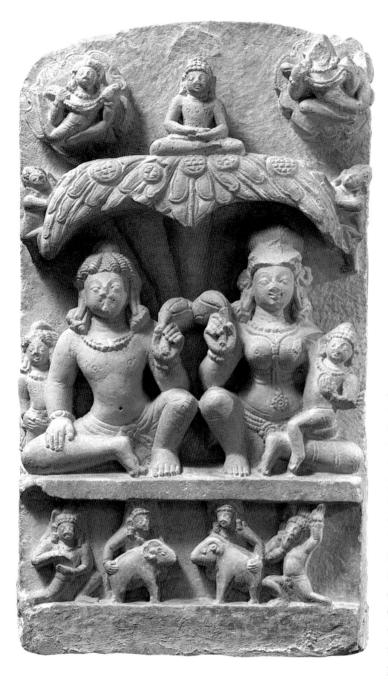

A Family Group

Uttar Pradesh; c. 600 Cream-colored sandstone 20 in. (50.8 cm) Los Angeles County Museum of Art Gift of Mr. and Mrs. Harry Lenart This well-preserved stele is divided into three sections. The two large figures in the middle zone are seated below a tree serving as a parasol. Each holds an identical flower, which may be a lotus. The lady supports a young boy on her thigh. Another boy stands next to the male, while four more cavort in the recessed panel below. Clearly they are attempting to instigate a ram fight. In the upper portion of the stele a meditating Jina is seated on top of the tree. Two adorants appear to be climbing up the sides of the tree, and two celestials with garlands fly against cloud cartouches.

This represents one of the mystery themes of Jain art, for no precise textual description of such reliefs has yet come to light. They are generally thought to depict the parents of Jinas, though in a similar relief in the exhibition [24], the couple are identified as yakshas rather than parents. While they have been found in a wide area stretching from Gujarat to Bangladesh, they do not exhibit consistent iconographic features. The common elements are the couple, the child in the female's arm, and the Jina above. According to Shah (1987A, 47-52), the parents can be differentiated primarily by the tree above them. Often, however, the tree is much too stylized to be recognizable. If the tree portrayed here is the asoka, then the Jina is Mallinatha and the parents, Kumbha and Prabhavati.

Whatever their exact identification, there can be little doubt that conceptually the subject is related to the Buddhist tutelary couple of Panchika and Hariti and to the Hindu family group with Siva, Parvati, and their sons and attendants. In Buddhist reliefs it is common to depict cavorting boys, as in this stele, and in Saiva images too the attendants often frolic in like manner. Also noteworthy is the representation of the child in the arm of his mother. He is a boyish version of the older Jina and has the same hairstyle. The baby Buddha too is often depicted as a younger version of the adult. 20

Р.Р.

A Family Group

Bihar; c. 900 Copper alloy; 5³/₄ in. (14.6 cm) Norton Simon Art Foundation, Pasadena, California

Stylistically this bronze belongs to the Bihar school of sculpture of about the tenth century. Apart from the graceful plastic qualities of the two central figures, details such as the large comma-shaped flame motif along the nimbus fringes are typical of Pala-period bronzes. Although basically similar to the earlier stone example [58], this bronze group differs in significant ways. Each parent here carries a small

seated figure, as if holding a doll. Because of the effaced condition of these figures they can barely be recognized as children. Each is seated in the meditation posture and has the right arm raised to the chest, as if making the gesture of reassurance (abhayamudra). Five other identical figures adorn the front of the base, and a sixth is attached to the polelike tree trunk between the two oval nimbuses. It is possible that this figure has a snake canopy above his head. Higher up is a meditating Jina whose face and hair are difficult to discern. What does seem certain is that the seated animal in front of him is a bovine and could be either a buffalo or a bull. If it is the former, then the figure would represent the Jina Vasupujya; if the latter, then he would be Rishabhanatha. Considering that no hair seems to fall down the shoulders, the figure must be identified with Vasupujya. In that case the tree, whose stylized leaves can be recognized on either side, could be either the patali or the kadamba.

If the figure at the top is Vasupujya, then this becomes a very rare sculpture, for that Jina was not a popular figure in art. However, he may have had a following in Bihar, for he was a prince of Champapuri (a modern Bhagalpur district in Bihar). His association with the patali tree may also be significant, for the same tree, or its presiding yakshi, Patali, has given its name to the famous city of Pataliputra (the modern Patna). His father was also known as Vasupujya, and his mother was Jayavati. One reason that he was known as Vasupujya is because the group of eight gods called the Vasus worshiped him. A closely comparable relief with a group of five identical figures on the base and two in the arms of the parents is in the National Museum, Dhaka (Shah 1987A, fig. 203). There is also a very similar eleventh-century bronze from Bangladesh in the Linden-Museum, Stuttgart (Kreisel 1987, 67, no. 76). 20

P.P.

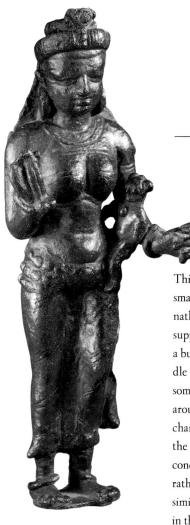

Goddess Ambika

Bihar; 5th century Copper alloy; 5³/₈ in. (13.7 cm) Dr. and Mrs. Siddharth Bhansali, New Orleans

This well-proportioned figure standing on a small base is Ambika, the yakshi of Jina Neminatha. Her little son is perched on her hip and supported by her left arm. The right hand holds a bunch of mangoes, and the left grasps the handle of something whose upper part is lost. Handsomely proportioned, she wears a sari secured around the hip with a girdle consisting of three chains, reminiscent of Mathura female figures of the Kushan period. A transparent scarf does not conceal her ample breasts. Her ornaments are rather simple, and the arrangement of the hair is similar to that seen in the seated stone Ambika in this exhibition [61]. The back is unfinished, but it is clear that she was provided with a nimbus.

The exact provenance of this bronze is not known, but it is thought to have been found in a hoard somewhere in Nepal, perhaps in the Himalayan foothills bordering on Bihar. There is a second Ambika in the group and five Jinas, which relate stylistically to the Jina images in the Chausa (Bihar) hoard (fig. 10; Gupta 1965, pls. xix—xxi). Although the sculpture is of the fifth century, it exhibits features of earlier female forms (Asher 1980, pls. 1 and 10) and does not quite display the soft plasticity of the sixth-century Rajgir figures (ibid., pl. 20) or the seated stone Ambika [61].

If indeed the date suggested for this figure is accepted, then it may well be the earliest known representation of Ambika. (For another early bronze, possibly from Bihar, that may depict Ambika, see Pal 1978B, 109, no. 61). These eastern Indian bronzes of the goddess precede anything found in Gujarat. (For the concept and history of Ambika see Tiwari 1989).

P.P.

61

Goddess Ambika

Bihar; 6th century
Buff sandstone; 27 in. (68.6 cm)
Los Angeles County Museum of Art
Purchased with funds provided by
Robert H. Ellsworth in honor of
Dr. Pratapaditya Pal

Richly ornamented and with her hair arranged elegantly, the four-armed goddess sits in *lalitasana* on a seated lion. She supports a plump baby on her left thigh. Unfortunately his head is broken, but his raised right hand exhibits the gesture of reassurance, as does the child Jesus occasionally when seated in the Virgin's lap. The other hands of the goddess hold (clockwise from her lower right) a *matulinga* (lemon), a bunch of mangoes,

and a spear, whose outline only remains. The iconography matches the description of Ambika in the *Acharadinakara*, a ritual text of the Svetambaras (B. C. Bhattacharya 1974, 102, fn 1).

This particular sculpture was probably placed in its own niche in an important temple of Neminatha in Bihar. It may also have occupied a side shrine, as Ambika does at a temple in Ellora (Ghosh 1: pl. 122). Whatever the exact function of the sculpture, it remains one of the finest known images of Ambika. The lively representation of the well-fed boy, the graceful posture of the goddess, and the serene expression on her beautifully chiseled face are especially noteworthy features.

P.P.

See color illustration on page 35.

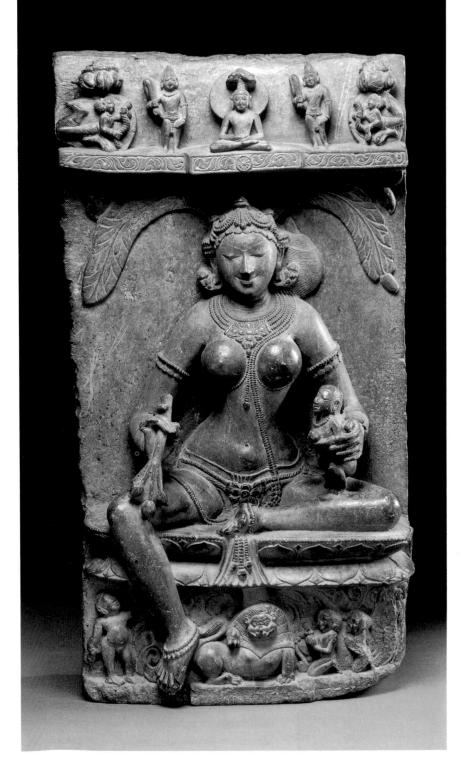

Goddess Ambika

Orissa; 12th century Gray chlorite; 201/4 in. (51.5 cm) The Board of Trustees of the Victoria and Albert Museum, London

May Ambika, of golden complexion, riding on a lion and accompanied by her two sons, Siddha and Buddha, and holding a bunch of mangoes in her hand, protect the Jaina sangha [monastic community from obstacles. (Kalpa-pradipa; Tiwari 1989, 25).

The voluptuous Ambika, worshiped on behalf of mothers and infants, is depicted seated on a double lotus throne with her child beneath a mango tree. She protects the infant with her left hand and holds a mango branch in her right. Her second child is shown on the lower frieze, reaching up to his mother. The iconography of the mango and its association with rounded female forms, especially breasts, is underscored by the similarity between the words for "mango" in Sanskrit (amra) and Hindi (amb, amba) and likewise the words for "mother" (amba and amma, respectively). Ambika's vehicle, the lion, is seated alertly beneath the lotus throne and is accompanied by the figures of two kneeling worshipers, presumably the donors who commissioned this sculpture.

Ambika is the yakshi of Neminatha, whose haloed form appears directly above her. The goddess first appears in sculptural form relatively late, around the sixth century, and only after the tenth century in multiarmed tantric forms. She seems to have been adapted from a Hindu goddess of the same name.

This sculpture bears a striking resemblance to reliefs of yakshis, including Ambika, at the Navamuni caves at Khandagiri, near Bhuvaneshwar, Orissa, datable to the eleventh or twelfth centuries (Tiwari 1989, pl. 58). Local inscriptions from the mid-eleventh century refer to new images being set up at this time, which suggests a renewed interest in Jainism in Orissa in the twelfth century.

Andrew Stirling, writing in 1825 (Skelton 1965, 40), observed that many sculptures made of the local chlorite stone were collected in the region of Khandagiri Hill from the remains of demolished medieval Jain temples. 20

Yaksha Couple

Karnataka; 12th century Stone; 29⁷/₈ in. (76 cm) Prince of Wales Museum of Western India, Bombay

- A. Dharanendra
- в. Padmavati

This pair was evidently intended to accompany an image of Parsvanatha; the two images reflect the work of the same sculptor in their modeling, ornamentation, and iconographic features. They are fine examples of the ornate sculptural style that prevailed in this region at the time, but for some reason this pair was never completed and installed.

The four-armed Padmavati is holding a beautifully carved lotus in her lower right hand and a goad in her upper right. In her upper left she holds a noose, while the broken lower left hand, judging by the gesture of her companion, must have displayed varada, or the boon-conferring gesture. This fits well with the description mentioned in the Trishashtisalakapurushacharita, the Jain canonical text by Hemachandra. Her high and elegant crown is topped by a single serpent hood. In the larger group she would have occupied a place to the left of the Jina; hence, to maintain a visual balance, her left leg is pendant. The details of her sari and waistband have not been carved, and even her bracelets and other ornaments have remained incomplete.

The yaksha Dharana has almost identical attributes, even though these do not conform to his iconography. He normally would have been shown holding a serpent, but he does have a hood of three snakes.

The sculptures have several similar features. In both, the details of the noose and the lotus are exceptionally fine, and even the flow of the garland is gracefully maintained. Both aureoles are architectural, consisting of molded *stambha*, or pillars, on either side of the images, over each of which is a *torana*. These are decorated with six floral-scroll roundels, and at each apex is a beautifully carved *kirtimukha*. 20

S.G.

CAT. 71A >>

CAT. 71B >>>

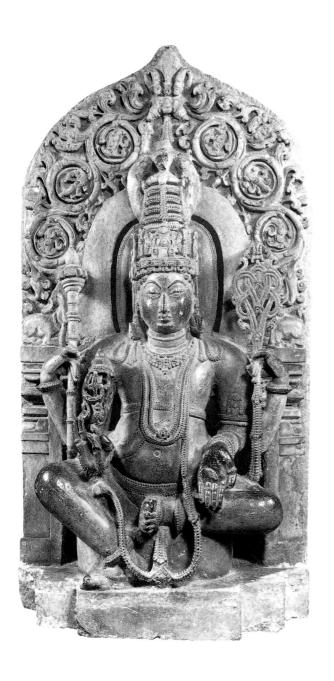

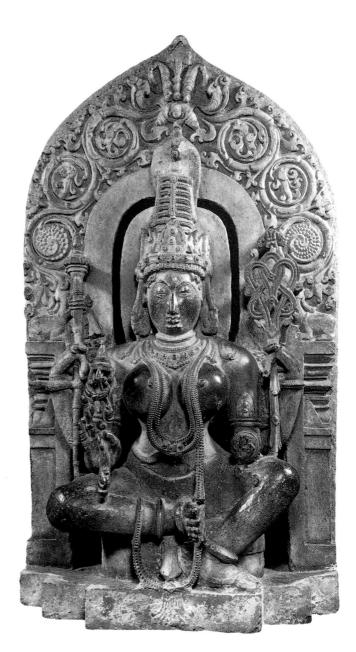

Two Yakshis

- A. Karnataka [?]; 9th century
 Copper alloy; 9 in. (22.9 cm)
 On loan from the Royal Ontario
 Museum, Rueben Wells
 Leonard Bequest
- B. Central India; c. 900
 Sandstone; 31½ in. (80 cm)
 Courtesy of the Trustees of the British Museum

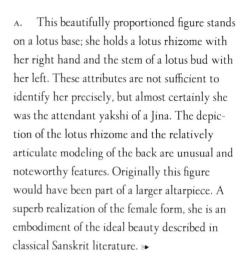

Р.Р.

B. This yakshi is represented in eight-armed form, seated in *lalitasana* posture on a lotus pedestal. Her attributes include disc, mirror, conch, and cup, and her upper arms hold a garland of flowers that arcs behind her head, an unusual treatment of this motif. Her two remaining hand gestures are *abhayamudra* (reassurance) and *varadamudra* (charity). She is attended by musicians, garland-bearers, and her vehicle, the seated elephant. Above her is an enthroned Jina with attendants.

The yakshi's name, Sulochana ("beautiful-eyed"), is inscribed in a contemporary script on the base of the image. This yakshi is rarely represented in Jain sculpture, and her name is not found in lists of yakshis in Digamabara texts. One of the earliest complete series of images of the twenty-four yakshis in which Sulochana appears is to be found at Deogarh. Each deity in the series is named by an inscription, and they are believed to date from the temple's foundation, c. 800. It is clear from this and other sources that the names of the yakshis were still fluid at this time and that they continued to evolve until as late as the thirteenth century. This sculpture of Sulochana is a rare and beautiful example of one of the more obscure Jain yakshis, who ceased to be worshiped toward the end of the medieval period. 2>

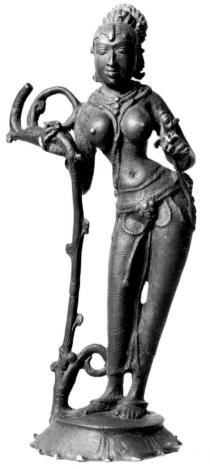

CAT. 72A A

CAT. 72A, back >

CAT. 72B >>

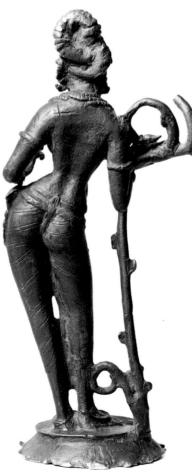

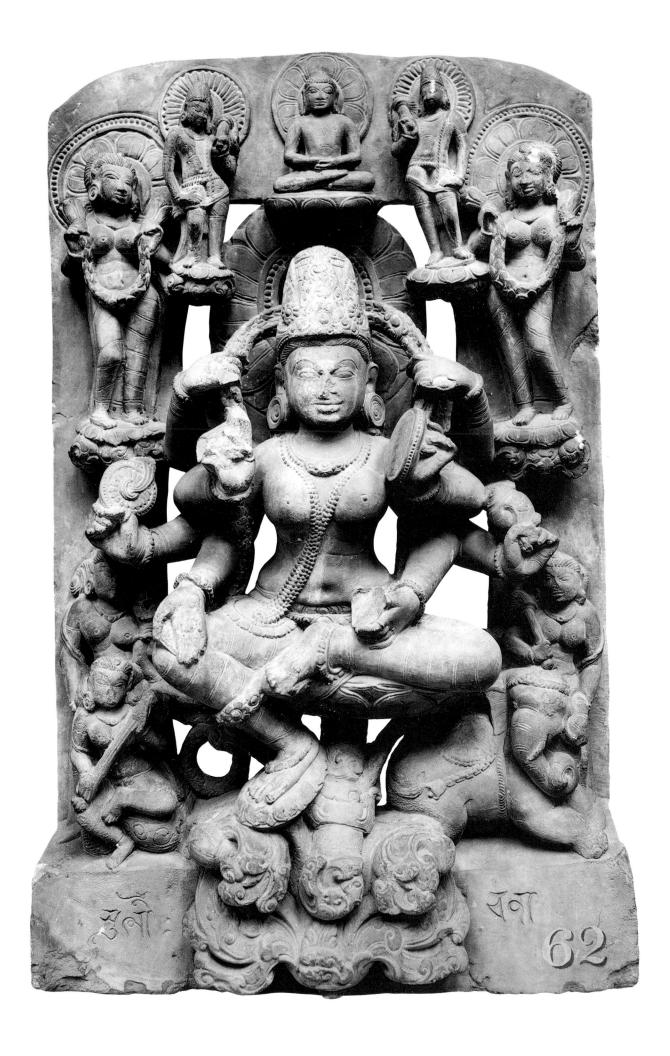

Yaksha Purnabhadra

Rajasthan, Jaipur; c. 1850–1900 Opaque watercolor, gold, silver, ink, and colored foil replicating gemstones on paper; 19⁷/₈ x 15³/₄ in. (50.5 x 40 cm) Los Angeles County Museum of Art Gift of Mr. and Mrs. Harry Lenart

Purnabhadra ("fully auspicious") is regarded by Jains, as well as by Hindus and Buddhists, as the benevolent king of the yakshas. He is one of the most exalted and oldest of them, predating even Mahavira and the Buddha. Beautiful and elaborate shrines are known to have been erected for his worship, such as the one at Champa in ancient Anga, Bihar, which is described in several Jain texts (Coomaraswamy 1980, 19–21; Misra, 45–7, 85–7).

Buddhist accounts describe Purnabhadra as being blue and holding a citron and a mongoose, like the god of wealth, Jambhala (Bhattacharyya, 380). This multiarmed, elephant-headed form of Purnabhadra is apparently a late Jain conception and may derive in part from the following legend. When Purnabhadra's wife, Bhadravati, accidentally hit the god Kubera with a flywhisk while she was thinking about an elephant, Kubera cursed the couple to make them take the forms of elephants (Misra, 85). Purnabhadra's protective function probably explains why he is shown in this painting carrying several weapons, including a punch-dagger (katar or jamadhar).

The grid in the upper left corner of the painting contains mystical characters symbolizing esoteric Jain religious concepts used in meditative worship and rituals.

An almost identical image inscribed as Purnabhadra is in a series of yakshas housed in the Digambara Jain temple library in Jaipur (Dr. Pal, personal communication). 2>

S.M.

- A. Gujarat; 6th century Copper alloy; 7 in. (17.8 cm) Private collection
- в. Rajasthan; 11th century Brass; 16 in. (40.6 cm) Doris Wiener, Inc./ Nancy Wiener, Inc.

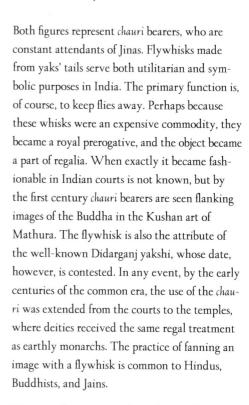

These two bronzes once formed parts of two different altarpieces. Obviously the later example, в, belonged to an image of impressive size. The smaller figure, A, is distinguished by an elegant hairstyle that is usually encountered in figures of the Gupta period. The larger figure is stylistically related to several chauri bearers in altarpieces of the eleventh century discovered in Vasantgadh in Rajasthan (Shah 1955-56, figs. xvi, xvIII−xIx). ≥►

P.P.

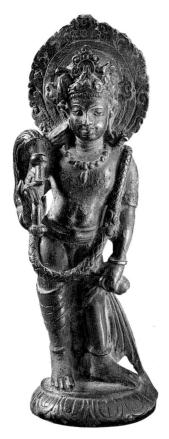

CAT. 74A CAT. 74B ➤

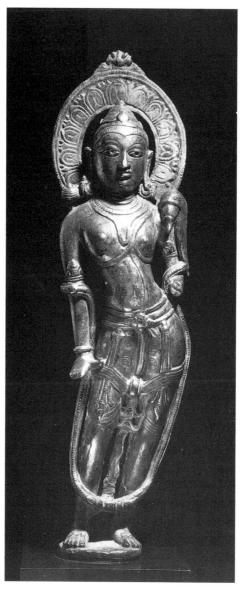

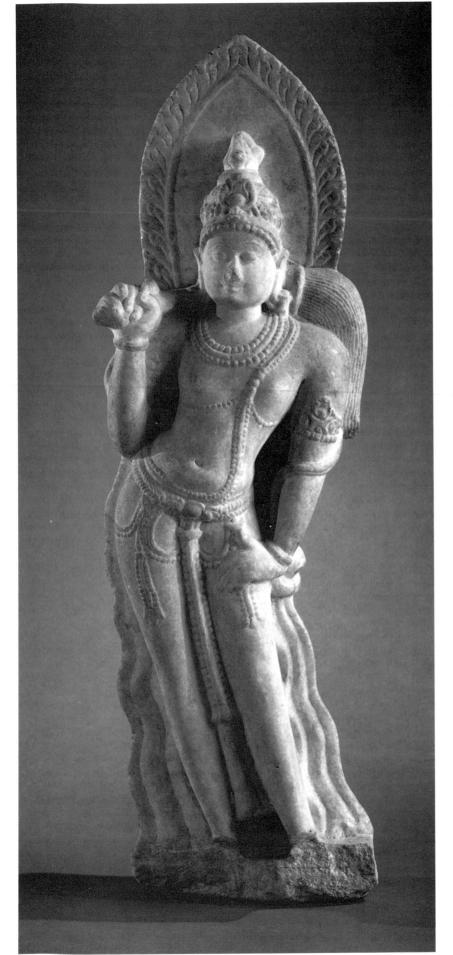

A Divine Acolyte

Rajasthan, Mount Abu region 11th century White marble; 24³/₄ in. (62.9 cm) Robert Hatfield Ellsworth Personal Collection (Shown at U. S. venues only)

This bejeweled acolyte stands with his hip prominently thrust out to his right and his left hand resting on his thigh. Across his shoulders is the honorific chauri. The figure's divinity is also conveyed by the arched, flaming halo behind his elaborately crowned head. Judging from the directional orientation of his stance, the figure probably originally flanked an important Jina image to his right.

The use of white marble for temples became popular with the Jains of Gujarat and the Mount Abu region of southern Rajasthan from about the eleventh century onward. The temples of Mount Abu are especially renowned for their visually overwhelming abundance of the pristine material, which is employed in a rich panoply of divine forms. The white marble used for most Jain temples in western India was quarried at Kumbharia in northern Gujarat and typically has somewhat warmer hues than the marble from Makrana (near Jaipur, Rajasthan) employed by the Mughals for such monuments as the Taj Mahal (Shah and Dhaky, 324). 20

S.M.

See color illustration on page 96.

Chaste Monk Avoids the Lures of Women

Folio from an

Uttaradhyayanasutra manuscript
Gujarat, Cambay; c. 1450
Opaque watercolor on paper
4½ x 115% in. (11.4 x 29.4 cm)
The Board of Trustees of the Victoria and Albert Museum, London

The Uttaradhyayanasutra is an important canonical text, believed by the Svetambara sect to contain the last teachings of Mahavira. It is concerned with the rules of behavior that govern monastic life. This folio illustrates the maxim that monks should strive to attain perfect chastity and to this end must avoid the attractions of women. A Svetambara monk, clad in white, diaphanous robes, stares out of the picture impassively, while two beautiful young women, dressed in rich garments and jewels, attempt to engage his attention. Female musicians and a dancer add to the distractions. The monk is depicted frontally, with the cool passivity of a

sculpture, while the women are enlivened by the daring combination of a three-quarter view for head and torso, and full profile for the feet, imparting tension and movement. The fluttering of sari ends, breast shawl, and long, plaited hair all add to the sense of animation. The painting beautifully illustrates the strength of will that a monk must exert to honor his vows of chastity.

A curious feature in the folio is the interruption of the text to allow for the perforation of a binding cord, though no such hole has been made. The perpetuation of such a convention, a memory of past practice and the continuation of a sacrosanct format, is a reminder of the static nature of much mid-fifteenth-century Jain artwork. The bulk of Jain studio painting in this period is associated with the two great centers of Jain patronage, Ahmedabad and Patan. This manuscript bears a later colophon stating that it was produced at Stambhatirtha in Cambay on the Gujarat coast, a major port and hub of Jain mercantile activity. 20

J.G.

85

Three Folios from a Balagopalastuti Manuscript

- A. Yasoda's Vision of the Universe
- B. Vasudeva-Krishna Adored by a Jain Monk [?]
- c. Dancing Siva

Gujarat; c. 1450

Opaque watercolor on paper Each $4\frac{3}{16}$ x $9\frac{1}{4}$ in. (10.4 x 23.5 cm)

Private collection

Although the Western Indian style of manuscript painting is largely encountered in a Jain context, it was not confined to the service of the Jain community alone. Some of the finest manuscripts of the fifteenth century were Hindu, as witness the three folios from this Sanskrit copy of the Balagopalastuti ("praise to the youthful Krishna"). This is a devotional text attributed to the Vaishnava saint Bilvamangala (active c. 1250-1350), which gained widespread popularity in Gujarat toward the end of the fourteenth century, among Jains as well as Hindus. The subject of the text, the loving adoration of Vishnu in his incarnation as Krishna, appears to have inspired the freshness and celebratory air of these paintings. That the text should be popular with Jains is not surprising; Krishna is regarded as a cousin of the Jina Neminatha.

ससिनायंगातनरं उमधनाष्ट्रद्वासेना से बया। मयं इसिकाम न दाद छं जानी। ष्णीबव्यानना बादिहातिविका ववदानदृष्ट्यासमस्त्रङगदामानानस्य गामविसायप्रंपायास्यकेशवः। थ पकासमिना हासमन । १९७व विषामें इला ता पिद्ध वस्त्र स्वास वारलामालयः निर्वाहस्मयमाना नासरसालाकाणेलस्वलधूलीपाक **अनाअनपरिलम्बन्यां तब्दाति॥श्**

сат. 85а

сат. 85в

сат. 85с

The first folio shows a scene from the life of the infant Krishna, when his surrogate parents, Yasoda and Nanda, reprimand him for eating dirt. The relevant text describes the scene: "Krishna now went to the road and ate dirt according to his desire. . . . 'Open!' [Yasoda] said. When he opened his mouth, then his mother saw within the entire universe (the three worlds), and she was amazed." The second folio depicts an enthroned Vishnu being revered by a mendicant. Vishnu is shown with most of his conventional attributes: three arms bear conch, discus, and mace; the fourth assumes a gesture rather than holding a flower. He wears three peacock feathers in his crown, confirming the Krishna affiliations of this text. The monk gives every appearance of being a Svetambara Jain.

The third folio depicts an eight-armed Siva in an ascetic guise (with the uncut hair of a yogi), poised before his bull mount. Siva is engaged in a wild dance and bears attributes that may be read as allusions to other members of the Hindu pantheon: he holds the multiheaded snake Sesha, upon whom Vishnu reclines in his cosmic sleep, and a white elephant that probably refers to Airavata, Indra's mount. The peacock is Karttikeya's vehicle, establishing his presence, while the milkmaid (gopi) holding up a crown reasserts the primacy of Krishna.

These folios follow a style established in the palm-leaf tradition and were created no later than the mid-fifteenth century. They may be compared with a cloth scroll-painting of the Vasantavilasa that, according to its colophon, was commissioned in Ahmedabad in 1451 (Mehta 1925), now in the Freer Gallery of Art, Washington. The freshness of the drawing and restrained use of color, confined to a palette of red, blue, green, crimson, and white, sets these paintings apart from the lavish and often labored style that appeared in the latter half of the century, dominated by the use of gold and ultramarine. 2

сат. 86а

сат. 86в

сат. 86с

See color illustration for сат. 86в оп раде 92.

Two Folios from a Kalpasutra Manuscript

- A. Trisala's Joy
- Mahavira's Departure with Indra
- c. The Birth of Mahavira
- D. Nemi's Renunciation before His Marriage

Uttar Pradesh, Jaunpur; c. 1465 Opaque watercolor and gold on paper Each 45/8 x 111/2 in. (11.7 x 29.2 cm) Terence McInerney, New York

The fifteenth century was a watershed in the development of the Western Indian style. For one thing, that style ceased to be confined to western India, as important Jain manuscripts from Delhi and Jaunpur (Uttar Pradesh) demonstrate. This geographic extension would in turn have opened it up to other influences.

These double-sided folios are extravagant in their use of gold lettering on a crimson ground and in the use of gold for the figures. The latter treatment has the unfortunate effect of obscuring the quality of painted line and flattening the figures. Nonetheless the strength of composition and the decorative details are impressive. The figures in Trisala's Joy, in which the queen is assured by Indra that Mahavira's embryo is alive, are alert and bright, with sharply drawn

lines. The news is greeted with music performed by four female musicians. The figures have an almost hypnotic gaze, which sets up a tension within the picture, although the treatment of flying drapery has become rather static. The projecting-eye convention is particularly acute, the farther eye extending beyond the profile heads to a disturbing degree. The textile designs read clearly against the red ground.

On the reverse of this folio, B, is a scene that may represent the deities Indra and Indrani bearing off newborn Mahavira on a decorated elephant to the mythical Mount Meru. The painting's rich colors are well preserved, giving it a heightened intensity.

The Birth of Mahavira, c, is the conventional bedchamber scene but has a distinctive north-Indian element in the rooftop pavilion and crenellations visible at the upper margin of the composition.

D depicts the critical event in the life of Nemi, who in the upper scene is approaching his bride Rajamati's pavilion. Enroute he asks his charioteer what the cries of distress he can hear are, and on learning that they are the cries of animals to be slaughtered for the wedding feast, he renounces his bride, and the world, to pursue the life of a mendicant. 20

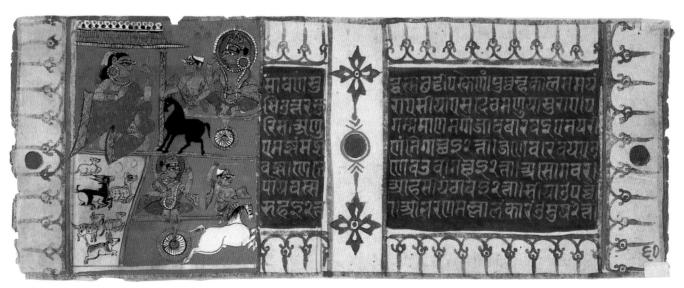

сат. 86р

See color illustration on page 96.

Entertainment at Indra's Court

Folio from a Kalpasutra and Kalakacharyakatha manuscript Western India; c. 1475
Opaque watercolor and gold on paper 4⁷/₁₆ x 10⁹/₁₆ in. (11.3 x 26.8 cm)
San Diego Museum of Art
Edwin Binney 3rd Collection

This folio is from one of the most sumptuously illustrated of all Jain manuscripts. It is known as the Devasano Pado manuscript because the bulk of it is in the repository of that name in Ahmedabad. It is also unusual in that it contains no text, and the entire surface is covered with a single composition.

In other manuscripts this scene is identified as Indrasabhanataka (Brown 1934, 14–15; fig. 8), and occasionally it is singled out for full-page treatment. In none, however, is the scene filled

with as many dancers or the composition as lively. On the left of the folio the four-armed Indra is seated on a throne with three parasols above and two flywhisk bearers behind him. His upper hands hold a thunderbolt and an elephant goad. The object in the lower left hand is unrecognizable. The remaining hand is held against his chest with a finger pointing up. Two male deities sit before him, and a female offers him a garland. Behind them are three rows of female dancers striking a variety of poses.

The painting creates a lavish effect through the juxtaposition of gold, crimson, and ultramarine; the added use of white heightens its brilliance. Paintings of this period are marked by a high degree of finish, which tends to conceal the quality of line that is perhaps the most distinguishing feature of the Western Indian school of painting. 2>

J.G.

88

Two Folios from a Kalpasutra Manuscript

A. A Seated Jina

в. Mahavira

Western India; c. 1500 Opaque watercolor and gold on paper Each $4\frac{1}{2}$ x 11 $\frac{1}{8}$ in. (11.4 x 28.3 cm) Gursharan and Elvira Sidhu

These two illustrated folios appear early in the *Kalpasutra* text. The first, A, shows a seated Jina together with the eight auspicious symbols. No specific identity attaches to this figure, and he

may be interpreted as representing all of the twenty-three Jinas preceding Mahavira. This Jina is enthroned in an elaborate architectural setting reminiscent of installed sculptures and similar to the aureoles of the Karnataka yakshas in the exhibition [71]. He is flanked by two monk devotees. The auspicious emblems are arranged above and below the central figure. They are, from upper left: mirror, auspicious seat, powder box, water-filled pot, pair of fish, auspicious srivatsa mark, auspicious whorl (nandyavarta), and auspicious solar symbol (svastika). Peacocks adorn the throne, and a cloud-and-sky motif runs along the upper margin, introducing an awareness of landscape, a rare element in Jain painting.

See color illustration for CAT. 88B on page 91.

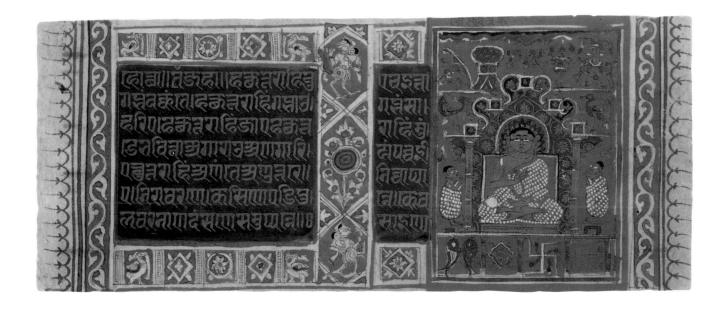

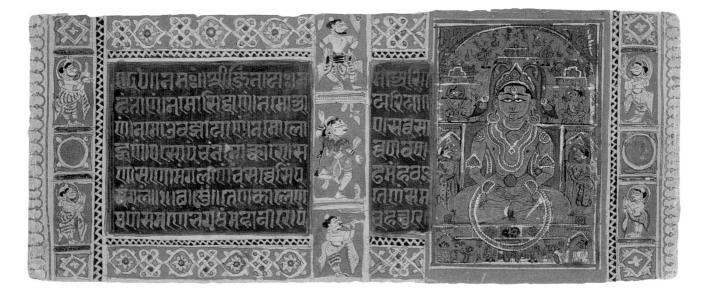

CAT. 88a A A

The text, written in gold on a crimson ground, is bordered by a series of panels with decorative infill. These include hamsa (ganders) and two kinnari, semidivine female bird-creatures, who in Jainism serve as attendant minor deities. Each end-border has a continuous vine-scroll motif in red and blue, and a fringe in blue reminiscent of textiles.

The second folio from this manuscript depicts Mahavira in the Pushpottara heaven, where he resided before descending to earth for his final existence. Crowned and adorned with garlands and jewels, he is seated in meditation posture on a throne with lion and elephant supports. Two

more elephants pour libations above the image in an act of auspiciousness. He is flanked by attendants, and above him are celestial musicians. In the accompanying margins, devotees pay homage, and musicians and dancers celebrate his imminent descent. Border decorations include the continuous-knot design and floral medallions. Both paintings display the characteristic features of studio production at the beginning of the sixteenth century: an overlavish effect created by the use of gold, crimson and ultramarine, to the detriment of clarity of line and form.

Marriage of Rishabhanatha

Folio from a *Kalpasutra* manuscript Western India; 16th century Opaque watercolor and gold on paper 4½ x 10¼ in. (11.4 x 26 cm) Dr. and Mrs. Siddharth Bhansali, New Orleans

The marriage of Rishabha is the archetypal ceremony that, in the Jain worldview, set the pattern for marriage as it is known even today in the Jain community. According to the *Kalpasutra* and subsequent commentaries, such as that of Hemachandra, Rishabha was directed to marry Sunanda, a woman who had lost her twin brother; this brother was also her husband. Rishabha married both his own twin sister, Sumangala, and the widowed Sunanda. Treatments of this subject customarily depict only one bride, who

represents both women. This scene shows the bride and groom seated before the officiating priest. Note the presence of a ritual fire for spiritual cleansing and the columns of stacked waterpots on either side of the marriage pavilion.

This painting illustrates the static, somewhat mechanical style that the bulk of Jain painting had assumed in the sixteenth century. The drawing is linear and acutely angular, with strong color applied in flat areas. The iconography, however, differs considerably from the textual description and other representations of the subject (Brown 1934, 51 and fig. 120). The inclusion of the bearded brahmins clearly indicates a time before the birth of Jainism, but the form of the wedding pavilion is of the sixteenth century and can still be seen today in India. 20

J.G.

उसात्रणे अस्याकासित्रण्कासवयात्रणे तस्मणे वेनामधिसा प्रवसादिसेता तंकवा असार इवा प्रदम्साया इवा प्रदम् तिस्काय (प्रद्या प्रदम्हिणा इव प्रदम्भितं वेक (प्रद्या प्राप्त सम्बद्धा । स्वाकासित्रणे दस्काद्स प्रदान । प्रदिश्चाव स्वाकासित्रणे दस्काद्स प्रदान । प्रदिश्चाव

Ma

90

Two Folios from a Laghu Samgrahanisutra Manuscript

A. Assembly for a Jina

в. Heavenly Realm

Western India; c. 1575

Opaque watercolor and gold on paper Each $4\frac{1}{2}$ x $10\frac{3}{8}$ in. (11.4 x 26.4 cm)

Gursharan and Elvira Sidhu

See color illustration for CAT. 90A on page 48.

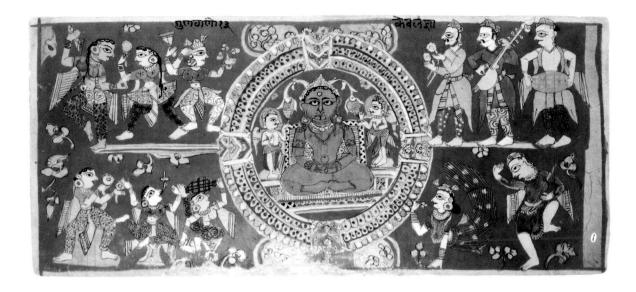

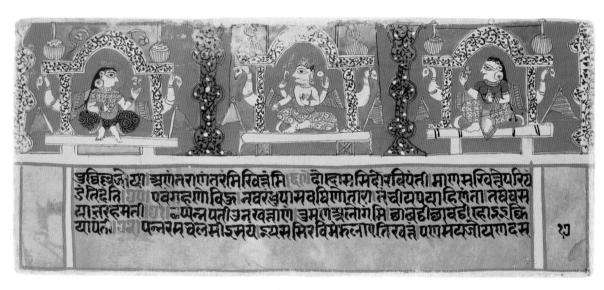

CAT. 90A ↓ ↓
CAT. 90B ↓

These two folios are from the Laghu Samgrahanisutra, a canonical text composed by Sri Chandrasuri in 1136. It is concerned with the Jain cosmological vision. Illustrated editions of the text tend to contain not only cosmological paintings with numerous continents and oceans but also depictions of the different classes of gods. The first folio, A, depicts a Jina in samavasarana, the heavenly assembly where he delivers a religious discourse. The Jina, attended by two flywhisk bearers, is presented in meditation posture. The circular enclosure, constructed by Indra, has four directional openings that penetrate its triple walls. The texts describe a metaphysical realm of richness and purity constructed of gems, gold, and silver. Beyond the heavenly walls of samavasarana mortals celebrate this teaching of the divine laws by the newly elevated Jina. Musicians and dancers are depicted in two registers on either side of the enclosure.

The second painting, B, illustrates a heavenly realm in which a minor deity and his consorts are each installed in a vimana (pavilion). Each is seated beneath a torana, with birdlike forms providing supporting brackets. The figures are represented frontally with their heads in full profile, displaying prominent fish-shaped eyes. The reliance here on black outline, flat use of color, and linear pattern for much of the pictorial interest may be compared with another version of this manuscript painted at Matar in central Gujarat in 1583 (Chandra and Shah 1975, fig. 41). The continued use of the red ground as a unifying element points to a western Indian provenance for these two folios also. 2

Vasudeva and Emblems

Folio from a Samgrahanisutra manuscript Gujarat; 1575—1600 Opaque watercolor on paper 4½ x 10¼ in. (11.4 x 26 cm) Dr. and Mrs. Siddharth Bhansali, New Orleans

Vasudeva is an epithet for Krishna and appears to have been absorbed into Jainism at an early period. In a Jain context the Vasudevas are a group of nine minor deities whose attributes are equivalent to those of Vishnu. The painting's text identifies these attributes, which are depicted from left to right: "Vasudeva recognizes the weapons: disc-jewel, bow-jewel, sword-jewel, gem-jewel, club-jewel, kaustubha-jewel, conchjewel." The textual description of Vasudeva as dark-skinned, dressed in yellow garments, and possessing the above attributes is common to both Svetambara and Digambara sources, strongly suggesting that Vasudevas were established in the Jain pantheon before the theological schism that occurred shortly after Mahavira's death. The early absorption of this Krishna cult into Jainism is probably due to its populist and antiBrahmanical aspects, which had mass appeal. The rise of the Krishna cult can be seen as the beginning of a popular bhakti movement opposed to Vedic ritualism, as were the Jain theologians. Jain faith in the primacy of knowledge over ritual is demonstrated in a passage from the Uttaradhyayanasutra, where the power of a very learned monk is compared with the strength of Vasudeva.

In this painting Vasudeva is seated on an elaborate throne with a cantilevered umbrella. He is dark blue in complexion and dressed in yellow robes. An attendant stands behind holding a flywhisk. There are a number of features that link this folio with the largely Hindu tradition responsible for the well-known Chaurapanchasika style, most notably the floral designs on the throne legs, the use of the fish-eye convention, the absence of the projecting eye, and the distinctive style of the attendants' robe with its pointed ends. This particular manuscript was probably illustrated in the same workshop as the Laghu Samgrahanisutra manuscript [90] and at around the same date. 20

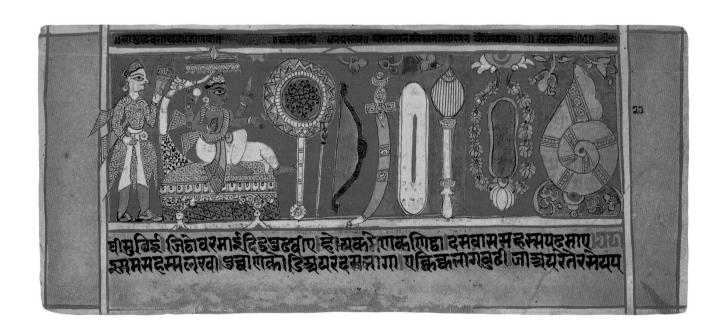

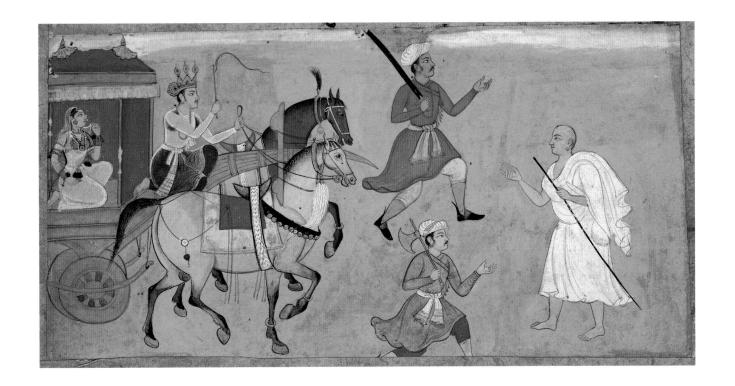

Scene from the Love Story of Madhavanala and Kamakandala

Provincial Mughal; early 17th century Opaque watercolor on paper 4 x 9 in. (10.2 x 22.9 cm) The Art Institute of Chicago Samuel M. Nickerson Fund

This painting reflects much of the fidelity and refinement that had been achieved within the Mughal court ateliers over the previous fifty years, although there is no reason to assign this work to an imperial workshop. Indeed, the restrained use of decorative elements and the lack of interest in landscape, together with the horizontal manuscript rather than vertical codex format, point to a studio still in touch with traditional Indian painting.

The subject is a secular verse written by Vachaka Kusalalabha in 1559. This provincial Mughal painting, part of a larger manuscript, was most probably produced in one of the Rajasthani courts, which in the course of the Mughal emperor Akbar's reign (1556–1605) came under the influence of imperial court culture. The painting depicts an episode from a love story in which the heroes encounter a Jain Svetambara monk on the road. The standardized male types and the particularly distinctive use of red and yellow (as seen in the canopy of the carriage, the saddlecloth, and the garments of the sword bearer) point to production in the latter part of the Akbari period. Likewise, the tonal treatment of the undercarriage is reminiscent of the grisaille technique widely practiced in Mughal painting of this period. The space given to the white-robed monk provides a skillful counterpoint to the richly colored activity of the procession scene. A related series of paintings, which almost certainly are from the same manuscript, is attributed to Jaisalmer and dated 1603 (Berlin, 1971). 2

See color illustration on page 98.

Folio from a Samgrahanisutra Manuscript

Western India, probably Rajasthan c. 1630 Opaque watercolor on paper $4\frac{1}{2} \times 10\frac{1}{4}$ in. (11.5 x 26 cm) The Board of Trustees of the Victoria and Albert Museum, London

In the early seventeenth century, editions of the Samgrahanisutra were produced in a manner reflecting aspects of the prevalent Mughal style. This penetration of central court culture into distant regions was ubiquitous. The painting centers of western India were closely linked to the Mughal capital through the prominence of their ports, which served to connect Delhi and Agra with the international trade of the western Indian Ocean. It appears that popular works such as the Samgrahanisutra became a major vehicle for the development of a new subimperial style in this period, associated with Gujarat and Rajasthan. Paintings such as the one illustrated represent a clear break from lingering medieval Jain conventions. They demonstrate an adoption of Mughal elements wedded to a traditional Western Indian format with its use of compartments and registers. The conventions employed for the depiction of horses, with slender legs issuing from rounded bodies, seem to derive directly from Mughal styles developed in the late-sixteenth-century Akbari period. Similarly, the costume conventions are of Mughal inspiration, but the decorative and unnaturalistic handling of landscape betrays the intervention of non-Mughal elements (witness the schematic use of tree and flower motifs). The origins of this

style remain unclear, though southern or eastern Rajasthan rather than Gujarat seems most likely, judging from similarities to early-seventeenthcentury Mewari painting.

This text presents a particular aspect of the Jain cosmological view, that of the great world rulers, who are represented as subordinate deities in the service of the Jinas. These rulers are grouped in ten classes, and it is the first named, Asurakumara, who is depicted in this painting, seated on a lotus throne in the upper left. He is associated with Indra, a Vedic deity from whom he is ultimately derived, and wears a crown adorned with peacock feathers. Asurakumara, whose yellow dhoti contrasts dramatically with his dark complexion, is accompanied by his so-called "six jewels," who celebrate him in song and dance. These jewels are the celestial dancers (natta), the celestial musicians (gandharva), the horse (ghoda), the elephant (hathi), the chariot (ratha), and the soldiers (subhata). In addition, the two right-hand frames of the lower register depict a young bull and a buffalo. 20

See color illustration on page 44.

A Jain Monk Receiving a Prince

Folio from an unidentified manuscript Rajasthan, Mewar; c. 1635–45
Opaque watercolor on paper 6½ x 10½ in. (15.9 x 26.7 cm)
Los Angeles County Museum of Art Gift of Mr. and Mrs. Robert L.
Cunningham, Jr.

The Mewar school of painting, centered on the court of Udaipur, is largely devoted to Hindu subjects and the recording of the secular pursuits of courtly life. Paintings concerned with Jain subjects are accordingly rare. The left half of this painting portrays a naked monk of the Jain Digambara sect seated in a rich interior, receiving a Rajput prince. The details of the interior, including a throne with cantilevered umbrella and precious glass bottles set in a wall niche, suggest a palace setting. Before the monk is a folding bookstand. The subject of this scene is therefore probably the prince receiving religious

instruction from the Jain monk. The upper register in the right half of the painting depicts the arrival of the monk accompanied by a nun, a courtly figure, and a merchant. The monk and the nun each hold a whisk broom to sweep in front of them as they walk. Below are the prince's gun bearer, horse, and groom. Each scene is set against a flat, monochromatic ground—lime, yellow, and red, respectively—and has decorative floral infill designs.

Although touched by elements of Mughal dress and portraiture, the compartmentalized composition, which allows a form of linear narrative, is drawn from the Hindu and Jain painting traditions. The use of flat, saturated colors likewise establishes the essentially traditional nature of this painting. Other folios from this manuscript are in the San Diego Museum of Art (Edwin Binney 3rd Collection; Archer and Binney 1968, no. 4). **

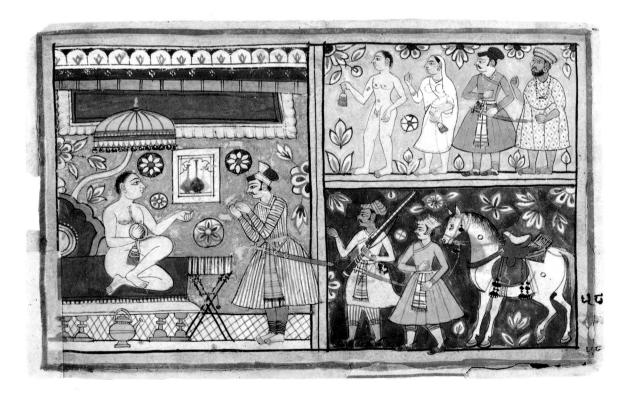

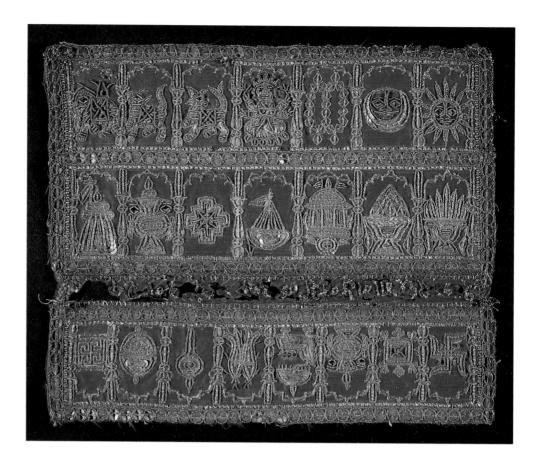

Book Cover with Auspicious Symbols

Gujarat; 1669 Couched gold- and silver-toned twisted wire, silk-wrapped metallic thread, and metal sequins on red silk satin 9½ x 11½ in. (24.1 x 29.2 cm) Chester and Davida Herwitz Family Collection

Jain sacred texts were often kept in ornate silk or cotton covers decorated with various auspicious symbols. This particularly lavish example is dated 1669 by the otherwise illegible inscription on the damaged spine. The luxurious materials suggest that it was made for a wealthy and important patron. The cover is embellished with two registers depicting symbols of the fourteen auspicious dreams of Mahavira's two mothers that foretold the future savior's noble nature; in the opposite-facing register are the ashtamangala (eight auspicious signs).

The fourteen auspicious dreams occurred to Mahavira's brahmin mother, Devananda, on the night when Mahavira descended from Pushpottara heaven to enter her womb; his surrogate kshatriya mother, Trisala, had them on the night she received the transferred embryo from Harinegameshin [54]. Each saw an elephant, a bull, a lion, the lustration of the goddess Sri, a garland, the moon, the sun, a banner, a vase of plenty, a lotus pond, an ocean of milk, a celestial chariot, a heap of jewels, and a raging smokeless fire. Symbolic motifs representing these dreams are arranged sequentially from left to right in the two contiguous registers of the cover.

The eight auspicious signs are seen in Jain sculpture as early as the first century; unlike the dream symbols they are not exclusively Jain but are shared by Hindus and Buddhists. Varying in identity and order depending upon the specific usage, they are also employed in special secular events such as coronations. A Jain set is depicted here in a separate register facing in the opposite direction. From left to right: auspicious solar symbol, auspicious srivatsa mark, water-filled pot, auspicious seat, pair of fish, mirror, powder box, and auspicious whorl. 2

S.M.

New Orleans

See color illustrations on page 88.

Two Folios from an Upadesamala Manuscript

A. Enthroned Parsvanatha B. Enthroned Santinatha Karnataka, Bijapur; 1678 Opaque watercolor on paper Each $4\frac{1}{2}$ x 10 in. (11.4 x 25.4 cm) Dr. and Mrs. Siddharth Bhansali,

According to M. A. Dhaky (personal communication) these two folios belong to a Prakrit didactic work called Uvaesamala (Sanskrit Upadesamala, meaning "garland of advice") by the Svetambara pontiff Dharmadasagani (c. mid-sixth century). The first folio of the manuscript (A) contains two-and-a-half invocatory verses. The other (B) is the last leaf and begins with a tantric invocatory verse in red ink followed by a colophon informing us that it was prepared for the merchant Nemidasa in the year 1735 (1678) in the city of Bijapur (see appendix). This is very likely the Bijapur in Karnataka, although there is a town by that name in Gujarat as well. The style of these paintings is more characteristic of the Deccan than of Gujarat, especially in the forms and attire of the two females and the highly realistic rendering of the rooster on which Padmavati stands. However, the donor was probably a Svetambara from Gujarat visiting Bijapur for trade.

On both pages the text is neatly configured between double red lines, and on the Parsvanatha folio it is interrupted by one of the conventional red dots marking the places for the binding cord. In both paintings the Jina is seated in a meditative posture on a throne that is viewed aerially, despite the fact that the surrounding nimbus (prabha) is shown in elevation. Both Jinas resemble sculptures adorned with jewels, flowers, and garlands, and both are attended by a flywhisk-bearing yaksha and yakshi. The Jina Santinatha is readily identified by the presence of the deer at the base of his throne, and Parsvanatha by the snake attribute and the seven-hooded snake canopy. Parsvanatha also has his divine attendants, Dharanendra and Padmavati, standing on their vehicles (vahana), the elephant and rooster, respectively. The attendants, although themselves ascribed semidivine status, are dressed in dhoti and sari in a contemporary style, with the frontal pleating fashionable in southern India. The males wear modern turbans of the type favored in Mughal circles. Their garments are edged in gold, and they wear gold jewelry and pearls, the accouterments of prosperity.

Although essentially iconic in purpose, these paintings have a surprising vitality, stemming in part from the daring use of color, most striking in the juxtaposition of pink-and-crimson garments against the red ground. The figures are also relatively large for the size of the paintings, adding to the impact. 20

Jain Book Cover with Diagram of a Cosmic Being

Gujarat; 18th century Opaque watercolor on wood 12½ x 5½ in. (31.8 x 14 cm) Jean-Claude Ciancimino

This remarkable manuscript cover is decorated with a diagram of the Jain cosmology visualized in terms of an abstract human body. The use of the human body as an analogy of the cosmos is not unique to Jainism but was developed to an advanced level of complexity in Jain metaphysical thought. Its origins probably lie in ancient Vedic hymns, which speak of the cosmos being created by the gods cutting up and sacrificing the original purusha. Put at its simplest, the cosmos and the body are both understood as expressions of a common energy system. In this cosmic diagram, the head represents the highest realm, where blissful escape can be achieved, and the feet the lowest realm, where inert matter prevails. The earth is depicted in a circular diagram of a realm known as Jambudvipa, after the jambu tree atop mythical Mount Meru at its center. From this mountain radiate the continents, oceans, and rivers. Diagrams of this type are not to be read literally but rather are to enable the meditator to grasp the macrocosm and the microcosm within a single contemplative act.

In a departure from the usual practice, where the cosmic being is a male, here the diagrammatic representation of Jambudvipa is held in the hands of a female figure, whose body is depicted as a hierarchy of cosmological realms. Above this map of the earth are the eight heavenly realms occupied by the blessed who have attained moksha, or liberation. Below are the seven levels of naraka (hell), where eternal punishments of graded degrees of horror are inflicted on the damned. The use of the human body as cosmological chart is not confined to diagrams but finds three-dimensional expression in the ground plan and elevation of Hindu and Jain temples. The spire represents Mount Meru, an axial pivot linking the upper and lower realms. Around its slopes is the sculptural program depicting the heavenly realms, and beyond the plinth radiates the earth. This cosmic vision was not exclusively Jain, but through these Jambudvipa paintings its visualization was elevated to a high degree of refinement. 20

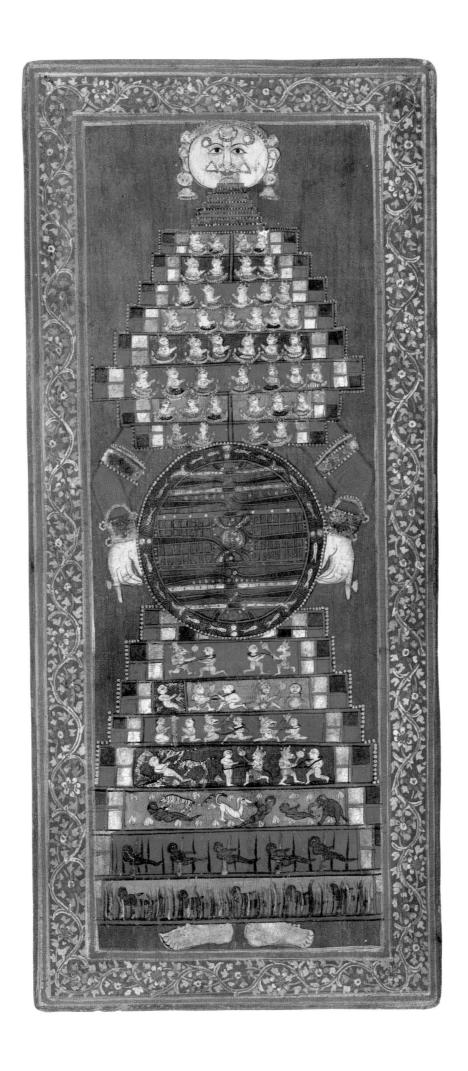

THE COSMIC AND MORTAL REALMS

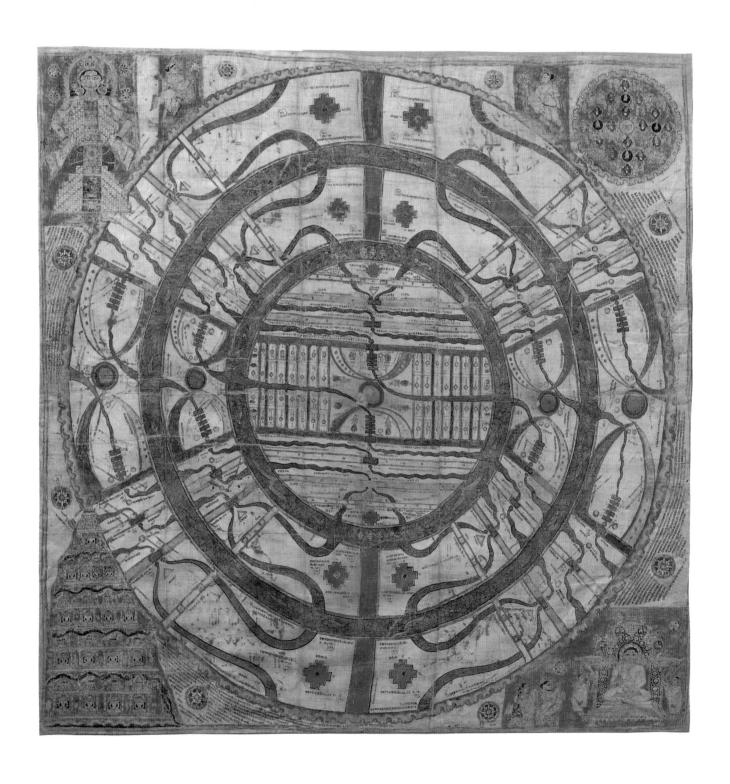

Cosmographical Paintings of the World of Mortals

- A. Western India; c. 1400

 Opaque watercolor on cotton
 c. 48 x 48 in. (121.9 x 121.9 cm)

 Private collection
- B. Gujarat, perhaps Jamnagar
 17th century
 Opaque watercolor on cotton
 31½ x 25 in. (80 x 63.5 cm)
 Private collection

In Jain cosmography the universe is divided into three worlds: the upper, occupied by the celestials; the middle, by the mortals, including all sentient beings; and the lower, belonging to the damned and the disorderly. The most important among the three is the middle world, manushyaloka, or the world of the mortals. It is the place where liberation from the chain of rebirth is possible and where the Jinas are born. Paintings of this world therefore have remained particularly popular with the devout, and two examples from different periods are included here.

Although both paintings display schematic representations of the mortal world, there are significant variations that reveal different iconographic traditions. The world is pictured as a diagram of concentric forms. The narrow blue circles and the streamerlike configurations represent water and the broader buff circles the landmasses. The central circle depicts the continent of the woodapple tree, or Jambudvipa, which includes the Indian subcontinent and has the cosmic Mount Meru in the center. This inner continent is encircled by two oceans and two

further continents. The third and outermost continent is said to end abruptly at a chain of mountains that is not clearly discernible in the earlier example. This is why such images are often called *adhai dvipa pata* (paintings of two-and-a-half continents).

It is not possible here to discuss at length the complex iconographical features of the two paintings, but a few salient features can be pointed out. Both the oceans and the continents are much more detailed in the later painting. The first ocean, known as Lavanasamudra (sea of salt), is filled with aquatic animals, human beings, and auspicious pots placed in an orderly fashion. More interesting is the lively rendering of the next ocean, known as Kalodadhi (black sea). Here there are fantastic creatures, familiar animals such as elephants, chariots with human beings, and enshrined figures of Jinas receiving homage. The two outer continents have enshrined Jinas flanked by human couples in squares along the vertical axis. The outermost continent, Pushkaradvipa (lotus continent), is fringed at its terminus by stylized mountains containing mostly animals in what appear to be caves. In the early painting only the oceans have living creatures; the continents are filled with geometrical forms, sinuous channels, and text.

сат. 98а

 сат. 98в, overleaf

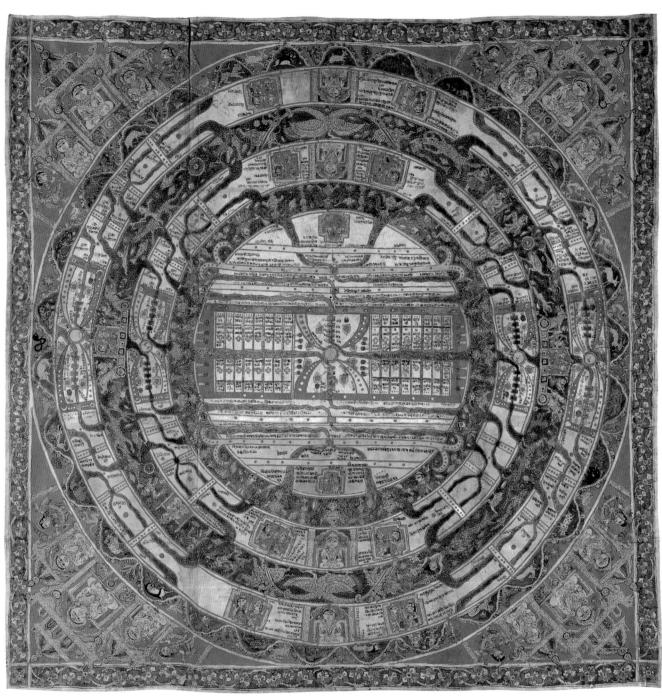

сат. 98в

The two representations also differ considerably in the field outside the mandala. In the earlier example the upper left corner is occupied by a stylized figure of a lokapurusha (cosmic man), expressing the parallel between the human body and the entire universe [97, 103]. The circular configuration at the upper right is the stereotypical representation of the mythical continent of Nandisvara-Dvipa, where the gods congregate to celebrate the birth of the Jinas. At the bottom right the enthroned monk is Gautamasvami, a renowned teacher, with adoring monks and householders. Across, in the fourth corner, is the Panchameru (five-Meru) shrine, symbolizing the central Meru of Jambudvipa and two each for the two other continents. In both paintings these five cosmic mountains are indicated by

hourglass forms in the center and along the horizontal axis. In the shrine each mountain is represented by a tier of Jinas.

In the later painting an identical array of enshrined Jinas with dancing females is in each corner. Each shrine contains three Jinas, all of them clothed and sumptuously adorned. Each is a *siddhayatana*, the shrine of a perfected being.

Both the line and the color of the early painting are particularly accomplished and are similar to manuscript illuminations of the period [82]. The more freely rendered later painting shows clear Mughal influences, particularly in the figural style as well as the costumes. 2>

S.A.

99

Victory Banner (Jayatra Yantra)

Gujarat, perhaps Ahmedabad or Patan 1447 Opaque watercolor on cloth $33^{7/8}$ x $23^{3/8}$ in. (86 x 59.4 cm) The Board of Trustees of the Victoria and Albert Museum, London

The dedicatory inscription (see appendix) informs us that this painting, characterized as a victory banner or victory diagram, was consecrated by Jinabhadrasuri, the head of the Kharatara chapter, on Diwali (the autumn festival of light and new year's day) in the year 1447 (v.s. 1504). Curiously, the space for the donor's name is left blank, which may imply that it was a readymade painting awaiting a donor. Since the painting was designed for rites meant to ensure victory, one would assume that the donor would be involved in a struggle, if not a battle, of some sort. Not only is this one of the earliest dated Jain paintings to survive, but it is also important for its subject matter. Although characterized as a victory banner, it primarily served as a visual aid in esoteric rites (yantra).

The body of the painting consists of a grid pattern divided into quadrants by two columns crossing in the center. These two columns include both numerals and mantras, while all other tiny squares contain only numbers. At the four cardinal points and at the center are larger squares with mystic syllables. Two borders of stylized flowers adorn the vertical sides.

Along the top of the painting are two registers with figures and symbols divided by a narrow band containing the dedicatory inscription. The focal point is the central parasol, which occupies both tiers. On either side of the post are female flywhisk bearers and, above, an auspicious waterpot flanked by a pair of peacocks. The umbrella is one of the fourteen jewels, symbols of a universal monarch, and the other thirteen elephant, cow, horse, general, queen, minister, wheel, conch shell, et cetera—are represented in the lower register. In the upper register are several deities including (from left to right) Ganesa, Brahma, Siva, Vishnu, Sarasvati, and two goddesses who cannot be identified. The last panel in this register depicts a stylized pool of water, flanked by two elephants set in a forest of decorative trees.

See color illustration on page 79.

At the bottom of the painting are two registers of uneven size. The upper register begins with a panel of trees followed by nine goddesses holding waterpots. They differ only in their complexions, three being darker than the others. The narrow register below is occupied by the nine planetary deities, seven elephants, and five horses. The significance of many of these iconographic elements remains unknown, but they are rendered with much finesse. Not only are the

figures articulately drawn, but the luxuriant garments and delicately limned landscape elements are similar to the most opulent manuscript illuminations of the period [82, 87]. 2>

S.A.

100

Scenes from the Life of Parsvanatha

Gujarat; c. 1475 Opaque watercolor on cloth 20 x 20 in. (50.8 x 50.8 cm) Dr. Alvin O. Bellak, Philadelphia

This is a rare and early example of a narrative painting showing scenes from the life of Parsvanatha. The central composition shows the Jina standing against a carpetlike panel of water with a thousand-headed serpent canopy above his head. This composition depicts the occasion when the titan Meghamalin had unleashed a mighty storm on Parsvanatha and the serpent king Dharanendra sheltered him with his hood. The iconic character of the representation is emphasized by the addition of adoring deities on either side of Parsvanatha, both inside and outside the central panel, and, below, the scene of a monk worshiping his footprints with the elephant-headed yaksha, also called Parsva. The other incidents of his life are portrayed with greater narrative intent in five panels, two on top and three below.

The panel in the upper left corner of the painting shows Parsvanatha meditating in heaven before his descent, followed by his birth, which is celebrated with music and dancing. In the upper right panel is the scene of his initiation. First he is being carried in an elaborate palanquin, and then he plucks his hair, which is being received by the god Indra.

The panel in the lower left depicts final liberation at the siddhasaila (hill of perfection), and the samavasarana of the gods. In the former, Parsvanatha is shown standing on a crescent moon atop a mountain, and in the latter he is seated within a mandala. Above are his parents. In the bottom center panel Parsvanatha stands between two trees, unfazed by an attacking wild elephant. The rest of the scene represents the pilgrimage of Kalikanda, with a seated Svetambara monk holding a rosary beside an image of the goddess Sarasvati. Below them are eight planetary deities. In the remaining panel we see monks and lay pilgrims arriving at the foot of the two mountain pilgrimages especially sacred to Parsvanatha. These are Sankhesvara, near Satrunjaya, and Khambhat (or Cambay), near Ahmedabad.

Except for the thousand hoods of Dharanendra, the scenes continue the iconographic tradition seen in earlier manuscript paintings. However, the theme of the central panel is depicted with much greater elaboration than one encounters in the manuscript illuminations. The story of the attack of Meghamalin and its presentation here are reminiscent of the paintings of the life of the Buddha seen both in Nepal and Tibet, where the central panel is always reserved for the similar attack of Mara. While the artist responsible for this attractive painting has adopted the aesthetic elements found in manuscript illuminations, he was particularly fond of rendering architectural details. 20

S.A.

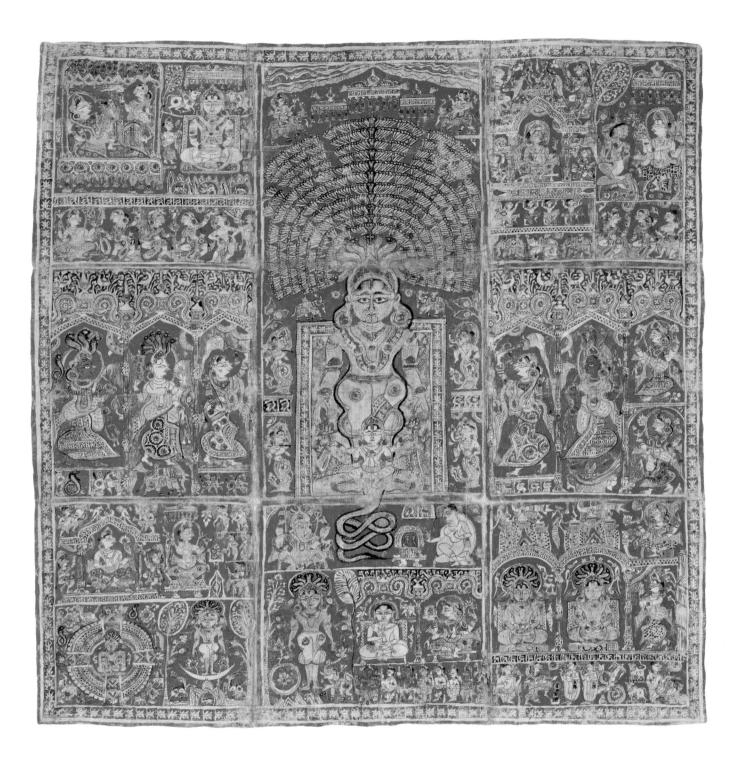

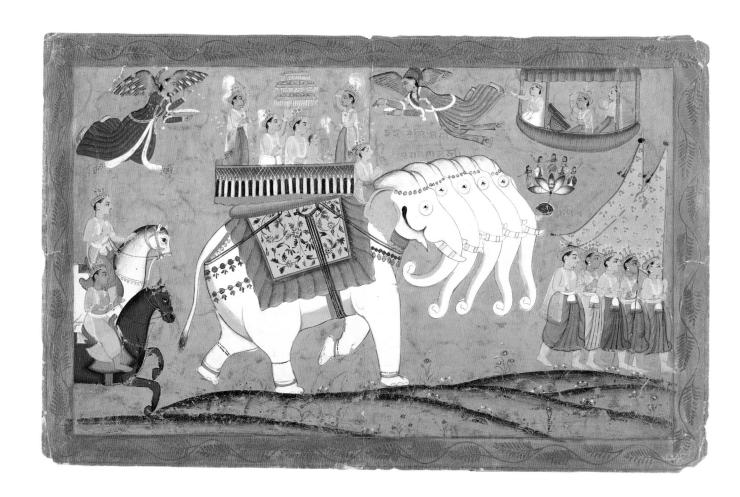

107

Indra and His Mount

- A. Indra Conveying the Infant
 Rishabhanatha
 Rajasthan, Amber; c. 1740
 Opaque watercolor and gold on
 paper; 10¹¹/₁₆ x 16³/₄ in.
 (27.1 x 42.5 cm)
 The Pierpont Morgan Library,
 New York
 Gift of Paul F. Walter
- B. Indra's Elephant, Airavata
 Western India
 Late 17th—18th centuries
 Copper alloy with silver inlay
 18 in. (45.7 cm)
 Figiel Collection, Atlantis, Florida

These two works are related to the lustration of the newborn Jinas by the god Indra on the cosmic Mount Meru [108]. The Kalpasutra describes identical lustration rites in conjunction with the lives of Mahavira, Parsvanatha, Arishtanemi, and Rishabhanatha. This painting, based on the narrative found in the Adipurana, is apparently from a series illustrating the panchakalyanaka (five auspicious events) in the life of Rishabhanatha, judging from an inscription on a folio from the same series in the San Diego Museum of Art (1990.0213) identifying the Jina's mother as Marudevi, Rishabhanatha's mother.

According to the legend (S. Doshi 1985, 95-97), shortly after Marudevi gave birth to Rishabhanatha, the god Indra and his consort, Indrani, descended from heaven and went to Marudevi's bedchamber in the palace. Indrani placed her in a trance and substituted a duplicate child for the baby Jina. Indra then took Rishabhanatha in a grand procession to Mount Meru for the lustration rites. After the ceremony, the baby Jina was returned to his mother and exchanged for the surrogate infant.

The inscription indicates that Indra is conveying the siddha [Rishabhanatha] on his mount, the multiheaded white elephant Airavata. Various celestial divinities are in attendance at the procession, including flywhisk and garland bearers and musicians. There are additional folios from the series in the San Diego Museum of Art (1990.0214), the Los Angeles County Museum of Art (M.74.102.4; Pal 1981, 28-29, no. 15), and a private collection.

The fantastically endowed elephant, B, is a rare sculpted representation of Airavata. Originally the figures of Indra and the baby Jina must have ridden in a howdah attached to the pachyderm's back via the support posts. Airavata has five trunks to indicate his celestial nature and is richly caparisoned with elegant textiles, hanging bells, and silver sheaths for his tusks.

Intriguingly, whereas most textual descriptions of Indra's elephant indicate its divine nature by stating merely that it has four or six tusks, artistic representations, such as the two here, typically portray the creature with multiple heads or trunks. This sculptural representation is even more elaborate than usual in that the trunks carry lotuses and a waterpot for lustration.

While elephants and other animals in Indian art are notoriously difficult to date on stylistic grounds alone, the attribution here is facilitated by the cuspate trellis pattern filled with foliate motifs on the saddle cloth, which together with other Mughalesque detailing suggests a date in the late seventeenth or eighteenth century (Markel 1989, 150, fig. 158). 2*

S.M.

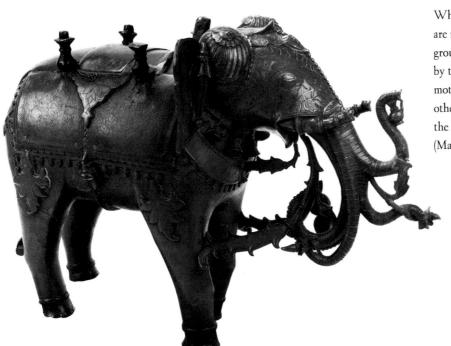

See color illustration on page 50.

Lustration of a Jina

Gujarat; c. 1800-25Opaque watercolor on paper $11\frac{1}{4} \times 7\frac{3}{8}$ in. $(28.6 \times 18.7 \text{ cm})$ Los Angeles County Museum of Art Gift of Leo S. Figiel, M.D.

The lustration of the baby Jinas on Mount Meru occurs immediately following their birth. The Kalpasutra relates that Indra and Indrani put the Jinas' mothers into a magical sleep. They then temporarily replace the baby Jinas with identical infants, taking the future saviors to Mount Meru. According to the narration of this event as it involved Mahavira, when he arrived at the mountain he playfully pushed it down with his big toe, and all the peaks bowed down to him to herald his spiritual superiority. Then, out of amazement and respect, the sixty-three other Indras (Svetambaras believe there are sixty-four Indras; Bhattacharya 1974, 10) and additional celestials bathed and anointed him (Brown 1934, 31, fig. 61).

In this painting the golden Jina is shown seated on the mountaintop receiving lustration, while winged musicians perform at his sides. Beneath the child is a crescent moon indicating the heavenly realm. The sixty-three Indras and other celestials are represented by crowned divinities who form a line on the sides of the mountain to pass the pots of water up from the cosmic ocean below. The chief Indra is at the foot of the mountain with his hands cupped to receive the divine oblations falling off the Jina.

Paintings illustrating the auspicious events in the lives of the Jinas, based on the Adipurana or Kalpasutra, were often done in sets. There is another painting from this series in the Los Angeles County Museum of Art (AC1992.270.1) that portrays Indra transporting a baby Jina on his elephant. 2>

S.M.

109

Siddhachakra

Gujarat, Ahmedabad
Late 18th—19th centuries
Couched gold- and silver-toned
twisted wire and metallic sequins
accented with applied glass and cloth;
silk and wool embroidery on silk velvet;
woven metallic ribbon binding
53½ x 32 in. (135.9 x 81.3 cm)
Private collection

This luxurious and intricately embroidered Svetambara Jain textile depicts a *siddhachakra* (circle of Jinas). Alternatively it is called a *navapada* (nine dignities), composed of the five supreme beings [13] and the four essentials of Jainism.

The five supreme beings consist of five types: the arhat (an emancipated soul establishing the Jain assembly), the siddha (an emancipated soul residing at the top of the cosmological universe), the acharya (the head of an order of Jain monks), the upadhyaya (a monk who teaches scriptures), and the sadhu (all other Jain monks). They are represented by the five seated figures in the central lotus medallion: center, north, east, south, and west, respectively. Curiously, while their respective complexions are prescribed in Jain texts to be white, red, yellow, blue, and black, here the siddha is golden, the upadhyaya is green, and the sadhu is blue. The lotus medallion is set in the center of a representation of a metal plaque, which is a more commonly surviving mode of depicting a siddhachakra.

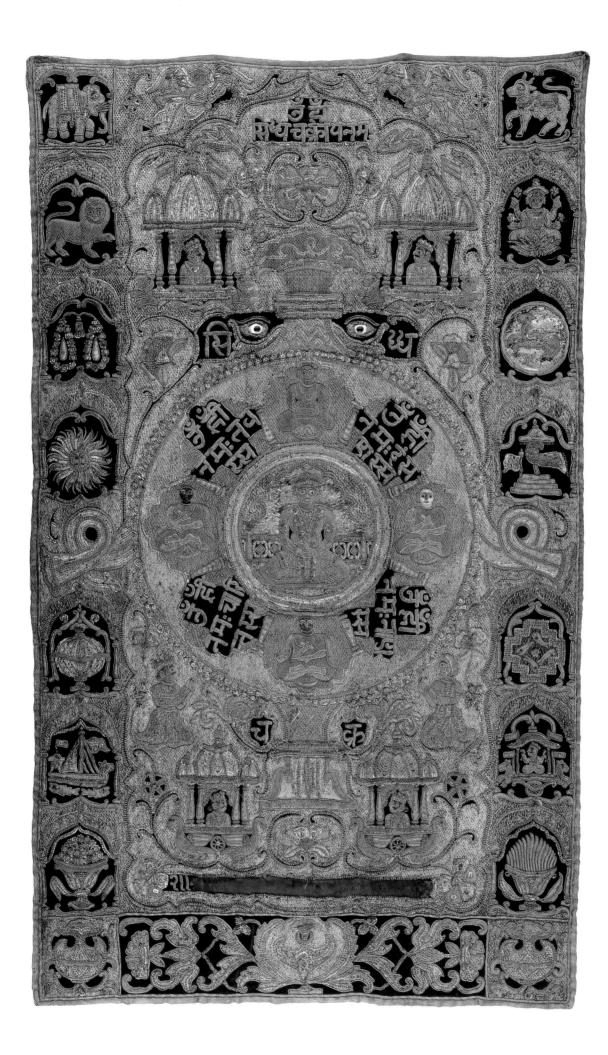

The four essentials of Jainism are written in mantras on the lotus petals between the five supreme beings. Analogous to the eightfold path of Buddhism, they are (clockwise from the northeast) right faith, right knowledge, right conduct, and right penance.

The remainder of the textile's decoration consists of a pair of glass eyes above the central medallion, four crowned male deities in celestial chariots, a pair of anonymous donor figures, various vegetal motifs, and symbols of the fourteen dreams [95] along the sides. As read from threads

remaining on the back, the now effaced and covered inscription near the bottom indicates that this is a memorial textile made in Ahmedabad.

The worship of the *siddhachakra* began relatively late in the history of Jainism, shortly after the beginning of the second millennium. They are still very much revered today, especially during the *siddhachakrapuja* festival in the month of Chaitra (March—April), when textiles such as this are hung by monks for use in the ceremonics (Shah 1955, 97—103; Ghosh, 3: 478—79).

S.M.

110

Wall Hanging and Canopy

Gujarat, probably Surat; 19th century Silver and gilt thread, gilt flat wire, flat gilt spangles, and cusped silver spangles

- A. Hanging: 58¹¹/₁₆ x 34⁵/₈ in. (149 x 88 cm)
- B. Canopy: 33⁷/₈ x 33⁷/₈ in. (86 x 86 cm) Prince of Wales Museum of Western India, Bombay

Of the two textiles shown here, the rectangular wall-hanging, known as a *chod*, provides an ornamental backdrop to the main image in a home shrine [7] and is generally offered by the donors along with the square piece, known as a *chandarva*, which is used as a canopy over the head of the Jina. Jain devotees commission such sets generally at Surat, particularly at the celebration of the end of the forty-eight-day fast.

The rectangular wall-hanging with crimson satin ground and violet borders is fully embroidered in silver and gilt materials. The main motif is a beautiful cusped arch springing from two tapering columns having bell-and-cushionshaped base and capital. The columns are adorned with leafy branches embroidered with gilded thread and spangles. The big flower on the pinnacle of the arch is flanked by peacocks. The sun and the moon are embroidered in raised work in the right and the left corners, respectively. Red silk is used for the eyes of the sun and green for the eyes and horns of the antelope within the lunar crescent. The rest of the ground is covered with golden lozenges filled with flowers of silver spangles and golden leaves. Floral designs adorn the borders and the corner squares are decorated with eight-petaled flowers on a red background. Spangles and thread form the border pattern in laid work. The flat wire,

CAT. IIOA ➤

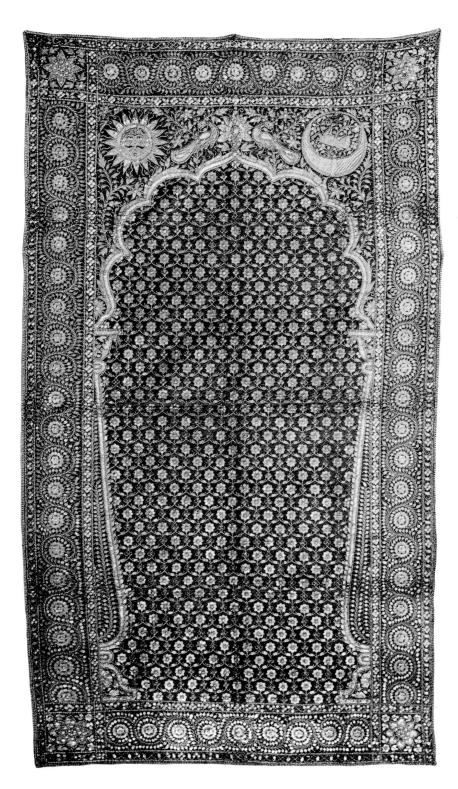

folded in a serrated pattern, forms demarcating lines between the ground and borders along all four sides of the piece. The hanging is edged with thick cotton multicolored piping and lined with crimson gajji (satin-weave silk) material. The juxtaposition of silk and silver materials effectively highlights the design, which has the effect of a relief from the use of cusped spangles in the midst of flat ones.

The square chandarva is of the same material and colors as the wall hanging. The design and embroidery of the ground and borders are also the same. Four floral sprays emerging from four corners converge into a circular central design, from the middle of which hung a tassel, now missing. The pattern, though in cotton, is reminiscent of temple ceilings, where a hanging lotus would be in the center. A thickly tasseled border is attached on all four sides. 20

S.G.

See illustration on page 67.

Panel with Sammeda-sikhara Pilgrimage

Rajasthan, Jaipur; c. 19th century White marble; 27 in. (68.6 cm) The Board of Trustees of the Victoria and Albert Museum, London

The places associated with the lives of the twenty-four Jinas, or *tirthankara*, assumed a special status in the Jain world as key pilgrimage centers. In a Hindu context a *tirtha* (bathing place) specifically refers to a sacred pool, but in Jainism the term has assumed a broader significance. This relief depicts a remarkable vista of Sammeda-sikhara ("peak of wisdom"), the most holy pilgrimage place for Jains. Jains of all sects believe that twenty of the twenty-four Jinas attained nirvana on the twenty peaks of this mountain. Sammeda-sikhara is situated near Madhuvan, in the Giridih district of Bihar.

A winding path leads the pilgrims some six miles from the town of Madhuvan to the hill shrines. Tents, carriages, wagons, and palanquins indicate the presence of pilgrims at the site, and hostels are visible in the foreground. The temples depicted in the lower left of the panel were built under the patronage of the Svetambara sect, and some date from the period of the Mughal emperor Akbar (r. 1556—1605). This tirtha continues to attract Jain pilgrims, and representations of the site (be they relief panels of this kind or, as is more common, paintings or photographs) are often to be found in Jain households today.

This panel was acquired in Jaipur in 1883 by C. Purdon Clarke, who in July of that year had been appointed the curator of the Indian collection at the South Kensington Museum.

J.G.

119

Scenes of Instruction

Rajasthan, Jaipur; c. 1800-1825

- A. Opaque watercolor and ink on paper; 10³/₄ x 8 in. (27.3 x 20.3 cm)
 Lent by the Minneapolis Institute of Arts
 Gift of Mr. and Mrs. Charles
 Cleveland and Helen Winton Jones
- B. Opaque watercolor and gold on paper; 7³/₄ x 11 in. (19.7 x 27.9 cm)
 Dr. and Mrs. Siddharth Bhansali,
 New Orleans

← CAT. 119A

сат. 119в >

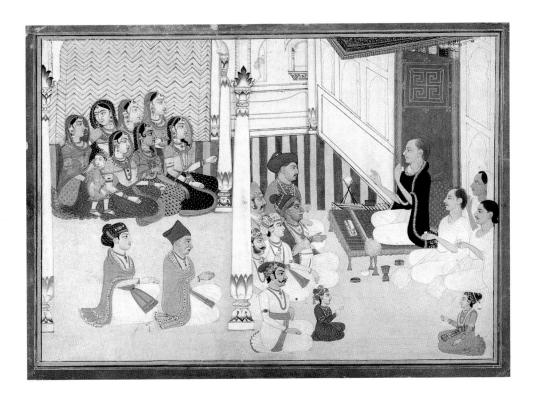

See color illustration for сат. 119в оп раде 45.

> These scenes of instruction each show a Svetambara Jain teacher expounding upon the theological complexities of the sacred scriptures and Jain precepts. The public and domestic reading of texts and the accompanying religious instruction are very important in the Jain tradition. Special letters of invitation [116] were often issued to well-known monks to spend the rainy season in a particular locale imparting religious instruction. Jain festivals typically involve the reading of texts as well as their worship in processions and rituals as symbols of knowledge.

> An inscription in the upper border of A identifies it as a portrait of Guru Gajendravijayaji. The Svetambara master is depicted here discoursing on a sacred text to an assembly of devotees segregated by gender in traditional Indian fashion. He wears a cloth mask similar to that of modern surgeons, a device habitually employed by Jain monks and ascetics to prevent the harming of small airborne creatures by breathing them in.

Apart from certain compositional differences, the second scene of instruction (B) is conceptually identical to the first. A Svetambara Jain teacher, in this case an anonymous master, is shown explicating theoretical intricacies to a group of followers, who are again grouped by gender. The open page of the manuscript in front of the teacher contains a saluatory invocaton to a siddha, or liberated being. The teacher wears a black shawl, which is unusual for portraits of Svetambara teachers, who are normally clad in white. He is flanked by three Jain monks, two of whom have their customary rajoharana (whisk broom).

Surprisingly, while the Jain teacher in the first painting is identified by the inscription but is portrayed in an idealized manner, the teacher in в is represented as a specific individual but is not identified. It is also intriguing to note in this context that the women in B are given stereotyped faces and garb, while the men are individualized. 20

S.M.

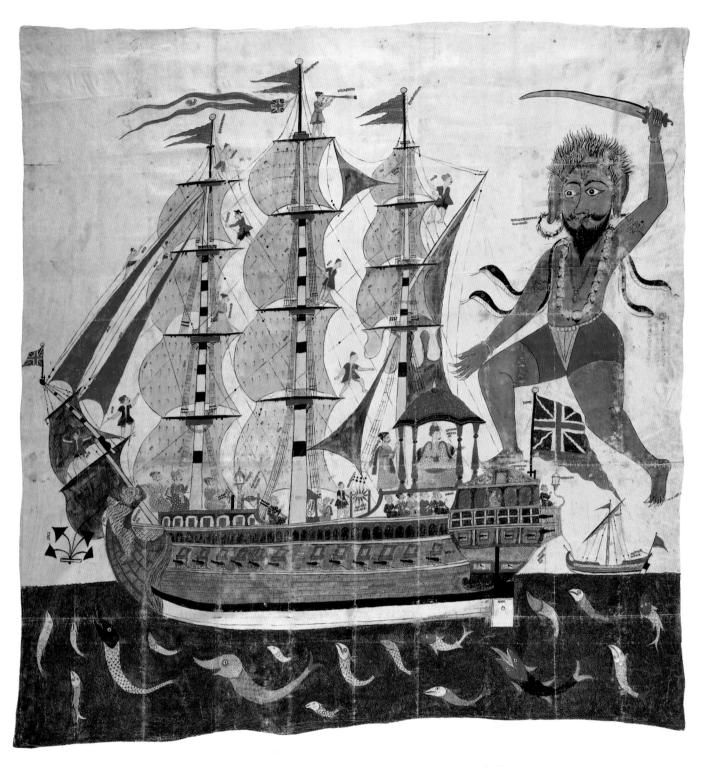

120

A Giant Demon Attacks a Ship: An Illustration to a Story from the Sripalarasa

Western India; c. 1775 Opaque watercolor on cotton 47 x 45 in. (119.4 x 114.3 cm) Private collection The painting has several small inscriptions that identify not only most of the figures but also the various parts of the ship. There is also a dedicatory inscription on the back informing us that it was commissioned in Bundi (once a state in Rajasthan) by the ascetic Chunilal Mahamuni. Unfortunately the date has been deliberately obliterated. What is curious is that the larger European-style vessel is a British ship, since it flies the Union Jack in three places, but the crew and the passengers are all Indians.

The picture illustrates an incident from a text called the *Sripalarasa* of Upadhyay Vinayavijaya. It is a didactic tale that extols the virtues of the worship of the *siddhachakra* (wheel of a liberated being)[109] and the *panchaparameshthin* (the five supreme beings)[13, 109]. The text appears to have been popular among Svetambara Jains in the eighteenth and nineteenth centuries, and a number of illustrated manuscripts are known

(Shah 1987A, 37-39). However, large paintings of incidents recounted in the story are unknown except for the present example.

Since the text remains unpublished, it is not possible to specifically identify the scene. However, in the story the protagonist Sripala, who was originally a prince, set out for distant lands to earn wealth through trade. During his voyages he was struck by many misfortunes, one of which is represented in this painting. As Sripala sits in the pavilion receiving a petition, the ship is attacked by a demonic figure who is clearly Saivite. The inclusion of a British ship suggests that the artist was from Surat, in Gujarat, which was an important British post on the Indian coast. It also demonstrates how artists adopted current modes and fashions with complete disregard for the time frame of the story. 2

S.A.

121

Game of Snakes and Ladders (Gyanbazi)

Rajasthan, perhaps Bikaner Late 19th century Opaque watercolor on cloth 23 x 20 % in. (58.4 x 52.4 cm) The Board of Trustees of the Victoria and Albert Museum, London

An early version of the familiar snakes-and-ladders board game, the quasi-religious game of gyan [jnana]-choupad or gyanbazi (game of knowledge) was popular with the Rajasthani courts in the eighteenth and nineteenth centuries, especially with the ladies. Played universally in India, it is available in Hindu, Muslim, and Jain versions. As a pastime the game became popular among Jain nuns and was regarded as an edifying religious pursuit. Subsequently it lost its seriousness and became a purely recreational activity.

The present pata is a fine example of a Jain version. The checkered board, representing the progress of one's life, is divided into eighty-four numbered squares, each with words pointing out the rules of conduct and the good and bad effects thereof. The game is played by throwing dice. The ladders denote good behavior and virtues that elevate the player to a higher level. The snakes denote downfall: the player descends to the tail after landing on the head.

The four-tiered pavilion at the top represents the heavens. Its summit, occupied by a crescent-shaped *siddhasaila* flanked by peacocks, is where the liberated beings live. A good Jain should strive hard to reach this goal by avoiding misconduct and attaining knowledge. The pavilion is flanked by the sun god astride a seven-headed horse and the moon god riding an antelope. ?

S.A.

See color illustration on page 87.

Chandra, R. 1936. Medieval Indian Sculpture in the British Museum. London: Kegan Paul Trench Trubner.

Chapple, C. K. 1993. Nonviolence to Animals, Earth, and Self in Asian Traditions. Albany: State University of New York Press.

Chatterjee, A. K. 1978. A Comprehensive History of Jainism (up to 1000 A.D.). Calcutta: Firma KLM.

——. 1984. A
Comprehensive History of Jainism
(1000 A.D. to 1600 A.D.).
Calcutta: Firma KLM.

Chenna, R. P. 1986. "Guilds as Promoters of Fine Arts in Medieval Andhradesa." Quarterly Journal of the Mythic Society 77, nos. 1–2: 168–74.

Chojnacki, Charlotte. Forthcoming. French translation of the Vividhatirthakalpa. Pondicherry.

Clementin Ojha, Catherine. 1990. La Divinite conquise. Nanterre: Société d'Ethnologie.

Colas, Gerard. 1990. "Le Devot, le pretre et l'image vishnouite en Inde du sud." In l'Image divine: Culte et meditation dans l'Hindouisme. Ed. Andre Padoux. Paris: Editions du Centre National de la Recherche Scientifique.

Coomaraswamy, A. 1914.
"Notes on Jaina Art." In
Journal of Indian Art and
Industry 16, no. 127: 81–97.

——. 1930. "An Illustrated Svetambara Jaina MS of A.D. 1260." Eastern Art 2: 237–40.

_____. 1980. Yaksas. New Delhi: Munshiram Manoharlal.

____. 1993. Jaina Art. Delhi: Munshiram.

Cort, J. E. 1988. "Pilgrimage to Shankheshvar Parshvanath." Center for the Study of World Religions Bulletin 14, no. 1: 63–72.

. 1989. Liberation and Wellbeing: A Study of the Svetambar Murtipujak Jains of North Gujarat. Ph. D. dissertation, Harvard University.

. 1991A. "Twelve Chapters from The Guidebook to Various Pilgrimage Places, the Vividhatirthakalpa of Jinaprabhasuri." In The Clever Adultress and Other Stories: A Treasury of Jain Literature. Ed. Phyllis Granoff. Oakville, Ontario: Mosaic Press.

. 1991B. "The Jain Sacred Cosmos: Selections from a Medieval Pilgrimage Text." In The Clever Adulteress: A Treasury of Jain Stories, Ed. Phyllis Granoff. Oakville, Ontario: Mosaic Press.

in Svetambar Jain Temples." In Religion in India. Ed. T. N. Mandan. Delhi: Oxford University Press.

. 1991D. "The Svetambar Murtipujak Jain Mendicant." Man 26: 651–71.

. 1992. "Svetambar Murtipujak Jain Scripture in a Performative Context." In Texts in Context: Traditional Hermeneutics in South Asia. Ed. J. R. Timm. Albany: State University of New York Press. ——. 1993. "An Overview of the Puranas." In Purana Perennis. Ed. Wendy Doniger. Albany: State University of New York Press.

———. Forthcoming A. "The Jain Knowledge Warehouses: Traditional Libraries in India."

———. Forthcoming B. "The Rite of Veneration of the Jina Images (Caitya-Vandana)." In Religious of India. Ed. Donald S. Lopez. Princeton: Princeton University Press.

Craven, R. 1979. "A Svetambara Jain Shrine." In Pharos 16, no. 2: 16–23.

Das, H. C., C. Das, and S. R. Pal, eds. 1976. Buddhism and Jainism. Orissa: Institute of Oriental and Orissan Studies.

Dehejia, Vidya. 1988. "Southern Indian Art." Orientations 19, no. 7: 58–71.

Del Bonta, R. J. 1987. "The Jaina Sculpture of Varuna." Kusumanjali 2: 273—76.

Desai, P. B. 1965. "Yakshi Images in South Indian Jainism." In Felicitation Volume (A Collection of Forty-Two Indological Essays) Presented to Mahamahopadhyaya Dr. V. V. Mirashi. Eds. G. T. Deshpande, Ajay Mitra Shastri, and V. W. Karambelkar. Nagpur: Vidarbha Samshodhan Mandal.

Desai, R. D. 1981. The Chaturmukh Jain Temple of Ranakpur. Ahmedabad: Seth Anandji Kalyanji Trust.

Devendra, Muni. 1983. A Sourcebook in Jaina Philosophy. Udaypur: Sri Tarak Guru, Jain Granthalaya.

Dhaky, M. A. "The Jaina Temples in Harasur." Kusumanjali 1: 197–200.

Doniger, Wendy, ed. 1993. Purana Perennis: Reciprocity and Transformation in Hindu and Jaina Texts. Albany: State University of New York Press.

Doshi, D. 1978. "The Panchakalyanaka Pata, School of Aurangabad." Marg 31, no. 4: 45—54.

Doshi, S. 1982. Homage to Shravana Belgola. Bombay: Marg Publications.

. 1983. "Islamic Elements in Jain Manuscript Illustration." In The Age of Splendour, Eds. Karl Khandalavala and Saryu Doshi. Bombay: Marg Publications.

_____. 1985. Masterpieces of Jain Painting. Bombay: Marg Publications.

———. 1994. "Colour, Motif, and Arabesque." In India and Egypt: Influences and Interactions. Ed. Saryu Doshi in association with Mostafa El Abbadi. Bombay: Marg Publications.

Doshi, S. and A. Sundara. 1983. "Jain Centres of Worship." Marg 35, no. 1: 15–30.

Dundas, Paul. 1992. The Jains. London: Routledge. Dwivedi, R. C., ed. 1975. Contribution of Jainism to Indian Culture. Varanasi: Motilal Banarsidass.

Ekambaranathan, A. and C. K. Sivaprakasam. 1987. Jaina Inscriptions in Tamil Nadu (A Topographical List). Madras: Research Foundation for Jainology.

Fischer, E. and J. Jain. 1974. Kunst und Religion in Indien: 2500 Jahre Jainismus. Zurich: Vertrieb Museum Rietberg.

. 1977. Art and Rituals: 2500 years of Jainism in India. New Delhi: Sterling Publishers.

Fleet, J. 1970. Corpus Inscriptionum Indicarum: Inscriptions of the Early Gupta Kings and Their Successors. Vol. 3, appendix 5. Varanasi: Indological Book House.

Folkert, K. W. 1989. "Jain Religious Life at Ancient Mathura: The Heritage of Late Victorian Interpretation." In Mathura: The Cultural Heritage. Ed. D. M. Srinivasan. New Delhi: American Institute of Indian Studies.

Forbes, A. K. 1924. In Ras Mala. Ed. H. G. Rawlinson. London: Oxford University Press.

Frauwallner, E. 1953–56. Geschichte der indischen Philosophie. 2 vols. Salzburg: Otto Muller.

Gadre, A. S. 1946. "A Rare Jaina Sculpture from the Baroda Museum (1301 A.D.)." Bulletin of the Baroda State Museum and Picture Gallery 2, pt. 2: 15–20. Ganesan, T. 1986. "Jaina Vestiges of Tirunarungonda in South Arcot District, Tamil Nadu." In Essays in Indian History and Culture. Ed. Y. Krishan. New Delhi: Indian History and Culture Society.

Ganguli, Kalyan Kumar. 1984. "Jain Art of Bengal." Jain Journal 18, no. 4: 130–36.

Ghosh, A., ed. 1974–75. Jaina Art and Architecture. 3 vols. New Delhi: Bharatiya Jnanpith.

Glasenapp, H. V. 1925. Kultur und Weltanschauung Der Jainismus. Berlin: Alf Hager Verlag.

_____. 1984. Der Jainismus: Eine Indische Erlosungsreligion. Hildesheim: G. Olms.

Goepper, R. 1993. "Early Kashmiri Textiles? Painted Ceilings in Alchi." In Transactions of the Oriental Ceramic Society 56 (1991–92): 47–74.

Gopalan, S. 1991. Jainism as Meta-Philosophy. New Delhi: Sri Satguru.

Gorakshakar, S. 1964–66. "A Dated Manuscript of the Kalakacharya Katha in the Prince of Wales Museum." In Bulletin of the Prince of Wales Museum of Western India 9: 56–57.

_____. 1981. "Jain Metal Images from the Deccan-Karnataka." Marg 33, no. 3: 89–99.

Goswami, R. P. 1979. Astadikpalas in Literature and Art. Ph. D. dissertation, University of Poona. Granoff, Phyllis, ed. 1991. The Clever Adulteress: A Treasury of Jain Stories. Oakville, Ontario: Mosaic Press.

_____. 1992A. "The Householder as Shaman: Jain Biographies of Temple Builders." East and West 42, nos. 2—4: 301—19.

_____. 1992B. "Worship as Commemoration: Pilgrimage, Death, and Dying in Medieval Jainism." Bulletin d'Etudes Indiennes 10: 181–202.

_____. 1993. "Halayudha's Prism: The Experience of Religion in Medieval Hymns and Stories." In Gods, Guardians, and Lovers: Temple Sculptures from North India, A.D. 700–1200. Eds. Vishakha N. Desai and Darielle Mason. New York: The Asia Society Galleries.

———. Forthcoming B.

"Patrons, Overlords, and
Artisans: Some Comments on
the Intricacies of Religious
Donations in Medieval
Jainism." In Sir William Jones
Bicentenary of Death
Commemoration Volume. Ed. V.
N. Misra. Bulletin of the
Deccan College Post-Graduate
and Research Institute.

Granoff, P. and Koichi Shinohara. 1992. Speaking of Monks: Religious Biography in India and China. Oakville, Ontario: Mosaic Press.

Gupta, P. 1993. Rasa in the Jaina Sanskrit Mahakavyas from the Eighth to Fifteenth Century A.D. Delhi: Eastern Book Linkers.

Gupta, P. L., ed. 1965. Patna Museum Catalogue of Antiquities. Patna: Patna Museum.

Guy, J. 1982. Palm-Leaf and Paper: Illustrated Manuscripts of India and Southeast Asia. Melbourne: National Gallery of Victoria.

Guy, J. and D. A. Swallow 1992. Arts of India: 1550–1900. London: Victoria and Albert Museum.

Hartel, H. 1993. Excavations at Sonkh. Berlin: Dietrich Reimer Verlag.

Humphrey, C. 1985. "Some Aspects of Jain Puja: The Idea of 'God' and the Symbolism of the Offerings." Cambridge Anthropology 9, no. 3: 1–19.

Humphrey, C. and M. Carrithers. 1990. The Assembly of Listeners: The Jains in Society. Cambridge: Cambridge University Press. Humphrey, C. and J. Laidlaw. Forthcoming. Archetypal Actions: A Theory of Ritual. Oxford: Clarendon Press.

Jain, C. R. 1926. The Jaina Puja. Bijnor: the author.

Jain, J. 1964. The Jaina Sources of the History of Ancient India (100 B.C.—A.D. 900). Delhi: Munshiram Manoharlal.

Jain, J. and E. Fischer. 1978. Jain Iconography. Vol. 1, The Tirthankara in Jaina Scriptures, Art, and Rituals. Vol 2, Objects for Meditation and the Pantheon. Leiden: E. J. Brill.

Jain, J. C. 1984. Life in Ancient India, as Depicted in the Jain Canon and Commentaries: Sixth Century B.C. to Seventeenth Century A.D. Delhi: Munshiram Manoharlal.

Jain, S. K. and K. C. Sogani, eds. 1985. Perspectives in Jaina Philosophy and Culture. New Delhi: Ahimsa International.

Jain, S. S. 1953. Colossus of Shravanbelgola and Other Jain Shrines of Deccan. Motiwala: Jain Publicity Bureau.

Jaina, Sagaramala. 1983. Doctoral Dissertations in Jaina and Buddhist Studies. Varanasi: P. V. Research Institute.

Jaini, P. 1993. "Jaina Puranas: A Puranic Counter-Tradition." In Purana Perennis. Ed. Wendy Doniger. Albany: State University of New York Press.

Jaini, P. S. 1956. "The Concept of Arhat." In Acarya Srivijayavallabhasuri Smaraka Grantha. Bombay: Sri Mahavira Jaina Vidyalaya Prakasan. _____. 1976. "The Jainas and the Western Scholar." Sambodhi 5: 121-31.

_____. 1979. The Jaina Path of Purification. Berkeley: University of California Press.

_____. 1980. "The Disappearance of Buddhism and the Survival of Jainism: A Study in Contrast." In Studies in the History of Buddhism. Ed. A. K. Narain. Delhi: B. R. Publishing.

Jash, P. 1989. Some Aspects of Jainism in Eastern India. New Delhi: Munshiram Manoharlal.

Joharapurakar, Vidyadhara. 1965. Tirthvandanasamgraha. Sholapur: Jivaraja Jaina Granthamala.

Johnson, A., trans. 1931–64. Trisastisalakapurusacarita. 6 vols. Baroda: Gaekwad Oriental Series.

Joshi, N. P. 1989A. Brahmanical Sculptures in the State Museum, Lucknow. Vol. 2, pts. 1 and 2. Lucknow: State Museum.

_____. 1989B. "Early Jaina Icons from Mathura." In Mathura: The Cultural Heritage. Ed. D. M. Srinivasan. New Delhi: American Institute of Indian Studies.

Joshi, S. 1985. Masterpieces of Jain Painting. Bombay: Marg Publications.

Kalyanvijay Gani, Pannyas. 1966. Srijinapuja Vidhi-Sangrah. Jalor: Sri Kalyanvijay Sastra-Sangrah-Samiti. Khandalavala, K. and M. Chandra. 1962. "An Illustrated Kalpasutra Painted at Jaunpur in A.D. 1465." In Lalitkala 12: 8—15.

Kramrisch, S. 1986. Painted Delight: Indian Paintings from Philadelphia Collections. Philadelphia: Philadelphia Museum of Art.

Kreisel, Gerd. 1987. Südasien-Abteilung. Stuttgart: Linden-Museum.

Krishna, A. 1962. "A Stylistic Study of an Uttaradhyayana Sutra MS Dated 1591 A.D. in the Museum and Picture Gallery, Baroda." Bulletin of the Museum and Picture Gallery, Baroda 15: 1–12.

Krishna Deva. 1987. Khajuraho. New Delhi: Brijbasi.

Laidlaw, James. 1985. "Profit, Salvation, and Profitable Saints." Cambridge Anthropology 9, no. 3: 50–70.

_____. 1990. The Religion of Svetambar Jain Merchants in Jaipur. Ph. D. dissertation, King's College, Cambridge University.

Leach, Linda York. 1986.
Indian Miniature Paintings and
Drawings (Part 1 of The
Cleveland Museum of Art
Catalogue of Oriental Art).
Cleveland: The Cleveland
Museum of Art in association
with Indiana University Press.

Legge, J. 1965 (reprint of 1886 edition). A Record of Buddhistic Kingdoms, Being an Account by the Chinese Monk Fa-Hien of His Travels in India and Ceylon (A.D. 399–414) in Search of the Buddhist Books of Discipline.

New York: Dover.

Lerner and Kossak. 1991. The Lotus Transcendent. Museum of Modern Art/Abrams.

London. 1982. In the Image of Man: The Indian Perception of the Universe through Two Thousand Years of Painting and Sculpture. Exh. cat. Hayward Gallery. New York: Alpine Fine Arts Collection.

Losty, J. P. 1992. The Art of the Book in India. London: British Library.

Majumdar, M. R. 1946–47.

"Some Interesting Jain
Miniatures in the Baroda Art
Gallery." In Bulletin of the
Baroda State Museum and Picture
Gallery 4, pts. 1 and 2: 27–32.

Manatungasuri. 1932.
Bhaktamara-Kalyanamandira-Namiuna-Stotra-Trayam. Ed.
Hiralal Rasikdas Kapadia.
Surat: Sheth Devchand
Lalbhai Jain Pustakoddhar
Fund Series (no. 79).

Markel, Stephen A. 1988. "A Marble Sculpture of Sarasvati by Jagadeva." Orientations 19, no. 5: 73–75.

______. 1989. "Jades, Jewels, and Objets d'Art." In Romance of the Taj Mahal. Ed.
Pratapaditya Pal. Los Angeles:
Los Angeles County Museum of Art in association with
Thames and Hudson.

_____. 1994. Origins of the Indian Planetary Deities.
Lewiston, New York: The Edwin Mellen Press.

Mathur, A. R., ed. 1988. The Great Tradition: Indian Bronze Masterpieces. New Delhi: Brijbasi Printers. Mead, Margaret. 1973. "Ritual and Social Crisis." In The Roots of Ritual. Ed. James D. Shaughnessy. Grand Rapids: William B. Eerdmans.

Mehta, N. C. 1925. "Indian Painting in the 15th Century: An Early Illustrated Manuscript." Rupam 22–23: 61–65.

_____. 1984. "Jaina Temples of Western India." Marg 36, no. 3: 96–97.

Misra, Ram Nath. 1981. Yaksha Cult and Iconography. New Delhi: Munshiram.

Meister, M. W. 1973. "Ama, Amrol, and Jainism in Gwalior Fort." *Journal of the Oriental Institute* (Baroda) 22, no. 3: 354–58.

Meshram, P. S. 1984. "Jaina Images from Masal." *Indica* 21: 87—90.

Mitra, D. 1959. "Sasanadevis in Khandagiri Caves." Journal of Asian Studies 1, no. 2: 127–33.

Moeller, V. 1974. Symbolik des Hinduismus und des Jainismus Tafelband. Stuttgart: Hiersemann.

Mohapatra, R. P. 1984. Jaina Monuments of Orissa. Delhi: D. K. Publications.

Muller, F. Max, ed. 1964. Sacred Books of the East. Vols. 22 and 45. Delhi: Motilal Banarsidass.

Nagarch, B. L. 1985.
"Antiquity of Adinath Jain
Temple at Palal." Jain Journal
20, no. 1: 13-23.

_____. 1987. "Newly Discovered Jaina Temple and Other Sculptures from Udaipur, District Vidisha (M. P.)." In Indological Studies: Essays in Memory of Shri S. P. Singhal. Ed. D. Handa. Delhi: Caxton.

Nanavati, J. M. and M. A. Dhaky. 1963. The Ceilings in the Temples of Gujarat. Baroda: B. L. Mankad for the Museum and Picture Gallery.

Nandi, R. N. 1980. "Client, Ritual, and Conflict in Early Brahmanical Order." Indian Historical Review 6, no. 1: 63–118.

Nath, R. 1981. "Note on the Individuality of Jaina Art." Jaina Antiquary 34: 33–38.

Nawab, S. M. 1956. Masterpieces of the Kalpasutra Paintings. Ahmedabad: S. M. Nawab.

_____. 1959. The Oldest Rajasthani Paintings from Jain Bhandars. Ahmedabad: S. M. Nawab.

Nawab, S. M. & Nawab, R. S. 1985. Jain Paintings, Volume 2: Paintings on Paper Commencing from v.s. 1403 to v.s. 1656 Only. Ahmedabad: S. M. Nawab.

Nicholson, J. H. 1987. Jainism: Art and Religion. Leicester: Leicester Museum Publications.

Norton, A. W. 1981. The Jaina Samavasarana. Ph. D. dissertation, New York University.

Padmarajiah, Y. J. 1984. The Jaina Theories of Reality and Knowledge: A Comparative Study. Delhi: Eastern Book Linkers. Pal, Pratapaditya. 1977. The Sensuous Immortals. Los Angeles: Los Angeles County Museum of Art.

______. 1978A. The Classical Tradition in Rajput Painting from the Paul F. Walter Collection. Exh. cat. New York: Pierpont Morgan Library and the Gallery Association of New York State.

_____. 1978b. The Ideal Image: The Gupta Sculptural Tradition and Its Influence. New York: The Asia Society in association with Weatherhill.

_____. 1981. Elephants and Ivories. Los Angeles: Los Angeles County Museum of Art.

______. 1988. Indian Sculpture, Volume 2 (700–1800): A Catalogue of the Los Angeles County Museum of Art Collection. Los Angeles: Los Angeles County Museum of Art in association with University of California Press.

_____. 1991. Art of the Himalayas: Treasures from Nepal and Tibet. New York: Hudson Hills in association with the American Federation of Arts.

_____. 1993. Indian Painting, Volume 1 (1000–1700): A Catalogue of the Los Angeles County Museum of Art Collection. Los Angeles: Los Angeles County Museum of Art in association with Mapin.

Paris. 1960. Art Tantrique. Exh. cat. Le point cardinal, 17 fevrier-fin mars. Texts by Henri Michaux, Octavio Paz, Souren Melikian. Patel, H. (n. d.) Silent Beauty of Stones: Architecture of Jainism. Ahmedabad: the author.

Pereira, J. 1977. Monolithic Jinas. Delhi: Motilal Banarsidass.

Prasada, Siva. 1992. Jaina Tirtho ka Aitihasika Adhyayana. Varanasi: Parsvanatha Vidyasrama Sodha Samsthan.

Punyavijayaji, M. and U. P. Shah. 1966. "Some Painted Wooden Book-Covers from Western India." Journal of the Indian Society of Oriental Art Special Number: 34—44.

Ramaniah, J. 1989. Temples of South India (A Study of Hindu, Jain and Buddhist Monuments of the Deccan). Delhi: Concept Publishing.

Ramaswami Ayyangar, M. S. and Seshagiri B. Rao. 1982 (reprint of 1922 edition). Studies in South Indian Jainism. 2 vols. Delhi: Sri Satguru.

Rosen, Elizabeth S. 1986. The World of Jainism: Indian Manuscripts from the Spencer Collection. New York: New York Public Library.

Roth, Gustav. 1983. "Legends of Craftsmen in Jaina
Literature, Including Notes on the Bell-Frieze and Mount
Mandar in the Jaina Canon and in Ancient Indian Art."
Indologica Taurenensia 11:
211-26.

Roy, A. K. 1984. A History of the Jainas. New Delhi: Gitanjali.

Roy Choudhury, P. C. 1986. "Buchanan's References to Jain Shrines." Jaina Antiquary 39, no. 1: 29–36.

SANSKRIT NAMES AND TERMS WITH DIACRITICAL MARKS

abhayamudrā āchārya āḍhāi dvīpa paṭa Ādi-Gaud Ādinātha Ādipurāņa Airāvata Ajitanātha Ambikā anekāntavāda anityavādin Arishtanemi Ārya Vridhahasti Āryadeva ashtadikpāla ashtamangala aśoka āstika daršana

Bhadrayaśas Bhagavadgītā bhāmaṇḍala bhandār bhāya

Asurakumāra

ātman

avidyā

āyagapata

Balarāma

Bhadravatī

Bālagopālastūti

Bappabhattisūri

Bilvamangala brahmachārin brāhmana Brāhmī Bhaktamāra Stotra Chaityavāsin Chakreśvarī Chālukya Chāmundarāya Chandrānana chandraśālā Chaurapañchāśikā chitra kāvya chitrapata Chitrasūtra dakshināvarta

dāna
daršana
devagaṇa
devanāgarī
Devanandā
devapūjā
Devī
dharamsālā
Dharaṇa
Dharaṇendra
dharmašāstra
dhyānamudrā
dikkumārī
Durgā Mahishāsuramardinī

Durgā Mahishāsuramard dvārapāla ekāntavāda gajasiṃha gaṇa gandhakutī Ganeśa Ganga Garuda gatṭāji Gaurī

Gautamasvāmī Gommateśvara

gopī Guṇachandra haṃsa Harivaṃśa hāthi Hoyśala

Indrāņī Indrasabhānāṭaka Jambudvīpa Jāṅgulī

hrim

Jayasimha Siddharāja

Jayavatī Jineśvara jñāna jñānapūjā Kālaka

jatāmukuta

Kālakāchāryakathā

kalaśa Kālī

Kalpa-pradīpa Kalpasūtra Kāmakaṇḍalā Kāmasena Kāmatha Pāla karandamukuta pān Pañchadaśī karnadardarikā Kārttika pañchakalyānaka Kārttikeya Pañchameru pañchaparameshthin kāyotsarga pañcha tīrthī pata kevalajñāna kīrtimukha Pañchika krauñcha parikāra Pārśvanātha kshamāpana patrikā Pārśvillagaņi kshetrapāla Pārvatī Kottiya paryushana kukkutasarpa patachitra Laghu Samgrāhanisūtra Lakulīśa pāṭalī lalitāsana pātli lāñchchita pato Prabandhakośa Mahābhārata prabhāvalī mahāvidyā Mahāvīra prajñā Mallinātha Prajñāpāramitā Manasā prakritī Mānatuṅga pramāņa pratihārya mandapa Mānikya Pratyangirā Pravachanasāra Mañjuśrī mantrākshara pūjā Pūjyapāda mānyushaloka mātulinga Pundarīka Pūrnabhadra māyā Pushkaradvīpa Mūrtipūjak nāgarāja Rādhā Nandīśvara Rajamatī Nandvāvarta Rāmāyana rangamandapa Narasimha Nārāyaṇa Rāshtrakuta Ravisena nātha Rishabhanātha natta rishi navapāda Nirvānabhakti sabhāmaṇḍapa Sachikā nityavādin

Padmapurāṇa Sachiyamātā
padmaśālā sādhanā
padmāsana sādhu
padmaśīlā sādhvi
Padmāvatī sādhya
Sadyojāta
śāhi
Śaiva

Śaka śākhā Śakra śakti Śaktikumāra Śākyamuni Samkara Sāmkhya samsār chakra paṭa samsāra Samyuta Nikāya sangha Śaṅkha Jinālaya śāntarasa Śāntinātha Śāntyāchārya sapta bhangi naya Sarasvatī Sarvānubhūti

śāśana devatā Śesha siddhapratimā śikhara Śīlabhadragani Simhanandi simhāsana Śiva Śivādevī Śivamkara Śivanāga Solānki Somabhatta śramana śrāvikā Śrī-Lakshmī Srīmantivai sringāra Śrīpāla śrīvatsa śudra Sumangala Supārśvanātha sūrī

Sūrya svadhyāya Śvetāmbara syādvāda tarjanīmudrā tīrthaṅkara toraṇa Triśalā

Trishashṭisalākāpurushacharita

tritirthīka Upadeśamālā upādhyāya

Upādhyāy Vinayarijaya

ushṇisha
Uttaradhyānasūtra
Vaiśākha
Vaishṇava
vaiśya
Vajrāṅkuśa
Vajraṣriṅkhalā
Vajrayāna
varnāśrama dharma

Vastupāla Vāsudeva Vāsuki vidyā vidyādevī Vijñāptipatra

vīṇā virāsana vīrya Vishņu

Vishņudharmottarapurāņa

Viśvakarmā Vṛishabhanātha vyāntaradevatā Yoganidrā yajña yakshī yamapaṭṭa Yaśodā

INDEX

Index prepared by Andrew L. Christenson.

Asterisks denote illustrations.

```
A
Acharadinakara, 176
Adinatha temple, *28, 252
Aghora, 32
ahimsa, 30, 59
Ahmedabad, 90, 92, 109, 244
Airavata, *207, *240, *241
Ajanta, 94
Ajitinatha, *31, *38, 145, 250
Akbar, 249
Akbari period, 215, 216, 254
Akota, 142
altarpieces, *33, *138, *143,
    145, *146-8, *150, *159,
    *163, *181
Ama, 69, 71
Ambika, 17, 33, 34, *35–36,
   71, *137, *142, *143,
    *148, *176, *177, *178-79
Antagaddasao, 128
architectural pieces:
   archway, *102, *103
   assembly hall, 110, *111
    pedestal, *104
    railing pillar, *105
    reliefs, *106-7, *114,
      115, *116
   See also domestic shrines
Arishtanemi, 164, 241
    See also Neminatha
Ashtapada, 65
Asurakumara, *98, 216
Atharvaveda, 36
```

ayagapata, 22, 26, 78, *118, 119

```
B
Bahubali, 15, *20, 28, 65,
    *157-58
Baladeva, *168-69
    See also Balarama
Balagopalastuti, 97, 206, *207
Balamitra, *203, 204
Balarama, 26, 33, 127, *128,
    164, 169
Bappabhattisuri, 68-69, 71
Basawan, 249
Bengal, 94
Bhadravati, 190
Bhagavadgita, 160
Bhagela, 21
Bhairava, *56, 228
Bharata, 65, 66, 157
Bharhut, 103, 105, 199
Bihar, 16, 20, 26, 94
    Ambika in, 34, 35
    bronzes, 25, 152, 175,
      176, 180
Bijapur, 97, 219
Bilvamangala, 206
Brahma, 30, 32, 66, *79,
    *238,239
Brahmanical tradition, 14,
    57 - 58
bronzes, 24-25
   See also altarpieces
```

```
Buddha: as baby, 174
    figures of, *30, 129
    first sermon of, 27, 142
    paintings of the life of, 226
    protected by serpent, 32
    rejection of austerities
      by, 14
   as yogi, *30
Buddhism, 16
   beliefs, 13-14, 59
   differences from Jainism,
       14, 59
    pantheon, 30
    philosophers, 59
   pilgrimage, 67
   royal support of, 20
   similarities to Jainism, 14,
      15, 16, 18, 29-30, 33
Buddhist art:
   cloth painting, 77
   flywhisk bearers in, 192
   mandala, 80, 122
   manuscript painting, 93, 94
   similarities to Jain art, 25,
      26, 27, 30-31, 34, 135,
      165, 174
   violence in, 30
C
caste system, 14, 58
```

celestial: drummer, *194

Chakresvari, 34, *36, *138,

*143, *181

garland bearers, *27, *136

nymphs, *195, 196, *197

phases of, 25-30 Η Chalukya dynasty, 91-92, Durga, 17, 30, 34, 66, 180, production of, 23-24 halo, 30-31 228, *238, 239 162, 181 ritual function of, 39, 46 Harappa, 16 Champa, 190 similarity to Buddhist art, E Harinegameshin, 26, 34, *48, Chamundaraya, 20 25, 26, 27, 30-31, 34, *170, *204, 218 Ellora, 23, 28, 33 Chandranana, 120 Harivamsa, 128, 164 135, 165, 174 chaumukha, *121, *132-33 similarity to Hindu art, 25, Hemachandra, 186 F Chaurapanchasika style, 214 Hemachandrasuri, 21, 252 26, 30-31, 34 chauri bearers Fa-hsien, 89 Hindu art: mandalas, 122 tranquility in, 30 flywhisk bearers, *27, 120, See flywhisk bearers Jainism: absorption of Krishna 130, *131, *134, *136, painted manuscripts, 97, Chausa bronzes, 24, *25 cult, 214 206, *207, 217 *137, *138, *144, 145, chitra kavya, 78 acceptance of female *146, *147, *148, *152, similarity to Jain art, 25, Chola dynasty, 20, 156, deities, 28 *154, *155, *163, *165, 26, 30-31, 34 161, 178 attitude towards Hindu 172, *173, *181, *185, violence in, 30 cire perdue process, 25 deities, 17-18 Hinduism, 16 conch, 32-33, *164 *192, 193 auspicious signs, *44, beliefs, 13-14, 16, 59 cosmic beings, 220, *221 *125, *218 G differences from Jainism, See also lokapurusha beliefs, 13-16, 40-43, Gajalakshmi, *56, 228 22, 50, 59, 61 45, 46, 47-48, 51-52, Gajendravijayaji, *254, 255 early, 14 D pilgrimages, 66-67 58-61 gandharva, 26, *108, 109, Deccan, 20, 26 contributions to Indian similarities to Jainism, 14, *194 Deogarh, 21 philosophy, 58-59 18, 29-30, 33, 58 Ganesa, 34, *79, 107, *124, Devananda, 218 cosmic diagrams, 220, 170, *238, 239 Hoysala dynasty, 20, 28, 194 Dhandhala, 72 *221, *222, 223, *224, Ganga dynasty, 20 Dhara, 71 234, *235 Garuda, 26, 34, *181 Dharanendra, 32, 33, *34, cosmography, 220, 223, illuminated manuscripts *134, *135, 145, *146, Gauri, 36 231, 234 Gautamasvami, *222, 225 See painted manuscripts *154, *165, 166, *167, development of, 16-21 Girnar, *21, 28, 65, 67-68, Indra, 17, *50, *56, 74, 81, *182-83, 186, *187, 219, differences from Hinduism, 69, 71, 115 *155, 216, 228 226, *227 22, 50, 59, 61 Gomedha, *137, *142, *148 court of, *96, 210 Dharmadasagani, 219 image-worship, 15-16, 18 Gomukha, 33, 34, *53, hymn of, 46 Dharmaghosha, 70 monks, 40, 42-43, *44, *138, *248 as figure in Jain Dharmaruchi, 70 *45, 52, 53, 54n1, 65, mythology, 34 Greek influence, 103 dharmasastra, 57, 58 67, 68, *93, *96, *202 Mahavira and, 46, *92, guardian spirits, 16-17, 28, 32 Didarganj, 192 nuns, 40, *43, 53, 54n1, See also yaksha; yakshi *208, 209, 242 Digambaras, 15, 20, 21, 34, 67, *202, *217 Parsvanatha and, 226, *227 Gujarat, 13, 19, 21, 27, 52, 58, 40, 61, 139, 152 pantheon, 17, 26, 30-36 Rishabhanatha and, 152, commissioning of painted 91, 204, 229 pilgrimages, 63, 65-66, *240, 241 architects, 29 manuscripts, 92 67 - 74domestic shrines, 18, Indrani, 46, *208, 209, conflict with Svetambaras, ritual, 41-43, 46-53 *19, 24 241, 242 71,93 royal support, 20 Isat-pragbhara, 42 Krishna's popularity in, 33 lokapurushas, 231, similarities to Buddhism, metal sculpture, 25 *232-33 14, 15, 16, 18, Mughal styles in, 216 I mahavidya, 36 29-30, 33 painted manuscripts, 97 Jagadeva, 23–24, 172 monk, *217 Jain art: coexistence of similarities to Hinduism, Vaishnavism in, 206 philosophy, 60-61 14, 18, 29-30, 33, spiritual and sensual in, 28 Gulbarga, 166 pilgrimages, 63, 65 57, 58, 59, 61 female divinities in, 28 Gupta period, 20, 128, 129, shrines, *121, *132-33 under Muslim rule, 19 patrons, 22-23, *51, temples, 47 130, 192, 199 91-92, *246 worship, 22 gyanbazi (snakes and ladders), Diwali, 18, 58, 78 See also Digambaras; 86, *87, 157 domestic shrines, 18, *19, 24, Svetambaras Gyaraspur, 134 52, *108, 109, *112-13

Jaipur, 24, 252 Kankali Tila, 16, 25, 103, 105 Μ Meghamalin, 226 Jaisalmer, 90, 215 Mewar, 24, 217 karma, 13, 14, 41, 42, 43, Madhavanala, *215 Jambhala, 190 Madhya Pradesh, 13, 20, 26 53, 59 moksha, 13 Jambudvipa, 220, *222, 223, Karnataka, 13, 20, 21, 26, 163 Mahabharata, 33 Mother goddess, 17 *224, 225 architects, 23 Mahakali, 36 See also Ambika Janguli, 180 bronzes, 25, 181 Mount Abu, *21, 24, 28, 29, Mahamayuri, *90 Jinaprabhasuri, 70, 72, 104 cult of Dharanendra Maharashtra, 13, 27 65, 66, 193, 247 Jinas, 14, 33, 42, 60 in, 183 mahavidya, 36 Mount Meru, *50, 70, 209, bodily features of, 31 sculpture, 159, 162, 184 Mahavira, 14, 16, 31, 72, 83 220, *221, *222, 223, central life events of, 65 Karttikeya, 207 aided by gods, 17 *224, 241, 242 circle of, 242, *243, 244 Kashmir, 18 birth of, 26, 46, *48, *92, Mount Satrunjaya images of, *1, *2, 15, *16, kayotsarga, 31 *204, *208, 209, 218 See Satrunjaya *25, *27, 30, *31, *32, Khajuraho, 21, *28 renunciation of, *94, Muchalinda, 32 *33, *38, 46, *47, *48, Khambhat, 226 204, *205 Mughal period, 215, 217, 249 *49, 66, *71, *83, *87, kinnara, 26 samavasarana of, *149 Mughal style, 25, 81, 98, 216, kirtimukha, *90, 91, *107, *91, *94, *118, 119, in heaven, *211 225, 241 *159, *165, *183, *198-99 *120-24, *126-67 image of, *133, *140, murals, 25, 94 passim, 210, *211, *212, Krishna, 117, 207, *238, 239 Muslim: artistic influence 204 *143, *155 *213, *238, 239 relation to Neminatha, lustration of, 241, 242 artists, 24 lustration of, *50, 242 32-33, 115, 164, three worlds of, 231, destruction of Jain temples, offerings to, 50-51 169, 206 *232-33 72 postures of, 31 kshamapana patrika, 78 Mahisha, *238, 239 worship of, 43, 46, 49-52 Kshetrapala, *56, 228 Mahmud of Ghazni, 172 N See also Ajitinatha; Kuberadevata, 70, 104 Mallinatha, *139, 174 Nachna, 130 Arishtanemi; Mahavira; Kumarapala, 21, 72, 74, Malwa, 91 Namaskara Mantra, 49-50 Mallinatha: Neminatha: 91-92, 252 Mamluk Egypt, 95 Nanda, *207 Parsvanatha: Kundakunda, 58 Manasa, 34 Nand Chand, 130 Rishabhanatha: Kushan period, 22, 26, 36, 78, Manasollasa, 94 Nandisvara, *12, *120, Santinatha; Sumati; 128, 152, 170, 171 Manatungasuri, 46 *I2I, *222, 225 Suparsvanatha; Kushmandini, 34, *144 Manbhum, 153 Narada, *108, 109 Vasupujya See also Ambika mandala, 30, 80, 81 Narasimha II, 194 Jinasena, 128 Kuvalaya Mala Kaha, 77 lotus, *122-23 navagraha, 34 Jinesvarasuri, 145 See also yantra Navamuni, 177 L mandapa, *19, *112, 113 Nemichandra, 179 K Laghu Samgrahanisutra, *213 mango, 176, 177 Neminatha, 34, 36, 65, 69, 71, Kaivalya, 13 Lakulisa, *30 Manikya, 248 127, *128, 133, *137, Kalaka, 21, 97, 201, *203 letter of invitation, 30, 78, 84, Manjusri, 90 *142, *143, *144, *164, Kalakacharyakatha, 92, *96, *85, 86, *251 mantra, 81 169, *177, 178 97, *200-201; *203, Lilavati Prabandham, 179 marble, 28-29 marriage and renunciation 204, 210 Lohanipur, 16 Marudevi, 241 of, *114, 115, *116, *209 Kali, 30, 36 lokapurusha, 81, *82, 83, Matar, 213 origin of name, 164 Kali (yakshi), *106, 107 *221, *222, 225, *230, Mathen, 24, 78, 86 relation to Krishna, Kalikanda, 226 231, *232-33, 234, *235 Mathura, 20 32-33, 115, 164, Kalinga, 16 lotus, 27, 31 ayagapata from, 26 169, 206 mandala, *122-23 Kalpasutra, 46, *91, *92, *94, as birthplace of religious Nepal, 16, 226 *96, 133, 201, *202, Lunavasahi temple, 66, 117 iconography, 16 nirvana, 14 *203-5, *208-9, 210, inscriptions from, 22 nonviolence, 30, 59 *211, *212, 241, 242, 247 as pilgrimage place, 70 Kamakandala, *215 stupas in, *25 Kambadahall, 165 Vaishnavism in, 128

O	samavasarana of, 145,	Rashtrakuta dynasty, 20	Sarasvati, 17, 18, *23, *26, 36,		
Orissa, 25	*146, *150	Ravisena, 120	53, *79, 90, 107, *171,		
O1155a, 25	scenes from life of, *83, 84,	Rishabhanatha, *25, *27, 34,	172, *173, 225, 226, *229		
P	226, *227	*41, *47, 65, 66, 84, 120,	Sarnath, 27, 142		
padmasana, 31	temple, *24	*132-33, *152, *153,	Sarvanubhuti, 33, 143, *144		
Padmavati, 33, 34, *134, *135,	Parvati, *238, 239	*155, *181, 248, 250	sasanadevata, 33		
145, *146, *154, *165,	pata, 25, 77	as combined form of Siva,	Satrunjaya, *28, 65, 66		
166, *167, *180, 186,	narrative, *83, 84, *85,	Vishnu, and Brahma,	Muslim devastation		
*187, 219	86, 226, *227, *256, 257	31-32	of, 107		
	tantric, *56, 77-78, *79,	hairstyle of, 152	pilgrimage pictures of,		
painted manuscripts, 25, 29,	*80, 81, *82, 83, *222,	lustration of, 241	*62, *64, *68–69, *73,		
*88–99 passim,	223, *224, 225–26,	marriage of, *212	84, 252, *253		
*198–221 passim	228, *229-33,	samavasarana of, *136, *138	reliefs from, *106, *107 Satrunjaya Mahatmya, 252 Saudharmendra, 34		
colors, 97	234, *235	ritual, 39–40			
covers, *90, *95, *198—99, *218, 220, *221	See also pilgrimage paintings	rock crystal, 122, *123,			
3000000000 V. 100000000 V. 1000000000	Patan, 52, 90, 92	145, *146	sculptors, 24		
earliest, 93	pato, *44, 45, *125	rosary, 52	serpent, 32		
Hindu, 206, *207	Phalavaddhi, 72	10341 y, 32	See also Dharanendra Sesha, *207		
manufacture of, 90	pilgrimage: paintings, 25, 30,	S			
as miniature murals, 94	*62, *64, *68–69, *73, 78,	Sachika, *17, 23, 180	siddhachakra, 242, *243, 244		
Mughal style, 98	84, 252, *253	Sadhadeva, *247	Siddharaja Jayasimha, 107		
origin, 89	shrine, *52	Sadyojata, 32	Simhanandi, 20		
on paper, 95	Prabandhakosa, 17–18	Sagalika, 120	Sirohi, 251		
patronage of, 91–92		Sahi, 97, *203	Siva, 20, *30, 32, 66, *79,		
Persian influence on, 97	Prajnaparamita, 90	Saivism, 20, 257	*207, *238, 239		
talismanic purposes,	Pratyangira, *56, 80–81, 228 Pravachanasara, 58	Sakra, 17	Sivamkara, 72		
90-91	Pravacnanasara, 50 Pundarika, 66	Sakti, 35	Sivanaga, 23		
See also Kalakacharyakatha;		samavasarana, 29, *48, 49, *76,	Skandagupta, 22		
Kalpasutra	Purnabhadra, 190, *191	86, 120, *213, 236, *237	Skanda-Kumara, 170		
paintings: on metal, 78	Pushpottara heaven, *211	ayagapata as precursor	snakes and ladders		
on paper, *38, *45, *47,	R	of, 26	See gyanbazi		
*50, 236, *237, *238,		of Neminatha, 115	Sobhanadeva, 24		
239, *240, 241, 242,	Radha, *238, 239	of Parsvanatha, 226, *227	Solanki dynasty, 21, 90,		
*249, 250, *254, *255	Rai Jabha Chand, *47, 250	of Rishabhanatha,	107, 199		
Pala period, 122, 154, 180	Rajasthan, 13, 21, 25, 52, 91		Somasundara, 67		
Palitana, 28	architects, 29	*136, *138	Sonkh, 103, 169		
Pallava kingdom, 20, 156	artists, 24	Samgrahanisutra, *98, *214,	Sramanical tradition, 14, 18,		
Panchameru shrine, *222, 225	Krishna's popularity	216, 233	20, 57–58		
Parsva, 226, *227	in, 33	Samkara, 58–59	Sravana Belgola, 20, 28, 65		
Parsvanatha, 14, 23, *28, 31,	marriage between Hindus	Samkhya philosophy, 58,	Sri Chandrasuri, 213		
34, 67, 69, 72, *80,	and Jains in, 58	59, 60	Sri Harsha, 17–18		
*132-33, *138, *143,	Mughal style in, 216	Sammeda-sikhara, 65, *67, 254	Sri-Lakshmi, 18, 34, *108,		
*154, *156, *159, 162,	Sachika's popularity in,	Samvara, *32, 134, *135	109, 110, *111		
*165, 166, *167, 180, 226,	180	Samyuta Nikaya, 77	Sripala, *256, 257		
*227, 228	Rajnapur Khinkini, 171	Sanchi, 25, 103	Sripalarasa, 257		
association with snake, 32	Rajput style, 81	Sankhesvara, 69, 226	Sri Sarasthana, 247		
attacked by Samvara, *32,	Ramayana, 33	Sanskrit, 58	srivatsa, 31		
*134, *135, 183	Ranakpur, 29, 196	Santinatha, *88, 142, 146,	311 valsa, 31		
cosmic representation		*147, 148, 180, 194, 219			
of, 234, *235		Santisvara Basti, 194			
enthroned, *88, 219		Sarada, 18			
Landard and the con-					

lustration of, 241

stamana, 14	temple, *21, 26, *28–29	Vamadeva, 32	Y		
Stambhana, 67, 71	construction, 24, 66	Vanaraja, 21	Yaganidra, 30		
Stambhatirtha, 206	destruction, 28	Vardhamana, 120	yaksha, 16, 26, 33–34,		
steles, *27, *136, *137, *144,	images, 48-53	Varisena, 120	53, *88, 120, 130, *163,		
*154, *174	libraries, 92	Vasantavilasa, 78, 207	*184, *185, *235, *247		
stupas, 16, *25, 70, *102,	offerings, 50, *51	Vasantgadh, 23, 192	See also Dharanendra;		
*103, 104	ritual, 46–53	Vastupala, 21, 24, 66	Gomedha; Gomukha;		
Sulochana, 188, *189	See also Adinatha temple;	Vasudeva-Krishna, 32, 127,	Gomedna; Gomukna; Parsva; Purnabhadra;		
Sumati, *124	Girnar; Lunavasahi	*128, 144, *214	Sarvanubhuti		
Sumtsek temple, *95	temple; Mount Abu,	Vasuki, 32			
Sunga period, 199	Satrunjaya; Sumtsek	Vasupujya, *175	yakshi, 16, 26, 33, 34, 53,		
Suparsvanatha, 70, *71,	temple; Vadi-	Vedanta philosophy,	*88, *105, 120, *184,		
*159, *162	Parsvanatha temple;	58–59, 60	*185, *188, *235, *247		
Surat, 257	Vimala temple	70–59, 00 Vedas, 14, 171	See also Ambika;		
suri mantra pata	textiles: canopy, *244, 245		Chakresvari; Didarganj;		
See under yantra	embroidery, 242, *243, 244	Vedic religion, 16–17, 34,	Kali; Padmavati		
Surya, *56, 66, *136, 228		36, 57	yantra, 18, 25, 29–30,		
Svetambaras, 15, 21, 34, 40,	wall hanging, 244, *245	vegetarianism, 45, 59	77-78, 80-83		
54n2, 61	See also pato throne-back, *179	victory banner, 78, *79,	siddhapratima, *49, *124		
ascetic, *249	Tibet, 226	225-26	suri mantra pata, 78, *80,		
conflict with Digambaras,		vidya, 36	81, 228, *229		
	Tihuyanadevi, 17	vidyadevi, 33, 36, *95, *143	vijay, 78, *79		
71, 93 domestic shrines, 18, 52	tilakaratna, *118, 119	Vijairaj 11, 90	See also victory banner		
	Timurid Persia, 95	Vijayachandra, 67–68	Yasoda, *207		
images, 48, 66	Tripura, 17	Vimala temple, *21, *29, 109	yati, 78		
lokapurushas, *230, 231,	triratna, *15, *104	Vira Ballala 11, 194	Yoga philosphy, 58, 59, 60		
234, *235	Trisala, *48, *204, *208,	Vishnu, 31, 66, *79, 206, 225	yogi, 30, 160		
mahavidya, 36 monks, *80, *96, 206,	209, 218	association with yogi, 30			
	Trishashtisalakapurushacharita,	in cosmic sleep, *207			
*215, 226, *227, 228	128, 186	serpent and, 32			
pato, *125	Tularam, 81	See also Krishna;			
patronage of painted	1.1	Vaishnavism;			
manuscripts, 91, 92	U	Vasudeva-Krishna			
philosophy, 60, 61	Udaygiri, 23	Vissuddhimagga, 77			
pilgrimage painting, 84	Umasvati, 58, 60	Vividhatirthakalpa, 104, 120			
pilgrimages, 63, 65, 70-72	umbrella, three-tiered, 27, 30	Vodva stupa, 104			
teachers, *254–55	Upadesamala, *88, 219	votive tablet			
temples, 47	Upanishads, 58	See ayagapata			
T	Uttaradhyayanasutra, 94, *96,	Vrishabhanatha, 31–32			
T	97, 206, 214	vyantaradevata, 33, 34			
Tamilnadu, 20, 25, 26, 160	Uttar Pradesh, 16, 20, 26, 133				
tantric: beliefs, 18, 29, 35, 36		W			
paintings, 29–30, *56,	V	Western-Indian style, 81, 84,			
77-78, *79, *80,	Vadi-Parsvanatha temple,	94-95, 97, 98, 99112,			
81, 228, *229	110, *111	205, 209, 210, 216			
Tatpurusha, 32	Vairoti, *143	wheel, *27			
Tattvarthasutra, 58, 60	Vaishnavi, 34, 181	wish-fulfilling tree, *179			
Tejahpala, 21, 24, 66, 117, 246	Vaishnavism, 32–33,	woodwork, 18, *19, 24, *108,			
	127-28, 206	109–10, *111–14,			
	Vajrankusa, 36	115, *116			
	Vajrasrinkhala, 36				
	V-1-1-1-1:				

Valabhi, 21, 141

Photo Credits

Unless otherwise noted, all photographs are courtesy of the lender; f. = figure; c. = catalog no.

Ranjit K. Datta Gupta: f. 2, 10-11, 14, c. 1-3, 7-10, 17-18, 22, 24, 26, 40, 49, 55-56, 63, 70-71, 79, 82, 112-13; Robert Del Bonta: f. 5; Courtesy Victoria and Albert Museum: f. 6-7, 18, 54, 60; Stephen Markel: f. 9, 16-17; Roy Craven: f. 15; Barbara Lyter, LACMA: f. 19—20, c. 12, 14-15, 46, 47A, 61, 73, 95-96, 98в, 103, 105, 109, 117, 119B-120; John Cort: f. 29, 38, 40-41; Steve Oliver: f. 37; David Cripps: f. 61; Peter Schälchli: c. 16, 19; Sotheby's: c. 23; Owen Murphy: c. 25, 45, 60, 67; Graydon Wood:

c. 27; Smithsonian photo/Rob Harrell: c. 28—29, 478, 65;
Noel Allum: c. 33; Shin Hada: c. 39, 75; Lacma: c. 43, 64, 74A, 83, 85—86, 89, 91, 101, 104; Howard Agriesti, Cleveland Museum of Art: c. 50; Spink and Son, Ltd., London: c. 53; Robert Newcombe: c. 68a; Maggie Nimkin: 74B; Paul Macapia: c. 77A; Prudence Cuming Associates Limited: c. 97; Ron Jennings: c. 102; Ann Hutchison: c. 111.

Accession Numbers for Catalogue Entries

Ι.	J-555	29.	1991.28	59.	м.1974.16.04.s	82.	55.65
2.	J.20	30.	м.71.26.38	61.	м.90.165	84.	IS 2-1972
3.	J-275	31.	1991.36	62.	ıs 61-1963	87.	1990:190
4A.	ıм 10 3 -1916	32.	N.74.13.7.s	63.	391/57	92.	1983.515
4B.	ıм 76-1916	34.	930 is	65.	1991.44	93.	182-1984
4C.	ıм 9 3 -1916	35.	is 10.1968	68a.	51-26	94.	м.88.222.1а,b
4D.	ıм 85-1916	37.	F.1975.17.22.s	68в.	49.93	99.	ıм 89-19 3 6
5.	IM 342-1910	40.	9243/A24370	69a.	F.1975.17.07.s	102.	68.8.112
6.	16.133	41.	в63s21+	69в.	F.1975.17.08.s	103в.	sa 38150
7.	38.14	42.	1872.7-1.99	70.	CMN/C/148/10	106.	1990:212
9.	22.2025	44A.	1987.142.339	71A.	119	107A.	м.1048.4
10.	48.3426	44B.	1880.241	71в.	121	108.	AC1992.170.2
13.	1990.140	46.	м.82.6.2	72A.	939.17.20; roma 2538	IIO.	78.5/9 and 78.5/5
17.	J.121	47B.	1991.22	72в.	1872.7-1.65	III.	92.162
18.	J.104	48.	F.1975.17.06.s	73.	м.88.33	112.	127
20.	м.85.55	49.	108.49	76.	IM 302-1920	113.	428
21.	ıs 18-1956	51.	1880.5	77A.	64.24	114.	67.244
22.	J.M.S.I./A25111	52A.	931	77в.	M.71.73.132	115A.	м.71.1.21
24.	212	52B.	ıs 937	78.	м.80.62	115в.	м.81.271.5
26.	J.885	55.	J.24	79.	876/A.	116.	MS 26
28.	1991.43	56.	CMN/c/148/11	80.	71.126	118.	ıs 541-1883
		57в.	м.86.83	81.	1990:0179		84.118.2
		58.	M.77.49			121.	324-1972

County of Los Angeles

BOARD OF SUPERVISORS,

1994

Yvonne Brathwaite Burke

Chairman

Michael D. Antonovich

Deane Dana

Edmund D. Edelman

Gloria Molina

CHIEF ADMINISTRATIVE

OFFICER AND DIRECTOR

OF PERSONNEL

Sally Reed

Los Angeles County Museum of Art Board of Trustees, Fiscal Year 1994–95

Robert F. Maguire III

Chairman

William A. Mingst

President

Daniel N. Belin

Chairman of the

Executive Committee

James R. Young

Secretary/Treasurer

Mrs. Howard Ahmanson

William H. Ahmanson

Robert O. Anderson

Mrs. Lionel Bell

Dr. George N. Boone

Donald L. Bren

Mrs. Willard Brown

Mrs. B. Gerald Cantor

Mrs. William M. Carpenter

Mrs. Edward W. Carter

Hans Cohn

Robert A. Day

Jeremy G. Fair

Michael R. Forman

Mrs. Camilla Chandler Frost

Julian Ganz, Jr.

Herbert M. Gelfand

Arthur Gilbert

Stanley Grinstein

Robert H. Halff

Felix Juda

Mrs. Dwight M. Kendall

Cleon T. Knapp

Mrs. Harry Lenart

Herbert L. Lucas, Jr.

Steve Martin

Sergio Muñoz

Mrs. David Murdock

Mrs. Barbara Pauley Pagen

Mrs. Stewart Resnick

Dr. Richard A. Simms

Michael G. Smooke

Ray Stark

Mrs. Jacob Y. Terner

Frederick R. Weisman

Walter L. Weisman

David L. Wolper

Julius L. Zelman

Selim K. Zilkha

Honorary Life Trustees

Robert H. Ahmanson

The Honorable Walter H.

Annenberg

Mrs. Anna Bing Arnold

R. Stanton Avery

B. Gerald Cantor

Edward W. Carter

Mrs. Freeman Gates

Joseph B. Koepfli

Eric Lidow

Mrs. Rudolph Liebig

Dr. Franklin D. Murphy

Mrs. Lucille Ellis Simon

Mrs. Lillian Apodaca Weiner

Past Presidents

Edward W. Carter

1961-66

Sidney F. Brody

1966-70

Dr. Franklin D. Murphy

1970-74

Richard E. Sherwood

1974-78

Mrs. F. Daniel Frost

1978-82

Julian Ganz, Jr.

1982-86

Daniel N. Belin

1986-90

Robert F. Maguire III

1990-94

THE PEACEFUL LIBERATORS

Jain Art from India

EDITED BY THOMAS FRICK

DESIGNED BY SANDY BELL

C A T A L O G U E P H O T O G R A P H Y

S U P E R V I S E D B Y

B A R B A R A L Y T E R

20

Text type composed in Kaatskill No. 976, designed by F. W. Goudy in 1929. Adaptation for Sanskrit by Scott Taylor. Display type composed in Charlemagne and Kaatskill typefaces. Printed in Hong Kong by Global Interprint.